THE CAMBRIDGE COMPANION TO

Piero della Francesca

A great master of the early Renaissance, Piero della Francesca created paintings for ecclesiastics, confraternities, and illustrious nobles throughout the Italian peninsula. Since the early twentieth century, the rational space, abstract designs, lucid illumination, and naturalistic details of his pictures have attracted a wide audience. Piero's treatises on mathematics and perspective also fascinate scholars in a wide range of disciplines. *The Cambridge Companion to Piero della Francesca* brings together new essays that offer a synthesis and overview of Piero's life and accomplishments as a painter and theoretician. They explore a variety of themes associated with the artist's career, including the historical and religious circumstances surrounding Piero's altarpieces and frescoes; the politics underlying his portraits; the significance of clothing in his paintings; the influence of his theories on perspective and mathematics; and the artist's enduring fascination for modern painters and writers.

Jeryldene M. Wood is Associate Professor of Art History at the University of Illinois, Urbana-Champaign. A scholar of Renaissance art, she has contributed to *Art History* and the *Renaissance Quarterly* and is the author of *Women, Art and Spirituality: The Poor Clares of Early Modern Italy.*

THE CAMBRIDGE COMPANION TO

Piero della Francesca

Edited by

Jeryldene M. Wood
University of Illinois, Urbana-Champaign

CAMBRIDGE
UNIVERSITY PRESS

PUBLISHED BY THE PRESS SYNDICATE OF THE UNIVERSITY OF CAMBRIDGE
The Pitt Building, Trumpington Street, Cambridge, United Kingdom

CAMBRIDGE UNIVERSITY PRESS
The Edinburgh Building, Cambridge CB2 2RU, UK
40 West 20th Street, New York, NY 10011–4211, USA
477 Williamstown Road, Port Melbourne, VIC 3207, Australia
Ruiz de Alarcón 13, 28014 Madrid, Spain
Dock House, The Waterfront, Cape Town 8001, South Africa

http://www.cambridge.org

First published 2002

Printed in the United Kingdom at the University Press, Cambridge

Typeface Fairfield Medium 10.5/13 pt. *System* QuarkXPress® [GH]

A catalog record for this book is available from the British Library.

Library of Congress Cataloging-in-Publication Data

The Cambridge companion to Piero della Francesca / edited by Jeryldene M. Wood.
 p. cm. – (Cambridge companions to the history of art)
 Includes bibliographical references and index.
 ISBN 0-521-65254-5 – ISBN 0-521-65472-6 (pbk.)
 1. Piero, della Francesca, 1416?–1492 – Criticism and interpretation. 2. Art,
Renaissance – Italy. 3. Art, Italian – 15th century. I. Wood, Jeryldene. II. Series.

ND623.F78 C26 2002
759.5 – dc21 2001043485

ISBN 0 521 65254 5 hardback
ISBN 0 521 65472 6 paperback

To Arthur

Contents

List of Illustrations

FIGURES

Acknowledgments

I am grateful to Beatrice Rehl, Senior Editor at the Cambridge University Press, for inviting me to work on Piero della Francesca and for her sound advice and enthusiastic support as the project unfolded. The National Gallery of Art generously granted permission to republish Marilyn Aronberg Lavin's essay, "Piero's Meditation on the Nativity," in *Piero della Francesca and His Legacy* (Studies in the History of Western Art 48, National Gallery of Art, 1995). Support from the Research Board at the University of Illinois, Urbana-Champaign, funded the research assistance of Jill Blondin, who tracked down the numerous bibliographic sources needed to prepare this volume. The contributors to this book have taught me much about Piero's oeuvre; their insights into the material have considerably influenced my own reconsiderations of the artist's paintings. I am particularly obliged to Marilyn Lavin for her careful reading of my essay on the Aretine frescoes, which has benefited from her corrections and recommendations. Friends and colleagues, including Diane Cole Ahl, Paul Barolsky, Anne Barriault, Andrew Ladis, Janet Smith, Gail Solberg, and Shelley Zuraw, offered constructive comments and raised stimulating questions that also have enriched this volume. Most of all, I thank my husband, Arthur Iorio, for his judicious criticism and for his willingness to engage in countless conversations about Piero's work over the last three years. I gratefully dedicate this book to him.

Contributors

Diane Cole Ahl is Arthur J. '55 and Barbara S. Rothkopf Professor of Art History and Head of the Department of Art at Lafayette College, and former president of the Italian Art Society. Her books include *Benozzo Gozzoli* (1996), which was co-awarded the Otto Gründler Prize in Medieval Studies, and *Leonardo da Vinci's Sforza Monument Horse: The Art and the Engineering* (1995), of which she was editor. She co-edited, with Barbara Wisch, *Confraternities and the Visual Arts in Renaissance Italy: Ritual, Spectacle, Image* (2000) and is the editor of the forthcoming *Cambridge Companion to Masaccio*.

Anne B. Barriault, writer-editor at the Virginia Museum of Fine Arts, is the author of *Spalliere Painting of Renaissance Tuscany* (1994), *Selections: Virginia Museum of Fine Arts,* and articles in the *Gazette des Beaux-Arts* and *Arts in Virginia*. She has been the recipient of an NEA Fellowship for Museum Professionals (1990), a Milliard Meiss Publications Grant, College Art Association (1992), and The Communicator and The Telly Awards for Video Scriptwriting (*The Fine Art of Life,* Virginia Museum of Fine Arts, 1999).

Jane Bridgeman is Programme Secretary of the Medieval Dress and Textile Society. A graduate of Birmingham University and the Courtauld Institute of Art, she was a Senior Lecturer in the History of Art and Design at Winchester School of Art. Dr. Bridgeman has published articles and essays on Piero della Francesca, Ambrogio Lorenzetti, Dosso Dossi, and Giovanni Battista Moroni.

Margaret Daly Davis is an art historian and academic librarian at the Kunsthistorisches Institut in Florence, Italy. She is the author of *Piero della Francesca's Mathematical Treatises: The "Trattato d'Abaco" and the "Libellus de quinque corporibus regularibus"* (1977) and of an exhibition catalogue on books of archaeology, 1500–1700, in the Herzog August Bibliothek, Wolfenbüttel (1994).

J. V. Field, who is an Honorary Visiting Research Fellow in the School of History of Art, Film and Visual Media, Birkbeck College, University of London, is the author of *The Invention of Infinity: Mathematics and Art in the Renaissance*

(1997, reprinted 1999) and has just completed *Piero della Francesca: A Mathematician's Art.*

Philip Jacks, Associate Professor of Fine Arts and Art History at George Washington University, is the author of *The Antiquarian and the Myth of Antiquity: The Origins of Rome in Renaissance Thought* (1993) and the editor of *Vasari's Florence: Artists and Literati at the Medicean Court* (1998). His most recent book, co-written with William Caferro, *The Spinelli of Florence: Fortunes of a Renaissance Merchant Family* (2001), explores the worlds of commerce and architectural patronage during the fifteenth century.

Marilyn Aronberg Lavin, a well-known authority on Piero della Francesca, has written four books, edited *Piero della Francesca and his Legacy* (1995), and published numerous essays and articles on the artist. Among her other publications are *Seventeenth-Century Barberini Documents and Inventories of Art* (1975), which received the Charles Rufus Morey Award for Distinguished Scholarship of the College Art Association, and *The Place of Narrative: Mural Decoration in Italian Churches, 431–1600 A.D.* (1990), for which she won first place in the 1991 Chicago Women in Publishing award competition. Dr. Lavin is also the Moderator of the Consortium of Art and Architectural Historians, an international computer listserve open to scholars and students in the field.

Timothy Verdon, a Canon of Florence Cathedral, is the Director of the Office for Catechesis through Art in Florence, a member of the Board of Directors of the Foundation and Museum of Santa Maria del Fiore, and Consultant to the Vatican Commission for the Cultural Heritage of the Church, as well as a Visiting Professor of Art History at Stanford University in Florence. In addition to numerous essays and articles on religion and art, he is the editor or co-editor of several books, including *Monasticism and the Arts* (1985), *Christianity and the Renaissance* (1990), *Alla riscoperta di Piazza del Duomo* (volumes 1–7, 1992–98), and the three-volume *Atti del VII Centenario di Santa Maria del Fiore* (2001). Monsignor Verdon has been a Fellow at the Harvard University Center for Italian Renaissance Studies (Villa I Tatti) and is an Honorary Member of the Accademia delle Arti del Disegno in Florence.

Jeryldene M. Wood, Associate Professor of Art History at the University of Illinois, Urbana-Champaign, is the author of *Women, Art, and Spirituality: The Poor Clares of Early Modern Italy* (1996). Her articles have appeared in *Art History, Renaissance Quarterly,* and *Konstihistorisk Tidskrift.*

Joanna Woods-Marsden is Professor of Art History at the University of California, Los Angeles. Her publications include *The Gonzaga of Mantua and Pisanello's Arthurian Frescoes* (1988) and *Renaissance Self-Portraiture: The Visual Construction of Identity and the Social Status of the Artist* (1998), as well as numerous articles, most recently on Renaissance portraiture. Dr. Woods-Marsden has received fellowships from the Harvard Center for Renaissance Studies in Florence (Villa I Tatti), the American Academy in Rome, the Center for Advanced Study in the Visual Arts in Washington, DC, the National Humanities Center in North Carolina, and the National Endowment for the Humanities.

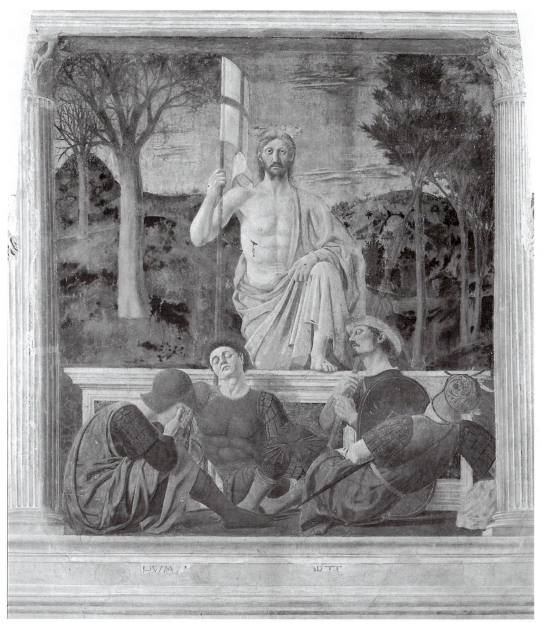

Plate 1. Piero della Francesca, *Resurrection,* Sansepolcro, Pinacoteca Comunale (Photo: Scala/ Art Resource, NY).

Plate 2. Piero della Francesca, Misericordia Altarpiece, Sansepolcro, Pinacoteca Comunale (Photo: Scala/Art Resource, NY).

Plate 3. Piero della Francesca, *Sigismondo Malatesta before Saint Sigismondo*, Rimini, Tempio Malatestiano (Photo: Scala/Art Resource, NY).

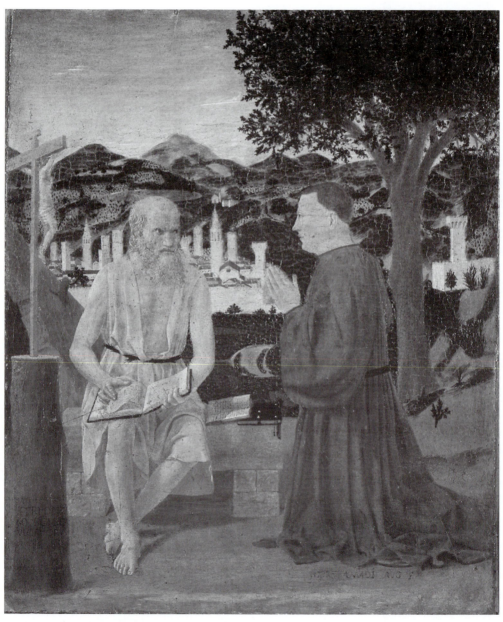

Plate 4. Piero della Francesca, *Girolamo Amadi Kneeling before Saint Jerome*, Venice, Accademia (Photo: Scala/Art Resource, NY).

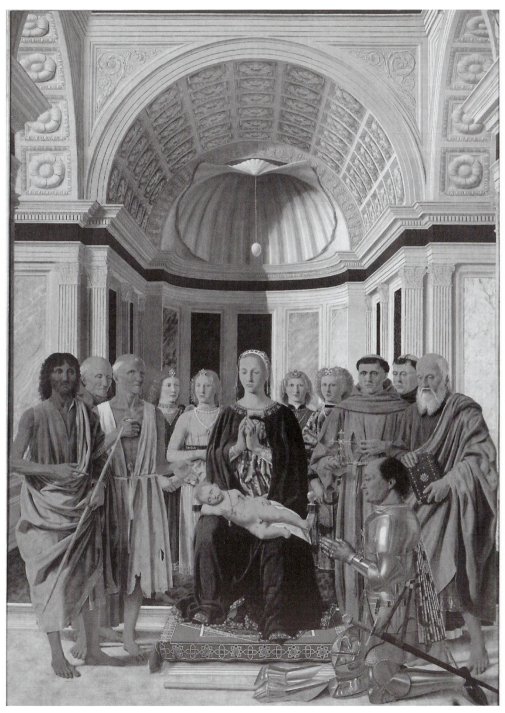

Plate 5. Piero della Francesca, Brera Altarpiece, Milan, Pinacoteca del Brera (Photo: Scala/Art Resource, NY).

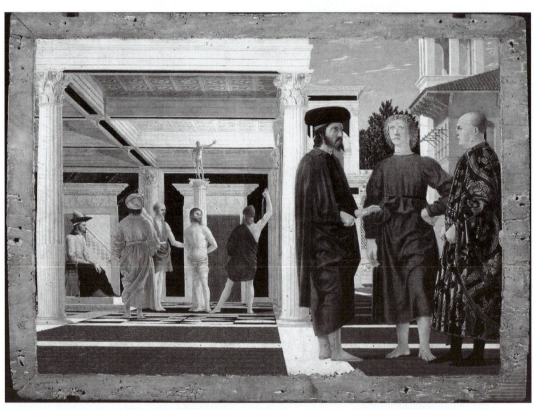

Plate 6. Piero della Francesca, *Flagellation of Christ,* Urbino, Galleria delle Marche (Photo: Scala/Art Resource, NY).

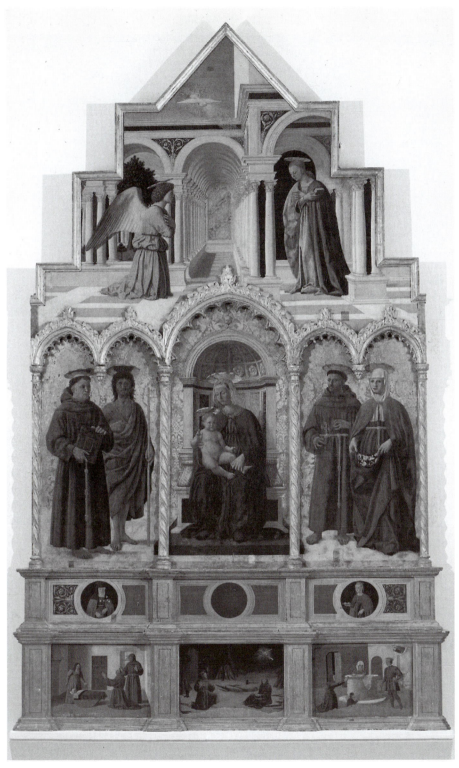

Plate 7. Piero della Francesca, Sant'Antonio Altarpiece, Perugia, Galleria nazionale dell'Umbria (Photo: Scala/Art Resource, NY).

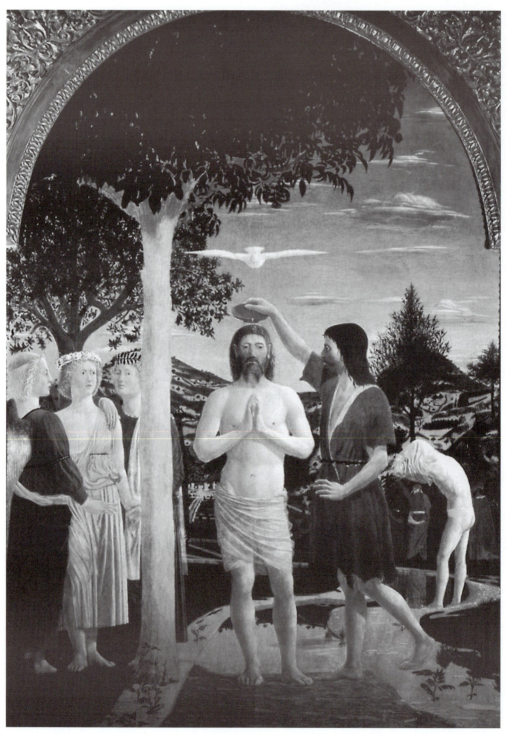

Plate 8. Piero della Francesca, *Baptism of Christ,* London, National Gallery (Photo: Erich Lessing/Art Resource, NY).

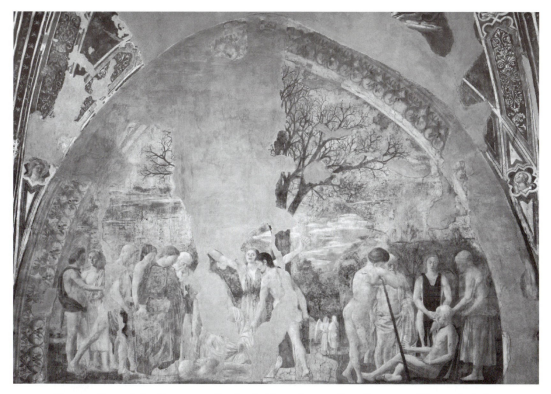

Plate 9. Piero della Francesca, *Death of Adam*, Arezzo, San Francesco (Photo: Scala/Art Resource, NY).

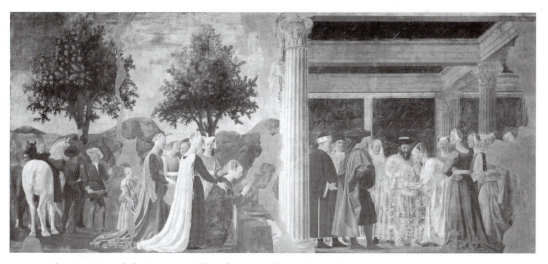

Plate 10. Piero della Francesca, *The Adoration of the Holy Wood* and *The Meeting of King Solomon and the Queen of Sheba*, Arezzo, San Francesco (Photo: Scala/Art Resource, NY).

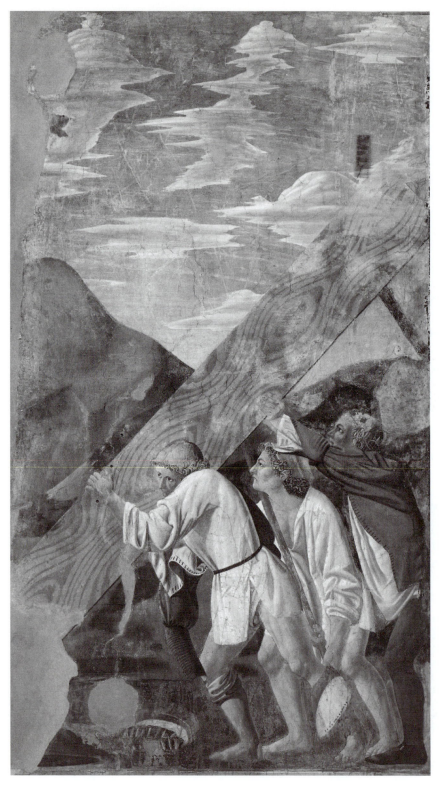

Plate 11. Piero della Francesca, *Transport of the Wood*, Arezzo, San Francesco (Photo: Scala/Art Resource, NY).

Plate 12. Piero della Francesca, *Vision of Constantine*, Arezzo, San Francesco (Photo: Scala/Art Resource, NY).

Plate 13. Piero della Francesca, *Battle of Constantine and Maxentius,* Arezzo, San Francesco
(Photo: Scala/Art Resource, NY).

Plate 14. Piero della Francesca, *Torture of the Jew,* Arezzo, San Francesco (Photo: Scala/Art Resource, NY).

Plate 15. Piero della Francesca, *Discovery and Proving of the True Cross*, Arezzo, San Francesco
(Photo: Scala/Art Resource, NY).

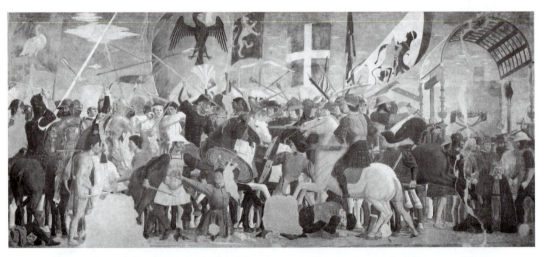

Plate 16. Piero della Francesca, *Battle of Heraclius and Chosroes*, Arezzo, San Francesco (Photo:
Scala/Art Resource, NY).

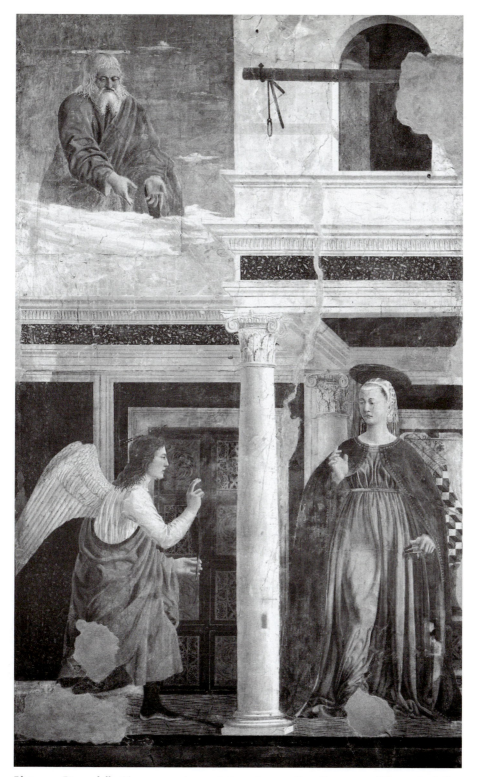

Plate 17. Piero della Francesca, *Annunciation,* Arezzo, San Francesco (Photo: Scala/Art Resource, NY).

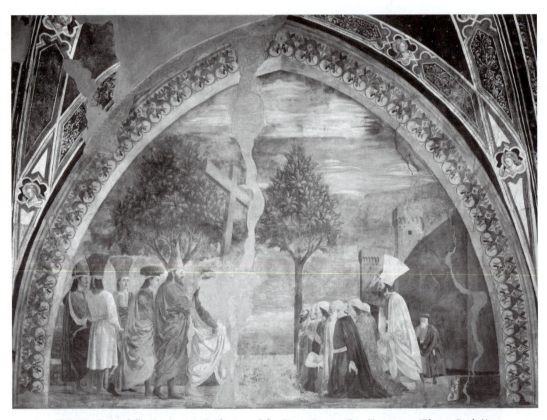

Plate 18. Piero della Francesca, *Exaltation of the Cross,* Arezzo, San Francesco (Photo: Scala/Art Resource, NY).

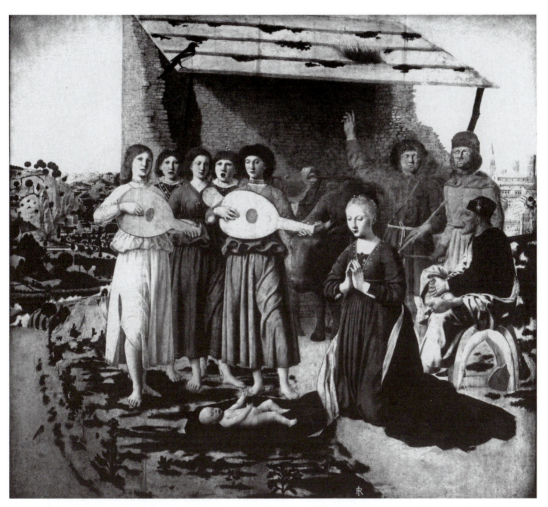

Plate 19. Piero della Francesca, *Adoration of the Child*, London, National Gallery (Photo: Anderson/
Art Resource NY).

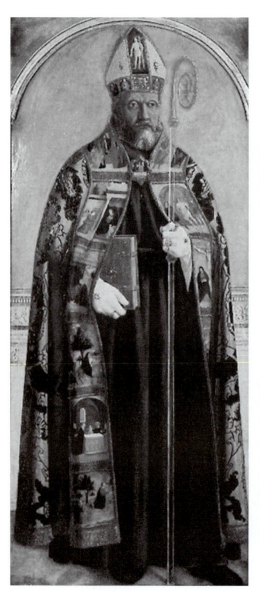

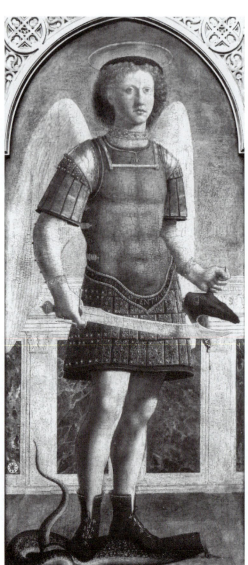

Plate 20. Piero della Francesca, *Saint Augustine*, Sant'Agostino Altarpiece, Lisbon, Museu de Art Antiqua (Photo: Nicholas Sapieha/Art Resource, NY).

Plate 21. Piero della Francesca, *Saint Michael*, London, National Gallery (Photo: Anderson/Art Resource NY).

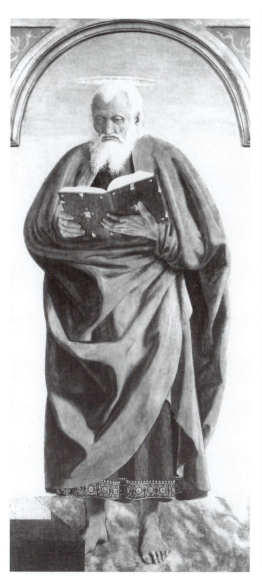

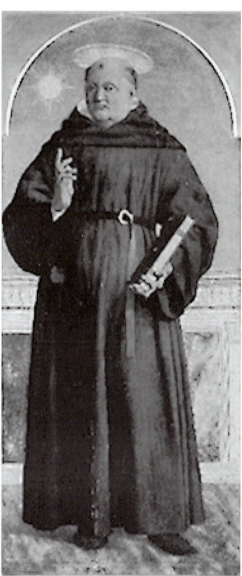

Plate 22. Piero della Francesca, *Saint John the Evangelist*, New York, Frick Collection (Photo: Copyright The Frick Collection, New York).

Plate 23. Piero della Francesca, *Saint Nicholas of Tolentino*, Sant'Agostino Altarpiece, Milan, Poldi Pezzoli Museum (Photo: Art Resource, NY).

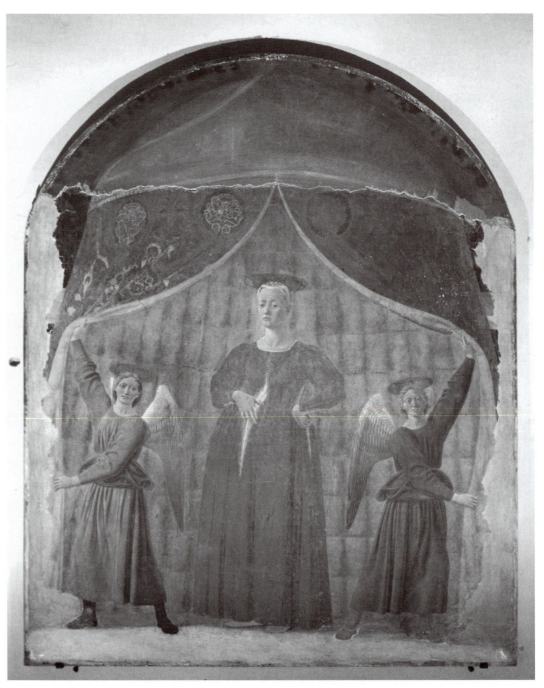

Plate 24. Piero della Francesca, *Madonna del Parto*, Monterchi (Photo: Scala/Art Resource, NY).

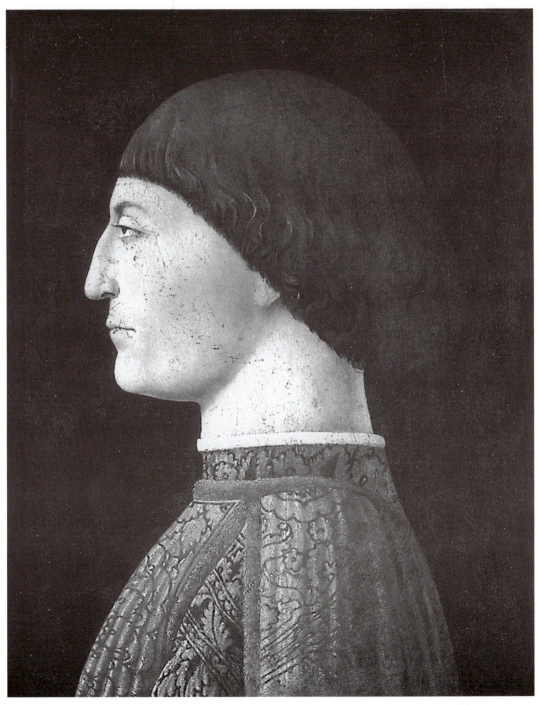

Plate 25. Piero della Francesca, *Portrait of Sigismondo Malatesta,* Paris, Musée du Louvre (Photo: Giraudon/Art Resource, NY).

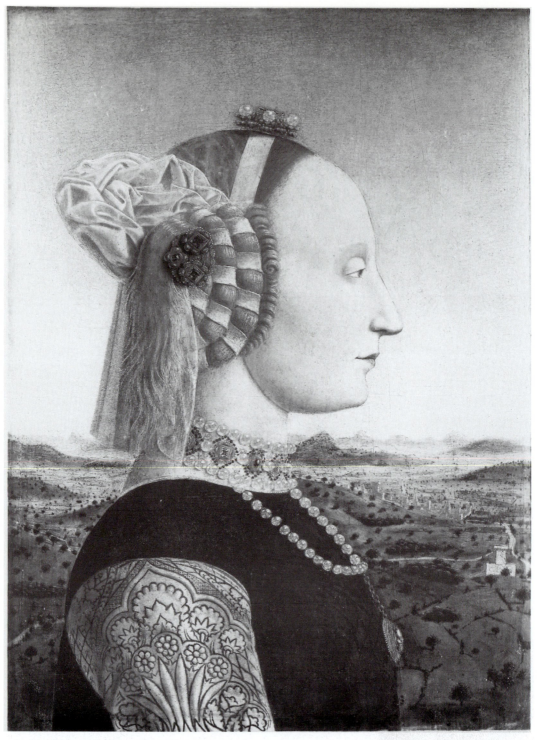

Plate 26. Piero della Francesca, *Portrait of Battista Sforza*, Florence, Galleria degli Uffizi (Photo: Alinari/Art Resource NY).

Plate 27. Piero della Francesca, *Portrait of Federigo da Montefeltro,* Florence, Galleria degli Uffizi
(Photo: Alinari/Art Resource NY).

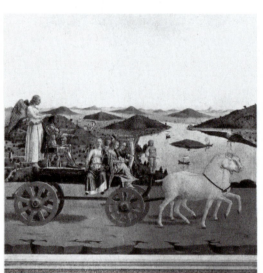

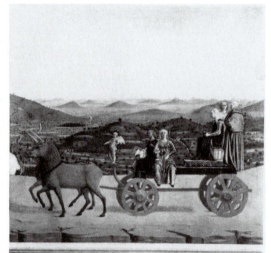

CLARVS · INSIGNI · VEHITVR · TRIVMPHO ·
QVEM · PAREM · SVMMIS · DVCIBVS · PERHENNIS ·
FAMA · VIRTVTVM · CELEBRAT · DECENTER ·
SCEPTRA · TENENTEM

QVEMODVM · REBVS · TENVIT · SECVNDIS ·
CONIVGIS · MAGNI · DECORATA · RERVM ·
LAVDE · GESTARVM · VOLITAT · PER · ORA ·
CVNCTA · VIRORVM ·

Plate 28. Piero della Francesca, *Triumph of Federigo da Montefeltro,* Florence, Galleria degli Uffizi (Photo: Alinari/Art Resource NY).

Plate 29. Piero della Francesca, *Triumph of Battista Sforza,* Florence, Galleria degli Uffizi (Photo: Alinari/Art Resource NY).

Introduction

Jeryldene M. Wood

Piero della Francesca (ca. 1415/20–92) painted for ecclesiastics, confraternities, and the municipal government in his native Sansepolcro, for monks and nuns in the nearby towns of Arezzo and Perugia, and for illustrious nobles throughout the Italian peninsula. Justly esteemed as one of the great painters of the early Renaissance, Piero seems to balance abstraction and naturalism effortlessly, achieving unparalleled effects of quiet power and lyrical calm in such masterpieces as the *Resurrection* for the town hall of Sansepolcro and the *Legend of the True Cross* in the church of San Francesco at Arezzo (Plate 1 and Fig. 9). In these paintings, as throughout his oeuvre, clear, rationally conceived spaces populated by simplified figures and grand architecture coexist with exquisite naturalistic observations: reflections on the polished surfaces of gems and armor, luminous skies, and sparkling rivers and streams. The sixteenth-century biographer Giorgio Vasari praised Piero's close attention to nature, the knowledge of geometry seen in his pictures, and the artist's composition of learned treatises based on the study of Euclid.[1] His perceptions about the intellectual structure of the painter's work remain relevant to this day, for Piero's art, like Leonardo da Vinci's, has attracted a wide audience, appealing not only to enthusiasts of painting but also to devotees of science and mathematics.

In fact, Vasari's belief that the scholar Luca Pacioli stole Piero's mathematical ideas, which is expressed vehemently throughout the biography, doubtless contributed to the recognition and recovery of the painter's writings by later historians. Although it occasionally eclipses his discussion of Piero's paintings, Vasari's outrage also highlights how unusual the formulation of treatises on mathematics and perspective was for a fifteenth-century painter. But most importantly, Pacioli's theft provided the biographer with a central theme for characterizing Piero's life – the notion of loss. According to Vasari, the artist "is cheated of the honor due to him" by

Pacioli; his prestigious paintings in Urbino, Ferrara, and Rome were lost or painted over; and "he was prevented by the blindness that overtook him in his old age, and then by death, from making known his brilliant researches and the many books he had written."[2] Vasari's profile of Piero is indeed ironically prophetic because the destruction of several major paintings and the meager documentation of the artist's life, projects, and workshop continue to plague modern studies of his work. Nevertheless, enough information survives to permit the construction of a reasonable chronology and to suggest how Piero gradually fashioned familial, communal, and artistic contacts into a network of individual and corporate patronage.

The Life of Piero della Francesca

Piero della Francesca was at the height of his career when he painted the *Resurrection* in the municipal building of his native Sansepolcro (Plate 1). Rising triumphantly from a marble sarcophagus, the all-seeing and all-knowing Christ in this fresco masterfully fuses the religious faith and civic consciousness of a town named to honor its cherished relics from the Holy Sepulcher in Jerusalem.[3] Piero's creation of such a striking communal symbol is not surprising, for in contrast to Leonardo and Raphael, who advanced their careers by moving to Milan and Rome, he remained a life-long citizen of Sansepolcro. Located amidst the rich agricultural lands of the Upper Tiber River, the town was a market center, a primary manufacturer of crossbows (emblazoned on its municipal coat-of-arms), and a crossroads for the trade routes traversing Tuscany, Umbria, Romagna, and the Marches.[4] By the time of his birth in the second decade of the fifteenth century, Piero's family had lived in Sansepolcro for several generations and belonged to its affluent merchant class.[5] Like other youths of his class, Piero was educated to pursue a vocation in commerce. Presumably he learned reading, writing, and elementary Latin at a local grammar school and then received higher education in commercial mathematics at a *scuola dell'abaco* (abacus school).[6] Vasari tells us that Piero studied mathematics until he was fifteen years old, when he decided to become a painter, but unfortunately does not supply details about his apprenticeship. Archival records indicate that Piero probably learned tempera painting in Sansepolcro, where he assisted the local artist Antonio d'Anghiari on panels and cloth banners from 1432 to 1438, and that he may have acquired his skill in the fresco technique by working with Domenico Veneziano at Perugia in about 1438. To be sure, Piero must have been already proficient in this medium when he was hired in 1439 to paint frescoes in the hospital church of Sant'Egidio at Florence. Because his name is linked to payments made for Domenico Veneziano's painting of the *Birth of the Virgin* in the Sant'Egidio records,

it also seems likely that his employment there was facilitated by the senior artist.[7]

During his stay in Florence, Piero had the opportunity to study the rich artistic patrimony of that city – from the fourteenth-century frescoes by Giotto in Santa Croce to the achievements of contemporary painters and sculptors during the 1420s and 1430s. Even a selective litany of the art available to Piero in Florence illustrates the difficulty of determining which works may have influenced him as a young artist. The paintings that he created in the 1440s, however, suggest his particular attentiveness to works of art in which monumental figures and architecture are set into illusionistic spaces composed according to the new science of perspective. For instance, Piero evidently responded to the imposing Brunelleschian architecture, coherent spatial structure, and solemn figures in Masaccio's *Trinity* at Santa Maria Novella, as well as to Masaccio and Masolino's dramatic history of Saint Peter in the Brancacci Chapel at Santa Maria del Carmine.[8] The perspective construction and simplified forms of Uccello's *John Hawkwood* in the Florentine cathedral and the lucid space and emotional restraint of Fra Angelico's *Descent from the Cross* in Santa Trinita also furnished compelling models. We do not know whether Piero saw Ghiberti's exquisite bronze reliefs for the second set of Baptistery doors, which were well under way during the late 1430s, but he would have known the heroic assembly of saints on the exterior of Orsanmichele, including Ghiberti's elegant *John the Baptist* and Donatello's ingenious *Saint George*. The inventive references to Roman art in Donatello's *Annunciation* in the Cavalcanti Chapel at Santa Croce and in the impressive *cantorie* (singing galleries) that he and Luca della Robbia had just completed for the cathedral, offered stimulating approaches to the synthesis of classical form and Christian content. Whether Piero also learned about the first contemporary treatise on painting by Leon Battista Alberti, composed after he too had been inspired by Florentine art during a visit in 1434, is a matter of conjecture.[9] Be that as it may, Alberti's explanation of perspective and the principles of painting in *Della pittura* (On Painting) not only accords with the morphology of Piero's paintings in the next decade, it also provides a singular precedent for the painter's own theoretical writings.

By 1445 Piero was back in Sansepolcro to sign a contract for his first major independent commission, an altarpiece for the chapel of the Confraternity of the Misericordia (Plate 2).[10] Family connections apparently contributed to his receipt of this commission. His father, like his grandfather, belonged to the confraternity; moreover, the della Francesca were acquainted with the Pichi family, the local nobles whose donation financed the altarpiece itself, and for whom Piero would compose a treatise on mathematics (the *Trattato d'abaco*).[11] For undetermined reasons, Piero left the Misericordia commission incomplete and journeyed north to work for several rulers, including the Este of Ferrara (in c. 1447–49) and

the Malatesta at Rimini, where his signed and dated fresco of 1451 still embellishes the chapel of Sigismondo Malatesta, the nephew of Sansepolcro's former lord (Plate 3).[12] Two panels of Saint Jerome, evidently painted for Venetian patrons, suggest that Piero attracted a local clientele along the Adriatic coast during his visits to Rimini, Ancona, and Loreto in those years (Plate 4).[13] Despite Vasari's emphasis on patronage from the Montefeltro family, Piero is not recorded in Urbino until 1469, where he had been called to estimate the value of a painting. How he came to the attention of the renowned Duke of Urbino is unknown, but he may well have benefited from the kinship uniting his Montefeltro, Malatesta, Este, and Sforza patrons.[14]

From the 1450s to the 1470s, the most productive decades of his career, Piero traveled regularly, completing frescoes for the Franciscan friars at Arezzo (c. 1452–66), in the Vatican Palace, and Santa Maria Maggiore at Rome (1458–59). He also provided a splendid polyptych for the church of Sant'Antonio at Perugia (c. 1455–68). At the same time, Piero preserved his commercial and domestic bonds with Sansepolcro, where he painted the high altarpiece for Sant'Agostino, contracted in 1454, and executed two frescoes in the municipal palace, representing the *Resurrection* and *Saint Louis of Toulouse,* in the 1460s (Plate 1).[15] During the last decades of his life Piero settled into a commodious new family home at Sansepolcro, which he decorated with paintings, including a *Hercules* that may have been part of a lost fresco cycle of heroes.[16] There, he composed treatises on mathematics (the *Trattato d'abaco* for the Pichi), perspective (*De prospectiva pingendi,* probably for Federigo da Montefeltro), and geometry (the *Libellus de quinque corporibus regularibus,* dedicated to Federigo's son Guidobaldo). Piero continued to accept commissions for paintings from relatives and acquaintances, such as the *Adoration of the Child* (Plate 19) for his nephew Francesco di Marco and his bride Madonna Laudomia in c. 1482–83, until his eyesight failed a few years before his death on 12 October 1492.[17]

Piero's Theory and Practice of Painting

The Brera Altarpiece manifests Piero's continuing dialogue with the principles of Florentine painting encountered during his formative years (Plate 5). Destined for the site of his tomb in Urbino, Federigo da Montefeltro kneels before the Madonna and Child in this altarpiece with his hands clasped in prayer, his sword sheathed, and his helmet, gauntlets, and baton momentarily laid aside.[18] Piero's compositional structure in this painting, which relies on logically contrived perspective and imaginative architecture to center attention on the Madonna and Child, calls to mind Domenico Veneziano's Saint Lucy Altarpiece of the 1440s (Fig. 1). The

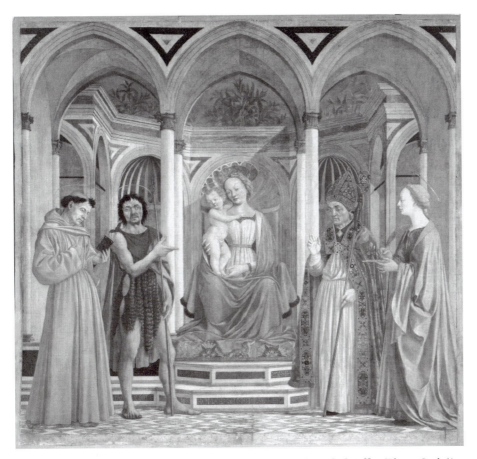

1. Domenico Veneziano, Saint Lucy Altarpiece, Florence, Galleria degli Uffizi (Photo: Scala/Art Resource, NY).

similarly complex illumination – direct, diffused, and reflected light – in both of these altarpieces models the figures and plays across opaque and transparent surfaces to create the illusion of generous space, volumetric figures, and diverse textures. Posed in a stepped semicircle and grouped by threes, Piero's saints, like Domenico's, perform distinct functions. John the Baptist establishes eye contact with viewers as he points to Christ and Mary (as Alberti recommended in *Della pittura*), whereas, the penitent Jerome looks toward the Madonna and Child to remind observers of the doctrine of salvation, and John the Evangelist, book in hand, exemplifies pious contemplation.[19]

Yet the verticality of the Brera Altarpiece – an anomaly that would have been even more obvious before a substantial strip was cut from the bottom of the painting – differs markedly from the square format typical of mid-fifteenth-century Florentine altarpieces like Domenico Veneziano's.[20] To counter the dense horizontal frieze of characters compressed in the

middle of the altarpiece, Piero creates an emphatic vertical axis through the architectural design and a perspective construction that converges at Mary's head.[21] The great barrel vault and the spectacular shell in the apse reiterate the slight curvilinear placement of the saints, while the perpendicular position of the vaults cropped at each side of the foreground extends the space outward towards the spectator. Dropping like a plumb line above and behind the head of the Virgin, an ostrich egg marks the center of the fictive space. Pictorial depth is measured around that egg, making visible what Pacioli called the "proper proportion of distance" in Piero's paintings.[22] As a result, the Virgin and saints, like the suspended egg, seem centered within the illusory space.

In addition to the Brera Altarpiece, Piero composed *De prospectiva pingendi* (On the Perspective of Painting) for the ducal court at Urbino. Written late in his career, the definition of painting espoused in this treatise refines the Florentine concept of *disegno* he had learned as a young artist.

Painting consists of three principal parts, which we call *disegno, commensuratio* and *colorare*. By *disegno* we mean profiles and contours which enclose objects. By *commensuratio* we mean the profiles and contours set in their proper places in proportion. By *colorare* we mean how colors show themselves on objects – lights and darks as the lighting changes them.[23]

If these principles are applied to the Brera Altarpiece, Piero's *disegno* ("the profiles and contours which enclose objects") distinguishes Duke Federigo from the saints, setting his famous features and stiff gleaming armor in sharp relief against the woolen garments of Saints John and Francis. At the same time, Piero unites the aging *condottiere* and the sleeping infant by isolating them below the horizon line and by aligning the duke's petitioning hands diagonally with the child's sloping body.[24] The relative scale of the figures dispersed on specific planes in the fictive space elucidates the concept of *commensuratio:* "the profiles and contours set in their proper places in proportion."[25] Duke Federigo's position as the figure closest to the picture plane explains his size, and the small stature of the angels surrounding the Virgin (elevated on a step so their feet roughly align with the other figures' knees, as Piero advised) is consistent with their location in the setting; only the Madonna is comparatively large given her relative position in the middle picture plane.[26] The light blue of the Baptist's mantle, shaded to a smoky gray-blue, the alternately shadowed and bright entablatures protruding at each side of the panel, and the gray and white pilasters in the apse exemplify Piero's *colorare,* "how colors show themselves on objects – the lights and darks as the lighting changes them." The surfaces of materials reflect or absorb light to convey the different textures of reflective armor, luminous pearls, burnished brocades, thick woolens, and diaphanous veils. Piero's *colorare* works in concert with his *disegno*

and *commensuratio*. It softens the profile of the Madonna's fully illuminated robe on the left while affirming the contour of her shaded right side. The dusky shadow behind the Madonna not only conveys the depth of the marble apse and the volume of the space around the ostrich egg, but its dark edge also strengthens the vertical axis of the painting. Touches of white selectively illuminate objects on each plane of the picture to interlock light and space; for example, on the duke's arm in the foreground, and on Jerome's left shoulder, Christ's crystal amulet, and John the Evangelist's beard in the middle ground.

Yet this kind of text/image analysis is ultimately unsatisfactory, for it fails to do justice to the translucent atmosphere, the gravity of the characters, and the fluency of Piero's picture as a whole; nor does it convey his eloquent interlacing of form and content. The pairing of Duke Federigo and the Christ Child, for instance, creates a psychological as well as a spatial interval. The distance between the sleeping baby and the duke provides a compelling reversal of the roles of God and man portrayed in the *Resurrection*, thereby deepening the poignant allusion to the *Pietà*. The superb compositional balance and the equilibrium of the monumental figures, as well as the exquisite details of Piero's picture, fashion a harmonious environment that stands in opposition to the chaotic reality of fifteenth-century Italy. Yet what a close study of the Brera Altarpiece elucidates most vividly is the subtle exaggeration of an art where space is excessively austere and ordered, where the light is too pure and bright for this world, and where the immobile characters are unusually quiescent.

The historical value of *De prospectiva pingendi* lies less in the direct application of its precepts to particular pictures than in the view it offers of Piero's cumulative thoughts about the conceptual and practical aspects of his craft after many years in the profession. The narrow parameters of Piero's treatise nevertheless raise questions about its purpose. For unlike Alberti's attention to the formal and psychological representation of the *istoria* (textual narrative) and his concern with the ethical training of painters in *Della pittura*, Piero explains only *commensuratio* – how artists should draw frequently encountered solid objects in correct foreshortening and properly position them in a measured three-dimensional space. Thus, when he explains the correct drawing of a man toward the end of the book, he addresses neither the spatial interaction of characters in the multifigured paintings typically commissioned in this era, nor the variations of pose, gesture, and expression needed to portray a narrative or a devotional image.[27]

Piero's extremely precise and detailed instructions for applying the principles of perspective to painting, which call to mind a modern programmer's complicated rendering of a simple task into computer language, are confusing in terms of the intended audience and function of the *Prospectiva*.[28] Most scholars concur on the sequence of Piero's three trea

tises: the *Trattato d'abaco* (Abacus Treatise) was composed first, followed by *De prospectiva pingendi,* and then the *Libellus de quinque corporibus regularibus* (The Book on the Five Regular Bodies).[29] The *Prospectiva,* however, differs from the earlier and later texts, which are both instructional manuals in applied mathematics. The *Trattato d'abaco,* according to its preface, is a textbook on commercial mathematics written in Italian for a member of the Pichi family of Sansepolcro, and the *Libellus,* dedicated to Duke Guidobaldo of Urbino, treats advanced studies in geometry to further the young prince's humanist education. Piero's explicit request that the *Libellus* be shelved next to his own book on perspective in the library at Urbino indicates that it was meant as a companion to the *Prospectiva* and that the latter was probably composed for the duke's father, Federigo da Montefeltro, who had established the collection.[30] That Piero had the Urbino treatises translated into Latin supports the notion that he directed his literary efforts toward these two *principi,* for both cultivated intellectual reputations. If Duke Federigo was indeed the intended patron for *De prospectiva pingendi,* this treatise presumably predates his death in 1482 and was likely composed in c. 1470–82, the decade of Piero's most sustained interaction with the Urbino court.[31]

Federigo da Montefeltro's education in classical history and literature, his interest in mathematics, and his aesthetic preferences imply that he would have been well disposed to the nuances of geometry and perspective addressed in Piero's *Prospectiva.* The duke's avid acquisition of manuscripts – be they ancient texts or contemporary interpretations of them – evinces his penchant for humanist studies; his magnificent library counted among its volumes antique texts such as Vitruvius's *Ten Books on Architecture* and Alberti's modern sequel, *De Re Aedificatoria.*[32] These architectural treatises clearly contributed to his ideas for the renovation and expansion of the palace at Urbino, which expressly manifests a visual aesthetic grounded in classical ideals of moderation and geometrically devised proportions. The harmoniously proportioned Court of Honor, the carefully crafted frames surrounding intricate intarsia doors, and the adornment of the latter with mythological deities and heroes, female personifications of virtue, and architectural prospects, exemplify the duke's passion for the classical. The astonishing trompe l'oeil cabinetry of the *studiolo* most famously represents the duke's taste in visual art. There, an expansive perspective view and beautifully rendered solid objects – a celestial globe, books, a cuirass – coexist with personifications, personal emblems and devices, and "portraits" of illustrious men. Duke Federigo's patronage demonstrates surprisingly little interest in narrative art. On the contrary, he favored portraits, allegories, and artfully rendered illusions, as in the *studiolo,* or as depicted in the painting of an "Ideal City," at one time attributed to Piero (see Fig. 28).[33] Piero's application of the principles of solid geometry to pictorial design and his adaptation of classical motifs to

a contemporary genre in his portraits of Federigo and his consort Battista Sforza are logical in light of the duke's preferences (Plates 26 and 27). Set before sweeping landscapes, the clean, volumetric profiles of the rulers dominate the front of this diptych, while erudite references to ancient coins, medallions, and epigrams enrich the Petrarchan triumphs on the reverse. Just as the visual virtuosity of Piero's ducal portraits doubtless pleased the duke's connoisseurship, the mathematical resolution of design problems in his *Prospectiva* most likely delighted his intellectual curiosity. One suspects that Federigo da Montefeltro agreed with Alberti's dictum: "I want the painter as far as he is able to be learned in all of the liberal arts, but I wish him above all to have a good knowledge of geometry."[34]

Formal and Iconographical Problems in Piero's Oeuvre

Seemingly irresolvable issues of style and iconography immediately confront scholars of Piero's work. In addition to the loss of important paintings, as Vasari recognized in the sixteenth century, our inadequate knowledge about Piero's workshop and the original locations of some pictures has hampered efforts to fix a chronology of his works or to interpret the enigmatic iconography of several paintings.[35] While debates over the dating and subject matter of pictures such as the *Flagellation of Christ* show little signs of abating, as we shall see, restorers and archivists have laid to rest similar arguments about other paintings, such as the Sant'Antonio Altarpiece.

The singular consistency of Piero's style throughout his career has frustrated attempts to establish a satisfactory sequence of his artistic development. Although his paintings verify the extensive employment of assistants, possibly even more than was customary practice among Renaissance artists during the busy 1450s and 1460s, we possess little information about Piero's actual workshop. Documents name Giovanni da Piamonte as his assistant on the *Legend of the True Cross* at Arezzo, and Vasari lists Luca Signorelli and Lorentino d'Andrea, whose paintings clearly demonstrate his influence, as well as the unknown Piero da Castel della Pieve, as his students.[36] Where Piero trained these apprentices is not clear either, though he must have operated an active workshop in Sansepolcro for most of his career, since he worked there continually from the mid-1450s until his death. In addition to the Aretine origins of Signorelli and Lorentino, the demands of the fresco medium and the magnitude of the project for San Francesco suggest that Piero probably maintained a second workshop at Arezzo during the execution of the *Legend of the True Cross* (c. 1450–66).[37]

Piero's *Flagellation of Christ* exemplifies the perplexing iconographical problems faced by scholars (Plate 6). First mentioned in an eighteenth-century inventory of the cathedral sacristy at Urbino, the painting was transferred to the ducal palace in 1916, but no earlier provenance has come

to light. The odd size of this painting – too large for a predella and smaller than an altarpiece or most independent panels of this period – precludes determining whether it was painted for religious or secular purposes. Though the inscription PETRI DE BVRGO SCI SEPVLCRI on Pilate's throne attests his authorship, the date when Piero actually executed the painting has been much debated; various suggestions range from c. 1444 to 1469.[38] The stylistic relationship of the *Flagellation* to Piero's other works, particularly to the *Legend of the True Cross* at Arezzo, has been rendered all the more problematic by the absence of firm dates for these paintings as well.[39] An inscription noted by Passavant in 1839, which no longer survives but was most likely on the original frame of the *Flagellation,* records the phrase "they met together" *(convenerunt in unam)* taken from Psalms 2:2: "The kings of the earth stood up, and the princes met together, against the Lord and against his Christ." The lost inscription, the resemblance of Pilate to the Byzantine Emperor John VIII Paleologus, and the peculiar mixture of Greek, Italian, and pseudoclassical clothing worn by the three figures in the right foreground have prompted iconographical explanations that associate the panel with mid-fifteenth-century issues such as the reunification of the Greek Orthodox and Roman Catholic churches and papal appeals for crusades to recover the Holy Land from Islam. Attempts to identify the three characters as portraits, taken in conjunction with a popular legend that the barefoot youth represents Count Oddantonio da Montefeltro, who was assassinated in 1443, have generated interpretations that connect the picture specifically with Federigo da Montefeltro's accession to power after his half-brother's murder. But in the end, such theories circle around a pair of assumptions: that the *Flagellation* was always at Urbino and that the three figures portray actual individuals.[40]

The Sant'Antonio Altarpiece presents a different set of problems (Plate 7). In contrast to the *Flagellation,* the location of Piero's polyptych in Sant' Antonio di Padova, the church of the Franciscan female tertiaries in Perugia, has been established since Vasari saw it there in the sixteenth century. But unlike the praise consistently bestowed on the *Flagellation,* the Sant'Antonio Altarpiece was criticized for the considerable participation of assistants in its production, for the perceived incongruity of its parts, and for the "old-fashioned" gold background in the central section. In a fortuitous turn of events for Piero studies, a recent campaign of restoration and archival research resolved a number of these crucial questions.

Documents discovered in the Perugian archives now persuasively date Piero's execution of the work to the years between 1455, when the sisters of Sant'Antonio received permission to have Masses said on the altar of their church, and 1468, when they requested assistance from the town council to pay for their completed altarpiece.[41] Additional records indicate that Franciscan and family connections may well have secured Piero's commission from the tertiaries. For not only was Piero employed on the

frescoes of the True Cross for the Franciscan friars of Arezzo during the 1450s and 1460s, but in 1469 the della Francesca brothers and the Baglioni family of Perugia also engaged in transactions related to their contiguous property near Sansepolcro. This association with the Baglioni is especially compelling because Ilaria, the daughter of Perugia's ruler Braccio Baglioni, entered Sant'Antonio in about 1460.[42]

A recent restoration has also clarified the problematical format of this complex polyptych. By verifying that the predella and the *Annunciation* are in fact part of its original conception, technical examinations have allayed scholars' suspicions that the odd format of the *Annunciation* and the unusual double predella indicate a drastic cutting or rearrangement of the altarpiece, or that Piero had combined parts from disparate projects to fulfill the commission. A date in the 1460s – the prolific period bracketed by the Misericordia and the Brera altarpieces – is logical for this polyptych in formal terms. The shimmering cloth-of-honor and cool marble floor of the Perugian *sacra conversazione* demarcate an area that compares to the relatively narrow space surrounding the Madonna and Saints on the Misericordia Altarpiece and to what was probably an equally unpretentious setting in the Sant'Agostino Altarpiece (commissioned in 1454).[43] Saint Francis's pose and his translucent cross correspond to the portrayal of this saint on the Brera Altarpiece, and the Madonna's red brocade gown and the rosette-coffered throne presage both her attire and the vaulted apse in the background of that panel. As for the purported disjunction between the "advanced" architectural setting of the *Annunciation* and the "retardataire" gold background in the center compartment, in truth, the Sant'Antonio polyptych is not anachronistic at all. Rather, it resembles countless altarpieces painted in Umbria during the third quarter of the fifteenth century that preserve traditional gold grounds, ornate predella sections, and fantastic gothic frames.[44] Some modern critics also have considered the *Annunciation* as an addition to the Sant'Antonio Altarpiece because they see the temporal reality in that scene and the timeless spiritual space created by the gold brocade in the *sacra conversazione* as inconsistent. Perhaps such assessments are looking at Piero's art through a Florentine lens. It is well worth remembering that despite Piero's Tuscan roots and his protracted dialogue with Florentine artistic concepts, neither he nor his patrons were Florentine. More probably, the coexistence of earthly and celestial realms in the Sant'Antonio Altarpiece (as was also true of Piero's *Baptism of Christ* in its original frame) visually parallels fifteenth-century spirituality, which viewed mortal existence as merely a prelude to eternal bliss.[45]

The results of the technical and archival research on the Sant'Antonio Altarpiece answer a number of critical questions, but they are by no means definitive. Iconographical ambiguities such as the representation of the Baptist with the Franciscan saints, for instance, need further clarification.

Still, the application of diverse methods of analysis by contemporary scholars to problematical paintings like the Perugian altarpiece and the *Flagellation* continues to expand our comprehension of Piero della Francesca's paintings and treatises. The varied interpretations and conclusions reached by the authors in this volume exemplify the active state of Piero studies.

The Piero Companion

The purpose of the *Cambridge Companion to Piero della Francesca* is to deepen the reader's understanding of Piero della Francesca and to encourage future discussions of his art. Accordingly, we have invited authors from several fields to consider Piero's pictures from a range of historical perspectives. The first four essays in the collection explore Piero's religious paintings. Diane Cole Ahl's study of Piero's Misericordia Altarpiece delves into the complex religious, civic, and cultural life of Sansepolcro, providing fresh information about the mission of the confraternity that ordered it and identifying possible painted and sculptural models for Piero's picture. Timothy Verdon brings theological as well as art-historical expertise to his investigation of Piero as a master of Christian art. His essay not only interprets three paintings by Piero in terms of their iconography and formal composition but also with respect to their possible reception by lay, confraternal, and monastic patrons. My own study of the *Legend of the True Cross* at Arezzo, like Ahl's contribution, investigates the local circumstances underlying a commission; in this instance, the possible motivations of the fifteenth-century Franciscan friars whose church the frescoes still adorn. In an essay originally published in 1995, Marilyn Aronberg Lavin's close reading of a single painting by Piero, the *Adoration of the Child,* analyzes the artist's "paradoxical" transformation of humble nature into exalted spiritual ideals. Jane Bridgeman, a historian of dress, then suggests a different way to approach the chronological and iconographical problems in Piero's oeuvre by correcting several misconceptions and offering new observations about the clothing worn by the characters in his pictures. The subsequent essays by Joanna Woods-Marsden and Philip Jacks take readers to the North Italian courts. Woods-Marsden's discussion of Piero's portraits of Sigismondo Malatesta, Federigo da Montefeltro, and Battista Sforza addresses issues of identity, self-promotion, and gender within Quattrocento ideological structures of power by clarifying the notion of a "true likeness" in the emerging genre of court portraiture. Jacks reviews the thorny problems of attribution and function associated with three paintings of "Ideal Cities," thought to have been ordered for the Urbino court, and connects this type of imagery with contemporary architectural theory and intarsia design. Complementary essays on Piero's

mathematical treatises by Margaret Daly Davis and J. V. Field demonstrate the distinctive approaches of scholars in diverse disciplines. Davis, an art historian, analyzes the "interrelatedness" of Piero's three treatises, details their reception by other fifteenth- and sixteenth-century art theorists, and underscores their importance to architects and designers of intarsia. Field, from a starting point in the history of mathematics and optics, dissects the particular kinds of problems posed in the treatises to explain Piero's place in the development of Renaissance mathematics and to explore the affinities between his mathematical and artistic practices. The final essay, by Anne Barriault, contemplates the "rediscovery of Piero" in the twentieth century. She probes the fascination of Piero's paintings as sources of inspiration for the art historians Bernard Berenson and Kenneth Clark, the painters Romare Bearden, David Hockney, and William Bailey, the poets Charles Wright, Gjertrud Schnackenberg, and Jorie Graham, and the novelist Michael Ondaatje. For these modern writers and painters, Piero's subtle imagination and quiet lyricism resonate across barriers of time and space, thereby enabling the past continually to edify the present.

I The *Misericordia Polyptych*

Reflections on Spiritual and Visual Culture in Sansepolcro

Diane Cole Ahl

I went to the church of the Most Holy Virgin of the Misericordia and before the high altar [was] the wooden altarpiece with images of the most holy Virgin and other saints by the hand of the famous painter, Piero Franceschi, otherwise known as della Francesca, of this city.

Monsignor Zanobio de' Medici, 1548[1]

The *Misericordia Polyptych* (Plate 2), commissioned in 1445, is renowned as the earliest surviving work by Piero della Francesca.[2] It stood in the church of the Compagnia di Santa Maria della Misericordia, a confraternity – a charitable organization of pious laymen – that performed works of mercy in the town of Sansepolcro.[3] Although the altarpiece was dismembered in the seventeenth century and time has dulled its once-glowing colors, it still inspires reverence in the beholder. While we may no longer share the confraternity's devotion to the Madonna of Mercy (Misericordia), its dedicatee, we can admire Piero's genius in creating so beautiful a work. From the monumental Virgin, whose open mantle echoes the arch of the central panel, to the imposing saints in the wings, the polyptych reveals Piero's genius at endowing his figures with a physical presence and spiritual eloquence that is unequalled in fifteenth-century painting. In the center, the Madonna solemnly opens her cloak to shelter the faithful who kneel at her feet. Beseeching her mercy through their prayers, the supplicants served as surrogates for the populace of Sansepolcro, the town in which Piero was born, lived, and died.

This essay interprets the *Misericordia Polyptych* as a reflection of the religious, civic, and artistic culture of fifteenth-century Sansepolcro. It begins by identifying the distinctive character of the town's spirituality, focussing on the confraternity of the Misericordia and its role within Sansepolcro. Next, it reconstructs the history of the commission and con-

siders Piero's relationship with his patrons, the Pichi family and the Misericordia. The discussion then turns to the style and iconography of the polyptych. The altarpiece is understood within the traditions of late medieval and early Renaissance art as well as the ritual devotions of the Misericordia. New proposals are offered on the sources of Piero's inspiration and the associations it may have evoked for those who prayed before it. As this paper hopes to demonstrate, the *Misericordia Polyptych* is important not only for what it reveals of Piero's style and relationship with his patrons, but for how it reflects the sacred and civic culture of Sansepolcro. The *Misericordia Polyptych* commemorates the Misericordia's dedication to the spiritual welfare of Sansepolcro and its special devotion to the Madonna of Mercy. Originally, the twenty-three panels comprising the polyptych were probably enclosed in a three-story frame of gilded wood, crowned with crocketed pinnacles and secured to the altar by buttresses.[4] The saints most venerated in Sansepolcro and by the confraternity are painted in the side panels: Saint Sebastian, protector against plague, whose victims had been tended in the hospital administered by the Misericordia since the early fourteenth century; John the Baptist, patron of Florence, which had ruled the town since 1441; John the Evangelist, patron of Sansepolcro;[5] and the recently canonized (1450) Franciscan preacher, Bernardino of Siena, a fervent advocate of the Madonna of Mercy's cult. The pilasters and pinnacles include the Archangel Gabriel and the Virgin Annunciate, who commemorate the Misericordia's special devotion to Mary; saints representing religious orders with congregations in Sansepolcro; and two local pilgrim saints, Arcanus and Giles, who in the tenth century named the town Sansepolcro in honor of the Holy Sepulcher of Jerusalem, the site of Christ's tomb and resurrection.[6]

The narrative scenes of the altarpiece exalt the town's identification with the Holy Sepulcher as they celebrate the confraternity. From the *Crucifixion* in the pinnacle to the five panels in the predella, they focus on the Passion and Resurrection of Christ. One panel depicts the Agony in the Garden, where Jesus prayed before his arrest on Maundy Thursday, a day of special significance to the confraternity. The adjacent scene portrays the Flagellation of Christ, the prototype for self-flagellation, the fundamental devotional exercise of the Misericordia. Three panels portray the Holy Sepulcher (Fig. 2), honoring the sacred site as well as Sansepolcro itself. The confraternity's insignia, the wreath-enclosed inscription MI[SERI-CORDI]A, is painted at the base of each pilaster, where it would be seen by the kneeling worshipper. It identifies the Misericordia as devotees of the Madonna of Mercy, commissioners of the altarpiece, administrators of the church and its contiguous hospital, and guardians of the community's spiritual welfare. Although the execution of this work was protracted over some fifteen years, Piero's personal investment in this work is certain to have been intense. The Misericordia was among the oldest confraternities

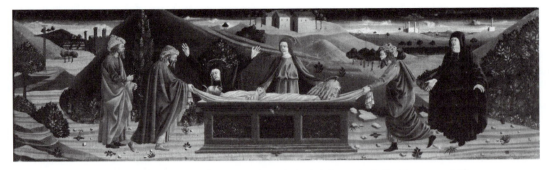

2. *Entombment of Christ,* detail of *Misericordia Polyptych* (Photo: Scala/Art Resource, NY).

in Sansepolcro, one to which his own family had belonged since the late fourteenth century.[7]

The *Misericordia Polyptych* is an important point of departure for understanding Piero. Its wedding of traditional iconography with a monumental style and conception, its luminous description of form, and the spiritual reticence of each figure reflect a synthesis of past and present. While it may be his first documented altarpiece, it is by no means a youthful painting; rather, it reflects a personality already formed and distinctive. By the time the polyptych was commissioned, Piero had been active for well over a decade.[8] Time and fate have deprived us of his earliest works: the processional candlesticks for which he was paid in 1431; the banners he painted in 1436 for Pope Eugenius IV. The altarpiece for the church of San Francesco in Sansepolcro that he began in 1432 with his teacher, the impecunious Antonio d'Anghiari, was never executed: acknowledging that he owned Piero fifty-six florins in back wages, Antonio borrowed money from Piero's father to buy materials for the work but did not finish it.[9] In 1437, the commission was transferred to Sassetta; in 1444, one year before the Misericordia asked Piero to paint the polyptych, Sassetta's altarpiece (Fig. 3) was installed in the church of San Francesco.[10] Costing 510 florins, the magnificent *Sansepolcro Polyptych* was the costliest altarpiece ever commissioned in fifteenth-century Italy and a significant influence on Piero.

The *Misericordia Polyptych* is a resonant reflection of the spiritual and visual culture of Sansepolcro that helped shape Piero. As historians have recognized, the sacred and civic culture of Sansepolcro was distinctive in many respects.[11] One, as mentioned above, was the town's association with the tomb of Christ, commemorated by its name and dedication to the Holy Sepulcher; another was its importance as a site of pilgrimage. When Saints Arcanus and Giles returned to the town from the Holy Land, they brought with them priceless relics of the Passion that became objects of public veneration:[12] wood from the "most holy cross on which our Lord Jesus Christ was placed for the redemption of human sin;" drops of his blood; cloth from the shroud wrapping "the most sacred body of our Lord Jesus Christ after he was lowered from the cross;" fragments of "the stone

from the Holy Sepulcher" from which "the name of this land was taken;" "hair and milk of the blessed Virgin and stone from her tomb;" and relics of John the Evangelist, the town's patron.[13] The display of these relics on September 1 – the jointly celebrated Feast of the Holy Sepulcher and of Saint Arcanus – was among the most important celebrations in the town, honored by processions, masses, and the giving of alms.[14] These relics were deemed so potent that Sansepolcro became an important destination for many pilgrims in the late Middle Ages and Renaissance.[15]

Another distinctive feature of Sansepolcro was the prominence of confraternities in its civic and sacred life.[16] Confraternities, which to this day survive in the town, were organizations of lay people who dedicated themselves to imitating Christ's example through their philanthropic activities and religious devotions.[17] In Sansepolcro, there were seven confraternities that sang *laude* (songs of praise and mourning) to the Virgin, Christ, and saints.[18] These *laudesi* (laud-singing) companies were complemented by seven confraternities of *disciplinati* (flagellants). *Disciplinati* flagellated themselves in imitation of Jesus's suffering before the Crucifixion, when he was stripped of his garments, spat upon, and whipped, thereby hoping to expiate the sins of humanity.[19] Confraternities often combined the devotional practices of both types.

As in other towns, the confraternities of Sansepolcro safeguarded pub-

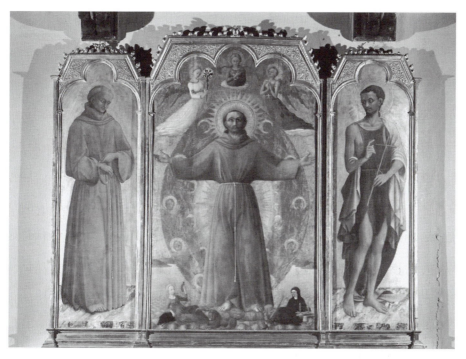

3. Sassetta, Three Panels from the *Sansepolcro Polyptych*, Florence, Villa I Tatti, Berenson Collection (Photo: Scala/Art Resource, NY).

lic welfare. They administered hospices for pilgrims, homes for the indigent, hospitals for the sick, and orphanages for foundlings. They distributed food and clothing to the needy, and they offered solace to prisoners. In so doing, they were following Jesus' example. Caring for the impoverished, tending the sick, comforting prisoners, and providing hospitality to strangers were among the seven acts of mercy prescribed by Jesus in Matthew 25:34–37 as prerequisites for salvation. Through their benevolence and performance of other pious activities – ritual flagellation, the singing of *laude,* attendance at weekly and special masses in confraternal chapels and churches – members were deemed, in their own eyes and those of the community, worthy of divine mercy at the Last Judgment. Even after death, their souls in purgatory were thought to accrue merit through the good works of surviving brethren. The guarantee of such benefits inspired many to become members or to make bequests to confraternities, especially in the wake of the Black Death (1348–50).

During the second half of the thirteenth century, confraternities, particularly those of flagellants, flourished in Sansepolcro and were central to its identity as a Christian community.[20] By the early fifteenth century, every adult male in Sansepolcro belonged to one of these sodalities, whose philanthropic activities touched the lives of each resident and pilgrim. Among the most venerable was the confraternity of Santa Maria della Misericordia. Although its original statutes are lost, other sources, including the revised statutes of 1570, provide valuable information about its history and special devotions.[21] The most important of these was flagellation, performed within the privacy of the confraternal oratory (chapel), both as imitation of Christ and penance for sinful behavior. The *disciplinati* also sang lauds in honor of the Virgin, as attested by a *laudario* (book of sacred songs) of twenty-five songs written in the vernacular, ascribed to the Misericordia and still preserved in Sansepolcro.[22] Dating from the late thirteenth century through 1449, the *laude* express the confraternity's fervent pleas for Mary's compassion and its hopes for salvation. Lauds written in 1449 invoke the intervention of Saint Sebastian, protector against plague, who would pray to "the Lord that this pestilence be lifted by your clemency and give us rest."[23]

Although the date that the Misericordia was founded is unknown, it had been firmly established by 1303, when a wealthy citizen of Sansepolcro bequeathed several houses to the confraternity. In the words of his testament, the houses were to serve "in perpetuity" as homes "of mercy [*misericordia*] and hospices for the poor," where the indigent were to be given "lodging without rent."[24] As the earliest bequest to the Misericordia, this donation suggests that charity toward the poor was a special obligation of the confraternity from its inception. When the Black Death struck Sansepolcro, the group's mission was expanded to include the populace at large. In June 1348, a hospital, dedicated to Santa Maria della Misericordia, was established by

the confraternity against the northeast flank of the town's defensive walls to care for the plague stricken.[25] Nearly 200 wills from the second half of the fourteenth century record donations of money, property, and beds for the hospital, indicating its importance within the community.

Members of the Misericordia and those for whom they cared would worship in the church, also dedicated to Santa Maria della Misericordia, annexed to this hospital. Along with a garden (presumably for growing medicinal herbs), administrative quarters, and a private oratory for members, the hospital and church comprised what must have been an imposing complex.[26] It visibly signified the confraternity's stature within the community, serving as a refuge for citizens and pilgrims alike. The great complex, today abandoned and in ruins, was vital to maintaining the town's welfare in the Renaissance and well into the twentieth century. The charitable mission of the Misericordia was expanded as economic travails increased over the course of the fifteenth century.[27] The confraternity distributed alms and food to the poor and provided medicine to the sick. It succored foundlings, ministered to condemned prisoners, and provided lodging and food to indigent pilgrims who came to Sansepolcro. Perhaps a new altarpiece for its church was deemed essential to serve the Misericordia and its growing constituencies within the town.

The commission for the *Misericordia Polyptych* has a complex history that spanned nearly four decades.[28] It originated with the bequest of Urbano di Meo dei Pichi, whose family, one of the wealthiest in Sansepolcro, had been associated with the Misericordia from its foundation. On 4 September 1422, Urbano bequeathed sixty florins to the confraternity for "an ornamented altarpiece for the high altar" of its "church or oratory."[29] This evidently was conceived as a replacement for an earlier image, presumably a Madonna of Mercy. On 28 June 1428, a carpenter agreed to follow a drawing by the painter Ottaviano Nelli in preparing the wooden panels and frame. Two years later, the carpenter was paid for his labors and the unpainted panels were delivered to the Misericordia.[30] It is almost certain that Ottaviano Nelli never actually executed the altarpiece: on 8 February 1435, one of Urbano's heirs conditionally pledged "to make and paint a panel for the high altar of the oratory," an evident attempt to honor Urbano's still unfulfilled bequest.[31]

As the long, protracted history for this commission reveals, the Pichi were not always diligent in fulfilling their obligations. The funds promised for the altarpiece in 1435 were not received, despite repeated efforts by the Misericordia.[32] More than a decade was to pass before the commission was awarded to Piero; by that time, Ottaviano Nelli probably had died. Although Piero had achieved a measure of fame by 1445, family connections also must have influenced the decision to hire him. One of his brothers was an administrator of the Misericordia's hospital in 1442, and another brother, the Camaldolite monk Don Francesco, was chaplain of

the confraternity in 1443.[33] While the Pichi remained involved with the work, the Misericordia assumed an increasingly active role in assuring its execution, even bringing litigation against the family to secure payment.[34]

The contract between Piero and the Misericordia, dated 11 June 1445, is quite specific.[35] Witnessed by eight officers of the confraternity, it required Piero to paint "the images, figures, and adornment . . . expressly detailed by the above Prior and council, or their successors in office." The reference to the "successors" reserved the right of officers, who could change with later elections, to modify the program. The altarpiece was to be made "according to the size and type of the painting on wood . . . there at present," an assurance that it would conform in these respects to the image it was to replace. Piero agreed that "no other painter [could] put his hand to the brush" and that the finest materials, "especially ultramarine," were to be used, both common stipulations in artists' contracts. He also was responsible for restoring any defects "of the wood or of the said Piero," a prudent guarantee. Finally, the altarpiece, which was to be executed by "no other painter . . . [but] the said painter himself," was to be delivered and installed within three years. For this, the artist would receive 150 florins, 50 as an initial "good faith" payment, with the balance to follow.

Although Piero was required by contract to finish the polyptych within three years, its completion appears to have been extended until 1462 or later. The commission, in fact, coincided with an increase in Piero's celebrity outside of Sansepolcro. During these years, he worked in Ferrara, Loreto, Rimini, Rome, and probably Arezzo, returning home but infrequently.[36] He also agreed to execute other paintings in Sansepolcro, among them, an altarpiece for the church of Sant'Agostino, commissioned in October 1454, but probably not finished until 1469.[37] It is true as well that the Pichi were slow to pay him, not tendering all of the promised "good faith" money until 1450 or later.[38] Piero's strategic response may have been to delay.

On 11 January 1454, the Pichi brought suit against the artist, demanding that he return to Sansepolcro by Lent to finish the altarpiece.[39] If the artist did not honor his obligation, he would forfeit the "good faith" payment. His father, who witnessed the issuance of this ultimatum, was required to reimburse the Pichi himself if Piero did not comply. The painter must have returned, for no further complaints are recorded. Numerous small disbursements to Piero are recorded over the years. The majority date from 1459 to 1462, suggesting that much of the work was painted at this time.[40] However, they do not equal the sum of 150 florins promised in the original contract. In the 1460s, the Misericordia was forced to intervene and took action against the Pichi to recover its money. The last known payment to Piero is dated January 1462.[41] In February 1467, he was still awaiting further compensation.[42]

Given these difficulties, Piero's evident unwillingness to complete the altarpiece may well be understood. Although its main panels and pinnacles

are by him, the pilasters and predella (see Fig. 2) were executed by another painter following Piero's conception. Stylistic and suggestive historical evidence indicates that the artist was the Camaldolite monk and miniaturist Fra Giuliano Amedei.[43] During the late 1450s and early 1460s, he resided in the Badia (abbey) of Sansepolcro. Fra Giuliano was associated with the Misericordia by 1460, when he painted its insignia on a stone plaque, still on the church's facade,[44] that recorded a new papal indulgence promulgated on 1 July of that year "on behalf of our community and the men of our confraternity." The indulgence, which offered remission of punishment for sin, was offered to "every person, male or female, young or old, confessed and contrite," who gave alms to the church on the Feast of the Annunciation (25 March) and "each Saturday."[45]

Encouraging worship in the Misericordia's church, the indulgence would have provided further incentive to complete the predella and pilasters. The former showcased the town's dedication to the Holy Sepulcher and the confraternity's practice of flagellation, while the latter commemorated the saints most honored in the community. Although it has been argued that these components were afterthoughts,[46] this is unlikely: predellas or historiated panels were standard elements in buttressed altarpieces from this region.[47] Furthermore, these didactic components, important conveyors of civic pride and confraternal identity, amplify the associations the altarpiece would have evoked.

Providing insight into the sometimes contentious relationship between the Renaissance artist and his client, the history of this protracted commission is important for another reason. It helps explain stylistic differences between the individual components, which were executed in response to the payments that the painter received. Technical evidence from the restoration in 1960–64 confirms that Piero executed the altarpiece in two distinct stages.[48] The central panel, the *Crucifixion*, the tiny panels of Saint Benedict and the Archangel Gabriel, and the saints on the left wing – Sebastian and John the Baptist – evidently were completed first. They were painted slowly and with care, accounting for their good state of preservation. By contrast, the saints on the right wing – John the Evangelist and Bernardino of Siena – and the panels of the Virgin Annunciate and Saint Francis above them were done somewhat hastily. The wood was less well primed, as shown by the heavy craquelure and faded colors, especially the green-tinged skin, where the *terra verde* (green underpaint) preparation shows through. Significantly, the saints on the right were painted on a single panel, rather than on two individual ones, as were their counterparts. This reflects a dramatic change in Piero's conception: the figures now inhabit a unified space in the manner of a *sacra conversazione*, the new single-panel type of altarpiece first developed in Florence that had begun to replace the archaic polyptych by 1440 or so.[49] The saints turn with greater ease and mobility toward the Madonna, implying more immediate access to her and, thus, their enhanced efficacy as intercessors.

The proposed sequence of execution is supported by stylistic evidence. The earlier figures reveal the influence of Masaccio, gleaned during Piero's sojourn in Florence, where he had joined Domenico Veneziano in painting the now lost choir frescoes of the church of Sant'Egidio in 1439. Saint Sebastian's intensely sculptural anatomy and stolid, awkward stance reinterpret the shivering nude in Masaccio's *Baptism of the Neophytes* (c. 1425) from the Brancacci Chapel, Santa Maria del Carmine, Florence. The youthful saint's nudity and ivory skin, pierced by arrows that draw rivulets of blood, contrast to the voluminous, heavy garments of the swarthy Baptist in the adjacent panel. The deep folds of the Baptist's scarlet mantle recall Piero's study of the apostles, especially Saint Peter, in the Brancacci Chapel *Tribute Money.* The *Crucifixion,* with the wailing Virgin in widow's weeds and grieving Evangelist, calls to mind the pinnacle of Masaccio's *Pisa Polyptych* (1426). Evoking a visceral response to Christ's death, so passionate a rendering would be suppressed in Piero's later work.

The central panel is one of the most famous images of Renaissance art. The statuesque Virgin, whose oval face, round features, and solemn expression reveal Domenico Veneziano's influence, suggests compassion yet majestic detachment, as befits the crowned Queen of Heaven. Those adoring her are not the poor who sought charity from the Misericordia, but rather the rich, as shown by their jewels, brocaded sleeves, and crimson garments, which required costly dyes to produce.[50] Space is gendered, with sexes segregated in accord with contemporary devotional practice. Although women are not mentioned in the Misericordia's statutes, their presence here suggests that they may have played an important role within the Misericordia as donors and caretakers in the hospital.[51] As shown by their hair and dress, they represent diverse marital status: the flowing locks of the maiden in front of the Madonna signify that she is unwed; the women beside her are married, as indicated by their tightly bound, upswept coiffures; and the old woman may be a widow, her hair covered by a black mantle.[52] Like the elderly gentlemen in the crimson overgown on the left, the woman in black is so distinctive in appearance as to suggest that she is a portrait. Presumably, both were members of the Pichi family, their patronage and consequent protection by the Madonna proclaimed by their presence here.

In contrast to these finely dressed figures and realistic portrayals, a confraternal brother of the Misericordia wears the black sackcloth robes that identify him as a member.[53] The hood, pierced with holes for his eyes, conceals his face: brethren wore hoods as they anonymously performed their charitable acts out of love of God and neighbor. The man crosses his arms over his chest, a gesture that priests used while celebrating Mass to signify their submission to God and to beg his grace.[54] This gesture may have served as a model for the brethren in their devotions as they prayed before the image, accepting the Lord's will and exhorting his mercy.

While the panel with the Madonna and her supplicants reflects an early moment in Piero's understanding of the altarpiece and its formal

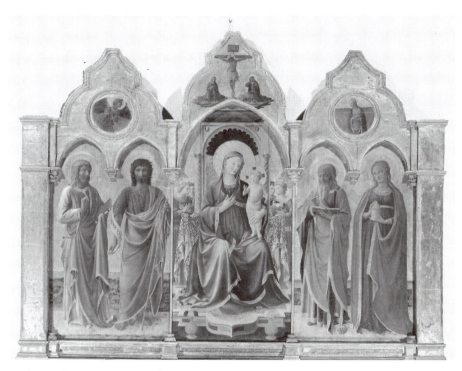

4. Fra Angelico, *Cortona Triptych,* Cortona, Museo Diocesano (Photo: Scala/Art Resource, NY).

constraints, the saints in the right panel reveal a more evolved conception. The unifying possibilities of the single-panel *sacra conversazione* are explored as the figures turn into the gold background, suggesting their mobility. In contrast to their counterparts on the left panel, the saints are idealized and elegantly posed. Their drapery is modelled with great softness, seen especially in the Evangelist's deep plum-colored mantle, which appears almost velvety in its texture. Certainly, the condition of these figures has compromised their appearance: contours that once were firm are blurred, and colors once bright are muted. Yet it seems clear that the suavity of these figures represent a later moment in Piero's style in which the influence of Masaccio, so strongly felt in the left panel, is a distant memory. The softly modelled contours, controlled gestures, and restraint of the figures suggest the influence of an altarpiece that Fra Angelico painted for the church of San Domenico in nearby Cortona (Fig. 4).[55] Despite the archaic frame and gold ground mandated by its provincial destination, the *Cortona Triptych* (c. 1436–38) similarly suggests a unified space and potential interaction between the figures, whose softly defined forms and sculptural gestures seem to be reflected in the later saints of Piero's altarpiece.

The influence of Sassetta's magnificent, double-sided *Sansepolcro Polyptych* (see Fig. 3), the commission begun by Piero and his teacher but later rescinded,[56] is evident as well. As mandated by its contract, Sassetta's

altarpiece was modelled after the *Resurrection Polyptych*, then in the church of the Badia of Sansepolcro, painted three-quarters of a century earlier by a follower of Pietro Lorenzetti.[57] The brilliantly colored and richly gilded *Sansepolcro Polyptych* was unequalled by any other fifteenth-century altarpiece for its decorative splendor as well as the dramatic immediacy of its narrative panels. There is no doubt that Piero studied this painting, the most famous in Sansepolcro; indeed, the *Misericordia Polyptych*, commissioned a year after Sassetta's altarpiece was installed in the church of San Francesco, may have been intended to rival it in scale and beauty. The lucidly balanced composition and pristine geometry of the *Madonna of Mercy* seem in part inspired by *Saint Francis in Ecstasy*,[58] and the saints on the right panel seem influenced by the slender proportions and suave rhythms of Sassetta's figures.

The *Misericordia Polyptych* reveals Piero's receptivity to innovation. At the same time, tradition played a significant role in its conception. As with the contract for Sassetta's altarpiece, the stipulation that the altarpiece resemble its predecessor suggests a reverence for earlier art that was fundamental to the spiritual and visual culture of Sansepolcro as it was in countless locales during the Middle Ages and Renaissance.[59] Since the fourteenth century, the town had turned to nearby Siena and Arezzo for its painting rather than Florence, from which it was more distant geographically. The aesthetic qualities of Sienese art predominated in Sansepolcro and influenced its conception of sacred art. While outmoded by Florentine standards of the mid–fifteenth century, the gold ground, polyptych format, and pinnacles of Piero's altarpiece were still much in vogue in Siena and Arezzo.

The influence of tradition also is evident in the style of the altarpiece, its novel aspects notwithstanding. A source for Piero that has not previously been investigated is the medieval wooden sculpture that for centuries had shaped the devotional and artistic sensibilities of Sansepolcro. Perhaps the town's most important sculpture was the *Volto Santo* in the church of the Pieve.[60] Although dating to the eighth or ninth century, it was devoutly believed to have been carved by Nicodemus, who helped to prepare Jesus' body for the tomb. This larger-than-lifesize image of the clothed, crucified Christ, thought to rival the famous *Volto Santo* of Lucca in its antiquity and miraculous powers, was the object of extraordinary reverence by townspeople and pilgrims alike. Equally venerated was a *Madonna and Child* (Berlin, Staatliche Museen: Fig. 5),[61] commissioned for the church of the Badia in Sansepolcro and carved by the priest Martinus in 1199. The sanctity of this image is proclaimed by the inscription on its base: "from the lap of the mother shineth the wisdom of the Father." This, too, was worshiped as a miraculous image. Both the *Volto Santo* and the *Madonna* were important precedents for the sculptural figures of the polyptych. Their imposing plasticity as well as their enclosed, simplified contours, the deeply undercut folds

of their drapery, and their austere expressions provided important models for the Virgin and saints, whose appearance is so statuesque. Indeed, the *Madonna,* who was suspended over the altar of the Badia and tilted toward the kneeling worshipper,[62] may have influenced Piero's conception of the Virgin, who seems to stand on an elevated plinth as if she were a sculpture seen from below.[63]

While both the *Volto Santo* and Badia *Madonna and Child* were venerated throughout Sansepolcro, another sculpture played a significant role in the devotional life of the Misericordia itself. This was a now lost Madonna, almost certainly a statue of the Madonna of Mercy, mentioned in documents of the 1430s and employed in the confraternity's rituals. The documents record payments for processional candles on the Feast of the Annunciation and on Maundy Thursday when the brethren would "go to undress the Madonna:"[64] adorned with jewels, crowns, or special robes, holy statues were carried in public processions by confraternities, and later "undressed" – that is, divested of ceremonial finery and cloaked in black mourning – when the members returned to the oratory to begin their private devotions.[65] On Maundy Thursday, when the

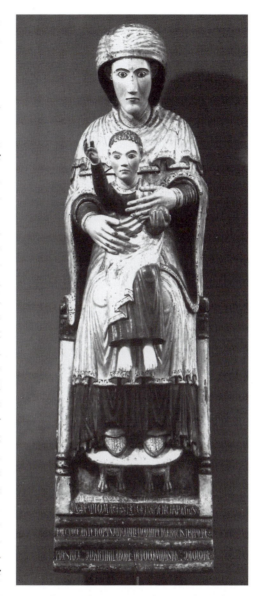

5. Presbyter Martinus, Sculpture of Madonna and Child, Berlin, Staatliche Museen (Photo: Staatliche Museen zu Berlin – Preußischer Kulturbesitz Skulpturensammlung).

Madonna was "undressed," flagellant confraternities whipped themselves to commemorate the foot-washing of the apostles, the Last Supper, and the agony in the garden, when Jesus' sweat "became . . . like blood" (Luke 22:44).[66] It is hypothesized that the lost Madonna may have provided a sculptural precedent for Piero, for it was important to the group's collective rituals.

Of all Piero's debts to the past, the most crucial was his portrayal of the

Madonna sheltering the devout beneath her mantle to signify her merci-
ful intercession. The iconography of the Madonna of Mercy is of great
antiquity.[67] It was inspired by innumerable literary and liturgical sources:
Byzantine hymns that beseech Mary, "Save us, Queen, with the veil of thy
mercy;" the "Salve regina misericordiae" ("Save us, Queen of mercy"),
intoned in the Latin liturgy; Cistercian visionary literature, in which the
Virgin protected monks under her mantle so they could dwell eternally "in
celestial glory." Lauds sung by the laity, most notably in confraternities,
movingly implore Mary's intercession with her son while they praise her
glory as Queen of Heaven and Mother of God. By the mid–thirteenth cen-
tury, such texts had begun to be translated into compelling images that
appeared in manuscripts, frescoes, processional banners, and altarpieces.
The iconography was popular among communal groups, especially confra-
ternities. By the 1260s, the oldest confraternity in Rome, the "Raccom-
mandati della Vergine" (Devotees of the Virgin), was given the Madonna
of Mercy as its patron, representing her on its processional banner.[68]

Piero's Madonna emerges from the rich visual legacy that had flour-
ished in Tuscany since the early Trecento, especially in Siena and Arezzo.
In Siena, artists from Duccio through Vecchietta portrayed the Madonna
of Mercy in manuscripts, panel paintings, and fresco. The work that pro-
vides most insight into the *Misericordia Polyptych* is the *Madonna della
Misericordia,* commissioned in 1444 from Domenico di Bartolo for the hos-
pital chapel of Santa Maria della Scala in Siena.[69] The now detached
fresco illuminates the expectations that worshippers might have brought
to Piero's altarpiece and suggests the intensity of Marian devotion in the
mid–fifteenth century.

Santa Maria della Scala functioned as a charitable institution that
lodged pilgrims and provided care for the indigent and infirm, as did the
hospital of the Misericordia.[70] The fresco depicts the seated Virgin and her
Child with a multitude of the devout kneeling beneath her mantle, which
is parted by angels. The scroll near the Virgin's head is inscribed with a
plea to Christ: "O my sweet son, look upon this people who hasten
beneath the mantle of she who is their advocate and you, their salvation,
and for the love I bear grant them all good things, and above all your guid-
ance."[71] Below an inscription proclaims: "Here is an image of the Blessed
Virgin Mary. Under your mantle the Christian populace is protected." Sim-
ilar hopes for the Virgin's advocacy and protection are likely to have been
held by worshippers in the hospital church of the Misericordia. Whether
donors or paupers, residents or pilgrims, members of the confraternity or
beneficiaries of its charity, all were potential recipients of her mercy and
of redemption through her son.

The Madonna della Misericordia was also a popular theme in Arezzo.
Numerous works chronicle the town's devotion to the Madonna of Mercy
in the early Renaissance. Paintings by Spinello Aretino and Parri Spinelli

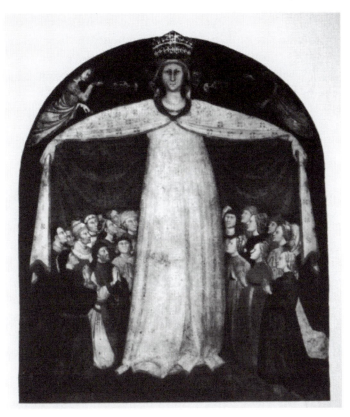

6. Parri Spinelli, *Madonna della Misericordia*, Arezzo, Santa Maria delle Grazie (After R. van Marle, *The Development of the Italian Schools of Painting* [The Hague, 1927], p. 9, fig. 144).

became objects of major cults, inspiring great outpourings of public devotion.[72] Bernardo Rossellino's relief of the *Madonna of Mercy with Saints Lorentinus and Pergentinus* above the portal of the Palazzo di Fraternità di Santa Maria della Misericordia identified the residence of a flagellant confraternity dedicated to philanthropy, especially in times of plague.[73] In Piero's day, the most venerated image may have been Parri Spinelli's *Madonna della Misericordia*, commissioned by San Bernardino of Siena for the town's oratory of Santa Maria delle Grazie and painted around 1445 (Fig. 6).[74] The Virgin is framed by angels swinging censers for burning fragrant incense, sanctifying the image and the altar. She beholds the worshipper as she protects multitudes of the faithful – popes, kings, the populace of Arezzo – beneath her cloak. So miraculous was this painting deemed that a new church was erected to enshrine it.

Although emerging from this rich tradition, Piero's altarpiece departs significantly from these works. As if to emphasize the Madonna's humanity, there are no angels parting her cloak or swinging censers. Rather than regarding the worshipper directly as do many images of the Madonna of

Mercy, she lowers her gaze to her devotees, creating an intimate bond between them. In contrast to the multitudes huddling beneath the Virgin's mantle in earlier paintings, only a privileged few kneel before her, suggesting the selectivity of her grace yet leaving room for the devout who might join them. Finally, Piero projects the perspective of the panel from the viewpoint of the kneeling worshipper as if Mary were a sculpture, perhaps alluding to the statue of the Madonna in the Badia or in the Misericordia's oratory. Piero's interpretation of this traditional iconography is distinctive. It reflects a clarity and economy of means that is found in every one of his paintings.

The *Misericordia Polyptych* addressed the needs of the varied constituencies who worshipped in the church of Santa Maria della Misericordia. It reinforced communal pride, honoring the saints whose preservation of Sansepolcro's welfare was invoked in civic statutes (1441): John the Baptist, "head and protector of the magnificent and illustrious people and community of Florence," and John the Evangelist, "head, protector, and governor of the commune and people" of Sansepolcro.[75] Its predella proclaimed the town's association with the tomb of Christ and alluded to the relics venerated in its churches, most notably, fragments of stone from the Holy Sepulcher. Recipients of the Misericordia's charity could pray before the image of the Madonna and imagine themselves among the devout beneath her cloak; donors of alms would receive indulgences for their generosity and be assured of her clemency. In times of plague, as one of the Misericordia's lauds implores, the populace might ask Mary to "take away bitter death and pestilence," or "with tears . . . pray" to Saint Sebastian for his intercession.[76]

Members of the Misericordia had a more resonant relationship with the image. The Madonna of Mercy was their patroness, inspiring their many acts of philanthropy, their self-flagellation, their singing of lauds. Piero's Madonna was not thought to have been a mere simulacrum or image, but the Virgin herself, honored by the candles lit before her and moved by their prayers. As they implored her in their lauds, the Virgin was the source of mercy:

> Mercy [Misericordia], we are crying out,
> Mercy, do not abandon us,
> Mercy to God, we implore you,
> Mercy to the sinner.[77]

A fifteenth-century painting is the repository and record of innumerable social relationships.[78] In the case of the *Misericordia Polyptych*, these relationships are complex. The history of the commission reveals the often antagonistic dealings between patron and artist. These account for the protracted execution and the different style of the altarpiece's components. In every element, the polyptych encodes the dedication of the

Misericordia to the Madonna of Mercy and to the welfare of Sansepolcro, whose unique culture – as namesake and commemoration of the Holy Sepulcher, as destination of pilgrims – was safeguarded by its confraternities. In its style, the altarpiece reflects the confluence of innovation and local artistic and iconographic tradition. While the *Misericordia Polyptych,* as the earliest surviving work by Piero, is crucial to our understanding of his stylistic formation, it is equally important to our appreciation of the artistic and spiritual milieu from which he emerged.

2　The Spiritual World of Piero's Art

Timothy Verdon

Revalued in the late nineteenth and early twentieth centuries for its formal qualities, the painting of Piero della Francesca has often been read in exclusively visual terms, with little or no attention to specific content. "The spell of an art as impersonal, as unemotional as Piero's is undeniably great," Bernard Berenson wrote in 1897, adding that "where there is no specialized expression of feeling . . . we are left the more open to receive purely artistic impressions of tactile values, movement and chiaroscuro."[1] Roberto Longhi insisted that "perspective induces Piero to organize everything inside the most simple and monumental contours . . . as if everything should really become one of the five regular bodies in order to assist the perspective construction."[2] And where content has been treated, the approach has at times been "abstract": Kenneth Clark beautifully but misleadingly described the Christ figure in Piero's *Resurrection* (see Plate 1) as a "country god . . . worshipped ever since man first knew that seed is not dead in the winter earth, but will force its way upwards through an iron crust."[3]

Today – thanks to relatively recent reflection, not only on Piero della Francesca and his iconographic sources, but on the entire relationship of Christian life with Renaissance culture – it is possible to recognize, in what Berenson saw as "impersonality," a kind of ritual gravity that disciplines but does not suppress emotion, and in Piero's use of technical innovations like perspective as an expressive as well as formal tool.[4] In the same way, powerful figures like the Christ in the Sansepolcro *Resurrection* now appear to be bearers of specific messages rather than anonymous icons of general truths: not a "country god" evoking regeneration, but the Jesus who rose from a cruel death on Easter morning.

Above all, the extraordinary stillness that Piero creates in his images – an interior quiet in his personages that pervades exterior reality, wrapping

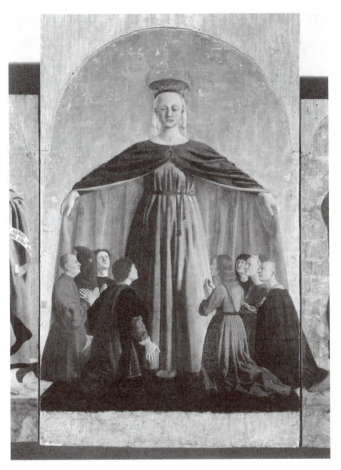

7. Piero della Francesca, Misericordia Altarpiece, detail: *Madonna*, Sansepolcro, Pinacoteca Comunale (Photo: Scala/Art Resource, NY).

the natural world in light and silence, imbuing perspective and geometry with human meaning – today is more easily perceived as "religious" in character. The late twentieth-century search for a spiritual center of gravity, together with interest in ancient disciplines of meditation and the nostalgia – amid ever more frenetic outward activity – for a lost inner calm, are experiences that open our eyes to the contemplative dimension in Piero that earlier critics failed to grasp. At the same time, the growing body of information regarding religious practice in fifteenth-century Italy invites translation of this sympathetic insight into something more concrete: a plausible interpretive framework within which to assess Piero as a master of Christian art.

Three early works can serve to introduce the spiritual world in and for which Piero della Francesca worked: a small panel in the Venice Academy, showing Saint Jerome in the wilderness with a disciple (Plate 4); the large

altarpiece in Sansepolcro with, as its main image, Mary spreading her cloak over believers (Plate 2 and Fig. 7); and the *Baptism of Christ* altarpiece, now in the National Gallery, London (Plate 8). Datable to a single period, which perhaps opened in 1445, when the Sansepolcro altarpiece was commissioned, these works of Piero's youth are typical of three related but distinct "environments" of Quattrocento religious and cultural experience: private piety, corporate or confraternal devotion, and the more traditional context of monastic prayer.[5]

These contexts of use are legible in the works themselves or in what we know of them. The Venice painting was clearly executed for the man shown alongside Saint Jerome, whose name, inscribed below his kneeling figure, was in fact "Jerome": "Hier. Amadi Aug. F.", "Jerome Amadi, son of Augustus."[6] The Sansepolcro altarpiece is known to have been executed for the Compagnia della Misericordia in that city, a charitable brotherhood that assisted the sick and needy; the figures over whom Mary extends her mantle are almost certainly portraits of members of the confraternity, and one of them actually wears the brotherhood's habit, its hood completely covering his face.[7] And the *Baptism of Christ* seems to have originated in a monastery, the Priory of Saint John the Baptist on the outskirts of Sansepolcro.[8]

In each painting, the subject and its interpretation shed light on the "world" for which the work was made, and each distinct world was part of the artist's own personal universe. Piero was in fact a practicing Christian, at least conventionally fervent, who left money to the Church in his will; he worked for lay confraternities and, in later life, would be elected prior of such a group in Sansepolcro; and, like most Renaissance artists, he was employed on several occasions to paint for communities of monks or friars. The works we will consider thus convincingly and authoritatively evoke, first, the scholarly and ascetic bent of cultivated laymen in fifteenth-century Italy; second, the practical piety of lay brotherhoods, which was typically eucharistic, Marian, and ecclesial in emphasis; and finally the biblical and liturgical framework of monastic contemplative prayer.

Saint Jerome with a Disciple

The panel now in Venice, showing Saint Jerome with a man in fifteenth-century dress kneeling before him with joined hands, is more than an ideal "double portrait" of the donor and his patron saint. Indeed, the inscription below the devout layman may – as some have thought – be a later addition, so conceivably the man's name was not really "Jerome" at all. Whoever he was, though, this gentleman has chosen Saint Jerome as exemplar and, apparently, as guide to Christ: the man is facing the saint, but Jerome himself is sitting in front of a crucifix angled in such a way that, if he straightened his head, he would see it. Piero perhaps wants us to under-

stand that Saint Jerome was looking at Christ when, adverting to the presence of his disciple, he turned to explain something.

The open book in the saint's left hand and the eloquent gesture of his right hand clearly suggest a process of textual elucidation: of explaining something through written sources. In the manner of scholars and teachers in all ages, Jerome has other books ready to hand, next to him on the stone bench where he sits: one open and another, beautifully bound, which is closed. All of this takes place, however, not in the scholar-saint's study, but in a natural setting – a valley at the foot of hills – with a city clearly seen behind Jerome in the middle ground.

Several other elements stand out. A robust young tree rises behind the kneeling layman, in compositional and "emotional" balance with the crucifix in the foreground, which is set in a neatly severed trunk on which Piero has signed his name. This trunk and the healthy tree beyond it define a diagonal into the picture's depth, which we cannot but notice due to the angle at which the crucifix is set, and this diagonal in turn is bisected by the gaze passing from Jerome to his disciple. The relationship between the two is thus defined, even "structured," by the cross of Christ.

In private paintings of this kind, such details are usually meaningful, and here the details are so original as to command attention. This work is in fact among the earliest treatments of a subject that will enjoy considerable popularity in late Quattrocento art, especially in Venice: Saint Jerome in the desert. Our small panel thus highlights aspects of a current in Renaissance spirituality in some way "typical" of educated laymen.

The presentation of Jerome as a hermit or anchorite is the first important feature. Late medieval and early Renaissance representations of this sometime secretary of Pope Saint Damasus I usually show him in Cardinal's robes: an anachronism, since the cardinalatial dignity was introduced long after Jerome's death in 420, but understandable, given the influence this saint had as official translator of the Bible into Latin, for which he was considered one of the four great 'teachers' – *doctores* – of the Western Church.[9]

The image of Jerome as a desert saint – a hermit or anchorite given to austere penitential practices – is historically accurate. After his conversion, Saint Jerome in fact spent several years in the Syrian desert, imitating the first Christian monks, famous for their extreme asceticism. This part of his experience was recuperated in a popular thirteenth-century devotional tract, the *Legenda Aurea,* or "Golden Legend," whose author quotes Jerome's own vivid description of his desert years: "every day was spent in tears, every day in groaning, and, if sometimes importunate sleep overcame me, the bare earth served my dry bones as a bed. . . . My sole companions were scorpions and savage beasts, and I only ceased beating my breast when the Lord had restored me to tranquility."[10]

At the same time, the author of the *Golden Legend* recalls Jerome's

vocation as a scholar. Quoting Sulpicius Severus, he describes the saint as "ever engaged in reading, ever in the midst of books, he rested neither by day nor by night. He was always either reading or writing."[11] Piero della Francesca in fact shows the saint not only as a hermit, poorly clothed and barefoot, his tunic open to allow him more easily to beat his breast, but also as a scholar with books.

What is Jerome reading, what is he "explaining" to his fifteenth-century follower? He himself tells us, as it were, in the prologue to his *Commentary on the Book of the Prophet Isaiah,* when he says: "I fulfill my duty, obeying Christ's command to 'search the Scriptures' (cf. John 5:39)." In the same passage, Jerome notes that, "if, in fact, as Saint Paul says, Christ is the power and the wisdom of God (cf. 1 Corinthians 1:24), then anyone who does not know the Scriptures does not know God's power or his wisdom. To be ignorant of the Scriptures is to be ignorant of Christ."[12]

We may say, therefore, that Piero's depiction of Jerome *with books* is meant to illustrate the saint's well-known commitment to biblical studies. In the same way, the placement of the crucifix in front of him, angled so that he can see it when he looks straight up from his book, suggests why Jerome studies Scripture: to find, in its pages, the power and the wisdom of God, Jesus Christ. Elsewhere, Jerome says, "when I read the Gospel, and see there the testimony from the Law and the Prophets, I contemplate Christ alone," and this probably explains the books on Jerome's bench: he is reading the New Testament, but cross-referencing what he reads with related passages from the Old Testament ("the Law and the Prophets").[13]

The final result, when the saint lifts his eyes from the page, will be to "see" Christ on the cross as the wisdom and power of God. In the verse quoted by Jerome in his Isaiah commentary, Saint Paul in fact insists that, while nonbelievers ask for miracles and philosophical learning, "we proclaim Christ – yes, Christ nailed to the cross; and though this is a stumbling block to Jews and folly to Greeks, yet to those who have heard his call, Jews and Greeks alike, he is the power of God and the wisdom of God" (1 Corinthians, 1:21–24).

The setting in which Saint Jerome expounds this privileged knowledge gleaned from Scripture – the knowledge of God's wisdom and power revealed in Christ's self-oblation – is itself part of the message. In the monastic tradition into which Jerome inserted himself, the renunciation of worldly ambition and wealth – what was called *fuga mundi,* "flight from the world" – typically found expression in the choice of some remote habitat in which the monk might encounter God in silence. Far from human cities and their distractions, the chosen spirit could prepare his heart to enter the "city of God," the heavenly Jerusalem.

In a letter to the city-dweller Heliodorus, Saint Jerome exalted the spiritual value of his own choice of the wilderness in rapturous language that we might imagine addressed to the layman in our panel.

O desert of Christ, burgeoning with flowers! O solitude, in which those stones are produced with which, in the Apocalypse, the city of the great king is constructed! O wilderness that rejoices in intimacy with God! What are you doing in the world, brother, you who are greater than the world? How long will the shadows of houses oppress you? How long will the smoky prison of these cities close you in? . . . Do you fear poverty? But Christ calls the poor blessed. . . . Does the unkempt hair of a neglected head cause you to shudder? But Christ is your head. Does the boundless expanse of the wasteland terrify you? Then do you walk in Paradise in your imagination.[14]

These ideas were both "ancient" and "modern" in Piero's day, for fifteenth-century Italy had its own Jerome figures, who kept the ideal of Christian solitude alive in the hearts of believers: monk scholars who fled the world in search of the "desert of Christ." The most famous by far was Saint Lorenzo Giustiniani (1381–1456), son of a noble Venetian family who, in his early twenties, had abandoned all to live a life of prayer and study with like-minded companions on San Giorgio in Alga, a desolate islet in the Venetian lagoon. From his knowledge of Scripture and the early Church Fathers, Lorenzo – who years later was named Bishop and first Patriarch of Venice – drew the material for short treatises on the spiritual life, with titles that suggest the "background" of our panel: *De vita solitaria, De interiori conflictu animae, De contemptu mundi* – "On the solitary Life," "On the Soul's Inner Struggle," "On Detachment from Worldly things." A biography by his nephew Bernardo, published in Venice in 1475, similarly evokes San Lorenzo Giustiniani's patristic asceticism, in a substantial chapter "regarding his hunger, thirst, nights spent in prayer and every sort of bodily penance."[15]

For educated Renaissance laymen, the asceticism of Saint Jerome and of modern imitators of his life had a further implication, deeply felt in the antiquarian climate of the age. Jerome, born c. 342 in the still "classical" world of late antiquity, had received literary training in the style of the Greco-Roman authors. After his conversion, this taste for pagan literature troubled him, however, and in a dream he saw himself chastised before the throne of Christ for preferring Cicero to Sacred Scripture. In the same letter in which he lyrically praised the advantages of Christian solitude to his friend Heliodorus, Jerome made clear that, for him, renunciation of the world included renouncing the pagan writers he had once so loved. Speaking of the day of final judgement, he says: "then Jupiter with his offspring will be displayed truly on fire. Foolish Plato will be brought forward also with his disciples. The reasoning of Aristotle will not avail. Then you, the illiterate and the poor, shall exult."[16]

This was an "inner struggle" that early Renaissance Italy knew well, as humanist thinkers and writers became ever more aware of the beauty of the ancient classics, but also of the "danger" they represented, with their exaltation of a wisdom *not* rooted in Judeo-Christian beliefs. How to rec-

oncile traditional Christian faith with the new taste for pagan philosophy and poetry? "What alliance can there be between the light and the shadows?" asked Saint Lorenzo Giustiniani,

What comparison of human learning with celestial wisdom? Celestial wisdom is delightful, speaks of mysteries, teaches the things of heaven, fills the spirit with faith, raises us up from lowliness to the highest regions! Human learning, on the other hand, scandalizes the ears, puffs itself up beyond all measure, is brought forth in vain ostentation, contradicts the holy simplicity of truth, detracts from the sentiment of faith, and alienates from Christ those who place their hope for salvation in detachment from the world.[17]

The resolution of this conflict, for Lorenzo Giustiniani in the fifteenth century as for Jerome a thousand years earlier, was a humble reorientation of one's literary tastes towards the Bible and the writings of the Church Fathers. "To avoid the snares of human learning, there are the oracular messages of the prophets, the writings of the apostles, the vast erudition of the saints, who speak not for themselves but because Christ is in them."[18] The kneeling disciple in Piero della Francesca's panel seems to follow this advice, turning not to pagan but rather to Christian antiquity: to Saint Jerome who, as he expounds the "oracular messages of the prophets and the writings of the apostles," reveals Christ crucified, archetype of all renunciation, "celestial wisdom" incarnate.

And all of this between the severed trunk and the vital tree, which must be visual references to the texts Jerome is expounding. The stump into which Jerome's crucifix is fixed in fact alludes to an Old Testament passage that the Church has always understood as adumbrating Christ's passion. Speaking of the enemies who had plotted his imprisonment, the prophet Jeremiah says: "I was like a sheep led obedient to the slaughter; I did not know they were hatching plots against me and saying, '*Let us cut down the tree while the sap is in it*; let us destroy him out of the living, so that his very name shall be forgotten'" (Jeremiah 11:19).

The other tree – the one behind Jerome and his disciple – in its youthful vigor alludes to the Old Testament characterization of the Messiah as *germen* (in Saint Jerome's Latin) or *virgultus*: a sapling, a life-filled young tree, in many translations called "branch." The Lord will vindicate his people, Isaiah says, and on "that day, the branch of the Lord shall be beauty and glory, and the fruit of the earth shall be the pride and adornment of Israel's survivors" (Isaiah 4:2). In Jeremiah this young plant is explicitly a person: "See the says are coming – it is the Lord who speaks – when I will raise up a virtuous Branch for David, who will reign as true king and be wise, practicing honesty and integrity in the land" (Jeremiah 23:5); and in Zechariah the Lord says: "I now mean to raise up my servant Branch, and I intend to put aside the iniquity of this land in a single day" (Zechariah 3:8–9); "here is the man whose name is Branch, who will shoot up from

the ground where he is and rebuild the temple of the Lord" (Zechariah 6:12).

This last reference – to a man who will "shoot up from the ground" and "rebuild the temple" (destroyed in 587 B.C.E., when Jerusalem had been occupied by the Babylonian army) – is an explicit allusion to Christ's resurrection. When critics asked Jesus by what right he had driven money changers from the twice-rebuilt Jerusalem temple, he had replied: "Destroy this temple, and in three days I will raise it again." His enemies failed to grasp Christ's meaning, but the Evangelist John explains, right after the phrase, "I will raise it again", that: "the temple he was speaking of was his body. After his resurrection, his disciples recalled what he had said, and they believed the Scriptures and the words that Jesus had spoken" (John 2:18–22). In Piero's panel, the Christ on the cross fixed to the severed trunk is turned toward the living tree, as if, even in death, the man "Branch" knew he would shoot up from the earth and restore the temple of his own body.

Jerome and his disciple have the cross and severed trunk in front of them and thus have no difficulty seeing Christ's suffering. His resurrection remains a matter of faith, though: the vigorous tree symbolizing new life is behind them, they will not see it unless they turn completely around. Yet it is this faith that Saint Jerome, through the kind of textual analysis we have suggested here, illustrates for his friend the belief that renunciation, sacrifice, even death for love of God and humankind, are not weakness, not folly, but the wisdom and power of God himself, revealed in Christ's death and rising. The grave intensity of Jerome's gaze, as he explains these things to his friend, reminds us of Paul's description of his own teaching in the first Letter to the Corinthians: "The word I spoke, the gospel I proclaimed, did not sway you with subtle arguments; it carried conviction by spiritual power, so that your faith might be built not upon human wisdom but upon the power of God" (1 Corinthians 2:4–5).

The Altarpiece for the Misericordia

Less erudite, more accessible in its range of messages, is the monumental altarpiece commissioned by the Compagnia della Misericordia in Sansepolcro on 11 January 1445. Made for the altar of the confraternity's oratory, this multicomponent work assembles twenty-six figures (as opposed to the two in the private painting just considered) in a complex but legible public image intended to mirror the faith of the community for which it was made, members of which are shown in the central panel (see Plate 2). Like countless other altarpieces of the period, this work has Mary as its main figure, surrounded by saints and "framed" above and below by scenes relating to her Son's life, death, and resurrection. Even if executed piece-

meal, as some critics have held, and with another artist for the predella panels, the Sansepolcro altarpiece is coherent in its iconography and was probably planned as a single unit of meaning.

It is not difficult to "read" a work such as this, given a few specific facts and some general theological information, of the kind many people possessed in fifteenth-century Europe. Here we know that the painting was *commissioned by a sodality,* a brotherhood of pious lay men and women who, motivated by religious faith, gave time, money, and physical and emotional energy to assist the sick and dying: an association with a strong sense of group identity that wanted its "logo" on the frame, "MIA": *"Misericordia,"* or "Mercy."

And we know that the painting they commissioned was *for an altar:* meant to serve as backdrop for the celebration of Mass, the rite in which the gifts of bread and wine offered to God on behalf of the community – gifts that symbolize the individual community members' lives – become the body and blood of Christ. This fact alone explains the iconography of the pinnacle panel above, and the predella panel below the central image: the *Crucifixion* and the *Entombment,* subjects focused on Christ's *body,* offered up on the cross, laid in the sepulcher. In traditional Christian belief, the Mass makes Christ's death on the cross present in an unbloody manner; and in medieval liturgical theory, the rectangular central part of the altar – between the base and the table top – was called the *tumba,* or "tomb."[19] That is to say, the altar on which the bread was placed was understood to symbolize the tomb in which Christ's body was laid. Thus the image of the Crucifixion, above, and that of the Entombment, below, were standard eucharistic allusions, easily decipherable in the context of the Mass. And in a town whose very name, Sansepolcro – "Holy Sepulcher" – alludes to the mystery of Christ's death and burial, this standard imagery had additional impact.

In the same way, the two panels at right and left of the Crucifixion, showing the Archangel Gabriel and the Virgin Mary, were conventional features. Together, these figures illustrate the Annunciation, the New Testament episode in which the heavenly messenger tells Mary she is to bear God's son. When she accepts, the child is conceived in her womb, and every Annunciation image is therefore also a representation of the Incarnation, the theological mystery of God "enfleshed," "made man," a true human being with a body physiologically derived from his mother's body.

In Piero's altarpiece, with its contextual eucharistic implications, the allusion to the Incarnation (through inclusion of an Annunciation scene) is readily grasped: the body that Christ offered on the cross, and that is sacramentally present in the consecrated bread and wine, is the same body conceived by his mother at the moment of the Annunciation. Piero's arrangement of the Annunciation panels to right and left of the Crucifixion – as if the "word" spoken by Gabriel to Mary "became flesh" on the

cross – seems to illustrate Saint Leo the Great's assertion that "the sole purpose of God's Son in being born was to make the crucifixion possible. For in the Virgin's womb he assumed mortal flesh, and in this mortal flesh the unfolding of his passion was accomplished."[20]

Here as in other altarpieces, the figures of saints flanking the central panel also have eucharistic meaning. The consecrated bread and wine – the sacrament of the body and blood of Christ – are "communion": these material elements signify and effect a sharing in God's own life. When in communion with God, believers are also in communion with all who have gone before them: with men and women of good will of all ages and places. Thus the Mass spiritually unites those gathered in prayer in front of the altar with the great personages of Judeo-Christian history depicted "behind" or "on" the altar: here, at Mary's right and left, Saint Sebastian, Saint John the Baptist, Saint Andrew, and the contemporary Franciscan saint, Bernardino of Siena.[21]

In the Mass text commonly used in the fifteenth century (the so-called "Roman Canon"), after the consecration of the bread and wine, the cele-brant in fact addresses God on behalf of all present, saying: "for ourselves, too, we ask some share in the fellowship of your apostles and martyrs, with John the Baptist, Stephen, Mathias, Barnabas, Ignatius, Alexander, Peter, Felicity, Perpetua, Agatha, Lucy, Agnes, Cecilia, Anastasia and all the saints." This text, constituting a kind of verbal altarpiece, expresses what is called the "communion of saints," and even believers with limited understanding of the rite and its Latin words would presumably have grasped that they on one side of the altar, and the saints shown on the other, were united in fellowship around the body of Christ between them.[22]

Less conventional is the choice of subject for the panel in the center of the altarpiece, directly above where the priest stands as he consecrates the bread and wine. Piero's central panel shows members of the confra-ternity reacting with controlled but visible emotion to Mary, who spreads her mantle to 'cover' – protect, give shelter to, receive in intimate contact with herself – the men and women depicted. This was a standard way of presenting Mary as "Mother of Mercy," *Mater Misericordiae,* and is com-prehensible in the case of a confraternity called and actively committed to "mercy"; Piero probably knew the Trecento fresco in the Florence Confra-ternity of Mercy, which similarly shows Mary in a voluminous cloak ven-erated by members of the sodality (Fig. 8), or the emblematic reliefs of Mary spreading her cloak over confraternity members that we find in the Venetian *"scuole"* (brotherhoods).[23]

What is unusual is use of this image type for an *altarpiece,* since the "Mater Misericordiae" format shows Mary without the Christ child, as an autonomous protective figure. Normally, it is precisely the presence of her Son that explains Mary's prominence in altarpieces, since the human flesh Christ offered on the cross and now gives believers in the Eucharist

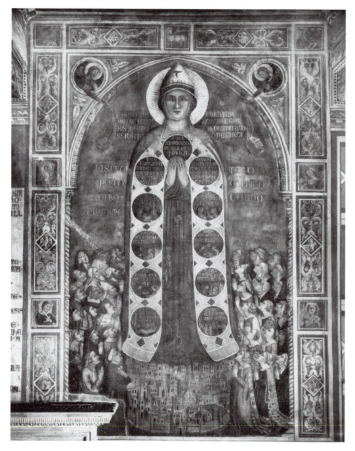

8. Florentine Master, *Madonna della Misericordia*, Florence, Bigallo
(Photo: Alinari/Art Resource, NY).

derives from her flesh. The "Madonna and Child" theme of innumerable
medieval and Renaissance altar paintings puts the Incarnation in mean-
ingful relationship with the Eucharist celebrated before the image: just as
Mary holds the body of the Child in her arms, so the priest holds the con-
secrated bread, and the Eucharist is perceived as "continuation" of the
physical presence of God among men that began with the birth of Christ.

And it was unusual, in this period, to show contemporary men and
women in an altarpiece as emotionally responsive to the subject. To be
sure, Piero's confraternity members are smaller in scale than Mary and the
flanking saints; yet their strong and varied affective response, and circular
arrangement around Mary – in an altarpiece whose other figures are all
shown frontally against the gold background – give these ordinary people
an importance that is quite extraordinary.

The spiritual significance of this innovation is clear: at the consecra-

tion of the Mass, when the priest elevated the bread and then the chalice of wine, the real men and women kneeling before Piero's altarpiece were to see themselves as part of the "communion of saints," sharing in the brotherhood of the great personages depicted at Mary's right and left. What is more important, beyond the raised bread wafer they could see themselves in intimate relationship with Christ's mother, from whose human body had come the body that Christ had offered on the cross and made present in the Eucharist. Indeed, seen in relation to the circular host – the eucharistic wafer elevated by the priest at the most solemn moment of the Mass – the disposition of these men and women in a circle around Mary made them too "bread offered," "body of Christ" born of the Mother of Christ.

And that is the whole point: what the Eucharist *is,* sacramentally, the community of believers *is* mystically. "You are Christ's body," Saint Paul assured the Christians of Corinth in the first century: "each of you a limb or organ of it" (1 Corinthians 12:27). This affirmation comes as the conclusion of a carefully constructed analogical presentation of the interdependence of parts in a "corporate" whole such as the Church: "A body is not a single organ, but many. . . . the eye cannot say to the hand, 'I do not need you'. . . . if one organ suffers, they all suffer together" (1 Corinthians 12:14–26). It is the rationale, the raison d'être of charitable organizations like the Sansepolcro Confraternity of Mercy: the healthy members of an organism must succor other members, less fortunate; "God has combined the various parts of the body . . . that there might be no sense of division in the body, but that all its members might feel the same concern for one another" (1 Corinthians 12:24–25).

This is more than metaphor. For Saint Paul and for Christian tradition, all believers together – rich and poor, healthy and sick, saints and sinners – constitute the "body of Christ" because, receiving the Savior's flesh and blood in the Eucharist, they are transformed into what they eat. A popular catechism of Piero's time – a little primer in the Christian faith written by a man whom Piero della Francesca could have known in his Florentine years, Saint Antoninus Pierozzi – makes this point with didactic emphasis: "the Body of Christ transforms those who receive it worthily into God. The Psalm says: 'I tell you, you are gods and all of you sons of the Most High', and Christ says to those who receive him worthily: I tell you, you have become gods and sons of the Most High God. And note that in the chalice at Mass is the blood in which Christ's body is contained, and in the host is also the blood of Christ."[24]

Another theologian of the period, Nicholas of Cusa, commenting on the phrase in the Our Father, "give us this day our daily bread," identifies that bread as Christ himself, and notes that "He is not food that gets changed into our nature, as physical food does . . . but rather the food of

life which unites us to him and makes us alive with his very life." Nicholas adds that,

all creatures that reach eternal life are, as it were, limbs of the one body of Christ, sharers in the one life of Christ, so that Christ alone lives in them. . . . If you would be truly alive, you must be united to Christ. But this union with Christ cannot be achieved except through union with his body, that is with the holy Christian Church. . . . You have to understand that faith, even the sacrament and all the virtues together cannot help you to achieve true life if you are not a member of the body of believers in Christ who form the community.[25]

In Piero's altarpiece, the members of the confraternity have been positioned in such a way as to make explicit their identity as "body of Christ," "limbs" of one organism, the "community of believers" that is the Church, its members compassionately concerned for others. And if they are collectively the body of Christ, then they have an intimate relationship with Mary, since – as noted – the body of Christ comes from Mary's body. As members of the Church, they are children of Mary, traditionally considered to be *Mater Ecclesiae* and *Mater Christianorum,* Mother of the Church and Mother of Christians. She became the "mother" of all believers at the moment illustrated in the *Crucifixion* placed above the central panel of this altarpiece: when, from the cross where he hung, "Jesus saw Mary, with the disciple whom he loved standing beside her. He said to her, 'Mother, there is your son'; and to the disciple, 'There is your mother'; and from that moment the disciple took her into his home" (John 19:26–27).

Mary thus prefigures the Church, which similarly "gives birth" to Christ in its members. "The Church, like Mary, possesses perpetual integrity and uncorrupt fecundity," says Saint Augustine, "and that which Mary merited in her flesh, the Church preserves in her mind – with the difference that Mary bore only one Son, while the Church bears many children, destined to be united in one through the One who is Christ."[26] A medieval theologian, Blessed Isaac of Stella, similarly insists that Mary and the Church both "conceive by the Holy Spirit, and without carnal desire, and both give the Father sons free from sin." In Blessed Isaac's view, Christ is "the first-born among many brethren; one by nature, through grace he has associated many with himself, so that they might be one with him."[27]

In Piero's painting, the Misericordia members are presented as "sons" and "daughters" of the Church (Mary), associated with the first-born Son, Christ, through eucharistic sharing in his body and blood, and – in Isaac of Stella's phrase – "one with him." Their expressions of awe and adoration suggest a dawning awareness of the dignity God has conferred on them: what Saint Paul calls the "illumination" of believers' inward eyes so that they may grasp the hope to which God calls them (cf. Ephesians

1:18–19). They gaze with love at mother Church, for it is from her that they receive Christ, and in her that they "become" Christ.

Mary herself – the Church – displays a joyful inwardness that is anything but "impersonal" or "impassive." Piero indeed contrasts her joy, in the main panel, with the grief Mary expresses in the *Crucifixion,* above. This noble figure gathering her children to herself might be mentally reciting the canticle spoken shortly after she conceived Christ: "Tell out, my soul, the greatness of the Lord, rejoice, rejoice my spirit in God my savior. . . . His name is holy, his mercy sure from generation to generation for those who fear him" (Luke 1:46–50). Piero in fact shows her here "conceiving" other children, who manifest God's "mercy . . . from generation to generation."

The *Baptism of Christ* in London

Probably painted for the church of a religious community, this altarpiece presents central truths of Christian faith in a more explicit way than the works for lay people discussed above (see Plate 8). Instead of "secondary" personages presented allusively – Jerome as a figure of Christian learning, Mary as a figure of the Church – here Christ himself is at the center of the image, shown in the opening event of his adult life, his baptism at the hands of John, recounted with minor variations in each of the four Gospels.[28] As in the works already considered, scriptural and patristic references suggest further levels of meaning, but the panel's primary function as backdrop for the Eucharist is absolutely clear in the central figure, which is quite literally the "body" of Christ.

Piero shows Christ standing in prayer in the Jordan river, at a point where the sluggish water has stopped its flow. John moves toward him and, from a bowl in his raised right hand, pours water over Christ's head, while – directly above the cup – the Holy Spirit in the form of a dove hovers. At Christ's right, separated from him by a tree, three angels look on. Behind these foreground figures, a plain stretches toward a town and distant hills, and in the middle distance are several figures in oriental costume. Somewhat nearer the viewer a man is disrobing in preparation for baptism.

Unseen but tangibly present for viewers conversant with the New Testament is God the Father, who chose this moment to acknowledge Christ as his "beloved Son," the "chosen one" (Matthew 3:17; Mark 1:11; Luke 3:22; John 1:33–34). The episode of Christ's baptism is in fact also the revelation of God as "trinity," for the three Persons – Father, Son, and Spirit – are mentioned together for the first time in this event.[29]

In this panel, where the central Christ has an iconic solemnity similar to Mary's in the Sansepolcro altarpiece, and the landscape is practically

identical to that in the Venice *Saint Jerome,* one feature surprises us: the prominence, in the overall composition, of the beautiful tree at Christ's right, growing at the edge of the water. Set next to the Savior and the river where he stands, it seems to illustrate the opening of the Book of Psalms: "Happy indeed is the man who follows not the counsel of the wicked. . . . he is like a tree that is planted beside flowing waters" (Psalm 1:1–3).[30] This is the kind of scriptural allusion we have already noted in the *Saint Jerome,* and here – in a work made for a monastic church where daily recitation of the Psalms was an obligatory part of the liturgy – the reference would have been grasped by all.

This association of the "man . . . like a tree" with Christ was not, moreover, private erudition (as are the "branch" allusions in *Saint Jerome with a Disciple*), but a well-known patristic interpretation of Psalm 1, with which the members of the religious community could have been familiar. Saint Augustine began his commentary on this text by stating that the "beatitude" referred to in verse 1 – *"beatus vir,"* "happy the man" – "applies to Our Lord Jesus Christ."[31] Augustine then interpreted, "he is like a tree that is planted beside flowing waters," to mean "near Wisdom in person, or near the Holy Spirit," and that suggests a link between his reading of the Psalm and the event of Christ's baptism, in which Christ appears "near" – right below – the Holy Spirit. The same explicit identification of the *"lignum . . . plantatum"* with Christ is developed by other early Christian writers, among whom Jerome, Ambrose, Hilary, Athanasius, Cassiodorus, Origen and Eusebius.[32]

Yet Piero's painting is clearly more than "textual illustration." This luminous vision seems to offer insights broader and deeper, of subtler color and richer texture, than the literary simile linking a man and a tree possibly could convey. The artist's visual equation of two discrete realms of meaning, humanity and nature, implies a relationship more concrete yet also more elusive than words – even inspired words – can communicate. With greater efficacy than the Venice *Saint Jerome* or the Sansepolcro altarpiece, the *Baptism of Christ* mediates an experience that is not only "religious" (in a conventional, albeit theologically rich sense), but *spiritual* and *mystical.* More than other early works, it invites reflection on Piero's use of form to symbolize spiritual truth.

We have suggested that the *Baptism* was painted for a monastic church, and the related possibility that its iconography was worked out for, and with the collaboration of, patrons familiar with the entire corpus of scriptural and patristic texts.[33] Yet even should such not be the case – even if the work were made for other patrons and another context – we should not exclude elevated meanings. For, as Mircea Eliade's studies of symbolism confirm, "symbols address themselves not only to the awakened consciousness, but to the totality of the psychic life. Consequently, we do not have the right to conclude that the message of symbols is confined to the

meanings of which a certain number of individuals are fully conscious. . . .
Depth psychology has taught us that the symbol delivers its message and
fulfills its function even when its meaning escapes awareness."[34]

This insight – which we might apply to the "message" of the severed
trunk and healthy tree in *Saint Jerome with a Disciple,* or that of the shel-
tering mother-figure of the Misericordia altarpiece – also explains how the
range of meaning desired by "fully conscious" patrons could be communi-
cated to artists. Even if, as we assume, the *Baptism* was painted for a
monastic community, it remains true that Piero della Francesca was not a
monk. Yet in some way he shared in the "totality of the psychic life" of his
putative monastic patrons, simply by virtue of living in fifteenth-century
Italy, with its regular and frequent liturgical celebrations, public sermons,
mystery plays, and so on.

At the very least, we can assert that – in its original setting – Piero's
Baptism would not have been analyzed but meditated upon. What for
modern viewers tends to be a schematic, rational process, for fifteenth-
century worshippers was probably more fluid: a gradual movement from
hint to hint as they daily encountered the painting in a context of prayer.
A classic description of this process, and one that focuses precisely on the
affective impact of images and other forms of symbolic communication,
may be found in Saint Augustine. He says that, "the presentation of truth
through signs has great power to feed and fan that ardent love by which,
as under some law of gravitation, we flicker upwards or inwards to our
place of rest. Things presented in this way move and kindle our affection
far more than if they were set forth in bald statements."[35]

Turning to Piero's painting, where little is "set forth in bald statements"
and everything seems to function as "sign," several questions arise. If sym-
bolism is a generally powerful expressive device, how does it work in the
specifically Christian context which constituted Piero della Francesca's
spiritual world? In a closely reasoned theology of the symbol, a modern
Catholic thinker, Karl Rahner, suggests a principle that the fifteenth-cen-
tury painter must have known instinctively: "All beings are by their nature
symbolic, because they necessarily 'express' themselves in order to attain
their own nature."[36] We shall return to this idea later, but for now it will
be useful to balance Rahner's formulation with an insight of the Protes-
tant theologian Paul Tillich, who says that "the depth and riddle of all
expression is that it both reveals and hides ultimate reality at the same
time."[37] This ambiguity reflects what another thinker, Louis Dupré, has
called the "negativity of religious symbols": that is, the way in which "the
symbolizing act itself accentuates the discrepancy between form and con-
tent," and how "religious symbols . . . convey . . . an awareness of their
purely analogous character."[38]

Certainly this negative characteristic is apparent in Piero's *Baptism,*
where the prominence given the tree – virtually equal with that given the

Christ figure – seems to juxtapose man and his natural environment in a particularly stark way. Our first reaction is that, although man may be "like a tree planted by running water," in fact he is *not* a tree. At this point, there enters what Dupré calls a "distrust of the given": in this case, a doubt that the visually perceived relationship, even when interpreted by the verse from Psalm 1, really explains the artist's unusual arrangement of elements.[39]

And that may be Piero's (unconscious) intention. For, if all beings are symbolic but at the same time hide as well as reveal their ultimate reality, then it is up to the artist to alert us to the ever operative fact that, in all of reality, there is "more than meets the eye." By selection and emphasis, artists in fact challenge viewers to penetrate the surface and grasp those deeper "truths" mediated by symbols. To achieve this, artists make aesthetic choices that constitute style: form, color, composition.

A particularly provocative stylistic choice in the *Baptism* is Piero's visual equation of the man and the tree, and even more the singular way both are treated. Piero's Christ is luminous and still, isolated against earth and heaven: a marble column or, better, one of translucent alabaster. The tree to his right – the trunk at least – has these same qualities: a light and glowing skin that Piero has matched with the color and tonality of Jesus' human flesh. In shape, too, the tree's columnar trunk serves as a geometric module or reverberation for the human figure beside it.

This chromatic and morphological congruence between the man and the tree sets them apart from the rest of nature in the scene, human and vegetational alike: it is the stylistic device that Tillich, in another context, called "numinous realism," the portrayal of objects "in a way that makes them strange, mysterious, laden with ambiguous power."[40] Numinous realism as a style mediates the religious experience of the holy present in the midst of the profane, "opposed" to it, but at the same time "standing for" – representing – the true depth meaning of reality. It introduces into art an experience similar to what, in religion, is called "sacramental."

A related question has to do with the use of symbolism in specifically Christian art. Christians of course have employed symbolic expression throughout their history, in writing, ritual, and the visual arts. This has varied from shorthand "indicators" like the fish, anchor, and chi-rho of the catacombs to the stylized images of Christ that even the Byzantine iconoclasts allowed. Indeed, Christianity as a religious system presupposes the use of symbolic images: the Gospel of Saint John presents Christ himself as incarnate "Word" (*Logos*) of God, and that makes symbolism a basic component of Christian thought, for – as Rahner points out – "the theology of the Logos is strictly a theology of symbol, and indeed the supreme form of it . . . [since] the Father *is* himself by the very fact that he opposes to himself the image which is of the same essence as himself, as the Person who is other than himself."[41]

What is more, as Dupré emphasizes, the fact that the Word took a material body reveals the sacramental character of matter and indeed of

the whole cosmos.[42] The Incarnation lies at the heart of all Christian use of matter, and that includes the making and display of works of art. Christ himself is a "work of art": the material image of the unseen God (Colossians 1:15), an "icon" that so perfectly conveys the substance of the "original" that Jesus can say: "to have seen me is to have seen the Father" (John 14:9).[43] Extending the logic of this affirmation, we might say – in Platonic rather than New Testament language – that images of God's own "image" are not mere outward signs distinct from the reality they represent but partake in some limited way of the reality of the Exemplar.

To make the same point in a more traditional way: it has been consistent Catholic teaching that works of religious art are "sacramental" in function, mediating God's grace to all who use them in appropriate ways. The Council Fathers at Trent required Church art to illuminate the intelligence and "incite devotion and sting the heart"; that is, they considered works of art to have the power to open realms of knowledge closed to discursive reasoning, influencing commitments and behavior and ultimately helping to transform human lives.[44] Religious icons or images, like the sacramental rites for which they often furnish a backdrop, are not only bearers of revelation given in the past but autonomous forms of religious revelation in the present, prolonging the process of hierophanization.[45]

In the foregoing paragraphs, we spoke of the whole religious image as a single symbol or unified bearer of symbolic meaning. Yet paintings like Piero's *Baptism* are really agglomerations of symbols that coexist and interpenetrate, enriching and illumining each another. Here "flowing water" is not narrowly biblical in its allusions but has ancient mythical associations with the source of life, with purification, with water divinities and their epiphanies. While remote, such echoes remain audible, inasmuch as the historical event which is Piero's subject – the Jewish rite of baptism applied to Jesus – had evolved (at least in part) under the influence of near-Eastern myth systems with which the ancient Jews came into contact. Old and New Testament alike hint at similar archaic associations, and the allure of this syncretistic view could have reached Piero della Francesca through the Hermetic tradition, revived by Renaissance thinkers.[46]

So too with the tree: the Psalmist's simile invites comparison with non-biblical sources. Ancient Indian and Mesopotamian myths which present the tree as an image of the cosmos, as cosmic theophany and symbol of resurrection and rebirth, are all apposite and in one form or another were known in Italy from the Middle Ages on. One ancient Eastern notion indeed posits a mystical bond between trees and men, with trees as mythical ancestors of the human race.[47] It is tempting to think of the Psalmist's figure of speech as a distant echo of such traditions.

This cosmic imagery is latent in the more precise symbolic associations offered in the Bible: associations, in the case of trees, with knowledge, life, integrity and – in the New Testament – with the cross as "medicinal plant," source of universal *renovatio,* what an early Christian poet called

"arbor una nobilis . . . decora et fulgida, ornata regis purpura" ("singular and noble tree . . . adorned, glowing, robed in royal purple").[48] The result is an indefinite range of symbolic meanings, some literary, others ingrained in the archetypal forms of consciousness: meanings that tap a vast reservoir of semantic energy and work on the imagination to disclose unsuspected relationships and levels of meaning.[49]

A follower of natural religion can find in Piero's *Baptism of Christ* the age-old emergence from water of a god come to purify humankind, and make all creation "new" in an eternal springtime. A Christian may see the "new Adam" (Christ) in a garden setting like that inhabited by the first Adam, and the tree as a reference to the cross – a new "tree of the knowledge of good and evil" – on which Christ would reverse the sin of the first Adam, and so on. The potential for contemplative reflection is limitless, due to the multivalence of the symbols themselves.

Yet there should be more, for rich as these allusions are, and subtly interwoven, they lack a focus. Whether Piero knew the myth of humankind's descent from trees or not, it is doubtful that he could think of men or women as being "like" trees. He might well have thought the converse, however, since Christianity has traditionally understood nature as mirroring the anthropocentric mystery of the Word made flesh. In fact the "focus" of this painting – the central symbol that subsumes and organizes all the other symbolic references – is Christ (we noted Rahner's insight that Logos theology is the "supreme form" of symbolic thought).

At the center of the *Baptism,* Piero shows us the Word who fully "expresses" the Creator's being, standing in the midst of the created universe. As Saint John says, "through him (the Word, Christ) all things came to be" – trees, streams, mountains, men and angels: "not one thing had its being but through him . . . (and) he was in the world that had its being from him" (John 1:3 and 1:10). A Pauline text adds that "in him (Christ) were created all things in heaven and on earth: everything visible and everything invisible . . . all things were created through him and for him. Before anything was created, he existed, and holds all things in unity" (Colossians 1:15–17).

In Christian perspective, this is literally the heart of things, the epicenter of history and material creation. In the language used by late medieval theology, we might say that Piero's real subject here is the Formal Cause of everything that exists, standing amidst his own varied "expressive" actions upon primal matter.[50] Particular manifestations – water, trees, and so forth – are not reduced to the status of metaphors, but God himself becomes a particular being in order to symbolize the dignity of all other particular, finite things: a symbol allowing the other realities we see to be meaningfully present.[51]

Here biblical simile and mythological analogy suddenly disclose roots that push into the ground of being itself. As Father Rahner says, because

of God's presence in the world through the Incarnation of his Word, Christ,

the natural depth of the symbolic reality of all things – which of itself is restricted to the world or has a merely natural transcendence towards God – has now in onto-logical reality received an infinite extension, by the fact that this reality has become also a determination of the Logos himself or of his milieu. Every God-given reality, where it has not been degraded to a purely human tool and to merely utilitarian purposes, states much more than itself: each in its own way is an echo and indi-cation of all reality. And if the individual reality, by making the all present, also speaks of God – ultimately by its transcendent reference to him as the efficient, exemplary and final cause – this transcendence is made radical, even though only in a way accessible to faith, by the fact that in Christ this reality no longer refers to God merely as its cause: it points to God as him to whom this reality belongs as his substantial determination or as his own proper environment. All things are held together by the Incarnate Word in whom they exist (cf. Colossians 1, 17), and hence all things possess, even in their quality of symbol, an unfathomable depth, which faith alone can sound.[52]

Seen in these terms, what Piero shows us is in the *Baptism* is not nature over against man, but the whole natural world as a "determination of the Logos," an extension of the nobly solitary figure of Christ at the cen-ter of the composition. From this "One" the uncountable "many" of cre-ated reality irradiate: water, trees, hills, clouds, angels, and men coexist in harmony because all multiplicity stems originally from an eternal unity of which Christ is the expression. And these multiple natural realities also function as symbols, suggesting connections and stirring associations in the human spirit, because in them the original One maintains himself even as he discloses himself in plurality (which here implies not dilution and weakness, as in Greek thought, but the ultimate fullness of a devel-oped unity).[53] The One indeed has resolved himself into many in order to know himself in that multiplicity; it is this primordial "symbolizing activ-ity" that allows – among other things – the human being to possess him-self in knowledge and love.[54]

All reality therefore derives from the Logos, and reality's character as symbol derives from Christ's character as expressive "Word" of the Father. It follows that the dynamic congruence described above, between the One (Christ) and the many (varied material realities created "through" him and that he holds together), reflects a deeper relationship still: what we may call the symbolic structure of the innermost life of God, who is three dis-tinct Persons in one godhead. In the Christian mystery of the Trinity, the Father, in order to know and love himself, differentiates himself from him-self as expressive Word or symbol, which he spontaneously projects out-wards in order to communicate himself to himself. Indeed, it is because God "must" express himself inwardly that he can also utter himself out-wardly; the finite, created utterance *ad extra* is a continuation of God's

immanent constitution.[55] And, as noted above, Piero's *Baptism of Christ* implies this Trinitarian–cosmic link: over the Son hovers the Spirit, while the Father remains unseen, or rather *is* seen precisely in the symbolic reality of the Son, the Word that defines once and for all "what (who) God wanted to be for the world."[56]

In the optic of contemplative faith, this then is the "subject" of Piero della Francesca's painting: God's intention for the world as Father, which he expressed at Christ's baptism when he said, "You are my Son, the beloved, my favor rests on you." It is the "Epiphany," the appearing before men in history of God's design for the universe, "the mystery of his purpose, the hidden plan," to "bring everything together under Christ as head, everything in the heavens and everything on earth" (Ephesians 1:9–10). In this theological perspective, moreover, Jesus was not alone at the Jordan – not alone as "Son" and "beloved": at the Baptism "the whole human race was present in Christ Jesus," Saint Hilary of Poitiers affirmed.[57] Yet even this does not exhaust the meaning of the event, for God's favor invests not only his human creatures, but, as Saint Gregory Nazianzen states, the natural world too has a part in the Father's "hidden plan." "Jesus comes up out of the waters, and raises up the whole world with him."[58]

In the ecstatic visual harmony Piero creates, where all things share equally in the bright effulgence of the unseen God, we in fact see Saint Paul's conviction that even "creation . . . retains the hope of being freed like us from its slavery to decadence, to enjoy the same freedom and glory as the sons of God" (Romans 8:21). In Piero's pictorial mediation of the Baptism event, the *One* to whom "God gives . . . the Spirit without reserve" (John 1:34) – that is, Christ – subsumes the *many*: in him "everything in the heavens and everything on earth" is perfectly symbolized. Piero's subject, if you will, is God as invisible Father pouring the plenitude of his Spirit on all the created universe, in Christ his Son.

A final word is in order on the figure of Christ, which we have called the central symbol of the scene. Piero's Christ is a virtual nude, projecting that unique power of the human body to symbolize the person and his primordial decisions.[59] What is more, the figure is an *ideal* nude: that is, Piero has borrowed from the sculptural repertory of Greco-Roman civilization a balanced, symmetrical rendering of human proportions able to convey the highest possibilities of our existence. In the idealized beauty of this Christ, Piero shows us our own bodies as they will be when glorified: a vision of the eschaton incarnate in one man, deeply appropriate to the eucharistic function of the painting. The majestic calm of the altarpiece, its quiet authority, flow from this idealism in the rendering of the central figure: for those who will receive the Body of Christ, and become transformed into what they receive, Piero adumbrates human perfection in the present, showing God in man and man in God here and now. He invites "remembrance of the lost, and anticipation of the regained, paradise."[60]

3 Piero's *Legend of the True Cross* and the Friars of San Francesco

Jeryldene M. Wood

> But the reader must judge of the truth of the divers legends which we have set down; for sooth to say, none of them is mentioned in any authentic chronicle or history.
>
> Jacobus da Voragine[1]

Celebrated for their quiet power and subtle beauty, Piero della Francesca's frescoes in the Cappella Maggiore of San Francesco at Arezzo dramatize a great Christian epic, the *Legend of the True Cross* (Fig. 9). This extraordinary saga traces the history of the Cross on which Christ died from its origin as a branch of the tree of mercy in the Garden of Eden, to King Solomon's disposal of the wood after a prediction that it would destroy his kingdom, to Saint Helena's discovery of the Cross on Golgotha, and its theft and return to Jerusalem in the seventh century. The triumphant vision of universal Christianity portrayed in the *Legend of the True Cross,* as often observed, is a medieval fabrication that subsumes the historical reality, for the Muslim Turks ruled the Holy Land and most of Byzantium by the time Piero painted the chapel at mid–fifteenth century. Yet the commingling of fabulous and actual events in histories and chronicles is commonplace in this era; at Arezzo itself a substantial collection of myths and anecdotes was traditionally associated with the Franciscans. According to legend, their chapter was founded in 1211 after Saint Francis expelled the ferocious demons fighting in the skies above the town, and some two hundred years later another Franciscan saint, Bernardino of Siena, brandished a large wooden cross as he crushed a revival of pagan ritual at a nearby ancient Roman well, the *fonte Tecta*.[2] The adventures of Benedetto Sinigardi (c. 1190–1282), a beatified Aretine friar who served as a Provincial Minister in the East and who is interred at San Francesco, are less popularly known. The veneration of this Beato, however, suggests a rationale

for the Franciscans' selection of the *Legend of the True Cross* for the chancel of their church in the absence of the usual relic, titular dedication, or association with a confraternity of the Cross. As we shall see, the neglected legend of Beato Benedetto bridges the interests of the friars of San Francesco and the predominant European discourses on church reunification and Islamic territorial expansion favored in the existing interpretations of Piero's frescoes. Because usefulness largely motivates the acceptance of myths and legends, what follows explores the *Legend of the True Cross* in light of local lore, the history of the Aretine friary, and contemporary Franciscan ideological issues.[3]

Impressed by his expulsion of the devils in 1211, many Aretines, among them the noble Benedetto Sinigardi, who took monastic vows from the founder himself, accepted Saint Francis's religious reforms. According to Nanni d'Arezzo's *Life and Miracles of Blessed Sinigardi of Arezzo*, dated 1302, Beato Benedetto rose through the ranks of the new mendicant order, leading the Franciscan chapter at Arezzo until he was appointed Provincial Minister for the Marches of Ancona in 1217 and, most importantly, Provincial Minister of the Holy Land in 1221.[4] A missionary and a peacemaker like Saint Francis, Beato Benedetto preached throughout the East from his bases at Antioch and Constantinople and participated in negotiations to unite the Greek and Latin Churches in 1232–34. Endowed by God with the power to perform miracles and to experience visions, he cured a highborn Saracen woman with the Sign of the Cross, converting her and her family to Christianity. When bandits obstructed his pilgrimage to the tomb of the prophet Daniel in Babylonia, God sent an angel in the guise of a fire-breathing dragon to carry him to the site, where he received a precious relic, a finger of the prophet, which he brought back to Antioch, and eventually to Arezzo. Nanni also reports that Beato Benedetto invested John of Brienne, the King of Jerusalem and regent for the Latin Emperor of Constantinople, as a Franciscan tertiary; in fact, some chroniclers believe that it was the Aretine friar who brought this ruler's body to Italy for burial in San Francesco at Assisi after his death in 1237.[5] During his return voyage to Italy, the Beato calmed the stormy seas that threatened to capsize his ship, and as the astonished crew watched, he was enveloped by a white cloud and spirited away. According to Nanni, the cloud transported him to the Terrestrial Paradise, where he conversed with the prophets Enoch and Elias, who, as legend had it, lived there awaiting the Last Judgment.[6] After returning to Arezzo, the Beato tirelessly preached Christ's Word, reconciled civic disputes, restored the sick, and aided the poor. He also possessed the gift of prophecy, predicting in 1268 the ascent of the Angevin kings to the throne of Naples. Throughout the legend Nanni emphasizes the Beato's acquaintance with Saint Francis and compares the two friars' virtues, including their observance of poverty and their reverence for the Virgin Mary. Beato Benedetto, he notes, composed

9. Cappella Maggiore, Arezzo, San Francesco (Photo: Scala/Art Resource, NY).

the antiphon *Angelus locutus est Mariae* in her honor. What is most impor-
tant, however, is that the Aretine Franciscans considered Beato Benedetto
the founder of their chapter. Thus it is not surprising that when he died in
September of 1282, they interred him before the high altar of their church
at Poggio del Sole on the outskirts of Arezzo, where they had lived since
about 1232.[7]

Construction of the current church of San Francesco began only after
the commune ordered the friars to move into town for greater safety in
1290. The complex must have been well under way by 1318 when the friars
requested permission to sell the old monastery and apply the proceeds to
their new residence.[8] Nevertheless, work on San Francesco progressed in
a piecemeal fashion for more than a century and a half because the friars
depended upon papal indulgences and the largesse of individual donors for
support. For example, Frate Angelo di Meglio, the superintendent
(*operaio*) of the construction, was not able to begin the three chapels in
the apse until 1366 (see Fig. 11).

Just as Nanni d'Arezzo's legend of Beato Benedetto evokes the life of
Saint Francis, so too the Aretine friars' new church invites comparisons
with San Francesco at Assisi. Like its predecessor, San Francesco at Arezzo
comprises upper and lower churches (though here the crypt only extends
from the high altar to midnave) and the altar dedications in the Aretine
apse recall those in the mother church. The high altar in Arezzo is of
course dedicated to the titular saint, the altar in the Guasconi Chapel (to
the right of the chancel) is dedicated to Saint Michael the Archangel, the
altar in the Tarlati Chapel (at the left) to the Virgin Mary, and the altar in
the Chapel of Pagno di Maffeo (adjacent to the latter) to the Crucifixion.
The murals painted during the first decades of the fifteenth century trans-
formed the entire apse end – the area enclosed by the *tramezzo* compris-
ing the chancel, family chapels and the friars' choir – into a visual testa-
ment of Saint Francis's devotion to the Passion and to the Virgin Mary.
Spinello Aretino frescoed the walls of the Guasconi Chapel with the
exploits of Saints Egidio and Michael the Archangel and the Tarlati
Chapel with a *Crucifixion*.[9] Near Spinello's beautiful *Annunciation* on the
nave wall just outside of the Guasconi Chapel, his son Parri painted fres-
coes honoring the Archangel, Saint John Damascene, and Saint Francis
himself by the entrance of the sacristy. In 1408 the merchant Baccio di
Masi di Bacci, whose fictive coats-of-arms hang like ancient Roman tro-
phies on each side of the triumphal entrance to the chancel, received the
patronage rights to the Cappella Maggiore. Although Bacci's testament of
1408 and subsequent codicils made provisions for its decoration, little had
been accomplished by the time of his death in 1417.[10] After numerous
delays, the Florentine artist Bicci di Lorenzo commenced work on the
exterior of the chapel, where he painted a *Last Judgment* on the triumphal
arch of the entrance during the 1440s (see Fig. 9). When he abandoned the

commission owing to his advanced age and infirmities (sometime after 1447), Bicci also had completed the Evangelists in the vaults of the high, narrow chapel, two of the Western Doctors of the Church on the inside of its entrance, and a Holy Spirit and angels above the window on the rear wall. We do not know precisely when Piero della Francesca painted the *Legend of the True Cross,* for the existing documentation only verifies that it was finished in 1466, about a century after construction of the chapel commenced.[11]

When they moved to San Francesco, the friars transferred works of art and cherished relics, including the remains of the Beato, who is still honored today in a chapel on the right side of the nave in an antique Roman sarcophagus (Fig. 10).[12] Because of the countless renovations and restorations of the church over the centuries, the original location of Beato Benedetto's tomb is uncertain. In light of the protracted construction of the building, the Beato was probably placed at least initially in the crypt, perhaps below the high altar as in the tombs of Beato Egidio in San Francesco al Prato at Perugia and Beato Ranieri Rasini in San Francesco at Sansepolcro, rather than in a separate chapel.[13] Upon completion of the apsidal chapels, the Beato was again accorded a place of honor near the high altar, possibly in a niche on the lower right-hand wall of the Cappella Maggiore or in the adjacent chapel of his mother's family, the Tarlati di Pietramala.[14] Notwithstanding its secular patronage and the *Last Judgment* over its entrance, the Cappella Maggiore was not an actual funerary chapel, for Baccio di Masi and his family were not buried there, but at the entrance to the friar's choir in the laity's section of the nave (see Fig. 11).[15] Thus, the chancel in effect enshrined the Beato, the local founder personally acquainted with Saint Francis of Assisi. Surprisingly, there is no evidence for an altarpiece in the Cappella Maggiore before the sixteenth century, much less for one comparable in grandeur to the large double-sided altarpieces commissioned in the early fifteenth century from the Sienese artists Taddeo di Bartolo and Sassetta to mark the burial sites of the Franciscan *beati* at Perugia and Sansepolcro.[16] Could it be that the frescoes narrating a famous legend of the Holy Land fulfilled a similar encyclopedic function at San Francesco: to celebrate the missionary zeal and sanctity of Saint Francis and Beato Benedetto?

Comprehensive pictorial cycles of the *Legend of the True Cross* are quite rare in medieval and Renaissance Italy. Thus the Franciscans' instructions to Bicci di Lorenzo and Piero della Francesca doubtless relied on the two best-known sources of the *Legend* available: the popular account in Jacopo da Voragine's *Golden Legend* (a copy of which was in their library); and Agnolo Gaddi's frescoes in the chancel of Santa Croce, the Florentine church where the Franciscan General Chapter was held in 1449.[17] Agnolo Gaddi's vibrant, densely populated frescoes replicate the verbose, discursive style of the *Golden Legend* (Fig. 12). Divided between

10. Tomb of Blessed Benedetto Sinigardi, Arezzo, San Francesco (Photo: Author).

the two feast days of the Holy Cross observed in May and September and meandering back and forth in time over hundreds of years, Jacopo's exposition is not strictly sequential. Instead, it intersperses references and digressions that elaborate on the principal characters and events, and it alleges accuracy or "truth" by recounting variations of the stories while leaving the issue of veracity to its readers. Piero's translation of Jacopo's literary imagery into visual form presupposes a knowledge of this kaleidoscopic narrative. Yet in contrast to Gaddi, he transforms the fantastic incidents, visions, prophecies, and admonitions of the story into a lucid pic-

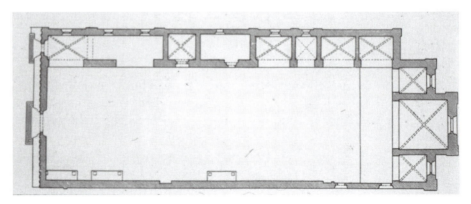

11. Plan of San Francesco, Arezzo (Photo after M. Salmi, *Un'Antica Pianta di S. Francesco in Arezzo* [Assisi, 1920], fig. 2).

torial epic and maintains visual logic by restricting the number of charac-
ters and episodes and by focusing on the most critical prophecies and their
fulfillment. In Piero's frescoes the coherent perspectival space, consistent
illumination, and nuanced characterizations exemplify the naturalizing
function of myth in that they condense, clarify, and efface complexities
and inconsistencies. In the *Queen of Sheba Adoring the Wood of the Cross*
and the *Meeting of Solomon and Sheba* (Plate 10), for instance, Piero con-
vinces observers that what transpires is at once credible and wondrous by
counterbalancing fifteenth-century clothing and authentic psychological
reactions with artfully formalized poses and gestures. The murmuring
grooms attired in complementary crimson and gray restrain their restless
horses at the far left of the painting, while gestures as placidly repetitive
as the ripples on a pond evince the surprise of the court ladies who watch
the kneeling queen. Having changed from simple traveling clothes to
majestic white and gold ceremonial dress at the right of the fresco, the
Queen of Sheba epitomizes the standards of female beauty and grace seen
in profile portraits of the period (see Plate 27), and King Solomon, also
attired in costly brocade, embodies the wealth, magnificence, and worldly
grandeur of a Renaissance prince.[18]

In its entirety, Piero's *Legend* offers a visual parable to fifteenth-century

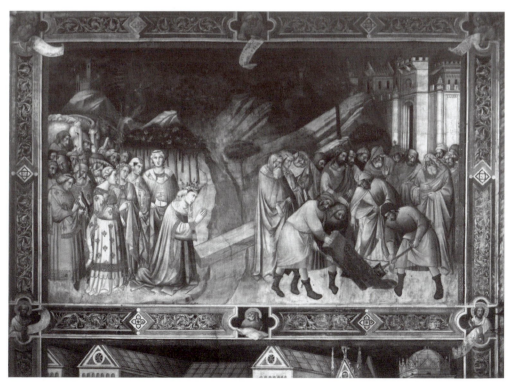

12. Agnolo Gaddi, *The Queen of Sheba Adoring the Wood* and *Solomon Orders the Burial of the
Wood,* Florence, Santa Croce (Photo: Scala/Art Resource, NY).

observers, one in which the events unfold in time, gradually disclosing an enduring religious lesson. Beside the window on the rear wall of the chapel, the glances and gestures of two men clothed in voluminous red and green drapery (usually identified as prophets) direct viewers to the first episode in the story, the *Death of Adam,* represented in the right-hand lunette (Plate 9).[19] Carefully contrived visual and contextual cues then guide observers through tales of queens and emperors to the opposite lunette, where the cycle concludes with the *Exaltation of the Cross* (Plate 18). The cast of characters in the paintings propels the story across the centuries, while the signifying objects – first the wood and then the Cross itself – communicate the timeless message of humanity's redemption. Piero emphasizes these symbols throughout the cycle by foreshortening them, placing them diagonally across the pictorial surface, or situating them before penetrations into depth that break with the mostly horizontal arrangement of figures and spatial planes in his compositions (Plates 10, 11, and 13). The division of the walls into three distinct registers by fictive architecture encourages a more or less vertical reading that follows the chronology of the legend; nevertheless, parallel themes (traveling monarchs and imperial battles) and corresponding visual motifs (repetition of color and consistent figure types) prompt typological comparisons between the facing scenes at each level of the chapel so that the allegorical components of the myth ultimately prevail over strict temporal sequence.[20]

Piero's great achievement at San Francesco was to impose visual clarity and coherence on Jacopo's intricate legend. Organized around a towering tree at the center, the composition of the *Death of Adam* (see Plate 9) introduces a visual mythos, a symbolic level of belief represented by the wood of the Cross, which will sustain the narrative throughout the complex cycle. The fresco depicts a continuous narrative derived from an apocryphal Hebrew legend, the *Quest of Seth,* starting on the right, where the weak and aged Adam, his open palm gesturing in speech, alerts his family to his impending death.[21] As Eve gently props up his head, their white-bearded son Seth bends forward, listening intently to his father's request "for a few drops of oil from the tree of mercy" in the Garden of Eden.[22] Just to the left, Seth reappears in the distance, having traveled along a winding path to the Garden of Eden, where he encounters the Archangel Michael. Refusing to supply the oil of mercy, the angel gives Seth a branch from the tree and predicts that from it the gift of eternal life will grow. By the time he returns his father has already died, Seth therefore places the branch from the miraculous tree into Adam's mouth. A splash of color – the youth garbed in blue and red as in Christ's customary dress – and a histrionic gesture – the woman with outstretched arms evoking lamentations of the dead Christ – highlight Seth and Adam at the center of the fresco. In narrative terms, Seth's obedience to the archangel's prophetic command literally sows the seed for subsequent events; moreover, his dis-

tinctive planting of the branch into Adam's mouth does not appear in the three versions of the story cited in the *Golden Legend,* nor does the bough conform to the kernel or seed described in Honorius's twelfth-century *De Imagine Mundi,* usually cited to explain this feature.[23] Gaddi's frescoes, however, do provide a precedent and thus suggest the Franciscans' desire to articulate a specific religious allegory: that the Christological tree which sprouts from Adam will heal the rift caused by original sin and grant redemption to believers. Not intended to represent the tree of mercy, which was inside the Garden of Eden, the visual prominence of the tree in Piero's fresco foretells the growth of the branch planted by Seth into "the mighty tree, which still flourished in Solomon's time."[24]

In the register below the *Death of Adam* the Queen of Sheba journeys to Jerusalem, hoping "to try the wisdom of Solomon with hard questions" (Plate 10).[25] Piero's zigzag composition fixes the observer's interest on the holy wood at the center of the fresco, while concurrently indicating chronological and spatial shifts in the story. The queen travels from the left until she halts at the bridge, but she enters the royal palace from the right; at the point where these opposing movements converge in the foreground, a great classical column aligned vertically with the majestic tree in the lunette emphasizes that the bridge at its left is the rejected wood.[26] Just as importantly it establishes a figurative connection between the diagonal placement of the beam and the strongly foreshortened corpse of Adam directly above. Here, as throughout the fresco cycle, Piero assumes that the primary audience, the friars in their choir, is familiar with the plot. To follow the events represented in the *Queen of Sheba Adoring the Wood of the Cross* and *The Meeting of Solomon and Sheba,* for example, observers had to know that the queen miraculously recognized the sacred wood and that she warned King Solomon in a letter: "upon this tree would one day be hanged the man whose death would put an end to the kingdom of the Jews."[27] In the monumental *Meeting of Solomon and Sheba,* an incident mentioned only in passing by Jacopo and not represented as a distinct episode in Gaddi's cycle, the queen's pensive expression hints at preoccupation with her disconcerting vision and raises the question of whether she will voice her concerns to Solomon.[28] Will the king whose renown for sagacity instigated his visitor's long journey remain blind to the significance of the holy wood while the inquisitive pagan queen sees its worth? Unlike Gaddi's step-by-step illustration of the story, which includes Solomon's vehement command to banish the wood after Sheba's prediction, Piero's *Transport of the Wood* on the rear wall of the chapel does not represent the king (Plate 11). Rather, Solomon's men, who have discarded their outer clothing in the heat of exertion, labor to bury the wood in a barely discernible hole at the lower left of the scene.[29] The straining muscles, twisting bodies, and intent expressions of the workers are marvelously rendered observations, but it is the illusionistically painted wood that

holds our attention. For fifteenth-century Franciscans devoted to the Passion, the plank cutting diagonally across the fresco most likely evoked an image of Christ carrying the Cross to Golgotha, just as scenes of a mother mourning her slain son conjured the Pietà.

The initial appearance of the cross in Piero's cycle is remarkably understated. In the nocturnal *Vision of Constantine* on the bottom tier of the back wall, an angel (once holding a tiny cross) swoops down like a magnificent bird, its bright radiance striking the front of the red and gold tent and the counterposed soldiers in the foreground (Plate 12).[30] Constantine's elevated head and chest imply obedience to the angel's command "to lift up his head" as he hears its message: "In this sign shalt thou conquer!"[31] Like the agitated horses in the *Queen of Sheba Adoring the Wood of the Cross*, a slight motion of the guard's hand at the right hints at something amiss, yet the courtier seated at Constantine's side looks outward undisturbed, unaware of the miracle that augurs the emperor's victory over his nemesis in the *Battle of Constantine and Maxentius* portrayed along the adjacent wall (Plate 13). Preoccupied with Constantine's advancing army, Maxentius forgets his own sabotage of the bridges near Rome, as the *Golden Legend* recounts, and drowns when the weakened Milvian Bridge collapses during his retreat.[32] Silhouetted against the open valley and curving river on which ducks peacefully swim and mounted upon a pure white horse, the calm, dignified Constantine leads his relentless troops in a slow march against the retreating army, whose discarded clothing and equipment register their impromptu flight.[33] Although Maxentius is still alive beneath the banners displaying a dragon and a Saracen's head, the absence of the bridge at the center of the painting signals his impending doom.[34] By excluding the bridge in the composition, Piero emphasizes that the Old Testament precursor of the True Cross, the wooden beam adored by Sheba in the composition above, has been superceded by its New Testament progeny, the jewellike symbol of redemption held by Constantine. The first Christian emperor lightly but steadfastly thrusts the diminutive cross forward over the tranquil waters of the Tiber, vividly acknowledging the power of the faith that the Hebrew ruler Solomon had failed to recognize.

The implication that Constantine immediately converted to Christianity after he defeated Maxentius, rather than after his mother Helena discovered the True Cross, exemplifies the mythologizing function of Piero's imagery in the chapel. Just as Constantine's victory unified the Roman Empire, scholars have argued, so too the *Battle of Constantine and Maxentius* (together with the Early Christian scenes on the left wall of the chapel) represents fifteenth-century efforts to unite the Eastern and Western churches and to regain the territories lost to Islam.[35] As their unwavering support of papal-backed crusades to the Holy Land attests, the Franciscans' fear of forfeiting the places affiliated with Christ's life was a pressing concern.[36] Given their chapter's historical connection with the

East through Benedetto Sinigardi, such a loss would have been particularly compelling for the Aretine friars because their Beato had not only guided the spiritual life of John of Brienne, the thirteenth-century Latin ruler of Jerusalem and Constantinople, but he had also participated in Pope Innocent IV's attempts to unify the Christian churches.

The merging of political interests and spiritual desires, whereby Christian truth triumphs over Jewish and Muslim error, finds expression on the left-hand wall of the chapel. In the large rectangular scenes challenges to belief appear on the left and the True Cross itself on the right (Plates 15 and 16); only when its fate is fully resolved does the True Cross again occupy center stage (see Plate 18).[37] Typological comparisons between Old and New Testament episodes reinforce this notion; for instance, in the *Torture of the Jew* and the *Transport of the Wood,* which flank the window on the rear wall (Plates 14 and 11). According to legend, after her arrival in Jerusalem to search for the True Cross, Saint Helena had a Jew named Judas cast into a dry well until he disclosed "the place which is called Golgotha . . . where I shall discover the Cross of Christ!"[38] In Piero's depiction of the hapless Jew's release, the wooden supports of the pulley used to lift up Judas cue observers to recall the downward-plunging plank in the *Transport of the Wood,* thereby distinguishing the insight of the Jew who converts to Christianity from the ignorance of the unconverted laborers, and indeed of their ruler King Solomon.[39] Visually linked to the fresco on the adjoining wall by a palace on the left, the extrication from the well and the consequent conversion of Judas serve as an effective prologue to Saint Helena's *Discovery and Proving of the True Cross* (Plate 15). This fresco in turn forms a thematic and visual pair with the story of the Queen of Sheba on the right wall of the chapel (see Plate 10). The royal women who recognized the holy wood and the True Cross mirror each other across the space in narratives similarly divided into distinct landscape and architectural segments and composed of complementary red-green color schemes. In contrast to the centrality of the wood in the legend of Sheba, however, the True Cross in the account of Saint Helena appears at the right of the scene, where it restores "a young man being borne to the tomb," whose sharply illuminated body rises towards the foreshortened wood like metal attracted to a magnet.[40]

In the *Discovery and Proving of the True Cross* Piero concisely dramatizes a line from the *Golden Legend:* "It remained only to distinguish the one to which Christ had been nailed from those of the thieves."[41] With consummate skill he depicts only three crosses in the two-part painting: two at the excavation, and a third, the True Cross, in the authentication episode at the right. The magnificent, classically inspired edifice behind the resuscitated youth stresses the miraculous nature of the event, for such architecture did not yet exist in Italy. At the same time, Piero prompts viewer identification with the historical past by painting a con-

temporary piazza bordered by a narrow urban street lined with fifteenth-century palaces (complete with rods for hanging ceremonial banners), as well as the recognizably Tuscan towers and churches in the distant view of Jerusalem in the left-hand scene.[42] Ostensibly modeled after images of the Church of the Holy Sepulcher on souvenir *ampullae* purchased by pilgrims, the lantern-topped dome just visible above the palaces at the right likely alluded to Saint Helena's foundation of that church, one of the sacred places which the friars administered in the Holy Land. For Franciscan spectators, therefore, the reference surely called to mind the Benedictine monks' attempt to usurp this coveted responsibility in 1441. And for members of the Conventual branch of the Franciscan order, such as the Aretine friars, the allusion probably resonated with additional force because in 1434 Pope Eugenius IV had consigned the holy sites supervised by the Conventuals to the Observants. Only permission to appoint a vicar at the Church of the Holy Sepulcher permitted the former to maintain a presence in Jerusalem.[43]

Approximately three hundred years after its discovery, the Persian King Chosroes stole the piece of the True Cross that Saint Helena had left in the Church of the Holy Sepulcher. According to the *Golden Legend*, after constructing a gold and silver tower "Chosroes, seating himself upon the throne as the Father, set the wood of the Cross at his right side, in the Son's stead, and a cock at his left side as the Holy Ghost, and commanded that he be called God the Father."[44] The strife and discord ensuing from the king's theft and his blasphemy of the Holy Trinity occupies most of the pictorial field in Piero's *Battle of Heraclius and Chosroes,* where in contrast to Constantine's "bloodless" rout of Maxentius on the opposite wall (Plates 13 and 16), the emperor utilizes force to stamp out heresy.[45] Piero choreographs the exhilaration and desperation of the clash by balancing grand simplified shapes and realistic detail, savage action and fatal stillness. Yet the outcome of the battle is never in doubt, for large upright banners marked with the imperial eagle, the papal lion, and a white cross on a red field flying above the vicious hand-to-hand combat and charging horses at the center of the fresco predict the Christian victory over the heathens, whose standards topple to the ground. To emphasize the point, a warrior in green and bronze armor at the right, perhaps Heraclius himself, thrusts his sword into the throat of a young soldier, slaying him beneath the falling Saracen flag and in front of a banner emblazoned with the star and moon signifying the Persian's blasphemy.[46] Just retribution swiftly follows victory at the far right, where the defeated and dethroned King Chosroes chooses to die rather than to accept Christian Baptism. The execution has been ordered and a soldier swings his sword back, gathering strength for the mortal blow, as the secular patrons of the chapel, three members of the Bacci family, bear witness.[47]

Piero crystallizes the Persian ruler's impersonation of the Trinity

through his physiognomical resemblance to God the Father in the *Annunciation* on the adjacent back wall (Plate 17). His imagery simultaneously counteracts King Chosroes's apostasy and manifests the triumph of true faith, for as the *Golden Legend* proclaims, at the Annunciation "the whole Trinity receives glory and the Son of Man the substance of human flesh."[48] The iconography of Piero's mural follows a local tradition established in paintings by Spinello Aretino and Parri Spinelli that depict God instructing Gabriel, who then appears, armed with the palm of victory, before the Virgin Mary.[49] As scholars have observed, the inclusion of the *Annunciation* is unprecedented in cycles of the True Cross and difficult to reconcile within the chronology of the story; however, Nanni d'Arezzo's *Life and Miracles of Blessed Sinigardi* offers a motivation for its exceptional insertion into the program at San Francesco. The Beato's *Angelus*, which was recited or sung daily after compline (the friars' late evening office), extols the Annunciate Virgin in its very first lines, "The angel of the Lord declared unto Mary. And she conceived of the Holy Spirit," up to its final supplication, "Pray for us O holy Mother of God. That we may be made worthy of the promises of Christ."[50] Situated on the wall clearly visible from the friars' choir and painted next to the portraits of the Bacci in the *Battle of Heraclius and Chosroes,* the *Annunciation* artfully links a communal devotion invented by the chapter's founder, customary Franciscan esteem for the Virgin, and the piety and generosity of the patrons with the promise of redemption pictured on the surrounding walls.[51] As important, the scene provides a visual pause, a time for the interjection of a hopeful prayer or meditation on the possibility of salvation, before the legend concludes with the restoration of the sacred relic to Jerusalem.

The *Exaltation of the Cross* elicits a specifically Franciscan level of signification in the chapel: as the Cross signifies Christ, by extension it signifies Saint Francis (Plate 18). When walled up entrances prevent him from entering the city, the Emperor Heraclius was advised to shed his lavish attire in imitation of Christ's humility. As the barefoot, chastened emperor advances towards Jerusalem with cross held high, the faithful greet him, as they had welcomed Christ on Palm Sunday. The progressive actions of the men – kneeling in wonder before the relic and removing their hats in reverence – echo those of Saint Helena and her ladies in the *Proving of the True Cross* directly below. By substituting an ecclesiastic, Bishop Zacharius, for the angel who counsels the ruler in most texts, Piero's *Exaltation of the Cross* departs from both written and painted precedents of the scene and eschews a visual and iconographical parallel with the Archangel Michael in the *Death of Adam* in the opposite lunette.[52] Presumably, the friars wished to compare the emperor's *imitatio Christi* with Saint Francis's because every Franciscan knew that the saint had disrobed before the Bishop of Assisi to symbolize his renunciation of temporal goods and, most significantly, that he had received the stigmata on the

feast of the Exaltation of the Cross.[53] As they contemplated the frescoes on this wall, the friars certainly would have pondered Saint Francis's ardent devotion to the Passion and conceivably they would also have remembered his encouragement of missions to the Holy Land, including his own visit to Antioch in 1219.[54] More pointedly, their reverence for Beato Benedetto, the Provincial Minister of Antioch who once strove to reconcile the Latin and Greek churches, would have intensified the cogency of the stories, reminding them of their historical custody of such sacred places as the Church of the Holy Sepulcher in Jerusalem and the Virgin's house in Nazareth.

The friars' belief that Saint Francis was an *alter Christus,* whose Christ-like poverty, humility, and suffering similarly offered the way to salvation, was a key concept of Franciscan theology.[55] The particular model for their imitation of Saint Francis, however, was vigorously debated by the Conventual and Observant factions of the Franciscan Order throughout the fifteenth century. As Conventuals, the friars of San Francesco followed the interpretation of Saint Francis's rule as it had been modified during the centuries after his death, not the vow of strict poverty espoused by Observant reformers such as Saint Bernardino of Siena. In fact, when the decorative program of the Cappella Maggiore was devised in the 1440s, the Conventual-Observant controversy was at a critical point. The General Chapter of the order held at Padua in 1443 was marred by discord, and when the General Chapter of 1449 met at the Conventual Santa Croce in Florence, the Observants convened their own meeting in the nearby Mugello. In addition to having placed the holy sites of the East in their hands, Eugenius IV had empowered the Observants to elect a Vicar General to administer their communities, although they remained under the jurisdiction of the Minister General of the order, who was a Conventual. Elected as the first Vicar General in 1437, Saint Bernardino furthered the Observant cause; still, he opposed division and favored a single, reformed Franciscan Order, as did his successor John of Capistrano.[56] Though most Quattrocento popes strove to preserve Franciscan unity, they tacitly supported the Observants by not preventing their appropriation of Conventual monasteries, such as San Francesco at San Sepolcro in 1445.[57] In the next year, Eugenius's bull *Ut Sacra,* which permanently established the office of Vicar General despite opposition from the Conventuals, inflamed rather than quelled the dissension.

That the politically charged atmosphere within the Franciscan order contributed to the Aretine Conventuals' formulation of an impressive new series of frescoes patterned after Gaddi's *Legend of the True Cross* in the chancel at Santa Croce is a distinct possibility.[58] On one hand, the friars asserted their Conventual position in the polemics over the interpretation of Saint Francis's monastic rule by emphasizing an unbroken lineage dating to the birth of the order via Beato Benedetto, who personally took vows

from the founder. On the other hand, the representations of legends and saints affiliated with both Conventuals and Observants in the murals that the friars commissioned for San Francesco during the fifteenth century suggest their desire to promote Franciscan unity. Piero della Francesca painted Saint Bernardino among the saints who border the *Legend of the True Cross,* and in 1463 Lorentino d'Arezzo portrayed him in frescoes for the Carbonati Chapel, where a *Madonna Misericordia* appears above four scenes of his life, among them, the *Destruction of the Fonte Tecta.* In 1480 Saint Bernardino materializes again in Lorentino's frescoes for the chapel honoring the distinguished Conventual preacher Anthony of Padua. In the lunette above the icon of Saint Anthony, the Sienese preacher displays his well-known monogram, the IHS, as if he were delivering a sermon.[59]

In essence, the fourteenth- and fifteenth-century paintings in San Francesco collectively bind the entire Franciscan Order to its traditional ministry as preachers and missionaries. The *Legend of the True Cross* in the chancel visibly advocates Saint Francis's desire to convert non-Christians to the faith, as set forth in his rule and as his friars – Conventuals and Observants alike – had put into practice by participating in the crusades and administering the Christian sites in the Muslim East. The Aretine friars similarly celebrated these historical ideals by honoring Benedetto Sinigardi, their own missionary who had worked miracles with the Sign of the Cross, convinced Saracens of the true faith, offered spiritual guidance to the King of Jerusalem, and assisted his pope's attempt to reunite Christendom. Viewed in light of the community's veneration for a thirteenth-century Provincial Minister of the Holy Land, Piero's frescoes connect local monastic history and ideological convictions with comprehensive peninsular issues such as the reunification of the Latin and Greek churches and the need to counter Islamic expansion. Framed by venerable Christian authors and saints and populated by legendary characters, the apocryphal saga of the True Cross at San Francesco basks in the glow of divinely inspired texts, orthodox beliefs, and historical events that substantiate the miraculous and the visionary. As Saint Francis drove the battling devils from Arezzo, as Beato Benedetto converted Saracens with the Sign of the Cross, and as the cross-wielding Saint Bernardino conquered superstition, so too the mythic Cross in Piero's *Legend of the True Cross* vanquishes its enemies to preserve the fiction of a universal Christian world.

4 **Piero's Meditation on the Nativity**[1]

Marilyn Aronberg Lavin

Most of Piero della Francesca's works make him seem, as a man, quite somber and aloof. In fact, we know nothing of his private personality. His voluminous writings yield only his intellectual activities, no personal remarks. The contracts he signed are for the most part standard, and although his name appears often in the rosters of elected officials in Sansepolcro, there are no clues to his political position or indications as to how he participated in town government. When he died, his property, except for some charitable donations, went to the family of his brother Marco, meaning that he himself had no direct heirs.[2] Even in death, then, Piero's personality remained opaque.

The panel of the *Adoration of the Child* (Plate 19), was painted some time in the 1480s and was among Piero's last works.[3] After his death, it was listed in two inventories, one of 1500 and another of 1515, as still in family hands (where it remained until the nineteenth century).[4] Although it comes down to us in a partially ruined state, according to the reports of the museum conservators, Piero had completed the painting: where the shepherds' heads and bodies are scraped down to original priming and drawing, there are small fragments of pigment showing the original finish. Joseph's head is abraded, for example, but his feet and hands are perfectly intact. However, what is not scraped down to the outline has been severely cleaned, and most of the heads and draperies have lost a glaze.[5] Nevertheless, in spite of all this damage, conceptually nothing is missing. The *Adoration* remains a paradigm of Piero's work done not for a commission but for himself, most probably for his own tomb.[6] Perhaps a unique prototype for the *Baptism of Christ*, which we know Mantegna made for his own funerary chapel two decades later,[7] this painting by Piero reflects his own volition and is therefore free of the restraints of patronage, whether private or public. I believe, in fact, that when Piero painted the *Tabula cum Nativitate Domini*,[8] he not only con-

firmed his belief in the reality of the mystical world, but also demonstrated a facet of his personality that until then had remained all but invisible.

Within an almost square composition (126 × 123 cm), a group of twelve relatively independent figures are held together by a single mission: each in his own way confirms the divinity of Christ. We shall see that the general conception of the subject depends, as so many of Piero's paintings do, primarily on the text of the *Golden Legend.*[9] Within this context, the central motif of Mary kneeling before the Christ child lying on the ground identifies the scene as an *Adoration,* the first moment in which the world celebrates the birth of the Savior. Quite a standard part of Nativity iconography by the mid–fifteenth century,[10] the motif follows a widely read account of Christ's birth by Saint Bridget of Sweden, one of the most important late medieval visionaries. Bridget reports that she saw a lovely, young, light-haired woman who, after a painless delivery, knelt to adore her child lying naked on the ground. Shivering with cold, the baby lifted his arms to his mother. "I heard the singing of the angels," says Bridget, "which was of miraculous sweetness and great beauty."[11] Piero represents these details, showing the Madonna with light red hair, kneeling in prayer before the earthbound newborn. He reaches toward her with outstretched arms, protected only by a portion of her robe. Reports of Bridget's vision were recorded in the Process of her canonization in 1391,[12] and quite soon after, the motif of Mary kneeling in adoration of the Infant was introduced into panel painting. We see it, for example, in a painting by a Pisan Master from about 1400 (Fig. 13).[13] In Piero's time the Bridgetine motif was still very much in use in Italy as well as in Northern Europe, and in fact his configuration shares a number of characteristics with works by other fifteenth-century painters. Alesso Baldovinetti's earlier large-scale fresco in the atrium of Santissima Annunciata in Florence, dated 1461–1463, shows Mary on her knees in the foreground of an arrangement that places the reclining Child quite close to the picture plane. The deep landscape vista on the left side of the composition anticipates Piero's distant vistas.[14] The Portinari Altarpiece, by Hugo van der Goes, painted in the Netherlands but shipped to Florence in 1483,[15] parallels Piero's naked Child and lower-class ethos. Domenico Ghirlandaio's Nativity, with kneeling Madonna and the Child on her robe, is dated 1485 and was similarly installed in a funerary chapel.[16] What distinguishes Piero's image from those of his contemporaries, however, is his rejection of their visual rhetoric. Without forfeiting the monumental timelessness of his earlier style, he eliminates any reference to an elaborate architectural setting, and to the retinue of the Magi, and returns his scene to the simplicity of the vision itself. In fact, he very pointedly presents all the traditional elements of the story in their most mundane guise, exalting, thereby, the humility of the theme. My purpose here is to define this paradoxical approach, characteristic of Piero's late paintings, in which he makes the high spiritual value of nature's lowliest forms into his overt subject.[17]

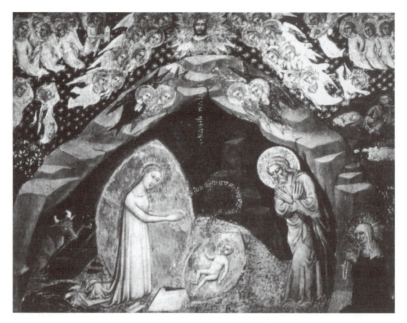

13. Pisan Master, *Brigitine Nativity*, Naples, Gallerie Nazionale di Capodimonte (Photo: Alinari/Art Resource/NY).

He begins by transporting the manger of the inn, on a snowy night outside Bethlehem, to a beautiful day in Tuscany in the outskirts of Sansepolcro.[18] He places the Adoration on a kind of natural podium, high above the level of a valley. We are shown a rural landscape on the left, and an urban vista on the right. In the distant landscape, lofty palisades tower over a winding river, as they do to the north of Sansepolcro. Dark green trees reflected in the water are clipped to perfect bulb-shaped roundness, with sunlight dancing on their surfaces. The urban view is equally clear, with tranquil, well-organized streets and towers kept in good repair. Once more, as in his painting of the *Baptism of Christ,* Piero shows the sanctity of his native land, both countryside and city, securing the terrain of Sansepolcro and its people as worthy of a saintly visit.[19] As in that earlier painting, his purpose on this occasion is to define, with great precision, the scene's locale. However, in contrast to the *Baptism,* where the spatial recession sweeps into the depth without obstruction (next to Christ's right hip), here the action is concentrated on the apron stage-like area that remains quite close to the picture plane. Such an arrangement, which has often been compared to Northern designs,[20] is an utterly new departure for Piero. Like the equally late Senigallia Madonna,[21] this painting lacks all mathematical indications as to how to read the space. Rejecting the clear and rational structure of his earlier works, the composition resists all orthogonal indications. Even the shed, which might have had geometric edges, is instead quite uneven; moreover, it is the one architectural element in his entire oeuvre that is set askew to

the picture plane.[22] These facts are all the more intriguing when we note that this shift to nonrational construction corresponds to the very period of Piero's most intense mathematical speculation.[23]

The character of the locale, on the other hand, is simple and straightforward. Every Italian farm has a high-placed promontory open to the sun called the *aiuola* (or *aia* in Tuscan dialect). This area is regularly used for threshing wheat. Piero has constructed such an *aiuola* close to the picture plane to give an unobstructed view of the infant who is often called the "Bread of Angels."[24]

No longer the amazonian matriarch of Piero's earlier paintings, Mary here is more lyrical and conventionally beautiful than any of Piero's other women. Her loveliness is enhanced by her braided hairdo and jewels at head and breast. She is the fairest among women (pulcherrima inter mulieres), the beloved wife (Sponsa) of the Canticle. At the same time she is humble as she kneels directly on the earth. The baby lying on her robe is a real newborn, his snowy body dramatically silhouetted against the royal blue. Although he is so young he is still without hair, his are the only eyes in the composition that are truly focused. As he lifts his arms with outstretched hands, he gazes directly at his mother with respect and gratitude. But it is his nakedness that is the crux of the revelation: his unadorned, well-formed body, as described in Bridget's vision, proves that the Word has indeed become flesh. Five angels worship him with music, three playing stringed instruments and two singing. With skilled fingers, the forward figures fret and pluck their lutes and bow the viol.[25] Their pastel dresses hang in columnar folds that mold their legs and leave their feet and ankles bare. In contrast to their simple garments, the two singers in the back are more ornately dressed. They intone the Gloria with open mouths, wearing the crossed "dalmatic" of deacons.[26] The richness of this liturgical garb, encrusted with pearls and other gems, proves that their song, and the action of the painting, has the value of a heavenly ritual. Yet Piero has made the "miraculous sweetness" of the angelic concert visible in the guise of peasant boys. Whether arrayed in finery or simply dressed, they stand in the grass and have no wings.[27]

The presence of the ox and the ass depend on ancient tradition. Even before the concept of the Virgin Birth was established, before the iconography of the Nativity had a narrative form, Christ's birth was represented on Early Christian sarcophagi simply by a feeding crib or manger (tegurium) and two lowly animals, an ox and an ass. The scene thus represented nothing more than the fulfillment of Isaiah's prophecy: "The ox knoweth his owner, and the ass his master's crib" (Isaiah 1:3).[28] In later centuries when the narrative was fully developed, the animals remained. So they do here, but with novel meaning. The ox who "knows his owner" looks at the infant and lowers its head in a kind of prayer. No one before Piero had depicted this animal expressing such heartfelt understanding. But the ass, which in both life and art is often conceived of as the epitome of contrariness,[29] paradoxically carries the devotional conceit to an even higher level of participa-

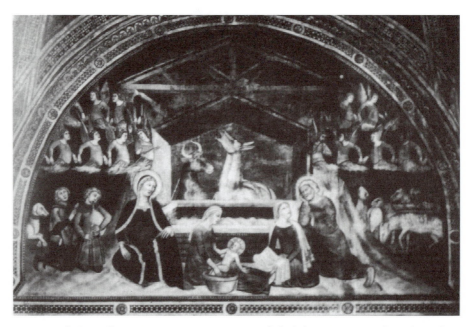

14. Biagio di Goro Ghezzi, *Nativity,* Paganico, San Michele (After M. A. Lavin, "Piero's Meditation on the Nativity," 1995, p. 131, fig. 5).

tion. This coarse animal (thinly painted alla prima and now quite transparent) lifts his head with open muzzle and brays with all his heart. According to its judicious placement, the beast joins in singing the liturgy:

> Benedicite, omnes bestiae et pecora,
> Domino; laudate et superexaltate eum in saecula.
> ("O all ye beasts and cattle, bless the lord: praise and
> exalt him above all forever.)[30]

Piero was not the first to employ the motif of the singing donkey. From the mid–fourteenth century on, Nativity scenes with the ass's open-mouthed head raised in song appear throughout Europe (Fig. 14).[31] But Piero reinforced the point in a particular manner. By juxtaposing the animal head directly with that of an angel, he shows the angels and ass as part of the same liturgical choir.[32] It has not been pointed out before that Piero often used this kind of visual joining to make similar points. In the corner of the lower right tier in Arezzo, for example, we find the head of a soldier and the head of a soldier's horse mysteriously fused.[33] In Arezzo, this optical linking serves to strengthen a sense of equality between the animal and the human being as two members of the same Christian army. The juxtaposition, in the case of the *Adoration,* implies that, in spite of the patent difference in the quality of their song, the angelic boys have been joined by the four-footed vocalist to verify the advent of the Savior.[34]

In Ghirlandaio's *Adoration,* the stable symbolizing King David's collapsed

tabernacle was given the elegant form of a Roman building in tatters, the crumbling roof and chipped sarcophagus referring also to paganism's fall.[35] Piero, by contrast, recreates the broken structure in lowly fieldstone, a farm shed with lean-to roof that was never supported with anything more elevated than two unworked staves.[36] In this form, the structure resembles most the flimsy tegurium of Early Christian art, often said to have been used to hide the truth of the Savior's royal status from his unbelieving foes.[37] As he so often did, Piero turned for the simple truth to the pristine early Church.

Two shepherds are positioned in front of the shed, having come from the fields still carrying their working staffs. In spite of their simple clothes, and their damaged faces, they express great solemnity. One raises his right arm to point heavenward; the other follows this gesture with his glance. In the long history of shepherds attending Nativity scenes, depending on their gestures, these rural characters express a variety of responses to the angelic message they have just received: awe, fear, surprise, and acclamation (as we see here).[38] Years before, Piero had given a similar gesture to one of the Elders in his painting of the *Baptism of Christ,* where, without doubt, it indicates a miraculous source of knowledge.[39] The motif in this case partakes something of all these aspects. But this rustic visitor has another trait that is unique: the staff he carries is cylindrical, and he holds it like a scepter. With one arm raised and a baton in the other, the figure refers to a famous statue-type of the Roman emperor Augustus. Although the most famous version of the statue (known as the Augustus of the Prima Porta) was not known in the Renaissance, the motif was familiar from coins (Fig. 15),[40] and other representations. It is appropriate here because, according to medieval legend, Augustus had mystic connections to the story of Christ's birth. On the day of the winter solstice, the birthday of the sun and the original date given to Christmas, Augustus celebrated a great victory and closed the gates of peace. Then, alone with the Tiburtine Sibyl, in a room on the Capitoline Hill, he asked the soothsayer if the world would someday see the birth of a greater man than he. Her answer was to show him a wondrous vision of the Madonna and Child seen as the Ara Coeli, the Altar of Heaven. This is the scene Ghirlandaio represented over the entrance arch of the Sassetti Chapel (Fig. 16).[41] I propose that with these gestures Piero raised the status of the lowly field hand to imperial dignity in order to

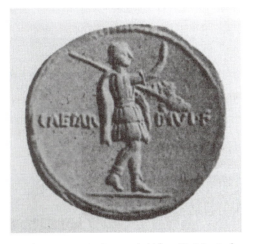

15. Augustan coin (reverse) (After H. Mattingly, *The Roman Coins in the British Museum* [London, 1923], vol. 1: pl. 15, no. 4).

16. Domenico Ghirlandaio, *Augustus and the Tiburtine Sibyl,* Florence, Santa Trinita (Photo: Alinari/Art Resource, NY).

allude to that same vision. With such an interpretation, we come to realize why he placed his scene on a promontory high above the valley's floor. It was to suggest the heavenly vision of the Ara Coeli, but to show it in its earthly form, divinely illuminated by the naturalistic splendor of the cloudless sky. The same paradoxical combination of high and low is found in the figure of Saint Joseph. In apocryphal stories about the Holy Family's journey, Mary rides to Bethlehem on a donkey (some say the very donkey of the Nativity scene). The donkey's saddle here serves as the old man's chair, and the water bottle that leans against it is part of the gear from the same trip.[42] The figure of Joseph, however, is anything but narrative. No longer the despondent husband of tradition, as in the Uccellesque predella of Quarata (c. 1435),[43] Joseph is ennobled by his pose. With his legs crossed and his hands with interlaced fingers in his lap, he is lost in thought. This meditative pose casts him in the role of judge, enthroned on the saddle as

though it were the curule chair.[44] Even more specifically, Piero gives Joseph the "heel-on-knee" position of the antique statue called the Spinario (in reverse), which at this very period had just been mounted on the Capitoline Hill where the Ara Coeli vision took place.[45] Characterized with these details, the Jewish Joseph joins the pagans in universalizing their cognition of the Messiah.

During his career, Piero had often expressed divinity in simple worldly things, finding lofty theological significance in humble forms. Two scenes from the altar wall in Arezzo make this point in a florid manner. In *The Burial of the Wood,* one of the earliest monumental representations of low-life in Italian art, he showed ruffians, one biting his lip, one exposing his genitals, one drunk, pushing the magic wood into a pool (see Plate 11). He emphasized their coarseness by juxtaposing the backside of the man in the corner with rear end of a horse (as another nearby horse gives a "horse-laugh"!)[46] Yet their labor to up-end the plank, as has often been pointed out,[47] is in the manner of Christ Carrying the Cross. On the other side of the window, on the second tier left of the altar wall, he depicted *Judas Raised from the Well* (see Plate 14) in an equally new way. Unlike compositions of this scene in other cycles of the Cross,[48] it is reminiscent of illustrations to, of all things, Boccaccio's *Decamerone* (Fig. 17).[49] The story tells of Andreuccio da Perugia who, having fallen into a dung heap, goes into a well to wash. When soldiers come for water, they run in fright when they see a man instead of a bucket.[50] Anyone in the fifteenth century seeing

17. Story of Andreuccio da Perugia from Boccaccio's *Decameron,* woodcut (ed. Venice, 1494] (After M. A. Lavin, "Piero's Meditation on the Nativity," 1995, p. 136, fig. 13).

dandies at a well where a man tied to a rope is emerging would have got-
ten the joke. But the way in which Judas is extracted carries another level
of meaning. He is pulled up by the hair in the same manner as Habakkuk
was carried off by an angel. When he was in Rome in 1458–59, Piero could
have seen the well-known example of this motif on the wooden doors of
Santa Sabina. Like Habakkuk, Judas is being carried off for a higher good
he does not yet understand.[51]

As the purveyor of his final expression of universal understanding,
Piero chose a very lowly and quite unlikely subject: a monumental magpie
(*gazza*), perching here on the roof of the shed. To understand the magpie's
meaning, we must remember that throughout history birds have been
taken as symbols of the soul, free to soar far and wide and finally ascend
to heaven. Their entrails were read for auguries and their endless circling
carried the notion of immortality. The small birds in the grass around the
Christ child here have this significance.[52] The magpie, on the other hand,
is usually considered a bothersome pest. A large and bony bird, it is known
as easily domesticated but a robber that hides the shiny things it steals.
Most of all, the magpie is annoying because of its continual and senseless
chatter. The ancients said the magpie was the very opposite of Calliope,
the Muse of Music, and a Tuscan proverb transfers the slander to a
woman's scolding tongue ("Le donne son sante in chiesa, angele in istrade
. . . e gazze alla porta": Women are saints in church, angels in the street
. . . and magpies at the doorway).[53] Piero again reverses the tradition. His
magpie is silenced. Perching on the corner of the shed, the long black tail
extends to its full length. The massive head and black beak are seen in dig-
nified isolation. It stands above the scene, noble in its perfect profile, ele-
gant but monastic in abstract black and white. In Piero's hands, the mag-
pie is not a shrill babbler of nonsense, but a silent witness to the truth.
Piero's magpie possesses the same divine knowledge to which the august
shepherd alludes. The magpie's unaccustomed and paradoxical silence sti-
fles the false words of the Old Law, just as the donkey's cacophonic bray-
ing sings the praise of the New. Both animals, linked by a descending diag-
onal that seems to separate light from darkness, verify the arrival of the
"true" Word.[54] The painting of the *Adoration of the Child* is the third in a
remarkable series in which Piero affirms the sanctity of Borgo San Sepol-
cro, his homeland: in the *Baptism of Christ,* which glorifies the feast of
first appearances, a distant vista of the town reminds the viewer of the
city's founding in the name of a sacred relic of Christ's tomb, brought from
the Holy Land by two pious travelers (see Plate 8).[55] In the *Resurrection of
Christ,* where he represents the actual relic, he reminds the viewer that
"Christ the Judge" dwells in Sansepolcro and keeps its government strong
(see Plate 1).[56] Here he shows the city's special calling as a replica of
Christ's tomb, to tell the future in the beginning. Sansepolcro, in the back-
ground of the Nativity, proleptically completes the cycle of salvation.

In representing the Nativity of Christ as a revelation, Piero seems to

have had a very specific text of the *Golden Legend* in mind. In the passage that follows the scene of Augustus and the Sibyl, Jacobus de Voragine gives the following outline of the revelation's recipients: (1) "The Nativity was revealed to the creatures which possessed existence and life, such as the plants and trees"; examples are the vines of Enge di that bloomed. (2) "The Nativity was revealed to the creatures possessed of existence, life, and sensation, that is, to the animals"; examples are the ox and ass that, "miraculously recognizing the Lord, knelt before Him and adored Him." (3) "The Nativity was revealed to creatures possessed of existence, life, sensation, and reason, that is, to men"; examples were the shepherds who spent two nights a year with their flocks, one of which was the winter solstice. And (4), "the Nativity was revealed to the creatures who possessed existence, life, sensation, reason, and knowledge, namely the angels." The text then goes on to tell how the Nativity functions in the world: (1) It came to pass for "confusion of the demons." (2) It took place to "enable men to obtain pardon for their sins"; the example is a prostitute. (3) It took place to "cure our weakness," for "as Saint Bernard says: 'Humankind suffers from a three fold malady – birth, life, and death . . . Christ brought a three fold remedy: His birth purified ours, His life corrected ours, and His death destroyed ours.'" (4) Finally, the Nativity came to pass "to humble our pride. For as Saint Augustine says: 'The humility which the Son of God showed in His Incarnation is to our benefit as an example, as a consecration, and as a medicine: as an example, to teach us to be humble ourselves; as a consecration, because it delivers us from the bonds of sin; and as a medicine, because it heals the tumor of our vain pride.'"[57]

Throughout his career, Piero had used his mathematical prowess to bring depicted forms to the ideal perfection we find so modern. The cool passivity and mathematical underpinning of most of his compositions make the construction so impressive that it often seems to be the main issue. In the fifteenth century, the same qualities of structural rationality, clarity of form, and emotional reserve struck an equally new but different note. The medieval paradigms of the religious hierarchy had been forbidding and distant. Piero gave them humanity in a new, perfected form. His figures were lofty and charismatic, affective and potent, worthy of their eschatological responsibilities. But they were also familiar and accessible. In this, his final painting, he loses none of his underlying structure, but he denies his former elegance. He strips his figures of their exotic garb and classical settings. He simplifies and, although it does not seem possible, he purifies his subject, recharging each detail into a kind of a summa of his personal philosophy of the high in the low. He does all this to convey but one, essential message: "Dominus natus est." I like to think that by expressing the fundamental dogma of the church with lowly creatures, the aged Piero revealed not only his profound respect for all of God's creation, but finally his own good humor and sense of divine joy.

5 *"Troppo belli e troppo eccellenti"*

Observations on Dress in the Work of Piero della Francesca

Jane Bridgeman

Piero della Francesca was particularly adept at imitating the sparkle of gems and gold, the clarity of crystal, and the textural contrasts of a gold-brocaded silk velvet. This was unusual for an Italian painter and is often ascribed to Flemish influence, but Piero's skill in imitating reality was praised by his contemporaries and, according to Vasari, helped lay the foundations of "modern" painting.[1] This same "modernity" sometimes obscures the fact that Piero's manipulation of dress for iconographical purposes is exceptionally eloquent. Thus, although his figures usually wear garments without pattern, trimmings, decoration, or jewellery, when such ornament is included it clearly fulfills a precise visual intention.

Piero's ability in choosing dress appropriate to his subject is exemplified in the Sant'Agostino Altarpiece, commissioned in 1454 for the church of Sant'Agostino in San Sepolcro. Here the four extant figures, Augustine, Niccolò of Tolentino, Michael and John the Evangelist (?) are each attired in a meticulously expressive manner.[2]

Saint Augustine wears the habit of an Augustinian friar, but is vested as a bishop, an image well suited to the location of the altarpiece in the Cappella Maggiore of his eponymous church (Plate 20).[3] The splendor of his attire reflects the saint's significance for the Augustinian friars, but perhaps also the interests of Piero's lay patrons who had bequeathed money to this church for "beautiful and costly vestments."[4] The richness of Augustine's vestments deliberately evokes all the authority of a Doctor of the Church and bishop. His cope and mitre, painted in painstaking detail, contain representations of gems, a costly textile, and embroidery. The pearl-covered mitre is "embroidered" with an image of the standing Christ holding a cross and is ornamented with a large ruby and four pearls, and its border has depictions of saints. Augustine's dark blue, cloth-of-gold cope is a skillful emulation in paint of a ceremonial vestment always made

from opulent and heavy silks, and the enamelled morse depicting the res-
urrected Christ, a tasselled fringe around the hem and the "embroidered"
orphrey containing scenes from Christ's Passion, are painted with an
extraordinary realism.[5] Other carefully observed details, the gloves and
rings, a red leather-bound book and the exquisite and unusual pastoral
staff – its crystal shaft topped with a golden crook – create an impression
of great formal dignity that implies the saint is vested for an important and
solemn occasion.[6]

The magnificence of Augustine's appearance is evident when compared
with that of *Saint Louis, Bishop of Toulouse* (Museo Civico, San Sepolcro)
painted by Piero in 1460 for a tabernacle in the Palazzo del Capitano, San
Sepolcro.[7] Saint Louis's plain blue cope is sprinkled with identifying
golden fleurs-de-lys, but ornamented with a much less elaborate orphrey
and fastened with a very modest morse. Another *Saint Louis* in the Cap-
pella Maggiore of the Franciscan church of San Francesco, Arezzo (attrib-
uted to an assistant of Piero) is portrayed in a cope with golden fleurs-de-
lys, but without an orphrey. Costly vestments such as those "worn" by
Augustine would of course, have been inappropriate for a Franciscan
saint. These subtle differences in the clothing of an image – the selection
of gold-brocaded silk textiles, the inclusion or omission of an orphrey –
were significant, and may well have been directed by the artist's patron.

Piero's venerable, grey-bearded Augustine in the Sant'Agostino Altar-
piece differs markedly from his somber but commanding figure of Saint
Nicholas of Tolentino (1245–1306), an Augustinian friar, famous for his
preaching, who was only canonised in 1446 (Plate 23). Here attention has
to be attracted through the saint's stance rather than through his attire,
and the artist has created the figure of a middle-aged and authoritative
Augustinian who, holding a large black book in his left hand, raises his
right in a commanding gesture as if about to speak. These two saints, a
Roman citizen of late antiquity and a friar from Tolentino (d. 1306), who
lived over a century before the artist was born, wear vestments and habits
commonly seen in fifteenth-century Italy. This visual anachronism was
irrelevant for Piero and his patrons: the "modernity" of their attire and
insignia was perhaps interpreted as signifying the saints' perpetual pres-
ence for those who invoked them.

In contrast, the apostle identified as Saint John the Evangelist wears
garments common in late Roman antiquity (Plate 22). The *colobium,* an
ankle-length sleeved tunic, and the *pallium,* a rectangular cloak, were
obligatory for clothing Christ and the apostles according to traditional
Christian convention.[8] Piero portrays the elderly Saint John, white-haired
and white-bearded, standing almost completely enveloped in his volumi-
nous cloak, engrossed in reading a book. The artist hints at the apostle's
status by painting it a rich scarlet, which any contemporary would have
known was intended to emulate the finest-quality woollen cloth. Similarly,

although barefoot, the apostle's apparent poverty is belied by the decorative hem of his dark blue tunic. It is "embroidered" with a deep border of gold thread, pearls, rubies, and other gems – a decoration of great richness that, in the fifteenth century, was a clear indicator of authority.

The fourth figure, the Archangel Michael, is portrayed as a victorious warrior who stands over the snakelike body of Satan grasping the decapitated head of the slain reptile in his left hand and a falchion in his right (Plate 21).[9] Here Piero creates a conceptual distance between viewer and image by combining a blue, gold-trimmed, muscled cuirass with a seemingly inappropriate, and very unmilitary, garment of extraordinarily fine transparent silk. The latter is seen at the neck and covering the lower arms; its cuffs and collar, like the skirts of the cuirass and its short shoulder pendants, are ornamented with pearls, rubies, and sapphires. This silk, as well as the gems and the archangel's large, gleaming white, feathery wings augment the unearthly appearance of this heavenly warrior. Although his sword and shoes are contemporary, Saint Michael's armor looks wholly fictive – it seems to owe little to the body protection worn by Piero's knightly contemporaries. Yet, the leather cuirass with its lateral gold hinges resembles similar body defenses worn by soldiers in Fra Angelico's almost contemporaneous *Life of Saint Lawrence* (1447–50) in the Cappella Niccolina (Vatican), and both artists could have drawn upon a type of Byzantine armor, based on Roman parade armor, which remained in ceremonial use in contemporary Constantinople.[10]

Piero rarely depicts elaborate silk weaves in his paintings, but in *The Meeting of King Solomon and the Queen of Sheba* in San Francesco, Arezzo (c. 1448 and before 1466) he depicts a white silk velvet cloth-of-gold, one of the most sumptuous textiles then available (see Plate 10).[11] The fabric is patterned with a gold motif of a stylised pine cone springing from an undulating branch sprouting with small leaves. This motif, seen here on a white background, is used for King Solomon's cloak and the Queen of Sheba's gown: it is clearly visible on Sheba's skirts and left sleeve – both unobscured by her white silk mantle. This stylised thistle (or pine cone) arranged in an asymmetrical repeating pattern was a common design for dress and furnishing silks, especially velvets and damasks, throughout the fifteenth century.[12]

Piero's choice of a gold and white textile in this scene was not arbitrary. By clothing the two protagonists in opulent and regal robes of gold and white, the artist effectively emphasizes both their status and this scene's theological significance. White cloth-of-gold was a peculiarly apt fabric in which to clothe Solomon and Sheba. It signified rejoicing and, typologically, this meeting was interpreted as a prefiguration of the Adoration of the Magi; that is, the recognition and acceptance of Jesus by the Gentiles. This symbolic acceptance of Christ by the Gentiles was clearly an event for joyous celebration.

Furthermore, in Quattrocento Italy white cloth-of-gold was associated with regal status, and silks of white and gold were the prerogative of heads of state and immediate members of their family.[13] This usage may perhaps have derived from Byzantium, but its long-standing tradition is reflected in Italian art.[14] Gold and white silk textiles clothe both Christ and the Virgin in the mid-twelfth-century mosaic of *Christ and the Virgin Enthroned* (Santa Maria Trastevere, Rome, 1140–43). Later, Trecento and Quattrocento depictions also often portrayed Mary in a mantle of gold and white as the Queen of Heaven as, for example, Fra Filippo Lippi in his fresco of the *Coronation of the Virgin* in the apse of Spoleto Cathedral, a work approximately contemporary (1467–68) with Piero's Arezzo frescoes. In Piero's *Sigismondo Malatesta before Saint Sigismondo* (Tempio Malatestiano, Rimini, 1451) Malatesta and his eponymous saint are properly dressed in white cloth-of-gold since it is necessary to identify each figure as a ruler (see Plate 3).[15] At this date a person's rank was identified not by the style of a garment, but by the quality (and cost) of the fabric from which it was made, whilst ampleness and length was an indicator of the degree of formality a man wished to display. Sigismondo Malatesta was buried in a semiformal gown like that depicted by Piero in this fresco, which, with its false hanging sleeves and knee-length skirt, was of a type worn by many men in mid-fifteenth-century Italy.[16] But he certainly wore more formal clothing than in Piero's portrait: a wardrobe inventory made immediately after his death in September 1468 includes two cloth-of-gold formal ankle-length gowns or *vestiti*.[17] Thus it seems likely that Piero was directed to depict Malatesta dressed in this particular garment.

In both *The Meeting of Solomon and Sheba* and the adjacent *Adoration of the Holy Wood*, Piero deliberately introduces visual contrasts in dress for iconographic reasons. In the latter the kneeling queen wears a brown gown (its bodice, sleeves, and skirt are clearly visible) and a blue cloak lined with white; whereas in *The Meeting* she is dressed entirely in gold and white. The sole element of dress identical in both scenes is the silk veil (covering Sheba's hair) and crown.[18] The brown and blue garments represent woollen cloth, not silk, and indicate that the queen is attired in travelling dress.[19] This is confirmed by the appearance of the two grooms beside the horses, since each wears a broad-brimmed hat typically used by contemporary male travellers.[20] In this scene Piero describes current convention, but by depicting woollen travelling clothes for the Queen of Sheba here, he accentuates the significance of her gold and white robes of silk in the next.

In the *Meeting of King Solomon and the Queen of Sheba* Piero deftly introduces a visual allusion to the famed wisdom of King Solomon and also to the judicial skills of the Queen of Sheba, which were to be exercised at the Last Judgment.[21] On the extreme left the viewer's eye is caught by the figure of a man in a scarlet woollen gown and wearing a scarlet

round cap (*pileus rotundus*) edged with ermine. This ermine edged cap (or sometimes a rolled hood) was the identifying badge of a graduate in law or medicine as required by university statute.[22] A combination of scarlet cap and scarlet gown as portrayed by Piero, here identifies a doctor of law.[23]

Crimson cloth-of-gold appears in only two of Piero's religious works: for the gown of the enthroned Virgin in the Perugia Altarpiece (Galleria Nazionale dell'Umbria, Perugia, c. 1455–69); and for the Virgin's gown and the garment worn by an angel in the Brera Altarpiece (Pinacoteca di Brera, Milan, c. 1470?) (Plates 7 and 5). In the former, a glimpse of the heavy crimson and gold folds of Mary's gown, almost hidden by the blue cloak, provides a strong visual contrast with the coarse grey-brown wool habits of the three Franciscan saints. This hint of queenly splendor is partially echoed by Saint John the Baptist's scarlet woollen cloak and the pink and white flowers gathered up in Saint Elizabeth's mantle. In the Brera Altarpiece the Virgin's crimson cloth-of-gold gown and its sleeves are clearly visible. The predominantly gold material falls in thick, stiff, and heavy folds over the stomach – indicating its weight – while the crimson pile surrounding the gold pine-cone motif below the neckline serves to emphasize the Virgin's hands held together in prayer. This same costly textile is chosen for the garment worn by the angel with a censer who stands behind the Virgin to her left. It has an edging of crimson velvet at the neck, cuffs and hem; the latter is further ornamented with a line of small pearls.

Close scrutiny of the details of hair and dress in the unfinished Brera Altarpiece raises questions about its traditional dating to c. 1470–74.[24] Similarities in the garments and the hair arrangements of the Madonna in the Brera Altarpiece, Piero's Annunciate Virgin in the Misericordia Altarpiece (Museo Civico, San Sepolcro, 1445–62), and his fresco of the Annunciate Virgin in San Francesco at Arezzo (c. 1454–58) imply that he painted the Brera picture earlier than the 1470s. In the Misericordia Altarpiece the Virgin wears a gown of scarlet wool and an unadorned blue cloak with a shaped neckline (see Plate 2). At Arezzo (see Plate 17), she has a slightly more ample gown and a mantle of the same design; as in the Perugia and Brera Altarpieces, her blue, white-lined, woollen mantle is ornamented with pearls, though the Brera Madonna has a more costly mantle edged with gold and clusters of pearls around the neck and hem. In particular, the hair in each of these images of the Virgin is depicted in the same way as in the Brera Altarpiece: it is pulled back from the forehead and away from the neck and ears. Bound up with white ribbon, it is pinned over the back of the head and covered with a transparent silk veil that falls onto the shoulders.[25] This arrangement clearly contrasts with the less severe style worn by the Virgin in Piero's *Adoration of the Child*, generally thought to be painted in the late 1470s or 1480s (see Plate 19).[26]

The armor worn by Piero's patron Federico da Montefeltro in the Brera Altarpiece, which has been dated by armor experts to c. 1455–60, similarly

casts doubt on the traditionally proposed date for this painting.[27] A suggestion that Federico commissioned the altarpiece around 1472, when he was in his early fifties, but for some reason wished to be portrayed in a suit of armor over fifteen years old, is unacceptable.[28] Indeed, it is inconceivable that one of the foremost military commanders of his day would have ever requested a portrait of himself in obsolete armor. In the painting Federico also wears a pleated *mezza giornea* (a half-tabard worn only with armor) of crimson cloth-of-gold, which reflects his status as ruler of Urbino. Attached at the shoulders, this garment was sometimes emblazoned with the wearer's armorials, as exemplified by a mounted knight on the left in Piero's *Battle of Heraclius and Chosroes* at San Francesco, Arezzo (see Plate 16).[29] Moreover, the conspicuous absence of any visual reference to three important honors awarded to Federico da Montefeltro in the spring and summer of 1474 must preclude a late date for this altarpiece. It does not display the emblems of the English Order of the Garter, the Neapolitan Order of the Ermine, or any indication that Federico was Gonfaloniere of the Church. Such omissions would be inexplicable if this work had been commissioned after 1474.[30]

In addition, the Brera Altarpiece lacks a portrait of either Federico's first wife Gentile Brancaleoni, who died in July 1457, or his second wife, Battista Sforza, whom he did not marry until November 1459.[31] If the altarpiece was painted between 1457 and 1459, as the duke's armor suggests, the unusual placement of Federico on the Virgin's left becomes more understandable: as a widower, he would have been able to choose the more modest position for his portrait.[32] This seems a more plausible reason than vanity, although a left-profile portrait certainly hid the facial injuries resulting from the loss of Federico's right eye and the bridge of his nose during a joust in 1450.[33] Furthermore, the votive nature of the Brera Altarpiece suggests that Federico da Montefeltro commissioned it as a thanksgiving – perhaps in the late 1450s after his recovery from a near fatal illness and his appointment as Captain General of Naples in 1454.[34] This dating would help to resolve recently raised problems concerning Piero's architectural references in the Brera Altarpiece. For it indicates that, like Masaccio in his *Trinity* fresco of c. 1425 (Santa Maria Novella, Florence), Piero combined elements of ancient and contemporary extant architecture to create a painted fictive interior and that he did not need to emulate an existing building.[35] And, as we have seen, a date of c. 1457–59 for the Brera Altarpiece would be consonant with the hitherto consistently disregarded dating of Federico da Montefeltro's armor.

Whereas Piero uses cloth-of-gold in the Perugia and Brera altarpieces to denote the regal status of the Virgin as an enthroned queen, formally presenting her baby son to the world in the company of saints, martyrs, and angels, in other representations the artist dresses the Virgin in more "earthly" and humble garments. In the Misericordia Altarpiece the Annun-

ciate Virgin wears a simple unadorned red gown and blue mantle, and at the Crucifixion in the summit of the painting she is depicted unusually, but appropriately, in a black mourning mantle and brown gown (see Plate 2). In the central panel of this work, however, her status as Queen of Heaven is indicated only by the golden crown holding her fine linen veil in place, and the single gold brooch (set with a large ruby surrounded by small pearls) that fastens her mantle. Here Piero depicts her as a compassionate Mother of Mercy and her plain, very conservative red woollen gown, tied with a rustic belt, seems an apt visual metaphor for the Virgin's dual role as queen and protector for those sheltering beneath her white-lined mantle of blue cloth.[36]

In contrast, the kneeling Virgin in the *Adoration* (National Gallery, London), perhaps painted c. 1483–84 or later, is the most stylishly dressed of all Piero's female representations (see Plate 19).[37] She is wrapped in an ample mantle of dark blue white-lined velvet, most of which is spread over the ground in front of her, as a silky blanket for her baby son. The design of her high-waisted gown of fine blue woollen cloth (combining a bodice and pleated skirt joined by a seam at the waist) was usual after c. 1470. Its V-shaped neckline, plunging to a high waistline under the bust, is edged with pearls and gold embroidery drawing attention to the horizontal neck of the scarlet undergown whose tight sleeves are seen at the wrists. Unusually, the Virgin wears a necklace of large pearls and a gold pendant set with a crimson gem. Her blonde hair combed behind her ears, rather than pulled back from the forehead, is braided and pinned at the back of her head. It is covered by a diaphanous silk veil fastened with a large jewel containing a crimson gem surrounded by four pearls. This formal ensemble was typically worn by affluent young, married, Tuscan women in the 1480s, as may be seen from comparison with the young woman in Botticelli's *Venus, Accompanied by the Graces, Offering Gifts to a Young Woman* (Louvre, Paris, c. 1486) (Fig. 18). Possibly a member of the Tornabuoni family, she wears a crimson gown very like that of Piero's Virgin: she also wears a pearl necklace and pendant. Her hair is partially covered by an opaque linen veil.[38]

The Virgin's garments in the *Adoration* contrast with those of Piero's *Madonna del Parto* painted over a decade previously (Cemetery Chapel, Monterchi, Plate 24). In this fresco, the opulent ermine-lined crimson velvet curtains of the canopy – the sort used for church hangings or for domestic palace furnishings – are the only indication of rank.[39] The Virgin wears a plain blue woollen gown. Probably a *gamurra da parto* or pregnancy gown, it is fastened at the front and sides by laces that could be loosened as the mother-to-be put on weight. After the birth it was comfortable for nursing.[40] This is obviously not an outdoor garment, since it is worn directly over the linen smock seen beneath the unlaced openings.[41] Depictions of such a gown are rare, even though the cult of the Madonna del Parto was

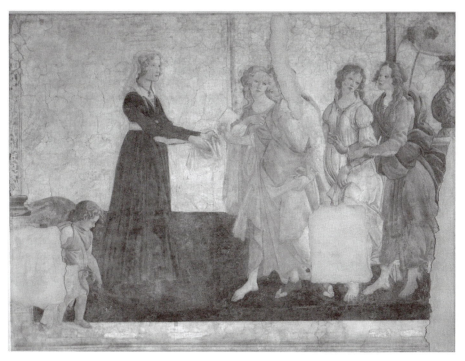

18. Botticelli, *Venus Accompanied by the Graces* (detached fresco from Villa Lemmi), Paris, Musée du Louvre (Photo: Erich Lessing/Art Resource, NY).

not unusual in Tuscany.[42] There are depictions by the Ferrarese painters Cosimo Tura and Francesco del Cossa, whom Piero may have known when he worked in Ferrara.[43] Tura's *Annunciate Virgin* (Museo del Duomo, Ferrara, 1469) painted on an organ shutter for Ferrara cathedral, and his undated *Allegorical Figure* (National Gallery, London) both wear front-laced gowns and appear pregnant.[44] Indeed, Tura's *Allegorical Figure* and Piero's *Madonna del Parto* are dressed in identical garments although the sleeves of Tura's figure are of crimson cloth-of-gold.[45] The female musicians below the three Graces in Cossa's *Triumph of Venus* (Sala dei Mesi, Palazzo Schifanoia, Ferrara, c. 1470), a scene associated with April – the month of love and fertility – also wear front-lacing bodices.

The image of the *Madonna del Parto* is extraordinary not because she is so obviously pregnant, but because she has no mantle as in other representations of the expectant Madonna, which always show her with a cloak (though perhaps the canopy might be said to act as a kind of conceptual mantle).[46] In Piero's unconventional representation of a Virgin of Childbirth, his Madonna is seen bereft of her outdoor wrap and apparently unveiled, as if on display in the privacy of her own home.[47] The painter's choice of clothing, and his unexpected removal of the traditional cloak creates an image which (even though the Virgin is flanked by angels) is

simultaneously austere and intimate. It must have had an extraordinarily powerful impact on the women who came to the chapel to pray.

Piero's use of dress for iconographic purposes is nowhere more apparently perplexing than in the *Flagellation* (Galleria Nazionale delle Marche, Urbino, see Plate 6). Some years ago this writer discussed the contemporary Byzantine dress of the seated figure in the background, and the clothing of the three men in the foreground group, including the central figure.[48] Recently, various authors have offered new interpretations of the *Flagellation* based on a proposed identification of the blue gold-brocaded garment of the man in the foreground.[49] Unfortunately, these remain unconvincing, not least because most art historians have little knowledge of the history of Italian dress at this period.

The most erroneous misinterpretation, reiterated many times over some twenty years, is that this man's garment and textile are Flemish because examples of such a textile (apparently) cannot be found in contemporary Italian works of art, but only in the works of Flemish painters such as Jan van Eyck and Rogier van der Weyden.[50] As is well known, however, no silk textiles were produced in northern Europe at this date. The source for all the damasks, brocades, and velvets or cloth-of-gold textiles depicted by the van Eycks, Rogier van der Weyden, Memlinc, and other Flemish artists was Italy (and to a lesser extent Spain). Not only are there many extant examples of such Italian fifteenth-century silk weaves, they are also well documented as imported into Flanders and Burgundy by Lucchese and Florentine merchants.[51] It is the case that the costly silk fabrics produced in Florence and Venice are very rarely represented in contemporary Quattrocento Florentine or Venetian painting. In mercantile republics such as Florence and Venice the public use of splendid silks by wealthy private citizens was ideologically suspect, a stance reflected in public art, where male donors in particular are always dressed in garments of woollen cloth, and even saints of regal status are dressed modestly.[52] Costly textiles are seen, however, in paintings from other areas of Italy and notably from princely courts: Mantegna's portrayal of the Gonzaga court (*Camera picta*, Palazzo Ducale, Mantua, c. 1470) is an obvious example, and there are others.

The blue gold-brocaded gown of the grey-headed bystander in the *Flagellation* immediately attracts the eye. Its color and pattern contrast with the plain fabrics worn by his companions. There is nothing Flemish here. The figure wears a formal Italian *vestito* or ankle-length gown made from an Italian silk velvet brocaded with the motif of undulating branches and thistles.[53] The design of this garment and of its textile clearly differs from that depicted in Rogier van der Weyden's *Descent from the Cross* (c. 1438) now in the Prado, Madrid (Fig. 19). The heavy fur-lined garment depicted by Rogier has very long, tubular, hanging sleeves with vertical slits at the front through which the arms pass and a deep V-shaped opening at the neck. Its textile, emulating an Italian brocaded velvet, is woven in a half-drop repeating pattern of stylized ogival forms and foliage arranged sym-

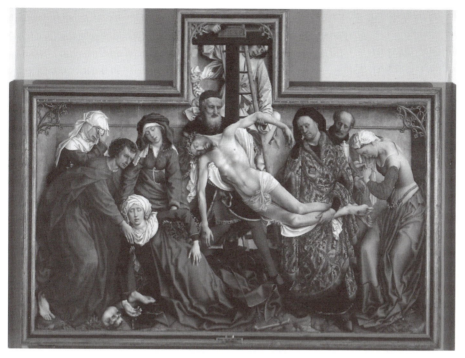

19. Rogier van der Weyden, *Descent from the Cross,* Madrid, Prado (Photo: Erich Lessing/Art Resource, NY).

metrically. The motif and pattern are quite different from the asymmetrical design depicted by Piero in the *Flagellation*.

Depictions of silk gowns in Italian art are rare, partly because much surviving art is Florentine or Venetian, and also because there were few painterly occasions in contemporary fifteenth-century religious art which demanded their inclusion. Woollen gowns were more frequently depicted; for example in Domenico Ghirlandaio's frescoes in Santa Trinita and Santa Maria Novella, Florence, notably in his portrait of the kneeling Giovanni Tornabuoni in the Cappella Maggiore of the latter church (1486–90). A useful comparison may be made between the silk gown in Piero's *Flagellation* and that worn by the kneeling donor in Jacopo Bellini's *Madonna of Humility* (Louvre, Paris, Fig. 20). Perhaps Lionello d'Este, ruler of Ferrara (1441–50), or a prominent member of the Este family, the donor's very splendid gold-brocaded crimson velvet gown has wide (semicircular) sleeves with open cuffs and, since his arms are lifted in prayer, a very visible fur lining.[54] In the *Flagellation* the wearer has both hands hooked in his crimson belt and so his wide fur-lined sleeves hang down. Bellini's textile motif, asymmetrically arranged, although smaller and of an earlier date, is similar to that of the blue garment seen in the *Flagellation*.[55]

The long gown, or *vestito,* depicted by Piero was worn in Italy for events of significance.[56] This ample, ankle-length, male garment with very wide

sleeves and open cuffs was perceived as conferring dignity. It was required formal wear for the young and middle-aged, but everyday wear for the elderly, and for academics, physicians, and lawyers.[57] Made of wool or silk, it had a fur lining in winter and a silk or linen lining in summer. It was called a "toga," not because anyone thought it *emulated* a Roman toga, but because, like the toga, a long gown was a symbol of formality.[58] Piero's contemporaries, the Zavattari brothers, depict the enthroned King Authari in an ankle-length blue and gold brocaded gown and a golden belt in their fresco, *The Court of Authari and Theodolinda* (Chapel of Theodolinda, Monza Cathedral, 1444), and Perugino's much later *Baptism of Christ* (Sistine Chapel, Vatican, 1482) contains portraits of two young men in ankle-length garments of cloth-of-gold on Christ's right.[59] These examples of ankle-length garments interwoven with gold, identify members of a ruling family present at events of some importance.

There have been some strange interpretations of the scarlet strip over

20. Jacopo Bellini, *Madonna of Humility with Donor*, Paris, Louvre (Photo: Scala/Art Resource, NY).

21. Francesco Botticini, *Assumption of the Virgin,* London, National Gallery (Photo: Copyright National Gallery, London).

the right shoulder of the Italian bystander in the *Flagellation*. It clearly hangs below the hem of the gown almost touching the ground. This is not a scarf (unknown in fifteenth-century Italy), nor a cloak or mantle.[60] It has been suggested that this is a stole.[61] Stoles were worn in Venice after 1470, but Venetian stoles were generally worn on the left shoulder and were shorter; moreover, they were not scarlet, but black or crimson.[62] Rather, this scarlet strip must represent the long streamer (liripipe or *becchetto*) of a rolled hood (*capuccio*) draped over the right shoulder.[63] Comparisons with other works depicting rolled hoods hung over the shoulder make this clear and also explain why the man in the blue brocade is apparently hat-less. Botticini's *Assumption of the Virgin* (National Gallery, London, c. 1475) portrays Matteo Palmieri kneeling bare-headed in adoration (Fig. 21).[64] His scarlet rolled hood, suspended by its liripipe, hangs over his shoulder; its gorget (*foggia*) hangs from the circular roundlet resting on his back.[65] The painting of *Rhetoric* (National Gallery, London), probably by Joos van Wassenhove, similarly portrays a kneeling man with a scarlet rolled hood hanging over his right shoulder (Fig. 22). There is no head-gear of any sort on the steps in front of *Rhetoric*, yet *Rhetoric's* companion paintings of *Music* and *Dialectic* each depict a kneeling recipient with a hat placed on the step beside him, and in *Astronomy,* there is a crown.[66] These examples show that in the *Flagellation*, the red strip must be the streamer by which the hood was always suspended over the shoulder when not worn on the head. Piero's bare-headed figure thus appears to signify his respect for his companions and those in the background scene.

22. Justus of Ghent (Joos van Wassenhove), *Rhetoric,* London, National Gallery (Photo: Copyright National Gallery, London).

In sum, to fifteenth-century eyes a long but belted gown suggested a formal, but not solemn occasion.[67] The man in blue and gold wears a semi-formal and princely Italian gown, and scarlet rolled hood, of a style c. 1444–50. His dress is not "exotic," foreign, Flemish, or perceivably Jewish.[68] Whether this figure is a portrait or not is open to speculation.[69]

Contemporary Greek clothing is seen in a number of Piero's paintings: in addition to the *Flagellation,* most notably in the Arezzo frescoes *The Discovery and Proving of the True Cross* and *Exaltation of the Cross* (discussed elsewhere, see Plates 15 and 18).[70] In his paintings the artist reflects the attitudes of some other fifteenth-century Italian artists by adopting contemporary Greek dress, and possibly armor, as a conscious metaphor for Christian antiquity (in the battle scenes and the *Dream of Constantine* at Arezzo, as well as in the London *Baptism,* see Plates 12, 13, and 8). During the Councils of Ferrara and Florence (1437–39) Italians were very

favourably impressed with the dignity (as they saw it) of Greek attire, whether clerical or secular. The appropriate formality of the dress of the Emperor John VIII Palaeologus, of the nobles in his retinue, and of the Greek Orthodox clerics drew a great deal of admiration and praise.[71] This reaction cannot be ascribed solely to its foreign appearance. The dress of other Eastern Christians who came to Florence did not receive such praise, nor did that of other foreigners visiting Italy, whether those who came on pilgrimage, or for diplomatic and commercial reasons.[72] More-over, a good many Italian traders and scholars were familiar with contem-porary Greek dress as worn in Constantinople, the Peloponnese, or around the Black Sea. In Florence, nevertheless, it produced a reaction from both highly educated scholars and pragmatic artisans that signified something more than mere amazement at the unusual or outlandish. It appears that Greek clothing was perceived as both authentically Roman and Christian.

The Florentine humanist Vespasiano da Bisticci (1421–98) made a point of emphasizing in his biography of Pope Eugenius IV (who presided over the Council of Florence), how exceptionally praiseworthy it was that the Greeks had retained exactly the same style of dress for over fifteen hun-dred years. Furthermore, he noted, this same style of dress could be seen on marble carvings at Philippi where there were men dressed in the Greek style of former times.[73] The ruins at Philippi are Roman, but it is clear from Vespasiano's comment that he and his contemporaries thought the Byzantine-Greek dress they saw in Florence in the 1430s was that worn in the Eastern Roman Empire around the time of Christ. It is possible, too, that the Greeks themselves believed their dress was of an unchanging style. Limited extant contemporary Byzantine pictorial evidence certainly suggests that the design of medieval Byzantine garments altered much more slowly than clothing in western Europe.[74] This perception of con-temporary Greek dress provides an explanation for Piero's use of Byzantine clothing, also recorded by contemporary artists as diverse as Pisanello, Filarete, Tura, and Zoppo, each of whom incorporated it into their work in various ways.

Yet Piero was not concerned with the historical accuracy of sacred his-tory. It is unlikely that in choosing to depict contemporary Greek gar-ments, he was attempting to reproduce historical clothing with "archaeo-logical" accuracy. His portrayal of apparently "timeless" but reputedly ancient and venerable Greek clothes was a means by which he could imbue his subject matter with an aura of antiquity and dignity – with exactly that combination of the antique and modern that so impressed Vasari.

Piero della Francesca's depiction of dress, like some other elements of iconography in his painting, is often overinterpreted. His portrayal of con-temporary clothing represents the way it was worn and perceived during his lifetime: Its visual meaning reflects usages commonly understood in

fifteenth-century Italy. Much of this social and visual language of dress is now forgotten and remains to be clarified. Piero's manipulation of elements of clothing and jewellery is, nevertheless, unusual within the contexts of familiar iconographies. As a painter he combines a subtle visual sensitivity with a concern for realism and ease of interpretation. It is not surprising that his contemporaries and successors admired him for the eloquence and directness with which he expressed himself in paint. It is an irony that Piero's great talent for clarity of expression – his "logic and realism" – has been so frequently misunderstood and obfuscated in its interpretation by subsequent generations.

6 Piero della Francesca's Ruler Portraits

Joanna Woods-Marsden

It is a hard task for a high ranking individual to have to affirm constantly for us his importance and his authority when he sees reflected in mirrors his all too human dullness and discovers within himself only sad and confused moods. That is why official portraits are needed; they relieve the prince of the burden of imagining his divine right. Napoleon does not exist anywhere except in portraits.

Jean-Paul Sartre, *Visages, précédé de Portraits Officiels*[1]

The history of Piero della Francesca's autonomous portraiture coincides with the history of Renaissance politics in that his two surviving independent portraits – and there is no record of other, lost ones – were commissioned by the two North Italian rulers who conducted the "most notorious feud in Italy between two reigning princes."[2] Sigismondo Malatesta of Rimini (1417–68) and Federico da Montefeltro of Urbino (1422–82) were outstanding *condottieri* (mercenary commanders) of the age whose states on the Adriatic coast were adjacent. Each sought to enlarge his own territory at the other's expense by engaging in guerrilla warfare across the shifting frontiers that divided them and plundering castles and towns. The parallelism does not end with the *signori*'s commissions of independent likenesses from the same artist in a period when such works were few and far between. They also each commissioned from Piero closely related votive paintings in which they themselves featured prominently as donors. Needless to say, Malatesta and Montefeltro were among the most assiduous promoters of self through the new genre of portraiture.[3]

Born illegitimate but later legitimized (a necessary step for succession to hereditary lands), they came to power in succeeding decades. Sigismondo Malatesta inherited the vicariate of Rimini in 1432 at the age of fifteen, and Federico da Montefeltro the county of Urbino in 1444 when

twenty-two. Although both city-states – small, economically poor, and strategically unimportant – were papal fiefdoms, the vassals' respective relationships with their overlords differed. The lord of Rimimi had the bad luck to attract the enmity of Pope Pius II, who melodramatically assigned him to hell as well as depriving him of much of his state, whereas Federico's charm and manipulative skills enabled him to satisfy most of the popes he served.[4] Having received humanist educations, these minor rulers became major patrons of the arts and letters, the patronage strategy devised by Sigismondo in the 1440s and early 1450s influencing Federico's more famous and successful efforts in the late 1460s and 1470s.[5] They hired eminent architects to design churches and construct their residences, the castle in Rimini and the palace in Urbino. Sigismondo maintained a court humanist, Roberto Valturio, and a house poet, Basinio da Parma, to compose works eulogizing him, and funded a *scriptorium,* in which manuscript copies of these flattering works were replicated as gifts to his peers, while Federico built up a famous library of over a thousand codices in some fourteen years.[6]

This essay seeks to construct the historical meaning of Piero della Francesca's autonomous portraits by reintegrating them into the ideological structures of power and into the social and personal circumstances of the three sitters in question: Sigismondo, Federico, and the latter's wife, Battista Sforza. In this period, when the despotic state as body politic was largely subsumed into the identity of its ruler, the Quattrocento prince shared common political goals and values with his peers, foremost of which were the retention and expansion of his territorial state and the affirmation of dynastic legitimacy and continuity. Focusing on a political reading, Piero's likenesses are interpreted as fulfilling a function of ruler portraiture: to fashion the sitters' identities as territorial princes. By adumbrating a style and iconography expressive of authority and power, Piero can be said to have been largely responsible for the pictorial formulation of his patrons' court ideology.

Organized in a series of rubrics, my discussion begins with an interpretation of Piero's portrait of Sigismondo Malatesta that stresses the importance of his dress; it goes on to consider the problematic date of his Montefeltro diptych and compares its portrayal of Federico da Montefeltro to portraits of him by Flemish artists. An evaluation of Sigismondo and Federico's unusual portraits in Piero's religious paintings calls attention to the subtlety with which he represented their political aspirations. Then I turn to Piero's portrait of Battista Sforza and its relationship to Francesco Laurana's sculpted likeness. After exploring the political implications of the continuous vista of land in the Montefeltro portraits and clarifying the iconography of the triumphs on the reverses, I bring the construction of gender difference to bear on the two likenesses of the Montefeltro diptych. Lastly, I address the issue of its reception based on what we know about the diptych's original frame and location.

Portrait of Sigismondo Malatesta of Rimini

Piero's panel portrait of Sigismondo Malatesta (Plate 25) has been linked chronologically to a votive fresco, dated 1451, of him kneeling before his name saint, Saint Sigismund of Burgundy (see Plate 3).[7] One of the earliest independent portraits of the modern era had been created, probably around 1440, for Malatesta's brother-in-law, Leonello d'Este Marchese of Ferrara, by the eminent court artist Antonio Pisanello (Fig. 23). How does Piero's presentation of Malatesta ten years later compare to the construction, known to both artist and patron, that was offered by Pisanello of the Estense ruler?[8]

The two *condottieri*, in profile and at bust length, are similarly clothed in luxurious doublets of gold brocade, decorated with large floral motifs.[9] Their heads are crowned with caps of abundant and stylized hair – in Sigismondo's case, chestnut in color – a bouffant coiffure that was perhaps dictated by the helmets worn by Italian *condottieri*. Both portraits

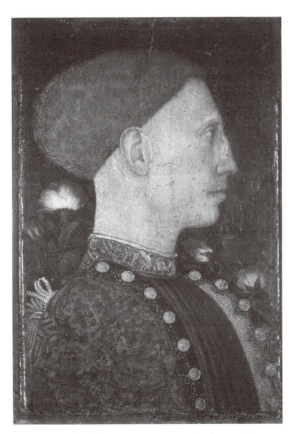

23. Antonio Pisanello, *Portrait of Leonello d'Este of Ferrara,* Bergamo, Accademia Carrara (Photo: Scala/Art Resource, NY).

emphasize the continuous profile of forehead and slightly hooked nose, the upright carriage, and firmly compressed lips. The pink flush in Sigismondo's cheeks has been credited to the influence of the Flemish artist Roger van der Weyden.[10]

Although the relationship of image to frame is identical, the likenesses differ in scale and proportions; Piero's work measuring 44.5 × 34.5 cm gave the sitter more breathing space than Pisanello's considerably smaller, narrower portrait at 28 × 19 cm. They also diverge in respect to the amount of volume with which each artist sought to fashion the *signore*'s persona. Depicting the light as if coming from the left, as Cennini recommended,[11] the painter seen today as a great modernist gave Malatesta greater volumetric substantiality, so that the concavities and convexities of his features are more fully modeled in light and shade than those of his brother-in-law, a feature especially apparent in the turn of Sigismondo's columnar neck and the shadows at his jawline. Pisanello sought a different aesthetic, and the blossoming rose bush that complements the curves of Leonello's back and breast, endows his image with a decorative elegance that was not emulated by Piero. Instead he gave Sigismondo's figure weight and *gravitas* by constructing his head as an almost perfect semicircle and by outlining his stern features starkly against a continuous black ground. Whereas Pisanello can be said to have focused on a linear construction of Leonello's poetic sensibilities and intellectual pretensions, the three-dimensional mass of Sigismondo's body in Piero's likeness can be read as a metaphor for his power. It implies the overwhelming physical presence of this large man as well as evoking his determination and headstrong sense of self.[12]

What were the political circumstances of Sigismondo's life at this time?[13] He was at the height of his power. The portrait dates from a period when, basking in his success as a *condottiere* on the battlefield, Malatesta turned his attention to the patronage of arts and letters with which to convey his greatness to posterity. In the years immediately prior to this work he had been appointed Captain of the Papal army and Gonfaloniere of the Church by Pope Eugenius IV in 1445. In 1448 he orchestrated a major triumph over king Alfonso of Aragon at the siege of Piombino, was hailed by Florence as the "Savior of Tuscany," and in 1450 was finally confirmed by Pope Nicholas V in the vicariates of Rimini, Cesena, Fano, and others, that he had ruled since 1432. By the late 1440s he was able to use his great Castello as a residence and had commissioned Leon Battista Alberti to remodel the church of San Francesco.[14]

On the medals that Pisanello and Matteo de' Pasti created for Sigismondo earlier, the ruler is usually constructed in armor.[15] Clothing was so important to the Renaissance that Malatesta's decision here not to be portrayed in armor must be seen as deliberate. Although Sigismondo was rec-

ognized throughout Italy as a great military leader, he had yet to achieve his political goal: a permanent, dynastic title whether from Emperor or Pope. "As both heir to an established rule and yet dependent on the papacy for confirmation of that rule," Ettlinger wrote, "Sigismondo fell into a peculiar category among despots: he was at one and the same time a hereditary ruler and an appointed governor."[16] As a hereditary papal vicar with a technically revocable title, he was subject to the vagaries of papal politics that shifted with each new pontiff. When the *condottiere* Francesco Sforza withdrew from the Romagna in the late 1440s Sigismondo hoped to fill the power vacuum left on the Adriatic coast.[17] The possibility of establishing an independent Malatesta state, over which he could rule with the same freedom as his Este brother-in-law over the papal fiefdom of Ferrara, must have almost seemed within his grasp when this likeness was being created.[18]

Malatesta's profile view had strong connotations for Quattrocento *signori*. Recalling the heads of Roman emperors on imperial coins, the profile embodied both the culture's fascination with the classical past and North Italian rulers' specific interest in territorial conquest. Given its dual association with Antiquity and Empire, the bust profile provided Sigismondo with a format that, on the one hand, could symbolize his authority and *virtù* and, on the other, offer a metaphor for the dynastic continuity that he sought for Malatesta rule of Rimini.[19]

The likeness can be read as a construction of Malatesta as a prince worthy of higher rank, one to be recognized, in the words of the humanist Guarino da Verona, as much as "wisest leader" (*ductor sapientissimus*), as the identity of "strongest soldier" (*miles fortissimus*) that was conveyed by so many of his medals.[20] It fashions Sigismondo not as the triumphant *condottiere* but as the ideal ruler, the just and wise prince later eulogized in letters by his court humanists, Basinio da Parma and Roberto Valturio. Piero's portrait can be said to visualize Sigismondo identifying with, and playing the role of, permanent Malatesta ruler so convincingly that he seems to have been transformed into one. In this interpretative reading Sigismondo in 1450 is figured in his hoped for, future identity as *rex*, to use the appellation given him by Valturio: "most splendid king of Rimini" (*Splendidissimus Ariminensium Rex*).[21]

Date of the Montefeltro Diptych

Had Sigismondo (d. 1468) lived to see the Montefeltro diptych, its iconography would surely have deeply impressed him. While his independent portrait was similar in type to those few other, surviving, independent likenesses that preceded it, the double-sided Montefeltro diptych that Piero

painted some twenty years later is in almost every respect an anomaly.[22] At 47 × 33 cm each, the proportions of the panels are slightly higher in relation to their width than Sigismondo's portrait. On the front, the confronting profiles of Federico da Montefeltro of Urbino and his wife Battista Sforza of Pesaro (1446–72) are silhouetted above the horizon against the sky; behind, a continuous panorama of land unfolds across the two panels (Plates 26 and 27). On the reverse, a similar vista of land again unites the background of both panels (Plates 28 and 29). The central register is a stage on which the triumphal processions of husband and wife take place, while on the lowest the prominent Roman capitals of the two inscriptions complement the classical style of the white marble parapets.

The identity of the life-size sitters and painter of the diptych have long been accepted as certain, but the date has been endlessly debated.[23] Most scholars now place it after the summer of 1472, when Battista died of pneumonia, and before the summer of 1474, when, to discourage Federico from making his services in the field available to other lords, Pope Sixtus IV raised his rank to a dukedom and the king of Naples inducted him into the chivalric Order of the Ermine.[24] Almost immediately, the king of England also conferred the Order of the Garter on him. It seems unlikely that Federico would have omitted pictorial reference in the diptych to such politically charged honors. Thus a dating of around 1473 will be hypothesized, and the sitters identified as count and countess rather than by Federico's subsequent title as duke.[25]

The hyperbolic inscription under Federico's triumph on the reverse may be translated as: "This Illustrious hero is celebrated for the fame of his *virtù* (military prowess). Carried in signal triumph and worthy of the scepter that he wields, he is equal to the greatest captains [of Antiquity]."[26] The inscription below his wife's triumph translates as: "She preserved modesty in prosperous fortune; her fame flew on [was celebrated by] all men's lips; she was adorned by the praises of her great husband's deeds."[27] As established long ago by Gilbert, the remote past tense that is used in the wife's eulogy, but not her husband's, would seem to confirm that Battista had already died at the moment of production.[28] In addition, a phrase in the inscription, VOLITAT PER ORA VIRORVM, is taken from Cicero's *Tusculan Disputations,* where it comes from a discussion concerning glorious, posthumous reputation.[29]

The Countess's inscription is held to be similar in tone to the encomia sent to her husband after her death and the orations made at her funeral. In them court humanists and mourners fabricated the myth that Battista's death was connected to the birth of a male heir, Guidobaldo, after eight daughters, rather than from – a considerably more banal cause – pneumonia caught on a fishing trip, five months after her delivery.[30] In short, when this double portrait was created, one sitter was alive but the other, it seems certain, was dead.

Portrait of Federico da Montefeltro of Urbino

Federico, like Sigismondo, does not wear armor on the work's front, unlike most of his other large-scale portraits; he is instead clad in clothes similar to those in which he was buried: a simple red doublet (*giubbone*) without jewels or chains, and the cylindrical red *berretta* often worn by *condottieri*-princes (see Plate 27).[31] His profile is as effectively silhouetted against the pale blue morning sky as that of Malatesta against a black ground. Unlike Sigismondo, who was portrayed in his maturity around thirty-three, Federico, at fifty, was on the cusp of old age. He is constructed with his back to the sun, and the diffused light that wavers delicately over pockets of soft shadows gathered around eyes, nose, and mouth, and across the broad expanse of red *berretta*, stresses their three-dimensional volume.

Once again a ruler is depicted in profile, assimilating his power to that of the imperial Caesars, as considered earlier. In addition, since the sitter's character and humanity are above all conveyed by his eyes, the presentation of one eye only, which is seen from the side, had the effect of masking Federico and Sigismondo's personalities rather than revealing them.[32] The rigidity of the profile format bespoke their psychological – not to mention social – distance from the portraits' viewers, elevating them, as it were, above the mundane affairs of this world.

The profile may have also carried an important subliminal meaning for these rulers. Both Malatesta and Montefeltro were likened to eagles: Malatesta's "aquiline nose" (*naso aquilino*) was listed among his outstanding physical characteristics,[33] and Piero accentuates the aquiline nature of the Urbino *signore*'s nose, fractured many years earlier, by making an already aquiline profile further resemble that of a eagle with curved beak. We will not be surprised to learn that the eagle, the swiftest of all birds and the one possessing the keenest eyesight, signified rule for the Renaissance. Attribute of Julius Caesar and Jupiter – two well-known seignorial role models – the eagle signified dominion and empire, and a hooked nose therefore symbolized, according to Pomponius Gauricus in 1504, a "regal and magnificent spirit" (*regalis ac magnificentiam animus*).[34] As further codified in 1586 by Giovanni Battista della Porta, a hooked nose epitomized sovereignty, because "the eagle is Queen of birds and hence promises the magnificence of a regal soul."[35] A memorandum concerning the depiction of a French monarch is instructive in this context. In 1482 the sculptor creating Louis XI's tomb effigy was told to transform the sitter's nose into one befitting his royal status: "the nose, as you know, is long and a little upturned. . . . The nose should be aquiline."[36]

The arms of most North Italian princes included an imperial eagle, and the eagle on Federico's coat of arms recalled the 1226 imperial investiture of the counts of Montefeltro.[37] Significantly, in light of Gauricus and della Porta's interpretation of a hooked nose, the count's enthusiasm for the sym-

bolic bird, which he had stuccoed all over his palace in Urbino, outdid by far that of his peers.[38] Since the eye was a metaphor for the phallus, the loss of an eye in the late Middle Ages could be read as a sign of impotence, and Federico's facial disfigurement, the loss of right eye and deformed nose, interpreted negatively as an outward sign of moral as well as physical deformity.[39] Fortunately, the connotations of the eagle were such that his nose at any rate could be read positively, as a sign of "regality."[40]

In the Renaissance, sitters habitually gave instructions to be "portrayed as if from nature" (*ritratto al naturale*), and the resulting portrait was routinely characterized as a "true likeness" (*una vera effigie*).[41] With his harsh profile, cheeks covered with warts, lines around eye socket and mouth, and fold of flesh at side of mouth, Piero's likeness of the count appears reasonably naturalistic – until it is compared to portraits of him created by Flemish artists, such as the double portrait of Federico and his heir dating a few years later, here attributed to Justus van Ghent (Fig. 24).[42] While retaining the profile view, the Flemish work did not censor, as had Piero, Federico's worn appearance, his lined forehead, drooping pockmarked cheeks, sagging double chin, down-turned, sardonic mouth, and wispy,

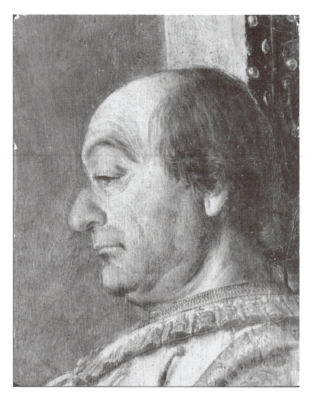

24. Justus of Ghent (attributed), *Portrait of Federigo da Montefeltro and His Son Guidobaldo:* detail, Urbino, Galleria delle Marche (Photo: Alinari/Art Resource, NY).

thinning hair. The Italian artist not only improved the texture of the *condottiere*'s skin, minimized the size and expressiveness of his mouth, and reduced the amount of flesh under his chin but also modified the count's fleshy, bulbous nose into a smaller, leaner – and, presumably, nobler – structure. Other Flemish likenesses of the same sitter, such as that in Hampton Court dating from the late 1470s, also stressed his homeliness and the leathery and blotchy texture of his skin.[43] In this respect Piero can be said to have followed Leon Battista Alberti's precept in his *Treatise on Painting* that artists should emend Nature in order to improve the sitter's appearance: "Plutarch tells how ancient painters, when painting kings who had some physical defect, did not wish this to appear to have been overlooked, but they corrected it as far as possible while still maintaining the likeness."[44] "True likenesses from life" were thus only acceptable to most aristocratic Italian sitters when presented under an idealized guise. Such was the tact of Piero's detached and iconic image of Federico that, concealing many of the ravages of time, it established the prince's "official appearance," a "trademark" image that would subsequently be perpetuated in countless replicas.[45]

The Signori's Portraits in Religious Paintings

What was the relationship between the image of rulership projected in these autonomous likenesses of Malatesta and Montefeltro and Piero's portraits of them as pious donors in contemporary religious paintings? In an attempt to explore not the rulers' religious devotion in life but its construction in pictorial fiction, we will consider their self-presentations in identical hierarchical poses, kneeling in pure profile in the same leftward direction, hands clasped in prayer.

In Piero's fresco of *Sigismondo Malatesta before Saint Sigismondo* in the chapel of the relics in San Francesco, the lord of Rimini, sought his patron saint's intercession with God for his eternal salvation (see Plate 3). Like the donors in Masaccio's *Trinity* in Florence from the mid-1420s, with which Piero was familiar, Sigismondo is depicted on the same scale as the saint. In 1450 in Northern Italy, however, such a notion concerning the ideological relation of the human and the Divine was still vanguard. Furthermore, unlike most midcentury devotional paintings in sacred sites, this donor exceptionally occupies the central location in the work – in effect the same position as in his secular likeness.[46] Equally unexpected in a religious work at the date, the site in which Sigismondo seeks the saint's mediation was constructed as secular, and identified by the lord's arms and *imprese* as a magnificent Malatesta chamber. Finally, when compared to the intimacy of the donor's relationship with his name saint in Piero's contemporary panel of *Girolamo Amadi Kneeling before Saint Jerome* (see Plate 4), the distance

that separates Malatesta physically and psychologically from St. Sigismund is striking.

The worshipper is identified by the large tournament shield centralized above his person, which also proclaims his actual rank as a knight.[47] Since possession of a stronghold in life was equated with possession of land, the image of Sigismondo's castle in the oculus can be said to symbolize dominion. Thus the castle and the heraldically disposed hounds, which frequently accompany the nobility in early modern imagery, can be read as emblems of Malatesta's sought-after rank as dynastic ruler.[48] Arguing for a different thesis, Lavin nonetheless defined the supplicant as a "sovereign ruler" and suggested that the fresco constituted a "political manifesto."[49] Inappropriate as this may seem for the religious site in which the work was painted and the devotional purpose it ostensibly served, the fresco can be said to reiterate a similar pictorial identity for the sitter as that projected by Piero's autonomous portrait.

Painted in the private setting of a tiny chapel to which few had access, Malatesta's fresco ostensibly represented a private act of devotion. The Montefeltro altarpiece, on the other hand, was commissioned by Federico as an altarpiece for the church in which he planned to be buried, possibly for his actual tomb (see Plate 5).[50] Contemplating his own demise, the donor prays in armor to the Virgin and child who, seated in front of an apse, are surrounded by saints and angels in a more conventional composition than that in Rimini. Probably painted between July 1472 and August 1474, that is, contemporary with the Montefeltro diptych, the asymmetry of the front plane of the altarpiece points up the extent to which the diptych was a deliberately contrived construct designed to recall the conjugal union.[51] No attempt is made here to disguise Battista's absence opposite Federico, the blank space in the altarpiece that she would have occupied being guarded by St. John the Baptist, her name saint, who points to the Christ-child, who will ensure her salvation in the next world.[52]

The angle of vision for the donor of a religious work is usually from below to above; in Mantegna's *Madonna della Vittoria* of the 1490s, for instance, Marchese Francesco Gonzaga gazes gratefully up into the face of the Virgin, who, having saved him at the battle of Fornovo, now blesses him in the altarpiece.[53] This is not case for our two *signori*. St. Sigismund looks down at the lord of Rimini but the latter does not tilt his head to acknowledge the saint's presence but looks straight ahead. As hierarchically posed as his former enemy, the lord of Urbino also gazes ahead, toward the place that Battista would have occupied, rather than up at the Virgin in supplication for eternal life for them both.

Unlike Masaccio's *Trinity*, where the donors kneel outside the pilasters that frame the scene, both lords are included *within* the pictorial space in which the devotional scene is enacted. Yet Piero fashioned them as worshippers who were as psychologically disengaged from the pious events in

which they participate as they are from the viewer in their autonomous portraits.[54] Neither could be characterized as a supplicant humbly pleading his cause; they seem rather to have come before the Divine as if to receive what they conceived as their due. The more ordinary mortals who comprised the membership of the Confraternity of Mercy depicted in Piero's *Madonna della Misericordia* gaze yearningly up at the Virgin as they plead for her protection in this world and intercession in the next (see Plate 2). By comparison, the pictorial sense of entitlement of both our *signori* vis-à-vis the Divine is palpable. The demeanor of neither temporal ruler in the face of Eternity in these sacred sites can be said to conform to the cultural or religious norm.

Piero and Laurana's Portraits of Battista Sforza of Pesaro

Returning to consideration of the Montefeltro diptych, we find that the countess's portrait constructed her as magnificently attired – *magnifica pompa* in a contemporary evaluation – wearing a dark bodice and gold brocaded sleeves with a thistle pattern picked out in red silk pile.[55] She is adorned in her most precious jewels with a focus on the very expensive white pearls that symbolized purity and chastity: an elaborate collar of two rows of large pearls, gold links, and precious stones from which hangs another pearl necklace bearing a gold pendant set with an onyx or chalcedony.[56] Since blond hair was a social sign of nobility for the culture, her fair hair may not be entirely reliable as a record of its color in life. It is woven with a white ribbon into large concentric shell-like coils over her ears, which are balanced by a piece of white satin that, tucked, folded, and pulled, protrudes beyond the back of her head. At the center of the coils a jewel was placed. This elaborate coiffure is completed by a head brooch, also of translucent pearls, anchoring the white ribbon to the crown of her head.[57] Together the head brooch and the tucked satin give her head a height and width that prevented her image from being overwhelmed by the volume, weight, and color opposite of her husband's red *berretta*.

Coming from the right, the single light source used for the two panels spotlights the countess's features so strongly that it threatens to drain them of color and definition.[58] A more conventional artist might have reversed the direction of the light so that the dead woman's face was shrouded in shadow while he who was alive looked confidently into the warmth of the sun's rays. Instead the strong flow of light creates a dimmed, somewhat diminished, presence for Battista, one that in the circumstances seems redolent of absence. Although Quattrocento female portraits were usually highly idealized, the current interpretation of Battista's likeness as posthumous would seem to be confirmed by the image itself as well as by the verb tense and the choice of quotation for her

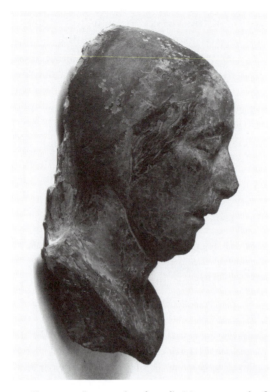

25. Francesco Laurana (attributed), Mortuary mask of a young woman: Battista Sforza(?), Paris, Musée du Louvre (Photo: Réunion des Musées Nationaux/Art Resource, NY).

inscription. Her blanched features and expressionless face resemble nothing so much as a waxen mask, and a strong case can be made that her image was based on a mask taken after her death, of which a terracotta cast, believed to have been made from the original molds, still survives (Fig. 25).[59]

Most surviving death masks, and the sculptures based on them, were made of old men, where the weight of the wet plaster usually caused the cheeks, mouth, and eye sockets to sink, and the cheek bones, jaws, and nose bridge to protrude, thus exaggerating the underlying facial bone structure.[60] While Battista's death mask shows the usual open mouth, closed eyes, and very visible cheek bones of such artifacts, the twenty-six-year-old still looks relatively young despite her nine pregnancies. Her ears, as was customary, were omitted from the mask, a feature concealed in the painting by the concentric coils of hair.

One other posthumous likeness of the countess survives, a marble portrait bust also worked up from the death mask, commissioned from Francesco Laurana and probably dating 1474–75 (Fig. 26).[61] This work of

great geometric purity is unusual among Laurana's female busts in being identified by a carved inscription: DIVA BAPTISTA SFORTIA VRB[ino] R[e]G[ina].[62] Translating as "goddess Battista Sforza, Queen of Urbino," the inscription on Battista's bust carries with it all the connotations of the commemoration after death of a Roman empress.[63] Laurana's sculpture, like Piero's painting, figures the countess with the mask's prominent nose; in other respects the mask's closed eyes have been half-opened, its open mouth closed, and double chin softened. In contrast to the painting, the snake of hair placed around the back of Battista's head in Laurana's bust reflects the mask's lack of information in this area and points up Piero's invention, for aesthetic purposes, of the unlikely, fantastical hairstyle in his painted portrait. The marble sculpture also follows the death mask closely by including the cap *(ciuffetta)* tied under her chin that covered the countess's hair and ears in her last illness. Together, the mask and sculp-

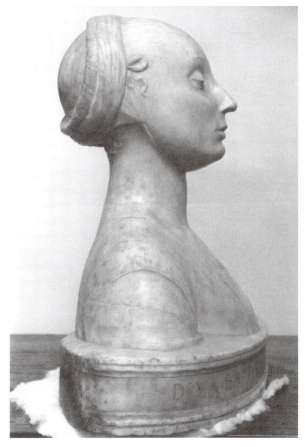

26. Francesco Laurana (attributed), Bust of Battista Sforza, Florence, Museo Nazionale del Bargello (Photo: Alinari/Art Resource, NY).

ture explain the presence of the same line under her chin in Piero's image, where it appears to serve no purpose.[64]

When Laurana's profile configuration of the countess is compared to that of his other female busts, it can be seen that Battista's chin is held at a higher angle than usual.[65] It has been suggested that the up-turned face of the mask, and hence the sculpture, may repeat the angle of Battista's backbone and head as she lay dead on the bier.[66] Be that as it may, the rigid angle of the white marble head confers great dignity on this sculpted "Queen." From the front, the harmony of the spherical head, symmetrically placed above the curved contours of neck and shoulders, is balanced by the oval base or socle with molded edges. From the side, the base echoes the curved configuration of the snake of hair encircling the back of Battista's head.

This base, which is carved from the same block of marble as the bust, is an anomaly in the development of the Italian Renaissance marble portrait bust.[67] The analogous art form of late medieval reliquary busts of saints, however, usually terminate with a molding or socle, or are sometimes set upon architectural or clawlike supports.[68] Another sculpture recently attributed to Laurana, also dated to the 1470s, showing a three-quarter length image of the child saint Cyricus, also terminates in a large oval base that is carved from the same marble as the cult image, as if to suggest that it is a type of reliquary that contains the saintly child's remains.[69] It is possible that the marble base of Laurana's bust of Battista Sforza was also intended to allude to those of late medieval and Renaissance reliquary busts portraying venerated, saintly figures. A case can be made that Laurana, commissioned to create a work commemorating the saintly, "martyred" countess, appropriated the "reliquary type" base from the religious realm, so that the secular portrait bust of the woman eulogized by her contemporaries for having sacrificed her life for that of her son, bore some resemblance to a saint's reliquary.[70] Indeed, the term DIVA in the countess's inscription was also used in the Renaissance to signify "saint" or "holy" as well as "goddess." However the base may be interpreted, it elevates Battista's image, both literally and figuratively, above the ordinary realm, endowing it with a cultlike presence that can be read as saintly as well as regal.

To modern sensibilities, Laurana's sculpture may be a more appealing representation of the departed countess than Piero's painted image, albeit no less idealized. Laurana's confidence in dealing with the three-dimensional volumes of the marble head highlights the fact that, although painted posthumous portraits such as Piero's were usually based on another two-dimensional image rather than a three-dimensional death mask, it was not uncommon in contemporary Florence to base a sculpted portrait bust of a prominent individual on a mask.[71] It could be argued that in this case the sculptor exploited his particular expressive medium with

greater skill than the painter when translating the pedestrian data of the mask – a literal copy after Nature – into a composition that evoked the life of a breathing creature.[72] It can nonetheless equally be argued that Piero sought *not* to produce a representation of the living woman but rather an ageless *idea* of the countess and her mask – the persona that signified the role or character of the actor in Greek drama. Her salient features, already abstracted and exaggerated in the death mask, were further abstracted by Piero in his image, not of the *woman* but of a *concept* for eternity of Federico's quondam consort. To the extent that the REGINA of Urbino could be said to have had "two bodies," Piero's image was surely intended to represent the body politic, not the body natural.[73]

It is hard not to feel skeptical when reading the sentimental accounts in the older literature of the great love affair that was interrupted by Battista's death, based on contemporary sources that construct Federico as devastated at his wife's demise – the same sources that claimed that her death was caused by Guidobaldo's birth. Nonetheless, the count's commission in 1474 of Laurana's beautiful marble bust can be read as deriving from personal, as well as political, motivations – that two years after his wife's death, she was still a strong presence in his thoughts and that he continued to mourn her absence.

The Continuous Vista of Land

Behind the portraits, as well as behind the Triumphs on the reverse, Piero has depicted a near view of fields on steep slopes and a distant view of conical hills that ascend and descend at regular intervals, interrupted by bodies of water and, on the front, by the walls and towers of a fortified Medieval town. The diptych shows the earliest surviving Italian portraits in which the sitters are placed against such a background panorama.[74] The way this vista has been framed in the literature as a "landscape" has implied the existence of such a genre in Italy during the fifteenth century, and that this work represents a standard example. Yet only later, in sixteenth-century Venice, would the term "landscape" (*paese*) be used by Marcantonio Michiel to define an important component, either setting or background, of the painted *poesie* by Giorgione and Titian.

The concept of a distant landscape seen in bird's-eye view derived from the Netherlands. Ottaviano Ubaldini, half brother and counsellor to Federico, owned a (lost) painting by Jan van Eyck, which is believed to have displayed a vista structured similarly to that in the *Rolin Madonna* (dating from the mid 1430s); that is, figures inside a tall structure through whose window openings a vast panorama of the surrounding town and country could be obtained.[75]

The idea of juxtaposing a *portrait* against such a vista, however, seems

to have originated around 1470 with Hans Memlinc, whose likenesses of Italian sitters working in Bruges became well known and very influential during the 1480s in Florence, where they were often shipped immediately upon completion.[76] In Memlinc's early portraits, such as his *Double Portrait of an Elderly Couple,* c. 1470–72 (Fig. 27), a balustrade introduced behind the sitters and visibly sustained by the column on the left, justified their location vis-à-vis the background, by implying that they were seated in a loggia high above a valley.[77] Piero's work offers no such rationale for his sitters' relationship to the background view. Battisti, however, speculated imaginatively that the design of the original frame may have used architectural forms resembling those of the marble parapet on the reverse.[78] The vertical elements of the frame could have consisted of small pilasters that seemed to sustain the horizontal elements, perhaps not unlike the much larger fluted corinthian pilasters depicted in the fresco of *Sigismondo Malatesta before Saint Sigismondo* (see Plate 3). Such a framing of the diptych's front might have simulated the illusion of a balcony similar to the actual loggia between the towers on the Urbino palace's northwest facade overlooking the Marches. Indeed, such a magnificent panorama of surrounding terrain can only be obtained from this site, which leads directly into Federico's personal suite of apartments where the diptych may have been stored.[79]

Although a Flemish iconographic motif, Piero's distant vista dotted with scrubby trees and undulating mountains did not follow Flemish landscape conventions – either Memlinc's views of flat, domesticated fields punctuated by bushes or tall, feathery trees; or van Eyck's backgrounds in which the distant elements retained the same fullness of articulation and color as the nearest ones. Instead, Piero used a form of aerial perspective in which the landscape forms that were furthest away were dissolved by light, so that the colors and the definition of the forms blurred into a blue haze as they receded toward the horizon.[80]

For the Quattrocento ruler such vistas did not represent a "landscape" but a view of the territory with which he identified as feudal lord. Without land, a ruler had no legitimacy or authority. On Pisanello's medal for king Alfonso showing a triumphal procession, the inscription lists the territories over which the king of Naples ruled: Aragon, Sicily, Valencia, Jerusalem, Hungary, Maiorca, Sardinia, and Corsica.[81] Piero's mountains must symbolize the state, constantly battled over, that was the political basis of Federico's identity as ruler. The continuous vista of land on both sides of the diptych was therefore a sign that carried ideological significance for the Quattrocento prince; it embodied political intentions relating to strategies of conquest and occupation.

Despite its political significance, this view is not a "portrait" of the Marches.[82] Just as the likenesses of the lords were highly idealized, so is this vision a construct in which nature has been mediated by culture.[83] No

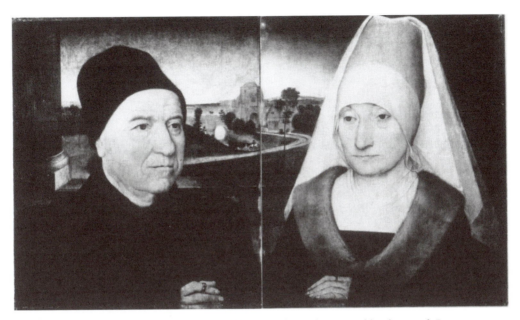

27. Hans Memlinc, *Double Portrait of an Elderly Couple,* Berlin, Gemäldegalerie and Paris, Musée du Louvre (Photo: Author).

matter how much the hills and fields appear to follow the inevitable laws of Nature, they represented an aesthetic order, a new and "improved" Nature invented by the artist. Piero presented an apparently natural world, in which the irregularities and disorder of Nature have been smoothed over; the landscape was as much a painted fiction as the portrayed protagonists.

When writing about the depiction of countryside in his 1452 *Treatise on Architecture,* Leon Battista Alberti emphasized the human activities of the lowest social class that took place in it. He was following Pliny who, when discussing the work of the landscape specialist Studius, mentioned his depictions of "all kinds of people walking or going by ship, riding by land towards the villages on donkeys' backs or in carriages."[84] In this work, however, Piero has ignored the existing feudal system of peasants attached to the land. There are signs everywhere of human habitation but no evidence of inhabitants. Federico and Battista are the only living beings in an unpopulated world. References to territory on Quattrocento medals also commonly omitted mention of those who lived there, and the absence here of human figures other than the lords may be read as signifying the power relations between ruler and ruled.[85]

Placed high above the horizon, the "close-ups" of the feudal lords dwarf the view of distant terrain, suggesting the sitters' looming – not to mention aquiline – dominion. Both town and country are subject to the rule that emanates from the ducal palace, set high on a hill and from

within which the rulers surveyed their state in life. Symbolizing the all-important relationship between lord and land, this painting is, on one level, about the ruler's possession of, and dominion over, his state.

The Triumphs on the Reverse

Piero's double-sided panels are the only Quattrocento portraits with scenes on the reverse (Plates 28 and 29). It was not until the beginning of the next century that another painter from Urbino, Raphael, would paint allegories on the reverses of a double portrait.[86] The three registers of the reverse depict a prolongation of the same panorama, a continuous parapet bearing the two inscriptions, and, between them, the triumphal processions of Fame for Federico and Modesty for Battista. As we will see, the triumphs celebrate the ideologies of war and religion: Federico's virtue of Fame derived from his successful military campaigns, while the virtue of Modesty was symbolized by Battista's Christian piety.

Gilbert connected the format of the Montefeltro diptych to that of contemporary medals in which the obverse depicts a profile head and the reverse often an allegory eulogizing the sitter.[87] Federico commissioned many such medals throughout his life for himself although apparently none for Battista.[88] Since inscriptions on autonomous portraits were extremely unusual at this date, the concept must derive from medals, where however they were usually much less elaborate. Deriving from Virgil and Cicero, the diptych's inscriptions reveal the enthusiasm for humanism at Quattrocento courts and suggest Federico's own classical erudition.[89]

The literary sources for the triumphs were classical and Petrarchan.[90] Classical accounts of the celebrations that Rome gave to returning conquering emperors were of enormous interest to Quattrocento *condottieri*-rulers, as was well known to their court humanists. At the papal court in Rome and the Malatesta court at Rimini, Flavio Biondo and Roberto Valturio generated such literary tracts as *Roma Triumphans* (Rome Triumphant) of 1459 and *De re militari* (Of military matters) c. 1446–55.[91] Such Roman triumphal processions were occasionally revived in the mid-Quattrocento, and their political potential exploited in Renaissance life, just as they had in classical Rome, where they were ostensibly a form of thanksgiving for the divine favor bestowed on the people in the person of the emperor.[92] The locus classicus for such a revival was king Alfonso's triumphal entry into Naples in 1443, soon after conquering the kingdom. As it happens, Piero's visual source for the triumphs shown in profile probably derived from a medal for the king created c. 1449 by Pisanello that may refer to this very event.[93]

The Triumph of Fame in Petrarch's poem *Trionfi* (1340–44) was often conflated with that given to Roman heroes. Describing a Petrarchan Triumph of Fame as if it were a Roman triumph, Jacopo Bracciolini wrote in

1474: "The victor *(trionphatore)* on a chariot pulled by four white horses, was dressed in purple embroidered with gold stars, wearing a rich crown, holding a scepter [of rule] in one hand, a victorious branch of laurel in the other, with a winged figure of fortune behind."[94] This description can be said to resemble closely Piero's image of Federico in his triumph – albeit he is depicted in contemporary armor rather than in purple – holding the *bastone* of command, while being crowned with laurel from behind by a winged figure, variously identified as Fame, Fortune, or Victory (probably the first) standing on a small sphere. The wheeled chariot or cart, driven by a cupid charioteer, is pulled by white horses. To triumph is everyone's dream, to triumph on the battlefield that of the Renaissance man of arms. One is nevertheless struck by the abstract nature of so much Renaissance iconography, and the discrepancy between the clarity and silence with which the idealized allegory of coronation with laurel is here presented, and the confusion and din that must have attended the *condottiere*'s theater of battle: the frenetic activity, constant clang of metal on metal, shouts of fear and pain, violence, brutality, and death.

There was obviously no equivalent Roman triumph for women, but Petrarch's poem also described a Triumph of Modesty *(Pudicitia)*, a virtue almost as relevant to Renaissance women as chastity.[95] Battista's chariot, on which she is fashioned as reading a small book (usually interpreted for reasons of scale as a Book of Hours opened to the Office of the Dead) is, as in Petrarch's *Trionfi,* pulled by unicorns, symbols of female virginity. Only a virgin, it was believed, could tame the fierce and independent unicorn. The unicorn was also an emblem of marriage and conjugal love, in which the tamed beast symbolized the bridegroom captivated by love.

Christian religious and ethical values were assimilated to the classical and Petrarchan subjects by the presence on Federico's chariot of the four cardinal virtues, in a depiction that privileges Justice (seen full-face at Federico's feet, holding sword and scales), Prudence (holding a mirror), and Fortitude (holding a broken column), over Temperance, seated with her back to the viewer. The cardinal virtues were considered necessary to the ruler, by Valturio in his role as military commander, and by Castiglione in that of virtuous prince.[96] In her study of Malatesta, Ettlinger proposed that a new model of the ruler arose in this period, one based on Roman *virtù* rather than Christian virtue, and Piero's depiction can be said to have integrated the Christian virtues into a context of classical *virtù*.[97]

On Battista's triumphal cart opposite, two of the three theological virtues – Faith (with chalice, host, and cross, and faithful dog) and Charity (wearing black instead of red and exceptionally shown with a pelican) – are seated at the front. Charity's unexpected attributes of black garb and pelican, a mother thought to nourish her chicks with her own blood, have been interpreted as another reference to Battista's maternal self-sacrifice.[98] Piero's painting thus reinforces the myth that the countess sacrificed her own life in exchange for that given to Guidobaldo. Indeed, the triumphs

of Fame and Modesty together can be read as a reference to the Triumph of Death, which separated them in Petrarch's poem.[99] The figure in white standing behind Battista may represent the third theological virtue, Hope, although she lacks the customary pose of eyes and hands held up to heaven. The identity of the other woman, seen from the back in grey, is mysterious; it has been suggested that she was intended to evoke the Clarissan nuns, in whose common tomb in Santa Chiara Battista was buried in the garments of a tertiary, as she requested.[100]

Gender Roles

Renaissance culture was convinced that women were born inferior to men; hence, the relations between the two genders, of male dominance and female dependence, was seen as ordained by God.[101] Treatises, such as Francesco Barbaro's *De Re Uxoria* and Leon Battista Alberti's *Della Famiglia,* articulate the fifteenth-century ideal of the wife's behavior and comportment in theory: obedience and subservience to her husband, chastity before marriage and fidelity after it, silence at all times, and the production of male offspring that, in the case of a ruling couple, would ensure dynastic continuity. In practice, however, the *condottieri*-prince's consort had much greater autonomy than her sisters in Republican Florence or Venice, in that she was called upon to govern the state during the lord's frequent absences.

The marriage in 1460 between the thirty-nine-year-old Federico da Montefeltro and the fourteen-year-old Battista Sforza was motivated by politics: it cemented an already existing alliance between the ruling houses of Urbino and Pesaro.[102] Through it Federico was assured that strategic access to the Adriatic port of Pesaro, through which all imports to Urbino had to pass, would be maintained.[103] Battista had the additional advantage of being highly intelligent and well educated by humanist tutors, one of whom went with her to Urbino so that she could continue her studies after marriage.[104] The curriculum of the *studia humanitatis* in which she was instructed, including Latin, history, philosophy, and even Greek, was essentially the same as that taught her brother Costanzo. Encouraged to speak publicly in Latin at the age of four, she later as an adult gave a spirited and eloquent oration to the papal court, a highly unusual event for an age when public rhetoric was deemed singularly inappropriate for the virtuous woman.[105]

In 1461, when she was fifteen, Federico mandated his consort full powers to rule the state during his absences. Battista, who was said to be dedicated to her studies, seems to have brought the same energy and precocious intelligence to the arts of administration and governance.[106] She was, for instance, so astute at foiling Sigismondo Malatesta's stratagem to conquer part of the Montefeltro during one of Federico's absences that even

that *signore* is reputed to have declared that she was "so wary *[proveda]* and shrewd *[saghace]* that she could have governed the kingdom of France."[107]

To what extent can these realities of Battista's life be said to be embodied in Piero's portrait of her? It is sometimes stated that Battista is especially honored by her location on the more honorable, dexter (viewer's left) side of the diptych. In double portraits, the male is always shown on the heraldic dexter and the female on the sinister, or subordinate, position, as for example, the donors in Masaccio's *Trinity,* or the sitters in Memlinc's *Double Portrait of an Elderly Couple* (see Fig. 27). Hence, it is virtually impossible that Piero's portrait of Sigismondo Malatesta (see Plate 25) once had a complementary pendant female portrait, given the direction in which he faces. Although the Montefeltro diptych is unique for its time in presenting male and female in reverse to the cultural norm, the reason is well known. As a young man Federico lost his right eye in a tournament and always thereafter avoided the depiction of his sightless eye in portraits.[108] Thus, the particular pictorial status that the front of the Montefeltro diptych appears to confer on the countess was due to the count's need to hide his disfigurement. Not only was a deformity considered a mark of divine disfavor, but rulers, like God, were supposed to be able to see clearly. By eliminating his unsightly, unseeing eye from his portraiture, Federico preserved the image of an all-seeing ruler favored by God.[109]

While artistic convention dictated that the two triumphal processions and Latin texts on the reverse, like the two portraits on the front, be given equal pictorial weight, the content of the inscriptions is unexpectedly revealing of the ideology of gender in this period. Federico is praised for his great deeds and Battista is also praised for his great deeds. The count, equal of the great generals of Antiquity, is said to be borne in illustrious triumph, to be celebrated by Fame, and to hold a scepter. However, the dead countess is said only to have been adorned by the fame of her great husband's exploits, while retaining her modesty in this, her good fortune. Regardless of Battista's important political role while alive, she was eulogized in death for the conventional role of conjugal support to the lead actor, her husband, rather than for those talents in which she was exceptional: her learning, quick intelligence, oratorical prowess, and skills in rulership.

The couple's roles within the triumphs are also gender specific. Piero constructed the armor-clad ruler as thrusting forward the *bastone* with outstretched arm in an active pose that recalls Marcus Aurelius's gesture of command and dominion in his equestrian monument, then outside the Lateran in Rome. At his feet, Justice, the count's representative, holds (Federico's) sword upright. Battista, on the other hand, merely sits sedately without moving, her eyes fixed on her book. The virtue of Modesty given to Battista had connotations of downcast eyes; indeed, she was praised for her *modestissimi occhi* (very modest eyes) – evoking the passivity, reticence,

and other submissive qualities that were part of the Renaissance social construct of the female ideal, none of them qualities of much value to the consort as regent.[110] The active, military life that led to Fame and the passive demeanor that denoted Modesty were, nonetheless, the standard virtues that Quattrocento rulers and their consorts sought to project in their imagery. Battista's brother Costanzo and his bride Camilla of Aragon, for instance, were given the triumphal carts and virtues of, respectively, Fame and Modesty at their marriage in 1475.[111] The secular and religious virtues in the diptych are also distributed according to gender-specific roles: the cardinal virtues to the male who represents the active life; the theological ones to the female who is fashioned as the emblem of contemplative piety.

It may be said that Piero's portrait does little to mediate Battista's actual life experiences, embodying instead the standard cultural ideal for the Renaissance noble female. While this ideology of gender is transparently patriarchal to the modern viewer, we must take cognizance that it would not have been apparent to an individual living then, and we may hypothesize that Piero fashioned an identity for Battista with which she herself could have concurred.

Original Frame and Location

The intended audience to which a work of art was addressed depended on its original location, which in turn usually reveals the work's function within the society for which it was created. How was the double-sided Montefeltro diptych originally framed, where was it located, and how may it have been displayed? Many fifteenth-century ruler portraits were sent as gifts to other princes but the provenance of the diptych indicates that it remained at the Urbino court.[112]

Although no fifteenth-century hinged pendant portraits have survived in Italy, the frames of this diptych are recorded as being hinged together, like a book, in the late sixteenth century.[113] If this were the case already in the Quattrocento, the physiognomical portraits of the ruling family in the interior of the closed diptych would have been "protected" by the allegorical visualization of their virtues and ethical values on the exterior.[114] The first image of the closed diptych would have been the triumph of the dead countess on the diptych's "front cover;" inside, the two open panels showed the facing portraits; when the work was turned over, the "back cover" revealed the count's triumph.

Contemporary hinged pendant portraits survive from Flanders and France, where they were more popular, and a Northern example may have been known in Urbino. Among those surviving, the closest analogy in terms of the sitters' social rank is a Provençal diptych with the pendant portraits of King René of Anjou and his consort Jeanne de Laval in a work

attributed to Nicholas Froment and dated to the mid-1470s.[115] The red velvet bag in which this double-sided hinged work was stored has also survived. The painting's small size (17.7 × 13.4 cm when closed) made it eminently suitable for storage in a chest along with the patron's precious jewels, gems, medals, and other treasures.

Since the double-sided format of the Montefeltro diptych would seem to preclude it from being hung on a wall, we need to envision it also preserved among the "effigies and portraits of all the emperors and noble men who have ever lived made in gold, silver, bronze, jewels, marble," to quote Filarete's (imagined) description of Piero de' Medici's treasure trove in his *studiolo* in Florence.[116] The Montefeltro diptych would have measured 42 × 35 cm when closed – more than twice the size of the Anjou diptych – and it was very likely stored in a leather or wooden case rather than a textile bag before being placed in a cupboard, perhaps in Federico's own *studiolo* in his private apartments. The late fifteenth-century double-sided *Portrait of Alvise Contarini* (?), attributed to the Venetian Jacometto, is recorded as having been kept in a leather case, although the likeness was already covered with a lid, also painted on both sides.[117]

If this is how Piero's work was stored, it would presumably have been produced in special circumstances to amaze the courtly visitor, whether another ruler, an envoy or a humanist, along with the lord's bronze, silver, and gold medals, classical coins, statuettes, and precious gems. Indeed, Piero's portrait of Sigismondo Malatesta, albeit not double-sided, may have been handled in a similar way. These early autonomous ruler portraits were such a novelty – in contemporary parlance, *novità* – that it seems likely that they were placed among the ruler's treasures, which in each case would also have included their numerous medallic and numismatic portraits, rather than hung on the wall.

We may imagine the courtly visitor, expressing his astonishment at the excellence of the work's conception and execution, which (he might well have said) filled his soul with delight. If very knowledgeable in the arts like Federico, he would also have praised Piero's work according to the criteria believed to have been standard in Antiquity, in the terms in which Piero de' Medici admired his own collection, if Filarete is to be believed: "He takes pleasure first in one [work] and then from another. . . . In one he praises the dignity of the image because it was done [by the] hand of man; and then in another that was more skillfully done, he states that it seems to be done by nature rather than by man."[118]

Conclusion

If the winged figure crowning Federico should indeed be identified as Fortuna, it could be said that she smiled on Federico as she had not on Sigismondo. In the course of Montefeltro's rule, he nearly trebled the size of

his state, largely at Malatesta's expense. By the early 1470s, as one of the wealthiest Italian princes, he had the financial means to devote to construction: fortifications along his border to ward off external attack, and town buildings to enhance his Magnificence. Federico, himself illegitimate, finally, after nearly thirty years in power and after so many daughters, had acquired a legitimate male heir – who was, furthermore, still alive at the moment of commission – with which to establish dynastic continuity and stability. This triumphant commemoration of the Montefeltro alliance recently severed by death can be read, on one level, as serving to recall the heir's genealogy and legitimacy, while, on another, to celebrate Federico's rulership of the state, over which the spouses' profiles – learned symbols of authority from the classical past – dominate so effectively, in Piero's brilliant visual statement about the connection between lord and land.[119]

Only Italian visual constructions were produced of Malatesta's facial features, but, as we saw, surviving Flemish likenesses of the lord of Urbino illuminate interpretation of the portraits produced by his compatriots. As enunciated by Leon Battista Alberti, Italian artists sought to render a recognizable portrayal from life that at the same time ennobled Nature's product. Rather than offering literal likenesses of Federico's homeliness or Battista's worn appearance in death, Piero conformed to his own and the culture's need for idealization by glossing over the inconveniences of Nature and inventing exemplary illusions that fulfilled a function of ruler portraiture: visual testimony to the *signore*'s virtue and power – and, therefore, credibility.

The Quattrocento patron usually dictated the iconography or subject that he wanted depicted. Only the artist, however, could give concrete form to his employer's abstract words by translating them into images. If the patron controlled the iconography, the artist's domain was the presentation or style of that subject. Throughout this essay, the likenesses have been interpreted, on the one hand, from the point of view of the sitters who commissioned and used them, and on the other, from the standpoint of Piero's art: the figure style of hieratic and majestic poses that so successfully conveyed princely inaccessibility and authority. It is due to Piero's great accomplishment as an artist, his clarity of conception and his skill in execution, rather than to any merits attributable to the sitters – albeit their status was so much greater than his in the Renaissance – that, half a millennium after their creation, we still value his beautiful portraits so highly.

7 The Renaissance *Prospettiva*

Perspectives of the Ideal City

Philip Jacks

Few pictures from the Italian Renaissance so capture our imagination as the idealized cityscapes in Urbino, Baltimore, and Berlin (Figs. 28, 29, and 30). By the same token, few have proven more elusive in terms of their attribution and interpretation. For all of their painterly skill, these panels do not reveal any particular stylistic traits that might betray the hand of one master or another, and although they are linked by a common critical fortune, no definitive evidence connects them to a single place of origin.[1] Rather than tackling the problem of their authorship head-on, this essay focuses on the function and meaning of these problematic paintings as objets d'art within the context of their time – specifically, in relation to architectural theory and the vogue for marquetry furnishings at the court of the Montefeltro in Urbino during the late fifteenth century.

Whoever created these architectural views shared more than an incidental interest in the built environment around them. In this respect, it is not surprising that early connoisseurs – notably Cavalcaselle, Morelli, and Berenson – tried to peg the authorship of one or more of these panels to Piero della Francesca. No other artist of his generation had so profound an understanding of the spatial complexities inherent in architectural form, with the notable exception of Leon Battista Alberti, whose theoretical writings on perspective and mathematics paved the way for those of Piero. Very likely the two crossed paths in Florence, where Piero first gained exposure to the new architectural style known as *all'antica*, and possibly again in Urbino, in his mature years at the court of Federigo da Montefeltro. Yet Piero's architectural sense was always firmly rooted in reality, whereas these *prospettive* (perspectives) offer a view into the world beyond – a blueprint of cities yet to be conceived, let alone built. Their constructions seem more like the ruminations of an architect – albeit one with a flair for pictorial invention, perhaps even a painter-turned-architect. This latter school of

thought has inclined to the possibility that the panels were created by a figure such as Francesco di Giorgio Martini, who trained as a painter in Siena and was later employed by Duke Federigo in the capacity of decorator, fortifications engineer, and architectural theorist.

One other possibility, in part borne out by cleaning and restoration of the paintings, is that they were the result of workshop collaboration. Vasari describes Alberti's early experiments in architectural perspectives, some of them quite complex. A series of "three small stories with some perspectives" (*tre storiette con alcune prospettive*) painted for the chapel of the Virgin by the Ponte alla Carraia in Florence was judged more skillful for its drawing than painting (*assai meglio descritte con la penna, che dipinte col pennello*). One of his finest paintings, according to Vasari, was a view of Venice with the Piazza San Marco, for which Alberti left the figures to other masters (*una Vinegia in prospettiva e San Marco, ma le figure che vi sono furono condotte da altri maestri*).[2] Whatever the accuracy of this account, it suggests the possibility that the *prospettive* with which we are concerned also involved more than one hand: The lines of perspective and proportions delineated by someone of architectural expertise, the figures and other decorative elements later applied by a painter.

What distinguishes the *prospettive* more fundamentally is that they defy the traditional genres of Renaissance painting. In the absence of human actors, there is no ostensible narrative. The architecture itself becomes the dramatis personae – foreground and background merge into a single vision. Insofar as the size and proportions of these panels approximate those of *spalliere* (paintings placed above wainscoting) and *cassoni* (wedding chests) from this period, it is assumed they served a similar decorative function within the household. And yet such painted furnishings invariably took their subject matter from ancient history or the Bible – allegories specifically intended to inculcate the virtues of domesticity and marital fidelity. Edifices could also convey a moral purpose, as Alberti stressed in his architectural treatise *De re aedificatoria*, only their meaning is more difficult to read in the case of these *prospettive*. Part of the problem is that while each of the panels render the lineaments of familiar monuments – both from ancient and contemporary architecture – taken together, they do not define a specific place. By contrast, in Ambrogio Lorenzetti's representation of *Good Government* for the Sala della Pace in the Palazzo Pubblico from a century earlier, the belltower of Siena cathedral peering over the cluster of turreted buildings makes clear the analogy of the artist's native city to a Heavenly Jerusalem. Of course, the physical context of Ambrogio's frescoes leads us on the track of interpretation, whereas the ideal perspectives – long ago removed from their original settings – force us to begin with the "subject matter" in determining where and how they may have been displayed.

To the degree that these three *prospettive* are not "representational," at least within the framework of the *istoria* (narrative) established by Alberti,

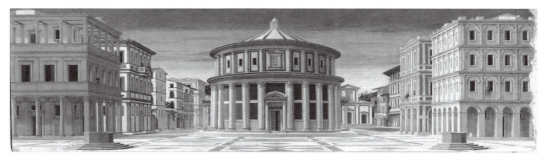

28. Anonymous, *View of an Ideal City,* Urbino, Galleria Nazionale delle Marche (Photo: Scala/Art Resource, NY).

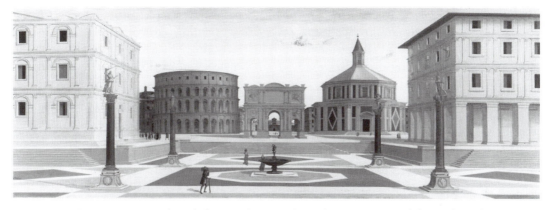

29. Anonymous, *View of an Ideal City,* Baltimore, The Walters Art Museum (Photo: The Walters Art Museum).

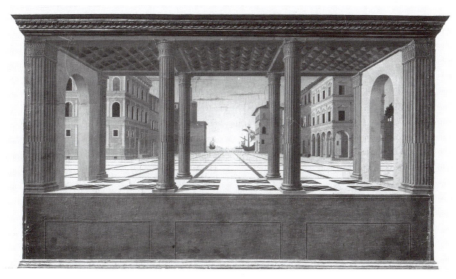

30. Anonymous, *View of an Ideal City,* Berlin, Staatliche Mussen, Preussischer Kulturbesitz, Gemäldegalerie (Photo: Staatliche Museen zu Berlin – Preussischer Kulturbesitz Gemälde-galerie, Fotonachweis: Jörg P. Anders).

it has been argued that they functioned as backdrops for theatrical per-
formances. As Richard Krautheimer points out, Renaissance theorists
could draw quite readily on ancient precedent. Vitruvius, in his treatise *De
architectura,* makes a somewhat off-handed comment regarding the tragic,
comic, and satyric stage sets of the Roman theater.[3] Clearly Alberti had
this specific passage in mind when he remarked that the poets of the the-
ater fall into three types: the tragic, who depict the miseries of tyrants; the
comic, who focus on domestic matters; and the satirical, who sing of the
shepherds' loves and the beautiful countryside. He then describes how, by
means of a rotating apparatus, a painted backdrop (*periaktoi*) would
instantaneously come into view, "revealing an atrium, house, or even a for-
est, according to the type of drama and the action of the play."[4] However
elaborate Alberti's own perspective paintings, there is no evidence to sug-
gest he manipulated these *prospettive* by a mechanical device or that they
were used in the production of his own play, *Filodosso.*[5] Indeed, theatrical
representations *all'antica* had not yet debuted in Rome by the time of his
death in 1472.[6]

* * *

Although the provenance of the cityscapes traces no further back than the
nineteenth century, such architectural views are documented in the ducal
collections at Urbino from the late sixteenth century. In 1587 Bernardino
Baldi, defending the "very good design" (*bonissimo disegno*) of Luciano da
Laurana, noted "certain panels, in which there were various scenes drawn
with rules of perspective and colored, which one cannot doubt are his, as
there is his name written among other things with characters in the
Slavonic language."[7] Laurana, born in La Vrana along the Dalmatian
coast, was sent by Alfonso of Naples to the court of Federigo da Monte-
feltro, who three years later, in 1468, granted him letters patent as the
architect of the Palazzo Ducale. Baldi frames his remarks in the context of
the palace, where presumably the panels then hung and where one hangs
today (Fig. 28). A pair of inscriptions in the pediments atop the palaces at
front left and right in the Urbino panel seemed to confirm the attribution
to Laurana. Both contain an undecipherable string of Greek and Latin let-
ters: One scholar claimed to distinguish the letters [V]RA[N]NA on the left
side, along with the digits "147_."[8] This would not rule out Laurana, who
died in 1479, though he had been effectively discharged of his duties as
ducal architect seven years earlier.[9]

Later inventories mention "a long painting of a perspective, old but
beautiful by the hand of Fra Carnevale" mounted over a door, but the
dimensions of this "long perspective" (three by thirteen *palmi*) do not
match those of the Urbino panel.[10] As for Fra Carnevale (born Bartolomeo
di Giovanni Corradini), he worked briefly as an architect and primarily as

a painter until his death in 1484. A number of altarpieces have been cred-
ited to him, as well as, most recently, the so-called Barberini Panels in
Boston and New York – though none comes close to the mastery of archi-
tectural proportions seen in the Urbino panel.[11] Whether or not the
Urbino panel can be identified with those recorded in the ducal palace, it
was very likely produced at the behest of the Montefeltro court. For by the
early nineteenth century the panel belonged to the sacristy of Santa
Chiara, a convent founded by Federigo's daughter Elisabetta on the
promontory just below the ducal palace.[12]

 Piero della Francesca's pervasive influence on the architectural culture
at Urbino has long been acknowledged, but to pinpoint their convergence
is more difficult. In the *Flagellation of Christ,* whose chronology is still dis-
puted, the interior decor of Pontius Pilate's house shows so striking an
affinity to the appointments within the Palazzo Ducale as to convince sev-
eral scholars of Piero's role in designing certain of the rooms (see Plate
6).[13] According to Marilyn Lavin, Piero may have designed his panel for a
particular location in the ducal palace, the Cappella del Perdono, though
this would imply a dating of the painting well into the 1470s.[14] Such speci-
ficity is characteristic of Piero, whether in his distant view of Borgo San
Sepolcro in the London *Baptism* or of the Riminese ramparts and Castello
Sismondo in his fresco of *Sigismondo Malatesta before Saint Sigismondo*
for the Cappella delle Reliquie in San Francesco (see Plate 3). This latter
scene, painted in 1451, has elicited much discussion for its sophisticated
illusionistic enframement of pilasters and trabeation. Whereas some have
seen this as Piero applying the lessons of Alberti, who at the time was com-
pleting *De re aedificatoria,* Piero's wall articulation is more closely rooted
in architectural practice than theory. As it now appears that Alberti did not
actually arrive in Rimini until 1453, Piero's source must have been closer
at hand. According to Christine Smith, Piero was looking to Matteo de'
Pasti's dado revetment in polychrome marble for the Cappella di San Sigis-
mondo. Planning on this chapel, which adjoins the cell housing the relics
of Saint Sigismund, had begun already two years earlier and its *all'antica*
effect was all the more impressive given that the carvers had reused spoils
taken from the sixth-century church of Sant'Apollinare in Classe outside
Ravenna.[15]

 If it is true that Piero tended to assimilate the language of architecture
– its tectonic and material properties – through close observation of build-
ing practice rather than by calling on his own fantasy, then the Brera Altar-
piece in Milan presents somewhat of an enigma (see Plate 5). Generally
dated 1472–74, it comes on the cusp of Alberti's death in 1472 and Laurana's
dismissal from the services of Duke Federigo in that same year. The artic-
ulation of the niche has been likened to San Martino a Galgalandi, a minor
work of Alberti's which Piero could not have seen, as well as Sant'Andrea
in Mantua, on which workers had barely broken ground, and more distantly

to the mortuary chapel of San Bernardino on the outskirts of Urbino, designed by Francesco di Giorgio over a decade later. Whatever his inspiration, Piero's articulation of architecture as mass — piers replacing columns and vaults replacing trabeated ceilings — heralded the new architectural idiom to which the young Bramante growing up in Urbino became the direct heir.

Kenneth Clark, the scholar most thoroughly convinced of Piero's master hand in the Urbino panel, noted a handling of tone and color superior to the architectural views in Baltimore and Berlin.[16] The Urbino panel and Montefeltro altarpiece, as Clark would have it, reflect Piero's "exclusive interest in architecture" at the end of his career as a painter, when he then turned to the study of mathematics. Various details of the Baltimore and Urbino panels seem lifted directly from these treatises: the matching wellheads, whose octagonal shapes reverberate in the pavement, are virtually identical to the stereotomic constructions illustrated in Piero's *De prospectiva pingendi*.[17] The eeriness of the Urbino panel — a city devoid of inhabitants and yet animated by an intellectual rigor — betrays the same sensibility as the Brera *sacra conversazione,* in which Duke Federigo kneels in gleaming armor before the inert Child — an ensemble as serenely silent as the architecture itself. Still, Piero's austere setting remains on a human scale, complementing the *istoria* without defusing its religious aura.

In this light, the Urbino panel appears wholly different — more a demonstration piece, and not just for the sake of technical virtuosity, but as the means of envisioning a mental construct. This was the ideal city whose components Alberti had laid out in Book VII of *De re aedificatoria*.[18] The specific nature of Alberti's visit to Urbino in 1469, the only one documented, is unknown; however, Federigo made no secret of his deep affection for the humanist-architect. In Cristoforo Landino's *Disputationes Camaldulenses* of 1475, the duke and Lorenzo il Magnifico engage in an imaginary symposium, conversing on civic virtue with Alberti as the *eminence grise* of this enlightened gathering.[19]

Whether or not Alberti had any direct imput on the design of the ducal palace or any other monument in the city, the impact of his ideas as theorist is more tangible. Piero's most expansive treatise, *De prospectiva pingendi,* an autograph manuscript of which belonged in the library of Federigo da Montefeltro, reads much like an elaboration on *Della Pittura*. Of the three components to painting, Piero substitutes *disegno* for Alberti's *circonscrizione, commensuratio* for *composizione* and, most importantly, *colorare* for *recezione di lumi*. Like Alberti, Piero recognizes that perspective is more than simply a series of geometrical formulas but that it needs to be used judiciously by painters. By Alberti's own admission, it was an architect, Filippo Brunelleschi, who had discovered perspective and who imparted its lessons to painters. And it was in architecture that the notion of *prospettiva* found its consummate form. So thought Giovanni Santi, a court painter for Guidobaldo da Montefeltro and the father of Raphael,

who composed his *Disputa della pittura* as an encomium to another painter well versed in perspective, Andrea Mantegna:

> Perspective, which brings on in its train
> Arithmetic, also geometry,
> And great architecture turns to it.[20]

Whereas the chromatic contrasts in the Urbino panel – pastel blues and browns against white – bring to mind the stunning effect of travertine stone against red brick in Laurana's grand Court of Honor, these fictive palaces are nothing more than a distillation of what architecture could express through the harmonies of color and proportion.

Physical examination of the painted surfaces suggests the perspective constructions in all three *prospettive* were rendered using a technique common in Quattrocento panel painting, whereby a series of lines incised in the wood established rectilinear elements such as pavements and architectural backdrops. Alberti's *costruzione legittima* was rarely followed to exacting measures during this era; it was merely the means to an end, a mathematical procedure for laying out the composition, the *istoria,* but ultimately it had to look right to the artist's eye. Even in the Urbino panel, which has the most consistent perspectival system of the three, small modifications were made after the lines were incised. A metal stylus was used to score orthogonals, a compass for the arcades (the surface is pricked throughout with pinholes). In the palace at far right, the pediment crowning the front originally matched its pendant on the left, but was later narrowed at its base. Similarly, its lateral facade directed toward the centralized building is delineated in the underscoring with four rather than five arches and slightly broader proportions.[21] As "corrected" by the eye of the painter, the perspectival diminution between openings of the arcade is barely noticeable. For whatever reason, the painter dispensed with the corresponding readjustments when it came to the upper stories, leaving the edges of the moldings on the two facades to oddly shift alignment. The frieze and architrave cantilevered from the wall similarly defy any architectonic logic.

What gives unity to the Urbino panel is the pairing of sacred and secular building typologies. According to Howard Saalman, its strict symmetry and visual hierarchies reflect the principle of architectural decorum as advanced by the leading theorists of the time. Thus, each social rank had its appropriate *qualità,* or architectural order, as Filarete called it; and though some citizens were deemed "more equal" than others, all were bound by the same codes of behavior when it came to the patronage of private and public monuments, and especially of their own homes.[22] Whereas the tabularium motif and stone construction of the palaces in the foreground fit the patrician status of their owners, the ground floors are left open as public thoroughfares. The less signorial residences tucked around

the corners of the piazza have unarticulated facades and overhanging roofs in place of classical cornices; conversely, their ground floors are shut off from the street. The church in the distant right corner appears nestled among the residences of common people, or *popolano,* very different in character from the majestic rotunda commanding the middle of the city. The lantern surmounted by a bronze cross would seem to identify this round *templum* as a Christian monument, perhaps a baptistery.[23] According to Mario Salmi, its circular form was meant to commemorate the *tempietto* that once stood in the Cortile di Pasquino in the Urbino ducal palace, a wooden model of which survived into the seventeenth century.[24] The columns of this temple number twenty-four, possibly alluding to the ancestors of Christ. In such a context, the generations leading back to King David might assume a broader significance in mind of the Temple of Solomon in Jerusalem, which Piero had earlier recreated for his cycle of the True Cross in Arezzo. The four porches at cardinal orientations of this building have been compared to the octagonal domed temple in the background of Perugino's *Christ Giving the Keys to St. Peter* in the Sistine Chapel, a fresco replete with analogies between Sixtus IV's pontificate and the reign of Solomon.[25]

Yet the Urbino panel does not depict just any utopia, but one sanctioned by Christian worship – all the more reason to suspect the guiding hand of Federigo, who had gone to Rome in 1474, shortly after the death of his young wife, Battista Sforza, to receive the title of duke directly from Sixtus. Later, the pope honored him with another distinction, the sword and *ermellino* (ermine fur) as a Knight of the Church. For those who would see the panel as an ideological representation of Montefeltro rule, this city is nothing less than a rendering of the Heavenly Jerusalem.[26] Apart from Alberti, the only one in Federigo's circle capable of conceptualizing a city on this scale would have been Francesco di Giorgio; indeed, one chapter of his treatise on architecture and military engineering is devoted specifically to town planning. By May of 1477, he had already entered the service of Federigo, charged with the decoration of the ducal apartments in Gubbio and to consult on the fortifications at Costacciaro.[27] It would appear Francesco di Giorgio's ingenuity was first put to the test in Urbino with Duke Federigo's decision in 1481 to renovate the Castellare with a massive spiral ramp.[28] By then Francesco di Giorgio was also completing the first redaction of his treatises; the autograph manuscript now in Turin contains some of the earliest reconstructions of ancient Roman monuments from the Renaissance (Cod. Saluzziano 148, Biblioteca Reale). His renderings of Santa Costanza and Santo Stefano Rotondo – both early Christian foundations commonly mistaken as pagan temples – in the form of peripteral domed structures may seem distant cousins of the *templum* in the Urbino panel; nevertheless, their forms are more properly Renaissance than antique. Francesco di Giorgio's credentials as a painter were already well established by the time he left Siena, and similar centralized

temples appear in the back-
ground of his religious altar-
pieces from that period (e.g.,
Nativity in the Pinacoteca,
Siena). Although Francesco di
Giorgio's name briefly emerged
as the author of the Urbino
panel, it has long since faded
from serious consideration.[29]

Given the commutability of
architectural drawings, whether
through the travel of architects
or the diffusion of sketchbooks,
there is no reason to fix the
design of the Urbino panel to a
set of physical coordinates. Piero
Sanpaolesi traced its architec-
tural motives to the buildings of
Giuliano da Sangallo and Baccio
d'Agnolo; and his conclusion
that the panel reflects more a

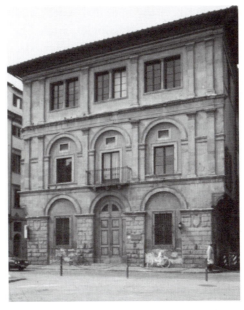

31. Palazzo Cocchi-Donati, Florence (Photo:
Author).

Florentine than Urbinate ambient is still persuasive.[30] Duke Federigo and
Lorenzo il Magnifico enjoyed a flourishing cultural exchange between
their courts. According to the bookseller, Vespasiano da Bisticci, Federigo
kept scribes in Florence producing manuscripts for his extraordinary
library. Among other tributes, the Florentine republic presented the duke
a silver helmet commissioned from Pollaiuolo, while the intarsia decora-
tions on the doors of the Sala della Iole and Sala degli Angeli in the suite
of ducal apartments, as well as on the cabinetry of the *studiolo,* are per-
haps related to compositions by Pollaiuolo and Botticelli.[31]

Krautheimer has called the Urbino panel "a never and nowhere realm,"
warning against the urge to match each motif to specific examples from
contemporary architecture.[32] Like any *prospettiva* – both perspectival view
and prospectus – this painting combines something of the familiar with
something of the irreal. The artist creates a seamless illusion between tra-
ditional vernacular forms and futuristic maquettes hardly feasible by the
technological standards of the time. The three-tiered tabularium wrapping
around the palace in the right foreground would have exceeded even the
most opulent of Renaissance palaces, yet it is not so far off in kind from the
Palazzo Cocchi-Donati on the west shoulder of the Piazza Santa Croce in
Florence, which was remodeled sometime after 1478 (Fig. 31).[33] Embedded
in this enclave of rusticated houses were the remains of a Roman
amphitheater. Its original form was largely obscured by the warren of
medieval streets that sliced through the core of the ancient fabric. The
architect, generally thought to be Giuliano da Sangallo, used this constraint

to reinterpret the classical syntax by flattening the superposed arcades and massive piers onto a single plane. The facade takes on the aspect of a *frons scaenae,* its sides elegantly notched out where the Via dell'Anguillara and Via Storta fan out from the piazza like the wings of Vitruvius's Latin theater. This notion is not so far-fetched when we realize that the piazza was often the site of jousting matches, of which the most memorable took place in 1469 to celebrate the coming of age of Lorenzo de' Medici.[34]

The newest architectural currents coming out of Florence provided inspiration to the marquetry workshops in Urbino and around the Marches. For the trompe-l'oeil architectural views in the *studiolo* at Urbino, these teams may have worked from designs furnished by Francesco di Giorgio, himself no stranger to Florence.[35] The same experimentation with scenographic effects may be found in the fictive architecture of *cassoni* produced at the ducal court during the 1480s and 1490s.[36] One intarsiated chest, thought to come from Federigo's private furnishings, shows a perspective with three palaces set behind a narrow proscenium (Fig. 32).[37] The orthogonals of the flanking buildings recede behind the central facade, whose stark frontality and blind arcades on the ground floor lend a stagelike quality to the architectural ensemble.

∗ ∗ ∗

There is some evidence to support the theory that the Baltimore panel once belonged together with its counterpart in Urbino, despite its Roman provenance (Fig. 29).[38] The dimensions are only minimally larger and the three pieces of wood are cut from separate boards, whereas the Urbino panel was sawn from one plank. More critically, the right edge of the Baltimore panel has visible traces of nail holes, as does the left edge of the Urbino panel, suggesting they may once have been joined in a continuous *spalliera* in one of the rooms of the ducal palace. The elevation of the arcaded palace on the right of the Urbino panel picks up again on the left of the Baltimore panel, except that the archivolts are detached from the flanking pilasters – a near verbatim quotation of the Palazzo Cocchi-Donati. Nonetheless, the tone of the architecture is more theatrical and the assemblage of monuments is more artificial. In the Baltimore panel buildings sit like props around a stage, most conspicuously, the Colosseum, whose perspective was rendered for the most part intuitively, without the aid of orthographic lines.[39] Like the octagonal baptistery and the houses behind, the amphitheater is constructed using a two-point perspective system at slightly higher eye-level.[40]

The artist of this panel lends his scene a distinctly *all'antica* cast, but the juxtaposition of ancient and modern belies a certain naiveté. Patrician palaces, both set on tall platforms stand in the two wings: On the right, the storeys are reduced in height more or less as Alberti prescribed in the

32. Cassone, XV century, Architectural perspective, Urbino, Galleria Nazionale delle Marche (Photo: Soprintendenza delle Marche).

ratio of 5:4:3. This same formula is then erroneously applied to the Colosseum, whose fourth order is articulated by half-columns rather than pilasters. The artist takes further license with the Arch of Constantine, which anchors the one-point perspective system of the pavement. Alternating pediments, like those crowning the palaces, curiously appear over the attic. Only two of the four Hadrianic roundels are shown, and these conflate the hunting scenes on opposite faces of the monument. If the painter had never witnessed the ruins of Rome, neither had he seen Ghirlandaio's rendition of the triumphal arch in his *Massacre of the Innocents* in the choir of Santa Maria Novella, nor drawings that may have circulated in architectural sketchbooks.[41] Presumably he knew of the Florentine Baptistery, of which the octagonal structure is reminiscent, but indirectly, perhaps through the famous projection Brunelleschi had made of it. The well at the center of the piazza, however, directly acknowledges Andrea del Verrocchio's *Putto with a Dolphin;* his statue of a cupid with one foot poised on a sphere was designed to spin above a bronze basin.[42]

Another peculiarity of this panel are the pedestrians, who appear sparse and nondescript from normal viewing range. On the left, a group of citizens leisurely makes its way into the main square from around the corner. An elderly statesman, distinguished by a dark outer cloak and the *mazzocchio* on his head, listens intently to the man on his right articulate a point. Another attendant to his left seems poised to respond, while an armed guard stands with legs astride a few paces ahead. In the piazza

below, two maidservants draw water from a public well; in the immediate foreground a wayfarer balances a cask of wine or oil on his shoulder, while steadying himself with a walking cane. These sole inhabitants go about their tasks oblivious to the lively personifications of virtues atop each of the columns, whose polychrome composition – shafts of red and black marble with gilt capitals – evoke the aura of imperial Rome. In the ancient forum, such honorific columns were typically erected to military heroes and surmounted by bronze effigies, or served as markers for political assembly, such as the Columna Rostrata. This convention was revived for the first time in 1447 with a competition, putatively judged by Alberti, for a commemorative statue of Niccolo III d'Este in front of the Corte Vecchia in Ferrara. At least one of the sculptors who executed this monument was Florentine, which is not surprising as its conception has been credited to Alberti.[43]

Like the Verrocchiesque well, the artistic genealogy of the graceful Virtues also leads back to Florence. Between 1469 and 1470 the magistrates of the Merchants' Tribunal in Florence commissioned Piero del Pollaiuolo and Botticelli to decorate their council hall with painted panels of the Seven Virtues. These compositions found their way shortly afterward onto one of the inlay doors of the Palazzo Ducale in Urbino (Fig. 33).[44] In contrast to the enthroned Virtues in Florence and on the doors at Urbino, the svelte figures in the Baltimore panel alight on their capitals in *contrapposto*. From their number, it is assumed they represent the cardinal virtues, Prudence, Justice, Fortitude, and Temperance; nevertheless, their identification is less clear-cut. The two figures at left mirror one another in the position of their arms. In front stands Justice wielding her sword overhead and holding a scale. Behind her is Temperance pouring water from a flask into a bowl, a traditional reference to the watering down of wine (Fig. 34).[45] Here the message seems directed to the ruler to temper his rage, as opposed to the tempering of physical desire, which medieval theologians linked to *pudicitia*, chastity or sexual modesty.[46] The two figures on the right columns strike identical poses. The closer of these sistervirtues is Fortitude, whose left arm embraces a column; however, its shaft is curiously unbroken. Typically a mace would appear as her other attribute, as on the reverse of Piero della Francesca's double portrait in the Uffizi, where Fortitude, bearing a broken column, accompanies Duke Federigo in the triumphal procession (see Plate 28). Here Fortitude proffers a crown of laurel in her right hand, an accouterment occasionally worn by Peace.[47] The companion to Fortitude would normally be Prudence, and the figure in the Baltimore panel holds a cornucopia in her left arm, which is not wholly foreign to that virtue (Fig. 35).[48] With her other arm, however, she balances a basket of fruit on her head. An intarsia panel in the *studiolo* at Urbino in which a basket of fruit and squirrel are placed before an arcaded portico that frames an enchanting city saddled by rolling hills,

33. Intarsia Doors (The Virtues), Urbino, Palazzo Ducale
(Photo: Soprintendenza delle Marche).

may explain Prudence's unusual appurtenance (Fig. 36).[49] Given the squir-
rel's instinct for gathering and storing food, the implication for the ruler is
that to maintain the material well-being of his state he must show pru-
dence in the dispensation of resources.[50]

Prudence, a virtue highly touted in Renaissance moral treatises, was
often singled out among the most admirable traits of Duke Federigo. "In
arms," commented Vespasiano da Bisticci, "his first profession, he was the
most active leader of his time, combining strength with the most consum-
mate prudence."[51] Fortitude and Prudence attend the duke in the tri-
umphal procession depicted on the back of Piero's famous dipytch, where
Prudence holds her usual attribute, the mirror, and her head is Janus-
faced, looking both forward and backward (see Plate 28). Whereas Pru-

34. Anonymous, Temperance, detail: *View of an Ideal City,* Baltimore, The Walters Art Museum (Photo: The Walters Art Museum).

35. Anonymous, Prudence, detail: *View of an Ideal City,* Baltimore, The Walters Art Museum (Photo: The Walters Art Museum).

dence is also attended traditionally by the snake, the artist of the Baltimore panel borrowed his figure from a different source: Donatello's statue of *Dovizia* in the Mercato Vecchio in Florence, commissioned around 1428–30. The sculpture and the column on which it stood were destroyed in the late nineteenth century, but earlier *vedute* (views) and numerous Renaissance imitations give a good idea of its appearance. The woman's pose is identical: her right arm, bent at ninety degrees, props a basket of fruit on her head, while holding a cornucopia. In this context, the basket of fruit identifies the virtue as Charity, in her earthly aspect as *amor proximi,* as opposed to the way she appears in the *studiolo,* in the theological aspect of *amor Dei,* suckling a child while holding forth a flaming heart. Abundance and Charity exist interdependently, as they had in Roman antiquity, when the emperors ordered public distribution of grain and other provisions, known as *alimenta.*[52] Just as fortitude enables the ruler to wield his scepter wisely, so abundance facilitates citizens in practicing charity as a civic duty.

With the virtues working in concert, authority is made manifest through orderliness, as symbolized by the triumphal arch of Constantine, Rome's first Christian emperor, in the background of the Baltimore panel. Alberti recommends the arch as the ornament most appropriate to mark the opening of a road, especially where it abuts a square or forum (*De re aedificatoria* VIII, 6). The arch should contain three lanes, a central one for soldiers and lateral ones for mothers and families to accompany the victorious army as it receives the returning heroes. In the Baltimore panel, a hooded matron

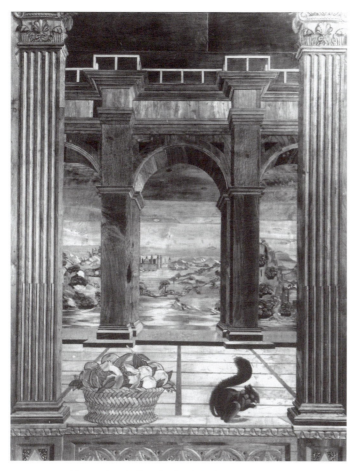

36. Intarsia (Squirrel with fruit basket), Urbino, Palazzo Ducale, Studi-olo (Photo: Scala/Art Resource, NY).

can be seen through the middle arch guiding her two children across the empty piazza. Is this a random detail or one chosen explicitly in mind of Alberti's text? Like the "veil" that cuts a section of the visual pyramid, here the triumphal arch screens our view to the distant turreted structure at the central vanishing point. Faced in brick, the crenellation of this feature denotes its function as a *regia,* or citadel, from whose pinnacle rises a flag. According to Alberti, a city laid out on a plain without natural defenses had different principles governing its planning than that of hill towns. Rather than a royal palace nestled in the center of the city, the building in the Baltimore panel corresponds to Alberti's description of the residence of a tyrant, "being a fortress rather than a house . . . positioned where it is neither inside nor outside the city . . . set well back on all sides from any buildings."[53] This afforded the ruler a clear prospect of his subjects, but made him vulnerable to attack. Alberti's solution was to position the

citadel at the visual focal point of the city, while maintaining a strategic vantage on the periphery. Alberti expressed this ideal configuration in the form of a circle inscribed in a larger circle and tangent to it. Roughly speaking, the same stratification can be seen in the Baltimore panel where the *regia* stands at the apparent tangent point, while actually demarcating the midpoint of the outer wall that envelops the city. The fountain in the foreground creates a visual counterpoint to the fortress: its water provides sustenance to the inhabitants, as the bulwarks give protection.

∗ ∗ ∗

Whereas the Baltimore and Urbino panels would have been viewed above eye-level on a wall, the perspective view in Berlin was designed as a free-standing piece of furniture to be seen on three sides (see Fig. 30). An illusionistic wainscoting takes up the lower third; three faux panels mark out the intercolumniation of the portico above. While the width of the painting is only slightly larger, the height of the cityscape is a full quarter larger than its counterparts.[54] Yet any effect of verticality is mitigated by the roof of the portico, with its diamond-studded surface, which truncates the tops of the palaces behind. This compression of pictorial space resembles many of the architectural vignettes on the doors of the ducal palace at Urbino, most of which were executed during the campaign of 1474–82. In these, the perspective illusion is shattered when the doors are opened and the orthogonals on either side no longer converge at a common vanishing point (Fig. 37). The Berlin panel, however, is broken into triads, and the columns create a screen for the "action" on the distant horizon, where one galleon has its sails unfurled, another appears to be mooring offshore, and another approaching the port. There is scarcely the pretext of an *istoria,* and yet the representation of boats at sea elicits the theme of Fortuna, which Renaissance merchants enthusiastically adopted for their personal devices.[55] Here again the architecture is suggestive of Florence, but only by way of isolated motifs. The palace in the left foreground has the same stylar treatment as the Palazzo Rucellai and another on the right recalls the facade of the Palazzo Antinori.[56] By contrast, the mausoleum in *opus quadratum* places the spectator in ancient Rome, namely, the Mole Hadriana (the Castel Sant'Angelo), identified by the garland frieze on its base and crenellated rotunda. Like the great sepulcher at the bend of the Tiber, this imaginary ruin stands like a beacon overlooking the harbor.

The Berlin panel unfolds like a continuous *tableau vivant.* Its tripartite organization may reflect the arrangement of similar city views from the period, in particular, one in Isabella d'Este's *grotta* in the Castello Regia at Mantua which comprised three sections displayed on a single wall.[57] Other perspectival views may have been placed in bedrooms over chests (*forzieri* and *cassoni*) or attached to bedframes (*lettucci*). A household inventory of

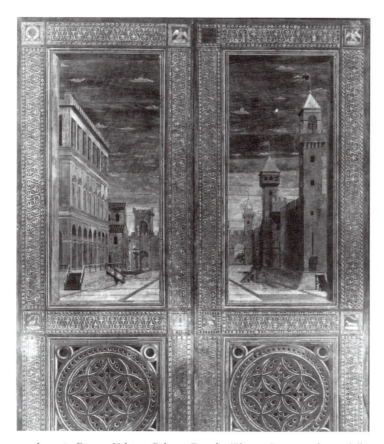

37. Intarsia Doors, Urbino, Palazzo Ducale (Photo: Soprintendenza delle Marche).

the Medici villa at Trebbio taken in 1498 includes a *"perspetiva"* painted on the headboard of one such bed, which John Shearman relates, at least in kind, to the Berlin panel.[58] This suggests a date for the Berlin panel in the 1480s or 1490s.[59]

Another architectural perspective in Berlin has more explicit links to Florence (Fig. 38). The panel has the proportions of a *spalliera* and was not originally made for the ornate *cassone* into which it is now set. The arms of the Medici and Strozzi carved on the sides of the chest are sixteenth-century or later in date.[60] Another *stemma*, that of the Pazzi, is painted on the escutcheon hanging over the corner of the palace on the right. As the Pazzi found themselves exiled from Florence following the conspiracy of 1478, this panel was probably confiscated and reused for another interior furnishing. Here, the palace on the right is of particular interest for the projecting corbels, or *sporti*, beneath the main floor. This, as well as the faux ashlar masonry in *sgraffito*, are typical features of late Quattrocento Florentine palaces. However, the specific combination of these elements

may point to a particular site from which the artist took his view: the Palazzo Lenzi-Quaratesi in the Piazza Ognissanti.[61] In the distance, to the right of center, rises a turreted gate resembling the old Porta al Prato. In the fifteenth century, a crenellated wall actually separated the piazza from the banks of the Arno. This gate, known more popularly as the Torre del Prato d'Ognissanti, stood roughly opposite the facade of the Church of the Ognissanti. From this vantage, the spectator appears to be standing on the steps of the church looking toward the Oltrarno. A fountain is known to have stood in the piazza, though nothing as elaborate as we see in the panel, and a bronze statue of Abundance holding a cornucopia and spear stands atop an immense urn spurting water into an octagonal basin.

If the Baltimore and Urbino panels established a vocabulary of forms from which intarsia workshops in Urbino took their cue, then it might be argued that the *prospettiva* on the Berlin chest stands at a later phase in the development of this genre. The cubic quality of its buildings is less painterly and more characteristic of the tesselated forms used in marquetry. Although the work seems to be of Florentine vintage, the artist was following a fashion of trompe-l'oeil intarsia by then widely diffuse in the Marches. What had changed was merely the artifice of image-making, which was illusory by its very nature. "The essence of these scenes," remarks André Chastel, "is to show how a ceremonial space worthy of a modern society should stand out from the rest of the city, by the almost magic game of pieces of wood skillfully arranged."[62] Like the Berlin *prospettiva* in our architectural threesome (see Fig. 30), the cityscape on the chest is confined to private residences. Moreover, their perspectives share other peculiarities: the sightlines are staggered toward the center, so that the buildings in the distance still read as volumes, despite the oblique angle of view. To the extent that the two Berlin *prospettive* seem to lack the universality of the Urbino panel, they also bespeak a patron more concerned with perspective for its scenographic effects than as a vehicle of political ideals. Gone is the underlying imprint of the beneficent tyrant, who envisages the city as a living organism in the Urbino and Baltimore panels. Rather these views take a particular vantage, much as the popular *vedute* of a later age.

Any number of names have been proposed for the authorship of the "Ideal Cities," including Piero della Francesca and his school, as well as Francesco di Giorgio; however, their connection to artists working at the court of the Montefeltro seems remote at best. The strong affinity of the architecture to the compositions in Duke Federigo's *studiolo* would point rather to the cadre of Florentine painters active at the turn of the sixteenth century.[63] This same medley of Florentine building types appear in the last decorations executed for the ducal apartments during the tenure of Federigo's son Guidobaldo. On one of the doors into the Camera della Duchessa, a double-arched gate and battlemented towers provide a dis-

38. Cassone, XVI century, Architectural perspective, c. 1480, Berlin, Schlossmuseum (Photo: Staatliche Museen zu Berlin – Preußischer Kulturbesitz Kunstgewerbemuseum).

tinctly Florentine cast, resembling the Porta Pinti and Palazzo Vecchio. A dating of the *prospettive* concurrent with the activity of marquetry workshops in Urbino also would rule out the possibility that they were created for theatrical productions. Nonetheless, Alessandro Parronchi has proposed that the Berlin panel was painted by Ridolfo del Ghirlandaio as a model for the stage set of Lorenzo Strozzi's play, *Pisana*, performed in Florence on the occasion of the marriage of Lorenzo de' Medici, Duke of Urbino, to Maddalena de la Tour d'Auvergne in 1518.[64] By this date the Berlin painting surely would have seemed retardataire to contemporary artists such as Raphael and Baldassare Peruzzi, who had already begun their forays into scenographic design, spurred on by the study of Vitruvius. In the last word he wrote on the subject, Krautheimer denied any direct link between the ideal perspectives of Urbino, Baltimore, and Berlin and theatrical representation in the early sixteenth century. Nor, despite Clark's confidence, can the Urbino and Baltimore cityscapes be securely attributed to Piero della Francesca or to any other specific artist working for the dukes of Urbino. Until the discovery of new clues, the line of descent from these *prospettive* to the Comic and Tragic sets of Sebastiano Serlio remains only an intriguing hypothesis – and one in which, despite Clark's confidence, the role of Piero della Francesca was largely indirect.[65]

8 Piero's Treatises

The Mathematics of Form

Margaret Daly Davis

The earliest essential primary source treating Piero della Francesca as a mathematician and as an artist-author on art is the biography dedicated to him by Giorgio Vasari. In 1550 Vasari wrote that Piero studied arithmetic and geometry as a young boy. Although Piero turned to painting at the age of fifteen, he did not abandon mathematics for painting. He accomplished, instead, marvelous results in both fields *("maraviglioso frutto et in quelle et nella pittura")*. Piero is apostrophized as – an excellent master in the difficulties of the five Euclidean, Platonic solids *("maestro raro nelle difficultà de' corpi regolari")*, and he wrote many books that were, in Vasari's time, preserved in the library of the Duke of Urbino. Vasari maintains further that many of Piero's writings were published, without acknowledgment of his paternity, by the Franciscan mathematician, Fra Luca Pacioli of Sansepolcro. Vasari's information concerning Piero's treatises was doubtless provided by a source intimately familiar with Piero's writings and well aware of their diffusion by Pacioli, surely a mathematical scholar able to judge the importance of Piero's contribution in the context of contemporary mathematical studies.[1]

Piero's early education in mathematics presumably followed the standard Tuscan pattern: approximately four years of instruction in reading, writing, grammar, and rudimentary Latin, followed by three to four years of arithmetical and geometrical instruction in a *scuola dell'abaco* (abacus school).[2] Such an educational program would have been complete when Piero was fifteen, which is the age at which Vasari sets the beginning of Piero's apprenticeship as a painter. At the abacus school the principal focus of instruction was commercial mathematics for future merchants. An impressive number of abaco treatises, which were used as textbooks in the schools, have survived in manuscript form. While the earliest were primarily arithmetical in content, they became, in time and with the addition

of a section on geometry, more ambitious in scope, constituting indispensable didactic instruments not only for merchants but also for architects and masons, engineers, painters, sculptors, goldsmiths, woodworkers, and intarsia carvers. Abaco treatises contained algebraical and geometrical exercises which demonstrated how to measure accurately the heights of palaces, round towers and walled fortresses, as well as the height, diameter, and weight of columns. They contained, further, exercises in how to calculate the surface area of unbroken walls and walls pierced with arches, as well as facades of buildings that were to be painted. The student learned to calculate the quantity of building material necessary for roofing a house, that of the stone required to face a palace and of the brick for paving a city square. As Filippo Camerota has shown in a recent and illuminating study, abaco treatises also taught exercises in perspective.[3] In this respect the abacus schools were fundamental to the education of builders and painters. Abaco textbooks also show that young students learned to measure vases and chalices, stones and spheres, all exercises essential to the training of goldsmiths and stone carvers. It is equally clear that artists and artisans were trained in the abaco schools. The first biographer of the architect, sculptor and goldsmith Filippo Brunelleschi, Antonio Manetti, wrote: "As a child Filippo learned reading, writing and abaco mathematics, as is the custom of all good men in Florence."[4] Of the architect Bramante, Vasari writes similarly: "In addition to reading and writing, Bramante applied himself mightily to the study of abaco mathematics."[5] And of Leonardo da Vinci, once again it is Vasari who recounts that Leonardo made such progress in his studies of the abaco, "that he confounded his master with the difficulty of the questions he raised."[6]

Piero della Francesca's concern with abaco mathematics extended beyond his youthful study. He composed a mature *Trattato d'abaco (Abacus Treatise),* a manuscript today preserved in the Biblioteca Medicea Laurenziana in Florence. It is Piero's first surviving mathematical work.[7] A handbook of arithmetic, algebra, and geometry, it was commissioned by a member of the Pichi family of Sansepolcro and hence was probably written in the town of Piero's birth. The *Trattato d'abaco* was written long after Piero had completed his education in mathematics, when he was already a practicing painter.[8] In the opening lines of the *Abaco,* Piero states that his manual was written as a guide to mercantile mathematics.[9] He begins with the addition, multiplication and division of fractions and turns expeditiously to the "Rule of Three" (*regola delle tre),* which Baxandall identifies as "the universal arithmetical tool of literate Italian commercial people in the Renaissance."[10] Piero defines this rule for his students, and his first example suffices to illustrate the problem. "If seven bracci of cloth are worth nine lire, how much will five bracci be worth?" Another important rule, the "Regula de la positione" (p. 62), is illustrated by the following

problem: "Two men want to buy a horse which is worth 35 ducats but nei-
ther alone can afford to buy it. The first says to the second, give me half
of your money and I shall buy the horse, the second says to the first, give
me $\frac{1}{3}$ of your money and I shall buy him. How much money does each
man have?" Piero's problems in commercial mathematics also treat such
topics as partnerships *(compagnie)*, and currency.

For historians of mathematics the next section of Piero's *Trattato
d'abaco*, the section on algebra, is of the first importance. Piero begins
here to formulate the solution to the cubic equation. Algebra, Piero
explains, treats fractions and whole numbers, as well as roots and
squares.[11] He then proceeds to define these terms, treating simple square
root operations, squares and cubes of binomials, and equations from the
second degree to the fifth.[12] Long before Piero, algebraic studies were
introduced into Italy by Leonardo Fibonacci, who codified the book of
rules he had learned in North Africa in his *Liber abaci* of 1202. Fibonacci's
work, in particular Book XV of his *Liber abaci*, which treats rules in geom-
etry pertaining to algebra, provided Piero the basis for his most important
investigations.[13] Fibonacci treats six forms of algebraic equations, three
simple equations and three composite ones. To Fibonacci's six forms,
Piero adds fifty-five new possibilities. These employ cubic equations,
biquadratic equations and equations of the fifth degree. Although nearly
half of these possibilities are fully illustrated with problems, they remain
difficult to follow for the nonmathematician.[14] A biquadratic equation, is,
for example, an equation including a simple unknown, the square of an
unknown, the cube of an unknown and an unknown raised to the fourth
degree.[15] If the *Liber abaci* of Fibonacci was clearly Piero's principle
source, a recent study has shown that Piero's algebraic studies can be sit-
uated within a tradition of mathematical inquiry which is medieval in ori-
gin, and many of the authors that Piero drew upon are identified.[16]

Although the *Trattato d'abaco* of Piero remained anonymous until the
twentieth century, it attracted the attention of the nineteenth-century his-
torian of mathematics, Guglielmo Libri, who, in fact, had Piero's *Abaco* in
his possession. While Libri was unable to identify its author, he considered
the treatise, which he believed to be fourteenth century and Tuscan, his-
torically significant, and he published its pages treating algebra in his *His-
toire de la mathématique*. These documented that numerous attempts had
been made by mathematicians to solve equations beyond the second
degree prior to the sixteenth century; for Libri, the proof that mathemati-
cians had sought to resolve the cubic equation before Scipione Ferro and
Nicolò Tartaglia.[17] Some half a century after Libri's book was printed, its
algebraic excerpts from the *Trattato d'abaco* (still not recognized as Piero's)
captured the attention of a German historian of mathematics, Moritz Can-
tor, who attempted to evaluate the mathematical content. On the one
hand, he demonstrated some of Piero's missteps as he attempted to solve

cubic equations and those of a higher order. And, on the other hand, Cantor maintained that the author of the algebra section possessed uncommon mathematical gifts. He surmised, on the basis of the final problem treating triangles, that the unidentified mathematician was equally talented in geometry. Indeed, in his *Lectures on the History of Mathematics (Vorlesungen über Geschichte der Mathematik)*, Cantor devoted far more attention to the still anonymous Piero than he did to any other contemporary mathematician.[18]

As Cantor suspected, Piero's chapters on geometry contained in the *Trattato d'abaco* reveal a very gifted mind. The geometrical section of the *Trattato d'abaco* is divided into two parts: the first treats plane gometry and the measurement of two-dimensional polygons; the second, solid geometry, and it contains exercises in measuring solid geometric forms and demonstrations of their proportional relationship to one another and to the sphere into which they may be inscribed. Piero's exercises in plane geometry are far more complex than, for instance, those treating the simple measurement of polygons in Leon Battista Alberti's *Elements of Painting (Elementi di pittura)*, and they extend far beyond the usual practical exercises in measurement contained in contemporary abaco texts.[19] Similarly, the exercises in solid geometry distinguish themselves from the practical work of Piero's contemporaries, who demonstrated, as mentioned, rules for measuring objects such as columns, towers, walls, wells, barrels, and chests.[20] In his section on solid geometry Piero treats the five Platonic-Euclidean bodies – tetrahedron, cube, octahedron, icosahedron, and dodecahedron – and their relation to the sphere, as well as irregular pyramids and solids of eight and fourteen faces, similarly placed within the sphere. For the measurement of such geometrical solids Piero employs the algebraic methods that he had elucidated in the preceding pages of his treatise.[21] Piero also employs the "golden section," that is, the proportion that was called "divine" by Luca Pacioli and other Renaissance theorists.[22] Neither Fibonacci nor Piero explicitly apply a technical name to this proportion. Both refer to it simply, in Euclidean terms, as the proportion for dividing a line into its mean and extreme ratio, so that the smaller section is in the same proportion to the larger section as the larger section is to the whole line. A line ABC is divided according to the section that later writers identified as "golden" when the smaller section AB is in the same proportion to the larger section BC as the larger section BC is to the whole line. This proportion cannot be expressed in terms of rational integers, that is, in terms of discrete whole numbers, but rather only in terms of square roots. Despite many studies on the use of the proportion by Renaissance artists and architects, there is no general agreement as to how widespread its application might have been. Piero's exercises, in any case, attest to the diffusion of knowledge of the golden section among artists and architects. The study of the five regular Platonic-Euclidean solids and

their irregular derivations, is, in part, founded on a knowledge of the golden section, for it is a prerequisite to the measurement of the pentagon and dodecahedron.

The five regular bodies are the only five equal-faced, equiangular solids that can be comprehended in a sphere: the tetrahedron is a pyramid composed of four equilateral and hence equiangular faces. The cube has six square faces. The octahedron, a double pyramid on a square base, has eight equal and equilateral triangular faces. The icosahedron has twenty equilateral triangular faces, and the dodecahedron twelve pentagonal faces. Plato singled out these essential forms as symbols for the four elements, fire, water, air, and earth, and for the universe.[23] Euclid made them the culmination of his compendium of solid geometry in Book XIII of the *Elements*. Moreover the regular bodies form the subject of two further books of the *Elements*, XIV and XV, which though now excluded from the Euclidan canon, were considered as an integral part of his work in the early Renaissance.[24] Piero's *Abaco* exercises concerning the five regular bodies provided the foundation for his *Libellus de quinque corporibus regularibus* (Book on the Five Regular Bodies), the second of his mathematical works that has come down to us. Moreover, the mathematical rules for the correct, scientific measurement of regular and irregular geometrical solids, as demonstrated in the *Trattato d'abaco*, were preliminary to his treatise on perspective, *De Prospectiva pingendi*, just as they are necessary to a thorough understanding of the treatise itself. Thus Piero's section on solid geometry in the *Trattato d'abaco* is a significant aspect of his treatise, for it is here that the interrelatedness of the three mathematical works by Piero which have survived, the *Trattato d'abaco*, the *Libellus de quinque corporibus regularibus*, and the *Propectiva pingendi*, may best be seen.

The *Libellus de quinque corporibus regularibus* was composed by Piero in the decade between 1482 and 1492, the year of the artist's death. He dedicated the treatise to Guidobaldo da Montefeltro of Urbino, who succeeded his father as Duke after Federigo's death in 1482. Thus it is a work of Piero's old age, a circumstance to which Piero refers in the dedication to Guidobaldo. Piero also speaks of Guidobaldo's illustrious father and his father's library in Urbino. He hopes that his treatise on the five regular bodies will be placed next to his book on perspective, his *"de Prospectiva opusculum,"* a work, he says, written many years earlier *("quod superioribus annis edidimus")*. It is also clear from his dedication to Guidobaldo, that Piero considers his achievement in the *Libellus* to be the application of arithmetical principles to the geometrical theorems of Euclid.[25] Piero's wish to have his two treatises stand together indicates that he intended the study of the *Libellus* to be associated with that of the *Prospectiva pingendi*.

Piero's *Libellus de quinque corporibus regularibus* did not belong, as did the *Trattato d'abaco*, to an already existing genre of mathematical text. Although inspired by the last books of Euclid's *Elements* (XIII–XV), which

culminate in the description, construction, and analysis of the relation-
ships existing among the five regular polyhedra, the *Libellus* is original in
conception and content. Piero's book is divided into four parts. The first
treats plane geometrical figures; the second, solid bodies inscribed in a
sphere; the third, problems of regular bodies placed within one another
and exercises concerning spheres; the fourth, irregular bodies. Three-
fifths of the exercises in Part I of the *Libellus* had previously been demon-
strated in the *Abaco,* and the same is true for two-thirds of the exercises
in the second part. In Part III Piero breaks entirely new ground in the first
thirteen exercises, as a result of a total immersion in Book XV of Euclid's
Elements. His intention, he explains at the outset, was to explain how the
sides of various bodies are related to one another and how the one may be
contained within the other. This results from his consideration and elabo-
ration of Book XV of Euclid's *Elements.* In fact, all but one of Piero's thir-
teen exercises relates directly to Euclid's book. Piero's second exercise, for
example, reads: "If a tetrahedron is placed in a cube whose side equals 12
braccia, what is the side of the tetrahedron?" Piero solves this problem by
first drawing diagonals through one face of the cube. "We know from
Euclid, I, 47 [i.e., the Pythagorean theorem], that if the sides of a square
equal 12, its diagonal will equal the square root of the squares of two sides
added together, that is R 288. And R 288 will, furthermore, be the side of
an inscribed tetrahedron according to Euclid, XV, 1." In this first proposi-
tion in Euclid's fifteenth book a tetrahedron is inscribed in a cube so that
each side of the tetrahedron equals the diagonal of each face of the cube.
Hence, knowing from Euclid XV, 1, the relationship of the side of a cube
to the side of a tetrahedron inscribed in it, Piero applied an arithmetical
procedure. He has, in effect, in the first part of Part III, applied arith-
metical problems to the fixed geometrical proportions that exist among the
regular bodies inscribed in one another as defined by Euclid.

The exercises in Book IV of the *Libellus de quinque corporibus regu-
laribus,* on irregular bodies, are mostly abstract and mathematical in
nature. Three of his expositions, however, can be directly related to archi-
tectural practice, for here Piero is concerned with the measurement of
three-dimensional bodies such as those that architects dealt with. The first
problem of this section of the *Libellus* treats the measurement of a
72-faced solid, one made up of twenty-four triangular and forty-eight four-
sided polygonal faces (Fig. 39). Piero writes that the medieval translator
and commentator of Euclid taught the construction of this body in Book
XII, proposition 14, of the *Elements.* The usefulness of Piero's mathemat-
ical exercises for artists and architects is never mentioned or even alluded
to by the author, and for this connection to be made explicit, we must turn
to Luca Pacioli, who repeatedly relates the study of geometry to the edu-
cation of artists and architects. Concerning the same 72-faced solid that
Piero wrote of in the *Libellus,* Pacioli, in his *Divina proportione,* wrote that

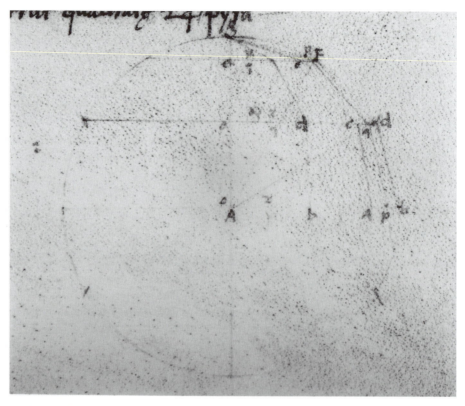

39. Piero della Francesca, 72-faced solid, *Libellus de quinque corporibus* (Photo: Author).

this solid was used by architects in their designs of buildings, its form being very convenient for the construction of apses, vaults and domes. He speaks of their being examples in many cities, Florence, Venice, Padua, Naples, and Bologna. Pacioli relates that half of this solid, the half resembling a hemisphere, is found in the Roman Pantheon and a quarter of the solid is used in the architecture of an apse, for instance, in the chapel of San Satiro and in S. Maria delle Grazie in Milan.[26] The fourth book of the *Libellus* also presents problems in the measurement of round columns and vaults. In the latter, Piero demonstrated how to find the surface area of a cruciform vault (Fig. 40).[27] The reader knows, he writes, that a cross vault is composed of two intersecting hemispheres. Piero's very finely drawn illustration of the vault, constructed with compass and rule, shows the architectural form encased, as it were, in its geometric block. Both demonstrations, that concerning the 72-faced solid and that concerning the cross vault, are taken up again in the *Prospectiva pingendi,* where Piero shows the measurement and representation in perspective of an apse, which, he writes, is one-fourth of a sphere (*"un quarto di una palla"*) and that of a cross vault (*"una volta in crociera"*) (Figs. 41, 42).

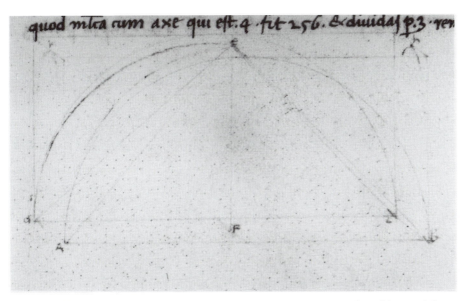

quod mitra cum axe qui est. 4 . fit 256. & diuidas p.3 . rer

40. Piero della Francesca, Cruciform vault, *Libellus de quinque corporibus,* folio 61r (Photo: Author).

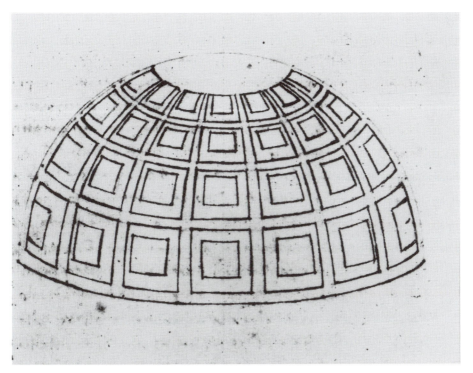

41. Piero della Francesca, Apse, *De prospectiva pingendi* (Photo: Author).

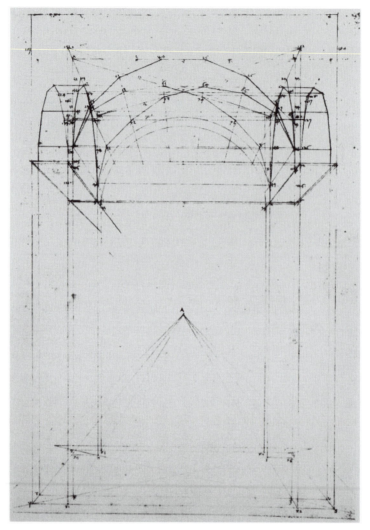

42. Piero della Francesca, Cross vault, *De prospectiva pingendi* (Photo: Author).

The solid geometry section of Piero's *Trattato d'abaco* and the entirety of his *Libellus de quinque corporibus regularibus* were both published by Luca Pacioli. First, in 1494, the *Abaco,* was printed in Pacioli's *Summa arithmetica,* and, then, in 1509, the *Libellus,* was translated into Italian in Pacioli's *Divina proportione.*[28] As mentioned earlier, Piero's authorship was not acknowledged in either case.

Although Piero betrays nothing regarding the relationship of his mathematical works to art and architecture, this implicit lacuna is to an extent filled by Pacioli. In addition to publishing Piero's manuscripts, Pacioli studied them attentively, and his books sought to convey Piero's knowledge not only to mathematicians but also to artists and artisans. In his first book, entitled *Summa de arithmetica geometria proportioni et proportion-*

alita, the author often draws the reader's attention to the contribution of mathematics to the process of creating works of art and architecture. Pacioli devotes particular attention to the importance of mathematics for building in the dedication of the *Summa* to Guidobaldo, Duke of Urbino (the same prince to whom Piero had dedicated his *Libellus*), and he is at pains to demonstrate his knowledge of Vitruvius's ancient treatise on architecture as well as that of Leon Battista Alberti's modern *De Re Aedificatoria.*[29] Mathematical principles, and more specifically the study of geometry and proportion, were, he writes in his dedication to Guidobaldo, not only essential to the construction of the Ducal Palace in Urbino, undertaken by Guidobaldo's father, Federico da Montefeltro, but they also underlay its artifice and the beauty of its ornaments.[30] In the dedication of the *Summa,* Pacioli mentions further the necessity of geometry, of compass and rule, for the mechanical arts of woodcarvers and intarsia makers, in particular.[31] A few years later Pacioli describes Piero's brotherly affection for the intarsia master Lorenzo Canozi da Lendinara, and he singles out for mention Lendinara's intarsia in the Basilica of Sant'Antonio in Padua and in the Ca' Grande in Venice.[32] The intarsia of Lorenzo da Lendinara and of his brother Cristoforo in the Santo in Padua and in the cathedrals of Modena and Parma reflect, in fact, a study of the stereometric regular and irregular bodies and of perspective that has its origins in the inventions of Piero della Francesca (Figs. 43 and 51). The cartoons drawn for these panels, which are filled with plane geometrical figures (e.g., triangles, rectangles, etc.) and faceted solids, doubtless appeared quite similar to drawings by Piero such as those included in the *Libellus de quinque corporibus.* In the Lendinara intarsia the representations of wells, chalices, and vases, of simple palaces and churches, and of *mazzocchi* all appear to reflect in a like way exercises contained in Piero's *Prospectiva pingendi.*

Piero's stereometric inventions in the *Trattato d'abaco* and the *Libellus de quinque corporibus regularibus* were, through the medium of Luca Pacioli's early and popular publications of them in the *Summa arithmetica* and the *Divina proportione,* transmitted to a wide public of artists and artisans, architects, and treatise writers. The remarkable woodcut illustrations of some fifty-nine stereometric bodies in the *Divina proportione,* patterned on drawings by Leonardo da Vinci, undeniably contributed to the immediate reception of Piero's regular bodies, especially in Northern Europe. In 1525 Albrecht Dürer published his *Instruction in Measurement (Unterweysung der Messung),* which was intended to form part of a never-completed manual for the education of young artists. In the fourth part of his treatise in which Dürer treats polyhedra, his definitions of the regular bodies recall those of Piero.[33] Where Piero illustrated his *Trattato d'abaco* and *Libellus* with drawings of the geometrical solids, Dürer provided instead two-dimensional diagrams as patterns for constructing in three dimensions the five regular bodies, nine irregular ones, and the sphere (Fig. 44). Dürer appears to have intended that the artist construct the solids in wood

43. Intarsia Panel, Urbino, Palazzo Ducale, Studiolo (Photo: Scala/Art Resource, NY).

or heavy paper and subsequently attempt to draw them in perspective. For this operation Dürer appears to reject Piero's cumbersome method of perspective construction for a more empirical "artificial perspective" (*perspectiva artificialis*) method, in which the polyhedron was viewed through a framed glass or screen with one eye only, in a limited, fixed position; the perspective image being fixed by means of threads running from the vertices of the solid to the visual plane in front of it. This procedure was the one used by Leonardo for his stereometric representations in the *Divina proportione,* and this method is described by Pacioli (who possibly learned it from Leonardo in Milan) in the same book (Fig. 45).[34] For Albrecht Dürer, the knowledge of the regular and irregular polyhedra was useful for the architect or stonemason in designing columns and in their decoration, as well as for painters, for whom he demonstrated the representation of

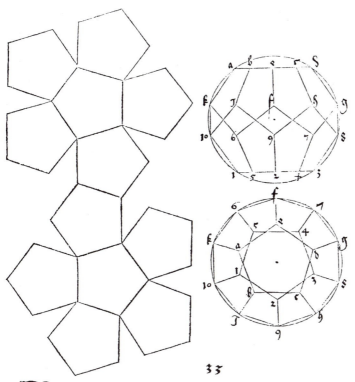

44. Albrecht Dürer, Pattern for dodecahedron, *Unterweisung der Messung* (Photo: Author).

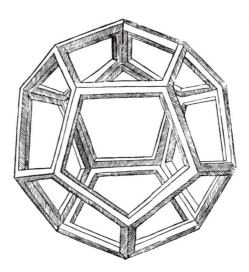

45. Leonardo da Vinci, 72-faced body, Luca Pacioli, *Divina proportione* (Photo: Author).

the cube in perspective *(perspectiva communis)* and, further, how this six-faced regular body cast shadows under specific light conditions.[35] Thus the German artist brought the theme of the regular bodies into direct relationship with the concerns of the practical artist. The stereometric bodies also appealed to the decorative inclinations of many sixteenth-century Northern artists, as, for example, Wenzel Jamnitzer, whose *Perspectiva corporum regularium* is, in essence, a pattern book containing the five regular bodies and some one hundred and fifty other geometrical solids deriving from these five Euclidian forms.[36] Instructions for constructing the bodies and for representing them in perspective are completely missing in Jamnitzer's work. But it seems intended for woodworkers, goldsmiths, and other similar artisans. In Italy, however, Jamnitzer's source was not forgotten: the mathematician Egnazio Danti wrote of Wenzel Jamnitzer's debt to Piero della Francesca, whose work had been published without acknowledgment by Pacioli.[37]

Piero's autograph manuscript of the *Prospectiva pingendi* was untitled; he himself referred to it as "a work on perspective" *(de prospectiva opusculum).*[38] At the outset Piero writes that painting consists of three principle parts: drawing, measurement, and coloring. More specifically, he will treat the second part, *commensuratio* (measurement), or "that which we call perspective" *("quale diciamo prospectiva").* This treatise on measurement and perspectival representation contains three books. The first book, Piero explains, will deal with points, lines, and surfaces (i.e., plane geometry); the second, with cubic bodies, square pilasters, and round and faceted columns (i.e., solid gometry); the third, with human heads, with the placement of capitals and bases, and with *torchi* (i.e., *mazzocchi*, the singular faceted geometric ring best known in the works of Paolo Uccello), and other three-dimensional objects. The text has been aptly described by Martin Kemp as "unrelievedly concerned with the geometrical drafting of the configurations, moving in step-by-step fashion through each construction, almost literally guiding the reader's hand as the constructions are pedantically laid out, point by point and line by line." Kemp continues by affirming that Piero's treatise "is closer to the practical geometry of the abacus books, than to a work of high mathematics or philosophical optics," an important conclusion recently confirmed by Camerota.[39]

Piero's perspective treatise is principally concerned with representing single objects in perspective. In this respect his aim differs substantially from that of Leon Battista Alberti, whose perspectival construction of a "view through a window" aimed to represent on a pictorial plane the relationships between many objects placed at variable distances from the viewer. Many of Piero's objects are architectural in character: wells, columns with bases and capitals, houses, churches, apses, and vaults. In fact, the representation of buildings and of the architectural orders and their parts occupies a primary place in Piero's book. Beyond being conceived for the painter, as it is often believed today, Piero's *Prospectiva*

pingendi was addressed equally to the architect and architectural drafts-man. Indeed, it comes as no surprise that Piero's perspective treatise, with its emphasis on the representation of buildings and the orders, found its earliest and most important echo in the field of architecture. In this con-nection we may well recall Pacioli's description of Piero as "the king to those of us in painting and architecture" (*el monarcha a li dí nostri della pictura e architectura*).[40]

At the conclusion of the first book of *De prospectiva pingendi* (on points, lines, and plane surfaces), Piero shows how to represent the ground plan of an octagonal building in perspective. In the fifth exercise in the second book, he demonstrates how to raise a column of sixteen sides from its ground plan, and he explains that buildings with many sides may also be elevated using the same method that he had applied to ele-vating the column and, moreover, that all will be shown foreshortened in correct proportion. The following exercise demonstrates the representa-tion of a square palace or house, called a *cassamento,* in perspective (Fig. 46). Piero also shows how to render foreshortened the thickness of the walls and of the doors. Similarly, in the subsequent example in the second book, he demonstrates how to represent an eight-sided temple in perspec-tive, a church with a round window on the main facade and an octagonal one on the side (Fig. 47). This demonstration is followed by another con-cerning a cross vault, an exercise, as we have seen, that he also presented in his book on the regular bodies. Here, however, Piero shows the cross vault foreshortened above the lateral walls. In essence, he demonstrates the perspective representation of a square chapel with a vault. In the last exercise in Book II he treats the representation of a row of columns in per-spective; this topic is also formulated in terms of buildings, loggias, and porticos.

Piero introduces the third book of the *Prospectiva pingendi* with the consideration that many painters disdain of perspective because they do not appreciate the efficacy of the representations constructed with an accurate knowledge of geometry (*"perche non intendano la forza de le linee et degli angoli, che da essa se producano"*). Nevertheless, he writes, it is a necessary science for the correct representation of what is seen from var-ious angles of view and at different distances from the viewer. Piero's first six exercises lead to that by demonstrating the correct representation of the *mazzocchio* (Fig. 48), an exercise closely related to the correct depic-tion of the parts of a column, as an unusual representation of a *mazzoc-chio* in Carpaccio's *Reception of the English Ambassadors* suggests.[41] In the demonstrations that follow he shows the correct measurement and repre-sentation in perspective of the base of a Doric column and those of an Ionic and a Composite capital (Fig. 49). The same methods are then applied to drawing the human head, in plan, in elevation, and then fore-shortened, after which Piero returns to architectural representation, demonstrating the foreshortening of a *cupola,* or dome, and an apse.[42] He

46. Piero della Francesca, Drawing of a house in perspective, as a modified cube, *De prospectiva pingendi,* Book 1, Proposition 29, Parma, Biblioteca Palatina, MS no. 576, folio 27r. (Photo: Author).

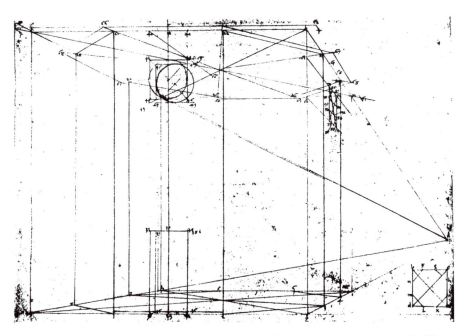

47. Piero della Francesca, Temple (church) with eight faces, *De prospectiva pingendi* (Photo: Author).

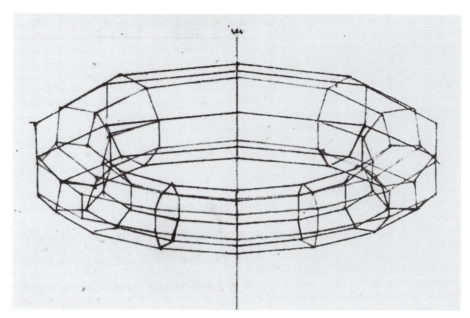

48. Piero della Francesca, *Mazzocchio, De prospectiva pingendi* (Photo: Author).

defines the apse form as a "quarter of a sphere seen from the concave side" (*quarto de una palla dal canto concavo*), and he meticulously measures and draws the apse divided into rectangles and triangles, with the single architectural elements shown in relief. Piero concludes by treating the representation of a vase placed on a pedestal (the ground plan of this solid consists of circles of various diameters) and the representation of a ring suspended from a vault (Fig. 50). It is perhaps noteworthy that Piero describes his vase as standing on a dining table (*sopra ad una taula da mangiare*) and identifies it as a vessel to cool wine and other liquids (*renfrescatoio col piedestallo*). In fact, the same object, placed on a table and

filled with fruit, recurs countless times in the intarsia panels of the Lendinara (Fig. 51).[43] Furthermore, Piero's demonstration of a ring suspended from a vault corresponds to the much-commented-upon depiction of the enigmatic suspended egg in his Brera Altarpiece (see Plate 5); in turn, Piero's egg finds its counterpart in the fictive illusionistic intarsia panel painted to Raphael's designs in the Stanza della Segnatura at the beginning of the sixteenth century.[44]

While the representations of the human head, the vase, and the ring are

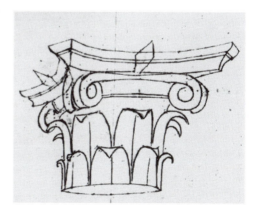

49. Piero della Francesca, Capital study, *De prospectiva pingendi* (Photo: Author).

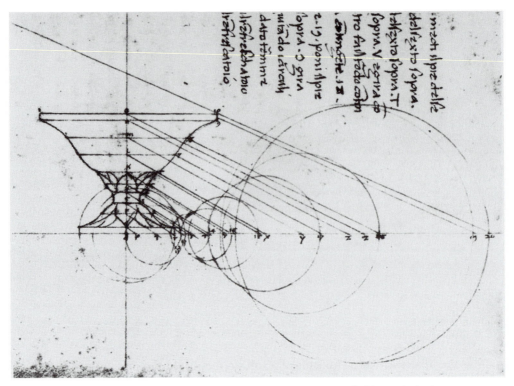

50. Piero della Francesca, Vase and ring, *De prospectiva pingendi* (Photo: Author).

51. Lorenzo di Lendinara, Intarsia panel, Modena, Cathedral (Photo: Author).

the only nonarchitectural demonstrations in his treatise, surely many other similar representations appeared in Piero's lost drawings and manuscripts alongside other architectural demonstrations. As we have seen, Pacioli wrote about perspective, and he praised Piero's treatise (then in the library of the Palazzo Ducale in Urbino) in his dedication of the *Summa* to Guidobaldo da Montefeltro. Moreover, in his dedication of the *Divina proportione* to the stone carvers and architects of Sansepolcro, he writes that he had studied Piero's book, his *"compendio, e per noi ben apreso,"* and that he hoped to soon be able to teach Piero's rules to stonemasons.[45] What Kemp acutely termed Piero's "full spatial plotting of most architectural structures" seems indeed to have been a principal reason for the immediate reception of his ideas by Renaissance architects. As mentioned earlier, little more than a century following Piero's death, the sixteenth-century mathematician, Egnazio Danti, in his commentary to Vignola's *Due regole della prospettiva*, recognized that the origins of the regular bodies published by Wenzel Jamniter lay in the work of the Master of Sansepolcro.[46] In the same book Danti traces the source of Vignola's first rule (*prima regola*) to a set of precepts or a method formulated by earlier theoreticians. It was called the "Rule of Baldassarre of Siena," the rule, that is, of the architect Baldassarre Peruzzi. Peruzzi, writes Danti, reelaborated this method and refined its precepts, increasing the ease and excellence of its application. Danti reveals further that Peruzzi had learned these principles from his master, the Sienese artist Francesco di Giorgio, and in yet another passage Danti states that the rule of Peruzzi derived from that of Piero della Francesca and that it had also been treated by Sebastiano Serlio.[47] Thus Vignola's commentary documents the earliest, almost immediate reception of Piero's methods of perspectival procedure in the studies of Francesco di Giorgio and traces their development and refinement in the work of Serlio, Peruzzi, and Vignola. Another treatise writer of the sixteenth century, Daniele Barbaro, is best known for his translation and commentary to Vitruvius's *De architectura,* but he also wrote two treatises on perspective that are founded in the study of Piero della Francesca. The first, *La pratica della perspettiva,* procedes from demonstrating simple regular bodies to more complicated irregular ones, and then to the accurate perspectival rendering of columns, bases, capitals, architraves, portals, vaults, and other architectural structures.[48] Like Piero, and Dürer as well, he treats the human head in plan, elevation, and perspective. Barbaro's still unpublished second treatise on perspective, *La pratica della perspettiva,* is preserved in the Marciana Library in Venice.[49] After a brief introduction to the principles of perspective, the author devotes the remainder of the study – over 200 folio pages – to the representation of regular and irregular bodies. As in Piero della Francesca's *De Prospectiva pingendi,* their study provided artistic exercises intended to develop a hand practiced in the accurate and fluent rendition of three-dimensional space and stereometric volume.

9 Piero della Francesca's Mathematics

J. V. Field

Piero della Francesca was a highly capable mathematician. It is probably because he is recognised as a figure of importance in the history of art, and thus classified within today's academic categories as a painter, that relatively little attention has been given to his place in the history of science. But in Piero's own time, there was nothing unusual in a painter having some skill in mathematics, that is, in the "practical mathematics" that formed part of the early education of prospective merchants and craftsmen.

The mathematics of the fifteenth century has been studied much less intensively than its art, but it is now clear that the period is notable for the increased use of mathematics in the crafts. There was also an increased availability of elementary instruction in mathematics through the "abacus schools" set up to provide a practical education for boys who were intended to engage in commerce and for prospective members of craft guilds.[1] This practical tradition led to important developments within learned mathematics. The first was through the rise of algebra as an independent discipline in the sixteenth century. Algebra then joined as an equal partner with geometry in the *Géométrie* (Paris, 1637) of René Descartes (1596–1650). This union was to prove immensely fruitful in connection with the later development of the infinitesimal calculus of Newton (1642–1727) and Leibniz (1646–1716).[2] The second development was in geometry. The study of perspective, which from the mid–sixteenth century onwards began to attract the attention of learned mathematicians such as Federico Commandino (1509–75) and Giovanni Battista Benedetti (1530–90), eventually led to the invention of a new kind of geometry – now called "modern" or "projective" geometry by Girard Desargues (1591–1661).[3] Changes within mathematics associated with the practical tradition can also be seen as affecting the development of the new relationship between mathematics and natural philosophy that played such an impor-

tant part in the rise of modern science in the sixteenth and seventeenth centuries.[4] There is a sense in which the new use of mathematics in natural philosophy in the later sixteenth and early seventeenth centuries can be seen as a "mathematisation" of man's picture of the world.[5] However, the further claim that the Renaissance reinvention of perspective played a crucial part in this process by introducing or initiating a "mathematisation of space" seems to me to be misguided.[6] One serious objection to the claim is that the authors on whose behalf the claim is made did not actually have a notion of space as an independent entity.

The idea that geometry is "the science of space" comes with the work of Blaise Pascal (1623–62) and concerns the infinite space of the geometry of Desargues, introduced in a work published in 1639. In this space, all lines are infinite, so that "the line AB" means the infinite straight line that passes through the points A and B. To Piero della Francesca and his contemporaries, as indeed to Euclid and his, "the line AB" means the straight line from the point A to the point B.[7] This finite concept of the line fits in well with the Aristotelian conception of space that was universal among natural philosophers of Piero's time. For Aristotle, space is extension, measured by body. For the geometer, concerned with abstract entities, the measure is a line of given magnitude, but the metaphysical basis is clearly the same. Space accordingly has no independent existence, and as it is defined by measurement we never need to think about a distance, say, that is "immeasurably large" or "infinite." Philosophers did, of course, discuss the infinite, but mathematicians, whose professional writings were generally in a nondiscursive style that did not require one to explain omissions, simply preferred to steer clear of infinity. Piero della Francesca's work conforms to this general pattern.

Piero's Mathematical Writings

Of the "many" mathematical treatises that Vasari tells us Piero wrote, three are now known. All are available in modern printed editions. The titles by which they are known may not conform to those given them by Piero, and the dates of composition of all three are uncertain. All three treatises belong in some degree to the *abachista* tradition.[8] It is not, however, certain that Piero attended an abacus school. He was apparently taught some Latin, which suggests he may have had a private tutor.[9] In fact, one of the treatises, called *Trattato d'abaco,* though clearly not written for use in a school, is closely similar to surviving texts that we know were used as a basis for teaching in abacus schools.[10] Piero's *Trattato* is written in Tuscan. Some of the problems from the *Trattato* appear in a neater or more developed form in the *Libellus de quinque corporibus regularibus,* which survives in a single Latin copy, though Piero may have

written it in the vernacular.[11] It thus seems that the *Libellus* was written after the *Trattato*. The third surviving treatise by Piero, originally written in the vernacular but known by the Latin title *De prospectiva pingendi*, is the earliest known work on the mathematics of perspective.

The *Trattato d'abaco*

As Gino Arrighi, the modern editor of Piero's *Trattato,* has argued, and as other scholars have since abundantly confirmed, Piero's treatise conforms in large measure with the conventions of schoolbooks.[12] There is very little discursive text, and instruction proceeds through a series of worked examples.

Piero provides a brief introduction describing the origin and scope of his work. We then begin with arithmetic – of which algebra was, at the time, regarded as an offshoot. Piero starts with multiplication, division, addition, and subtraction of fractions and gives a series of problems on the "rule of three"; there then follow more elaborate arithmetical problems such as

There is a fish that weighs 60 pounds, the head weighs $\frac{3}{5}$ of the body and the tail weighs $\frac{1}{3}$ of the head. I ask how much the body weighs.[13]

Today, a pupil would probably be told to treat this problem algebraically, starting off by setting the weight of the body of the fish equal to *x*. Piero, however, merely uses numbers – though later problems do involve an explicit "unknown" called "la cosa" (literally "the thing").[14] For the fish, the solution begins:

Do thus; say that the body weighs 30 pounds, $\frac{3}{5}$ of 30 is 18, which is the head, the tail weighs $\frac{1}{3}$ of the head, which is 6. adding together 30 and 18 and 6 makes 54; and you want 60, which you have [but] less six, . . .

There follows the application of methods used in earlier examples, involving a certain amount of multiplication, division, subtraction, and addition, using two incorrect answers to calculate the correct one,[15] until we end up with:

So the body weighs 33 $\frac{1}{3}$, the head weighs 20, the tail weighs 6 $\frac{2}{3}$, which added together make 60, as I said the fish weighed.

The problem is in principle a practical one, and one whose structure is similar to that of other practical problems of interest to tradesmen and their customers. In this it resembles many other problems found in "abacus books" from the thirteenth century onwards.

The most notable difference between Piero's *Trattato* and standard abacus books is that Piero's work contains many more geometrical prob-

lems than was usual. It is, of course, hardly a surprise that a mathematician who was also a painter should show more than the conventional degree of interest in geometry, but Piero's geometrical problems do not in fact show any immediate connection with his concerns as a painter. For instance, unless this is another, as yet unremarked, example of his "plagiarism," it was not Piero but Luca Pacioli (c. 1445–1517) who was to write a treatise on the mathematical properties of the Golden Section.[16] Most of Piero's problems are conventional. Again, a single relatively simple example can be used to show the style. This time, the problem is proposed in abstract terms, though still in numerical form.

There is a triangle ABC in which the side AB is 14, BC 15, AC 13; in which I want to put the 2 largest circles that are possible. I ask what will be their diameter.[17]

This is not a problem that is solved in Euclid's *Elements,* but it could be seen as a more complicated variant of the construction given in *Elements,* Book IV, Proposition 4, "In a given triangle to inscribe a circle."[18] On his previous page, Piero has, in fact, already solved a simple special case of this problem, in numerical form, and has then gone on to solve a general case, again in numerical form.

This tendency to divide up Euclid's general cases into special ones, and then to add more elaborate examples, is entirely typical of the abacus book tradition. So too is Piero's 13, 14, 15 triangle. This triangle has several simple numerical properties: for instance, its height is 12 (above the base 14) and the radius of the incircle (the circle Piero proposed to find) is 4.[19]

All the geometrical problems in Piero's *Trattato* are given in numerical form, and many are clearly related to elementary problems from the Euclidean tradition. Moreover, most of the conventional problems concerning finding the heights of triangles, finding their areas, dividing areas – triangular or rectangular – in various ratios, and so on, are found in Piero's *Libellus de quinque corporibus regularibus* as well as in the *Trattato.* Thus the *Libellus* also has close links with the abacus school type of mathematics.

However, both the *Trattato* and the *Libellus* contain problems which are not known from any earlier text and appear to be original to Piero, though he makes no such claim on their behalf. These problems concern some of the so-called Archimedean polyhedra. These solids are, in modern terms, convex uniform polyhedra. That is, their faces, which are regular polygons, are completely visible on the outside of the solid and are arranged in the same way around each vertex of the solid. Thirteen such solids are known, and all of them are described by Pappus of Alexandria (fourth century A.D.) as having been discovered by Archimedes (c. 287–12 B.C.), hence their name. Pappus's descriptions of the solids are, however, minimal: he merely lists the number and type of faces of each solid. Thus the solid now called a "cuboctahedron" is described as having fourteen

faces, six of them square and eight triangular.[20] Piero's descriptions of the six Archimedean polyhedra he discusses[21] are stated in terms that in principle allow the reader to visualise the solid, and accompanying illustrations show the solid inside a sphere. In fact, Piero's verbal description includes the sphere, so it is clear that he has added to Pappus's descriptions by recognising the equivalence of the vertices of the solid and thus noticing that it can be inscribed in a sphere. Piero is accordingly, and rightly, credited with having rediscovered the six solids in question, namely, those now known as the truncated tetrahedron (whose faces are four triangles and four hexagons), the truncated icosahedron (twelve pentagons and twenty hexagons), the truncated dodecahedron (twenty triangles and twelve decagons), the truncated cube (eight triangles and six octagons), the truncated octahedron (six squares and eight hexagons), and the cuboctahedron (eight triangles and six squares). Two of the solids are discussed in the *Trattato*, one of them reappears, together with four further Archimedean solids, in the fourth (and final) part of the *Libellus*. The easiest of these six solids to visualise is probably the last, the cuboctahedron, since Piero's description starts from a shape with which everyone is familiar, namely, the cube:

There is a spherical body, whose diameter is 8 *bracci*; I want to put inside it a figure with fourteen faces, 6 square and 8 triangular, with equal sides. I ask how big each side will be. This kind of figure is cut out from the cube, because that has 8 faces and 8 corners; which, cutting off its 8 corners, makes 14 faces; like this. You have the cube ABCDEFGH, divide each side into equal parts: AB in the point I, and CD in the point L, BD in the point K, AC in the point M, . . .[22]

As can be seen, Piero's line of thought is rapidly submerged (for the modern reader at least) in a welter of detailed instructions for carrying out the construction. This is a style we shall meet again in Piero's treatise on perspective, where, as in the *Trattato*, the reader is called by the informal *"tu"* (you) and addressed mainly in the imperative. In both the *Trattato* and the perspective treatise, *"tu"* is clearly expected to draw diagrams as he goes along, but Piero does supply a figure for the final state.[23] One of the figures showing the cuboctahedron is reproduced in Figure 52. This figure shows the solid with letters on its vertices. The circle shown running through the vertices of the solid is to indicate that they lie on a sphere.[24]

The *Libellus de quinque corporibus regularibus*

Most of what has been said of the style of the *Trattato d'abaco* is also true of the *Libellus de quinque corporibus regularibus*. Though the latter survives only in a single Latin copy, its style is that of vernacular works. Again, as in the *Trattato*, what we are given is essentially a series of worked numerical examples. However, the *Libellus* is novel in that all its problems are geometrical, even though their being posed in numerical terms means

52. Piero della Francesca (?), Drawing of a cuboctahedron, diameter 5.8 cm. From Piero della Francesca, *Trattato d'abaco,* Florence, Biblioteca Medicea-Laurenziana, Codice Ashburnhamiano 280 (359*), folio 108r.

that their solutions involve large quantities of arithmetic. Most of the problems in the first two parts of the *Libellus* seem to be directly copied or slightly adapted from those in the *Trattato*.[25] The second part consists of problems concerning the five regular polyhedra, taken individually. These problems are essentially adapted versions of the results in Euclid's *Elements,* Book 13 (to which references are given). The third part of Piero's *Libellus* deals with problems derived from the book he knew as Euclid's Book 15. From the sixteenth century onwards it became increasingly widely known that this book, and the preceding one, Book 14, were Late Antique additions to the *Elements,* but both would have been found in the versions of Euclid that Piero is likely to have known, and they appear later in many printed editions of the *Elements.* Book 15, and the third part of Piero's *Libellus,* deal with problems that relate one regular polyhedron to another, for instance, by inscribing one solid inside another by constructing the inner solid as having certain vertices in common with the outer one. The difference between Piero's treatment and that in *Elements* 15 is that Piero, while giving references to the propositions in *Elements* 15, poses the problems in numerical form.

The problems are again posed in numerical form in the fourth part of Piero's treatise, which concerns what he calls "irregular bodies." These include four Archimedean solids not described in the *Trattato*.[26] Then comes the truncated tetrahedron, already mentioned in the *Trattato*.[27]

There is no mention of the cuboctahedron. As in the *Trattato,* a diagram is supplied for each proposition, apparently as an aid to visualisation, and employing the range of pictorial conventions we have already encountered among the illustrations to the *Trattato.*[28]

After dealing with the truncated tetrahedron, the fourth (and final) part of the *Libellus* becomes a series of apparently more or less unconnected propositions that have the air of being tacked on as an afterthought. One proposition, repeated from the *Trattato,* is a very strikingly practical solution to an apparently realistic problem, namely, that of finding the volume of a completely irregular shape, such as a statue of a human or animal figure. Piero instructs the reader to construct a wooden tube of square cross-section, using four stout planks, taking care to see that the corners are well sealed, then filling it with water . . . and so on.[29] This is the last paragraph but one of Piero's treatise. One may perhaps be permitted to wonder whether the many historians who have called the *Libellus* "Euclidean" (presumably on account of its being entirely concerned with geometry) have actually read right to the end of the work. Piero's final proposition concerns the abacists' familiar 13, 14, 15 triangle. For all its emphasis on geometry, and its apparently surviving only in Latin, the *Libellus,* like the *Trattato,* very clearly has strong connections with the world of practical mathematics.

The Perspective Treatise: *De prospectiva pingendi*

The introduction to the *Libellus* tells us that the work was intended by Piero as a companion piece to his treatise on perspective. The works were, it seems, shelved next to one another in the library in Urbino.[30] This raises various questions concerning the intended, and actual, readership of the works – questions to which we shall return. It may also be taken as an indication that the original version of the *Libellus* was in the vernacular. The perspective treatise was written in the vernacular, though all known manuscripts of it, vernacular as well as Latin, have the Latin title *De prospectiva pingendi.*[31] As we shall see, like the *Libellus* – which not only draws on the *Elements* but also gives references to it – *De prospectiva pingendi* similarly shows some concern to establish a relation with the learned mathematical tradition. It thus seems possible that the Latin title is actually Piero's own choice.[32]

De prospectiva pingendi gives every appearance of being conceived as an instructional text. As in the *Trattato d'abaco* the reader is called *"tu"* and addressed mainly in the imperative. In fact, a very large proportion of the text of *De prospectiva pingendi* consists of immensely detailed drawing instructions. In most cases the pupil is, effectively, being told how to make a copy of the drawing that is provided at the end of each proposition. There is thus a clear analogy with the apprentice's being taught standard drawing skills by being made to copy the master's drawings in a workshop manual. What Piero has written is a workshop manual for teaching an

apprentice to draw in perspective, and the model for the style of presentation, through a series of worked examples, is clearly also that of the abacus books. Thus, although as far as we know, Piero's treatise on perspective was the first of its kind, it is not lacking in antecedents. Its descendants were legion. Almost every treatise on perspective addressed to painters follows the series of worked examples in the first two books of Piero's work.[33]

In one obvious respect, however, *De prospectiva pingendi* differs from both the *Trattato* and the *Libellus:* its problems are not posed in numerical terms. All the same, a few propositions do end with a brief run-through of a numerical example of the particular problem that has just been treated. The explanation for this more purely geometrical appearance of the perspective treatise is prosaic: The problems proposed are drawing problems, so the "solution" is a drawing and the treatment of the problem is accordingly geometrical rather than numerical. Piero's style of exposition should thus be seen largely as a matter of practicalities rather than an attempt to link *De prospectiva pingendi* with the learned mathematical tradition to which pure geometry belonged. However, as we shall see below, there are in fact many indications that he did wish his work to be seen as having a place in a learned context, namely, as a legitimate extension of the well-established "mixed science" of *perspectiva* proper.

In Piero's time, *perspectiva* was the complete science of vision, dealing not only with the nature and properties of light but also with the method of functioning of the eye and the sense of vision. There was a long tradition of treating such matters in a partly mathematical way, so Piero's almost exclusively mathematical discussion of what came to be called "artificial" or "painters' perspective" was entirely in accord with the methods used in the established part of the science.

Each of the three books of *De prospectiva pingendi* has a discursive introduction. The introduction to the first book begins by situating perspective within painting

Painting has three principal parts, which we say are drawing (*disegno),* proportion (*commensuratio*) and coloring (*colorare).* Drawing we understand as meaning outlines and contours (*contorni*) contained in things. Proportion we say is these outlines and contours positioned in proportion in their places. Coloring we mean as giving the colors as they are shown in the things, light and dark according as the light makes them vary. Of the three parts I intend to deal only with proportion, which we call perspective, mixing in with it some parts of drawing, because without this perspective cannot be shown in action; coloring we shall leave out, and we shall deal with that part which can be shown by means of lines, angles and proportions, speaking of points, lines, surfaces and bodies.[34]

These are the very first lines of Piero's introduction, so there can be no doubt that he is consciously setting out to write a treatise concerned with only one part of the painter's work. It thus seems inappropriate to assess

Piero's treatise as if it were to a significant extent conceived as a response to Alberti's Latin *De pictura* (1435) or its vernacular version *Della pittura* (1436). The scope of the works is entirely different. Alberti, writing initially in Latin, is addressing himself to patrons, or at least to courtiers who wish to find something intelligent to say when confronted with a prince's latest acquisition. Piero, who (as we have already noted) calls his reader by the familiar *"tu,"* is writing for fellow practitioners and making the specifically mathematical contribution that he is well recognised as competent to make.[35]

* * *

The main text of Book I of *De prospectiva pingendi* begins with a series of propositions relating to natural vision, for instance, that if two objects are of the same size then the one nearer the eye appears larger than the other.[36] For some of these propositions, Piero gives appropriate references to the corresponding propositions in Euclid's *Optics,* though it is not possible to decide whether these references are to Euclid's original work or to the recension by Theon of Alexandria (fourth century A.D.). Both texts were widely distributed, in Latin, in Piero's time and parts of them were also available in medieval works on optics, such as John Pecham's *Perspectiva communis,* which Piero seems to have known.[37] There are also some mathematical preliminaries, for instance, the theorem that if a set of concurrent lines divides any given line in a particular series of proportions then it will divide any other parallel line that cuts the set in the same series of proportions.[38] Piero gives references to the relevant theorems in Euclid's *Elements.*[39] Propositions directly relevant to perspective construction, and not to be found in Piero's ancient or medieval sources, begin at section twelve of Book I. The following proposition, I.13, deals with the problem of constructing the perspective image of a horizontal square lying with one edge along the ground line of the picture (i.e., along the line of intersection of the picture plane and the ground). In a style with which the persistent reader will become familiar in all later propositions of *De prospectiva pingendi,* Piero's solution to the problem, which involves a proof that the construction is mathematically correct, consists almost entirely of drawing instructions, delivered in the imperative. These instructions do, indeed, enable even a novice to produce a version of the drawing supplied at the end of the proposition, but there is no explanation of the significance of the construction that has been carried out. Piero does, however, prove that the construction is mathematically correct. Given the prolixity of the drawing instructions, Piero's proof of this crucial result is disconcertingly concise. However, it is perfectly correct.[40] All the same, it must be admitted that Piero's curious use of the same letters to designate two different points (for three separate pairs of points) in the same diagram

makes some of his argument difficult to follow – though the ambiguity it introduces in fact allows the proof to be shorter.[41] This may have been regarded as an elegance at the time, but the apprentice painter would surely have experienced something of the twentieth-century historian's difficulty in working through a line of reasoning concerning two pairs of similar triangles at the same time. The contrast with the prolixity elsewhere, and the generally elementary nature of the mathematics found in *De prospectiva pingendi,* strongly suggest that the proof in I.13 was put in because Piero, rightly, recognised the importance of the result and decided it was appropriate to supply a proof, even if the majority of his readers would have to take it on trust. In fact, this is one of the propositions in which Piero suggests some numerical values by way of supplement to the geometrical reasoning; and there are several other propositions where, as here, one may reasonably suppose that the apprentice merely checked the correctness of the result by drawing an accurate diagram.[42]

Having constructed the perspective image of a horizontal square, Piero goes on to divide it into smaller squares, to produce a simple *pavimento* (pavement) like that considered by Alberti. First, in I.14, he constructs the orthogonals (the lines that are the images of lines that run perpendicular to the picture plane), using the theorem in I.8, about concurrent lines dividing all parallel lines crossing them in the same proportions, to which we have already referred. This is the first appearance in Piero's work of what Alberti called the "centric point" of the perspective scheme. Piero gives it no name and continues to designate it by the letter A, as in the earlier part of his work (where it appeared merely as the meeting point of two lines). Piero has in fact proved the convergence of the respective images of orthogonals to the "centric point," a result Alberti merely used without proof.[43]

In his next proposition, I.15, Piero obtains the images of the transversals (the lines that are the images of lines parallel to the picture plane) by drawing the diagonal of the square and then putting in lines parallel to the ground line through its points of intersection with the orthogonals. That is, unlike Alberti, he does not repeat the perspective construction for each transversal. Piero's construction is thus rather easier than Alberti's to carry out in practice, since it involves fewer lines going beyond the edge of the picture field. These second and third stages of Piero's construction of the image of the *pavimento* resemble the corresponding stages of what is known as the "distance point construction." Piero in fact knew the distance point method, which he uses, without proof, in Book I, section 28.[44]

Dividing orthogonals and transversals in more complicated proportions allows Piero to go on to construct the images of pavements with more complicated patterns of tiles. There then follow regular polygons, shown as if drawn on the same horizontal plane used for the pavement. Piero deals with the most general case, in which none of the sides of the poly-

gon is parallel to the ground line (see Fig. 53), employing the convention of showing the "perfect" shape (that is, the real shape in space) in the lower part of the diagram, oriented so that it shares a ground line with its "degraded" version (that is, the perspective image) in the upper part. The same drawing convention is found in almost all subsequent treatises on perspective.

By showing the most general case Piero has, of course, given the reader the means of solving all the more simple cases, in which, say, two sides of the octagon lie along orthogonals. However, dealing with only the most complicated case is clearly not a recommended pedagogic method, and Piero's style here contrasts with the slow buildup of complexity we find in the *Trattato d'abaco,* in its geometrical problems as well as in its arithmetical and algebraic ones.

Book I ends with a proposition that is not a construction problem but a theorem. It concerns the assertion that this part of *perspectiva* is not a "true science" because its practice can lead to lines near the edge of the picture being shown as longer, in the picture, than they actually are in reality. That is, the "degraded" line comes out longer than the "perfect" one. Luckily the English word "foreshortening" agrees with the Italian *"scorcio"* in showing up the paradoxical nature of such an outcome. It is, however, entirely arbitrary to rule such an outcome unacceptable and, sufficient to prove that painters' perspective was not a "true science" (*vera scientia*). Perhaps some explanation for this fifteenth-century judgment might be found within *perspectiva* proper, but it is in any case sufficient for our present purposes to note that the criterion was not in dispute: Piero accepts that for painters' perspective to be a "true science" the degraded line must not come out longer than the perfect one. His defense of perspective is to prove that this outcome is not possible. The proof, like Piero's other propositions, consists almost entirely of detailed drawing instructions, the mathematical crux of the matter being treated extremely briefly. Closer inspection shows that this proof is incorrect, and that the theorem, in the form in which Piero proposes to prove it, is actually not true. Matters are further confused, mathematically speaking, by the fact that Piero's argument is not purely mathematical but depends on the angular width of the visual field of the human eye, which, following Pecham, he supposes to be a right angle. Though the proof is incorrect, the theorem would almost certainly appear to be true if checked by means of dividers in a diagram of reasonable size, and the actual rule that Piero proposes for choosing the viewing distance does in fact ensure that the degraded line will not come out longer than the perfect one. What we seem to have is a proof that will pass muster with readers of a practical rather than a theoretical bent – and we may note in passing that it passed muster with Daniele Barbaro (1513–70), who printed it in his *Pratica della*

53. Drawing an octagon in perspective, from Piero della Francesca, *De prospectiva pingendi*, Book 1, Proposition 29, Parma, Biblioteca Palatina, MS no. 576, folio 16r. (Photo: Davis).

perspettiva (Venice, 1568, 1569) – coupled with a practical rule that is mathematically correct.

The disjunction between proof and rule suggests that Piero was at least uneasy about the proof. What is clear, however, is that he feels the necessity to establish that his form of *perspectiva* is a "true science" and is proposing it as an extension of *perspectiva* proper.[45] A rather similar proposition occurs at the very end of Piero's second book (II.12), providing a proof that if a colonnade is shown running parallel to the picture plane, the columns near the edges of the picture will not appear wider than those near the center. This time, the proof is best described as approximate. Its lack of rigor consists merely (in modern terms) of ignoring some inconvenient sines and cosines. The theorem itself is true.

For the painter, the two theorems at the ends of *De prospectiva pingendi* Books I and II concern the construction of pictures, since they fix the angle the completed picture is to make at the eye of the ideal observer, whose position must be decided before the perspective construction can be carried out. However, both propositions are anomalous within Piero's text, first in actually being theorems rather than construction problems, and, secondly, in the way they return to *perspectiva* proper, drawing lines linking the eye of the observer to the things that are seen. Piero might have omitted both theorems without detriment to the practical usefulness of his text, provided he had included the unexplained, but adequate, rule for avoiding unacceptably long lines mentioned in I.30. Thus the inclusion of these theorems must be seen as following on from the references to natural vision in the preliminary propositions in Book I and as an indication of Piero's intention to establish painters' perspective as a legitimate extension of the accepted optical science of his day. It seems that for Piero these theorems and the whole of painters' perspective are part of the same scientific discipline that tells him, for instance, how to render the reflection of the background hills and figures in the still waters of the Jordan seen round Christ's feet in the *Baptism of Christ* (see Plate 8).[46]

* * *

De prospectiva pingendi Book II begins with a short introductory paragraph that tells one a solid has three dimensions (namely, length, width, and height), lists a few examples, and says it is things such as these with which Book II will be concerned. For the modern reader, as possibly for the fifteenth-century apprentice, this passage chiefly serves to introduce the technical terms that will be used in the main body of the text. The last lines of the introduction indicate that the connection of this work with that of the previous book is that some of the plane figures shown in Book I will now become the bases of solid figures. This is exactly what happens. In mathematical terms, Piero constructs prisms. For instance, the square becomes a cube, seen in various orientations and then transformed into a house (complete with such details as the thickness of the walls being visible in the door and window openings, see Fig. 46). More complicated polygons yield, among other things, the hexagonal plinth and body of a well-head, and the many-sided shaft of a fluted column. It is presumably because he has dealt with the column and another architectural element (a cross vault) that Piero then, in the final section of Book II, discusses the problem of showing a colonnade parallel to the picture plane.

The *pavimento* problems in Book I and the problems relating to simple solids in Book II are certainly realistic ones for the apprentice painter. Forms corresponding more or less closely to those treated by Piero can be found in the work of many fifteenth-century painters, and Piero's prob-

lems duly reappear, sometimes in simplified form, in the elementary per-
spective treatises printed in the following century. Since the solid forms
are so simple, detailed comparison with anything found in Piero's own
work is not likely to be very informative. To understand Piero's work, as
mathematician and painter, it is probably more useful to notice the rela-
tion of the house (Fig. 46) to the cube from which it has been derived: the
outline of the cube is still clearly visible in Piero's drawing. In any case, it
is clear that as far as the end of Book II Piero's subject matter was close
to the concerns of many other painters, of his own and succeeding gener-
ations.

Piero himself seems to have been aware that things were otherwise
with *De prospectiva pingendi*, Book III, for he provides the book with an
elaborate introduction. This is considerably longer than that to Book I,
and begins by explaining the great importance of perspective for the
painter. The defensive tone recalls that of the beginning of Piero's proof
that perspective is a "true science" (in I.30): "Many painters disapprove of
perspective (*biasimano la prospectiva*) because they do not understand the
force of the lines and the angles to which it gives rise: with which every
contour and lineament is portrayed. Therefore it seems to me that I ought
to show how necessary this science is to painting."[47] The remainder of the
paragraph is essentially concerned with the optical truthfulness obtainable
only though perspective. Piero ends by repeating that perspective is a true
science, working "through the force of lines" (that is, by the use of math-
ematics). Implicit in this defense is Piero's belief that the painter's busi-
ness is accurate representation, in accordance with what is known about
vision. He is also assuming, or asserting, a continuity between this science
of vision and the mathematical techniques used in his treatise. As we shall
see, the technique used in Book III differs from that used in the previous
books and is, in fact, closer to the mathematical methods familiar from
perspectiva proper.

Following what we might call Piero's "scientific" defense of perspective
there comes the humanist historical-rhetorical one: A list of the greatest
painters of Antiquity, taken from Vitruvius, though possibly not directly.[48]
All these painters are asserted to have followed the rules of perspective.
Piero exhorts his contemporaries to do likewise, says it is for this purpose
that he has written his treatise, and (here he turns the rhetorical volume
down to the level more usual for treatises) has divided it into three books,
"as I said in the first." He goes on: "In the first I demonstrated the degrad-
ing of plane surfaces of various kinds; in the second I have demonstrated
the degrading of square bodies *[corpi quadri]*, and those with more faces,
placed perpendicularly on the plane."[49] Piero's summary of the first two
books has reduced the matter to geometrical rather than specifically
representational essentials, and he writes in equally abstract terms of his
final book: "But since now in this third book I intend to treat of degrading

bodies enclosed by different surfaces and differently placed, because having to treat of more difficult bodies, I shall take a different approach and another way of degrading them, which I did not use in my earlier demonstrations, but its effects will be the same, and what one does is what the other does."[50]

The equivalence of the new method to the previous one is, of course, an important matter for the mathematician, since the previous method has been shown to be mathematically correct. Piero displays his awareness of this by repeating the degradation of some plane figures, including that of the horizontal square, performed in I.13, using the new method. Even a rapid glance at the accompanying diagrams, which have been redrawn in Figures 54 and 55, shows something of the difference between the methods. In Book I, the degraded square was constructed in a single drawing. In Book III we begin with two drawings, one (at the top) showing a vertical section (though with the square shown as if folded up into it), the next showing a ground plan. Both these diagrams show sight lines from A to the corners of the square. We are told that these are constructed using a nail driven into the point A and a string to make the line, or using a needle and a very thin silk thread, or a piece of hair from the tail of a horse. Presumably the string was used for large-scale drawings and the finer materials for smaller ones. There follow instructions for using paper and wooden rulers to transfer the positions of the intersections of these lines of sight with the vertical line just to the left of the square (this line represents the picture plane) to the vertical and horizontal edges of a third diagram, shown below and to the left of the first two, in which the degraded square is then constructed.

Part of the differences between the diagrams in Figures 54 and 55 is because in III.1 (Fig. 55) the nearest side of the square lies a little back from the ground line of the picture, whereas it lay along this line in I.13 (Fig. 54). However, the important difference is that in book III we are clearly in the world of the surveyor, taking sightings, combining plan with section. As becomes clear in later examples, Piero chooses important points of the original "perfect" shape and finds where lines joining them to the eye will cut the picture plane. Each of these points of intersection is a point of the "degraded" object. One then joins them up, with a curved line if necessary, to obtain a complete drawing showing the object correctly degraded.

This ray-tracing method of Piero's presumably seemed to him not to stand in need of proof. He simply tells the reader that A is to be the eye and proceeds to deliver drawing instructions in, as we have seen, the most practical of terms.[51] The problems of Book III are, however, entirely practical in the sense that they concern objects found in Piero's paintings, and in those of many of his contemporaries. He deals with a *torculo* (his name for a *mazzochio*) (III.4), a cube balanced on one corner and with none of its edges parallel to the picture plane (III.8), the molded base of a column (III.6), and two forms of column capital (III.7).

54. Diagram: Drawing a horizontal square in perspective. Copy of a diagram illustrating Piero della Francesca, *De prospectiva pingendi,* Book 1, Proposition 13, with some of the lettering omitted. (Photo: Author).

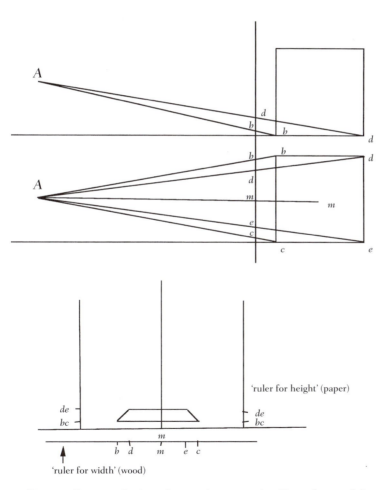

55. Diagram: Drawing a horizontal square in perspective. Copy of a set of diagrams illustrating Piero della Francesca, *De prospectiva pingendi,* Book 3, Proposition 1, with some lettering omitted. (Photo: Author).

After column capitals, Piero turns to the human head. For the column capital, one plan, composed of several superposed sections, and one side view had sufficed. For the human head we are given a side view and a front view plus two series of superposed sections, each with four components (see Fig. 56). Sixteen points have been taken round each section, and they appear in corresponding positions on the side and front views. The group of drawings shown in Figure 56 is the second set of illustrations to III.8. The first had shown the same head but without the numbering. Subsequent figures show lines of sight at an angle to the sections and side views and then a head seen slightly from below. Piero then uses the same head again, taking different sight lines, to obtain a view of it from below and slightly to one side. Though the features appear to be different, the problem is clearly the same as that which would need to be solved to make a correct drawing for the head of the second soldier from our left in the *Resurrection* fresco (see Plate 1).

After the heads, we have a quarter-dome divided into caissons, and two pieces proposed as *trompe l'œil:* a goblet *(rinfrescatoio)* that will appear to stand up from the table on which it is painted and a ring (the kind from which a lamp is suspended) that will appear to hang down from the vault on which it is painted (see Fig. 50). Vasari tells us that Piero did actually make a trick painting of a goblet of this kind.

Drawing the trick goblet and the ring is actually fairly easy (though making them look real enough to deceive the eye would require skills in other parts of painting). Drawing most of the other things in Book III is decidedly laborious. Piero's instructions cover folio page after folio page, swarming with numbers and mind-numbingly repetitious. To follow such instructions requires a degree of skill at visualising form in space that is almost certainly beyond the common, even among painters. We may guess as much from the fact that almost nothing of what we find in Book III reappears in the later perspective treatises that make so much use of the two earlier books of Piero's work. Most of these later treatises replace Book III with some chapters showing the use of instruments designed to make correct perspective drawings by mechanical means. These instruments are almost all sighting instruments, very like those used by contemporary surveyors. The principle they employ is thus the same as that Piero uses in Book III, but the mathematical skill required is minimal.

Mathematics and Painting

The *intonaco* of the *Proving of the True Cross* in the *Legend of the True Cross* at Arezzo carries incised lines delineating the contours of architectural elements, including all the verticals, and outlining each surface of the Cross (see Plate 15). *Spolvero* marks (pouncing) outline all the heads,

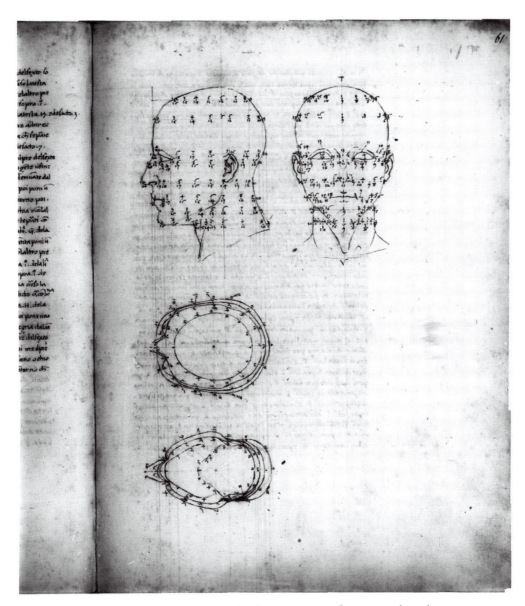

56. Piero della Francesca, Drawing a human head in perspective, first stage only, with points numbered, from *De prospectiva pingendi,* Book 3, Proposition 8, Parma, Biblioteca Palatina, MS no. 576, folio 64r (Photo: Author).

usually also marking some of the features, as well as all the drawing of fig-ures' hands, and the naked torso and arms of the young man who is com-ing back to life. A similar use of incisions and *spolveri* is found in the other scenes on the same wall and the adjoining end wall.[52] Photographs suggest that *spolvero* marks are present in corresponding parts of all the scenes of the fresco cycle. *Spolvero* marks do not appear to be present in most of the

drapery, though it is possible that in some passages they are merely hidden by the relatively dark color of the paint, for instance in the heavy pink-purple cloak of the figure on the far right in the *Proving* scene. This figure is of great compositional importance, and *spolvero* marks are visible in the drapery of a comparably important figure, namely, along the sinuous lower edge of the tunic of the figure in white (a color contrary to Alberti's prescription) standing with his head turned away from us close to the left side of the *Exaltation of the Cross* (see Plate 18). All this is visible to the naked eye. The restorers' use of infrared reflectography has now revealed the drawings that lie under the *intonaco*. These prove that there was indeed an extensive use of cartoons.[53]

The structure and design of Piero's paintings, both the composition in the plane and the composition of the scene in the pictorial space, show many traces of his mathematical skills. All pictures that contain a sufficient quantity of straight lines to allow one to check show a completely consistent use of perspective, and one, the *Flagellation* (Galleria nazionale delle Marche, Urbino), uses perspective to a degree that allows a complete reconstruction of the three-dimensional set up (see Plate 6).[54] However, Piero's capacity for visualizing three-dimensional relationships, seen in his rediscovery of the Archimedean polyhedra, is also seen in many paintings that show no formal perspective construction but nevertheless give a very convincing impression of a constructed space, such as the *Baptism of Christ* (see Plate 8). Thus Piero's mathematical skill should be seen not only as a part of his social character but also as a component of his artistic personality.

10 Piero's Parnassus of Modern Painters and Poets

Anne B. Barriault

Piero della Francesca has been called an enigma; a giant shadow cast across painters and poets of our times; an artist whose frescoes reveal "an eternal order of light and balance" – in the words of Zbigniew Herbert, the Eastern European poet. These observations represent three modern traditions of writing about Piero that belong to his legacy: Piero's art as seen through the eyes of poetic art historians, painters, and poets. When gathered together, select modern writers and artists who have responded to Piero's geometry, mystery, and "ineloquence," in Bernard Berenson's words, form a modern *Parnassus* of poetic tradition.

This modern tradition begins with Giorgio Vasari's *Lives of the Most Eminent Painters, Sculptors, and Architects.* There, the father of Italian art history tells us that Piero "did so well that he has been followed by our modern artists who have been able to reach the perfection we see today."[1] Vasari suggests that his own great grandfather was one of the first artists to be influenced by Piero, when he tells us that Lazzaro Vasari had painted with his friend Piero and that their art was sometimes indistinguishable. Arezzo, Vasari's hometown, was "a city made illustrious," he says, "by Piero's works." For Vasari – writing in the mid-1500s – art attained perfection with Michelangelo and Raphael. Vasari cites Piero as one of the artists whose now lost work in the Vatican inspired Raphael before he began to paint the papal apartments *(Stanze)*. Raphael's father, the painter Giovanni Santi, may have been among the first artists – or poets – to write about Piero, when he included Piero in a rhymed chronicle listing distinguished artists of the day. His poem – a hymn to his patron, Federigo da Montefeltro – praises master painters Masaccio, Uccello, Domenico Veneziano, Botticelli, and a certain "Pietro dal Borgo – older than these."[2]

Although Vasari remembers Piero as a great master of mathematics who

painted from nature, he also found spiritual order in Piero's light, as he did
in Raphael's. "Dazzling splendour," "burnished lustre," "flickering reflection
. . . in armour," so Vasari describes the scenes of illuminating angels who
pierce the darkness in Piero's *Dream of Constantine* in Arezzo and in
Raphael's *Liberation of Saint Peter* in Rome.[3] One look at each fresco, as
Vasari implies, attests that Piero was indeed a precursor to Raphael.

Raphael painted the *Liberation of St. Peter* at the Vatican after com-
pleting his *Parnassus* in an adjacent room. Raphael's *Parnassus* is regarded
not only as a tribute to perfection in painting – which Vasari saw in Piero's
works – but also as a tribute to poetry, the subject of the painting, and
painting's kindred spirit.

"As in painting, so in poetry," the Latin poet Horace wrote in his *Ars
poetica* of the first century B.C. His simile became a cornerstone of Renais-
sance art and theory, deeply rooted in antiquity, steeped in the study of
classical texts and the belief that both painting and poetry should imitate
human action and emotion – to please, to instruct, to edify.[4] Raphael's *Par-
nassus* has recently been described as being "at once about the springs of
poetry in the past and about the creation anew of poetry in the modern
world. . . . The *Parnassus* is, in a sense, the very history of poetry, of poetic
inspiration – itself the most recent example."[5]

In the *Parnassus*, Homer, Sappho, Virgil, Dante, Petrarch, and Boccac-
cio take their places on either side of Apollo and his Muses (Fig. 57). It has
been suggested that if Dante declared in the *Inferno* that the great classi-
cal poets included him in their company, so Raphael – by immortalizing
these poets in painting – should also stand with them. If we imagine
Raphael in this august group, following Dante's example, we allow poet
and painter to share the springs of poetic inspiration and imagination. If
we were to invite Piero, as Raphael's precursor, into their number as well,
we could begin to trace a modern history of poetic imagination inspired by
him. Who among "our modern artists," to use Vasari's language, would join
Piero in our newly imagined *Parnassus*?

Though his importance waned for nearly three centuries after Vasari's
writings, Piero della Francesca has come to be regarded as a major Renais-
sance painter. We know Piero today largely through a nineteenth-century
French connection. The poet Zbigniew Herbert reminds us that Stendhal
first rescued Piero "from oblivion."[6] Moved by Piero's "beauty" of expres-
sion, Stendhal wrote about the artist's synthesis of perspective, architec-
ture, and painting. By 1861, Piero's *Baptism* could be seen in the National
Gallery, London, and by 1879, copies of Piero's frescoes from Arezzo were
available in the Beaux Arts Academy in Paris.[7] Piero's art affected painters
of the day, especially Pierre Puvis de Chavannes, Georges Seurat, Paul
Cézanne, and Paul Gauguin.

If Stendhal helped to restore Piero to nineteenth-century painters,

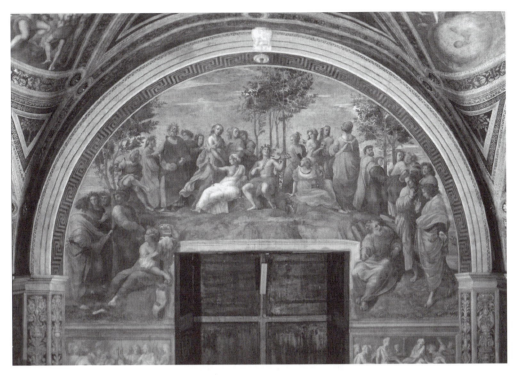

57. Raphael, *Parnassus,* Vatican Palace (Photo: Scala/Art Resource, NY).

J. A. Crowe's and G. B. Cavalcaselle's *New History of Painting in Italy,* published in England in 1864–66, restored Piero to modern art historians and critics, especially to some of the artist's most poetic writers from the late nineteenth and early twentieth centuries – John Addington Symonds, Bernard Berenson, André Malraux, Roberto Longhi, Kenneth Clark.[8] Longhi's poetic and seminal study of Piero, published in 1927, contains a prescient observation that Piero's art survives in major modern painting.[9] Inspired by Longhi, who praised Piero's synthesis of form and color in paintings both miraculous and natural, Kenneth Clark observed in the mid–twentieth century that Piero's sweeping epics and sacred images of the Christian faith "command our belief in mystery." Clark called Piero "a poet of color and tone." To others since then, Piero has been known as "the poet of form."[10]

Often viewed as an enigma in literature about him, Piero has also been described as "la grande ombra," the giant shadow cast across artists and authors of our times.[11] More so than a shadow, Piero may represent clarity and light. Zbigniew Herbert says of Piero's art: "Over the battle of shadows, convulsions and tumult, Piero has erected *lucidus ordo* – an eternal order of light and balance."

The Painters

Piero's geometric precision and carefully controlled gesture, it has often been observed, underlie Georges Seurat's still and stippled *Sunday Afternoon on the Island of the Grand Jatte* (1886). In his holy image *Ia orana Maria* (Hail Mary, 1891–92), Paul Gauguin reincarnates Piero's cool, columnar angels from the *Baptism* into Polynesian form – three figures as in Piero's trio (Fig. 58, and see Plate 8). In Gauguin's image, we see Piero's clarity of color and space: figures once seen against a lucid Tuscan landscape, now a tropical Tahitian setting. Gauguin drew upon eclectic sources from the East and West, including early Renaissance art. We know that he owned reproductions of works by Botticelli, Cranach, and Holbein. He had traveled to London, the home of Piero's *Baptism*, in 1885, before his first trip to Tahiti in 1891, when he painted *Ia orana Maria*; he based

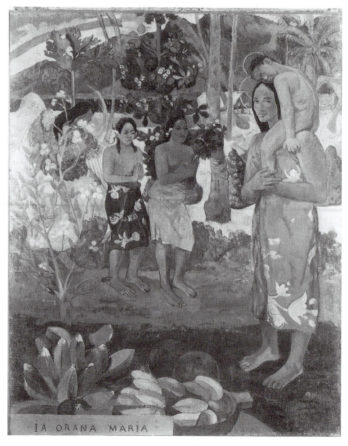

58. Paul Gauguin, *Ia orana Maria* (Hail Mary), New York, Metropolitan Museum of Art (Photo: Metropolitan Museum of Art, Bequest of Sam A. Lewisohn, 1951. [51.112.2]).

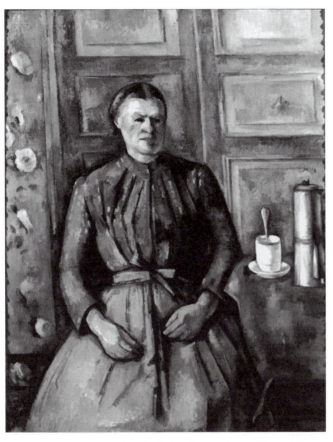

59. Cézanne, *Woman with a Coffee Pot,* Paris, Musée d'Orsay (Photo: Scala/Art Resource, NY).

the composition of his late Tahitian painting *Why Are You Angry?* of 1902 on his rival Seurat's *Grand Jatte* and thus, indirectly Piero.[12]

Much has been written about Piero's command of line and volume that many see beneath Paul Cézanne's paintings and, later, Pablo Picasso's. Cézanne's *Woman with a Coffee Pot,* from around 1895 (Fig. 59), and Pablo Picasso's portrait of *Gertrude Stein* and *Self-Portrait,* of 1906, share with Piero's paintings a careful integration of both surface and plane – gridlike yet dimensional. Cézanne's vision of nature as "cylinder, sphere, and cone" descends from Piero's "cubes and triangles" of "natural and accidental things" in his own writings on painting and perspective.

Mid-twentieth-century critic Adrian Stokes saw Piero as the first cubist; Herbert describes Piero as a "figurative painter who has passed through a cubist phase."[13] Beyond informing Cézanne's or Picasso's abstracted figures, Piero's art has also been associated, at least in spirit, with Piet Mondrian's geometrical compositions of primary colors, black, and white. Piero's indifference to ideal beauty, his equilibrium in painting

figure or column, curve or line, and his geometry of form have been related in theory to Mondrian's theosophical quest, to see through nature to the essential, unifying principles underlying art and reality, art and life.[14]

Schools of early twentieth-century painters – cubists and surrealists, futurists and the Novecento – contain aftereffects of Piero's art. Reconsidering their classical heritage following World War I, Italian painters Giorgio Morandi, Giorgio De Chirico, Carlo Carrà, and Gino Severini each refer to Piero in their art and in their writings. The 1991 exhibition in San Sepolcro, *Piero della Francesca and the Novecento,* examined the rebirth of Piero's painting in the works of these artists and others during the 1920s and 1930s.[15] Contributors to the exhibition catalogue invented evocative adjectives named for the artist himself: Novecento light is "luce pierfrancesca," Novecento landscapes are "toscano e piero-francescano." To Gino Severini, Piero's painting represented a perfection, both in its physical form and in its metaphysical content. A figure and still-life painter, Severini wrote about Piero in his 1921 treatise on cubism and classicism; that year, De Chirico defined a grand olympic style of painting (*olimpico*) measured against standards that he found in the geometry, luminosity, rigor, and simplicity of Raphael and the quattrocento "primitives." De Chirico and the Novecento saw affinities among these "primitives" – Giotto, Uccello, Piero, and Signorelli – and the classical art of Greece and Rome. So too, Bernard Berenson, one of this century's patriarchs of studies in Italian Renaissance art, associated the word "primitive" with early Italian Renaissance painting and ancient Greek sculpture. He saw a purity, simplicity, and impassivity linking Piero's art and the art of ancient Greece.[16]

De Chirico's contemporary, Giorgio Morandi, created still lifes and landscapes that have been described as Platonic at their very essence, informed by Piero's figures and architecture. In a classic photograph, Morandi sits at a desk before Longhi's 1927 edition of *Piero della Francesca.*[17] Longhi would later write another monograph on the expressive artist and writer Carlo Carrà, who recalls Uccello and Piero in his painting and acknowledges their influence in his writing. Admiring Piero's "marriage of instinct and intellect," Carrà captured aspects of Piero's abstraction in such paintings as the landscape *L'attessa,* 1926, and the figural *I nuotarori,* 1929 (Fig. 60). Reviving the art of fresco painting, Carrà and his collaborators reproduced Piero's paintings to illustrate their *Manifesto della pittura murale* of 1933.[18]

As we survey our imaginary *Parnassus,* we find Piero at the center, with Cézanne, Picasso, and the Novecento school on one side of the picture. On the other side, we might see Philip Guston and Romare Bearden, Americans trained in the cubist school and hired by the Works Progress Administration during the 1930s, a decade that saw a renaissance in American mural painting.

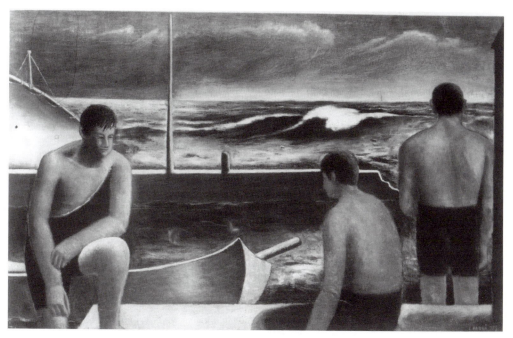

60. Carlo Carrà, *I nuotarori* (private collection).

Piero's and Uccello's narrative paintings, in which proper perspective and flattened volumes coexist, caught Philip Guston's eye and imagination, fueled by De Chirico's eerie pierfrancescan figures and architectural spaces. In Guston's *Martial Memory,* 1941, pierfrancescan surfaces and figures are brought close to the foreground plane, flattened against an architectural backdrop, and painted in a pierfrancescan palette of slate blue, ocher, and sienna (Fig. 61).[19]

"I would rather look at Piero's *Flagellation* . . . or his *Baptism* . . . than . . . at any modern painting," Guston once said in an interview. "I've had a reproduction on my wall of these two paintings for about twenty-five years in the kitchen, where you really look at things." Drawn to the tension in Piero's paintings that he calls "anxiety," Guston has written about how the impossible and the possible – order and immobility on the one hand and the anticipation of change on the other – coexist in the *Baptism* and the *Flagellation.* "What we see is the wonder of what it is that is being seen," writes Guston. "His work has a kind of innocence or freshness about it, as if he was a messenger from God, looking at the world for the first time."[20]

Guston's observation of Piero – that "one cannot determine if the rhythm of his spaces substitute themselves as forms, or the forms as rhythms" – reflects a pierfrancescan balance of thought and composition that pervades Guston's own art and the art of his contemporary, Romare Bearden.

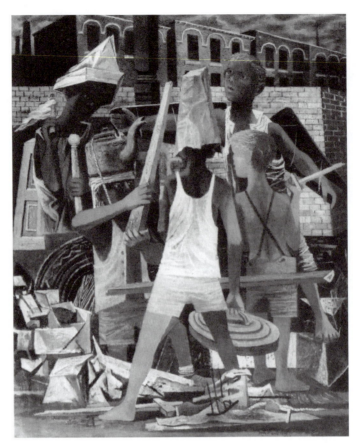

61. Philip Guston, *Martial Memory*, St. Louis Museum of Art (Photo Courtesy of the St. Louis Museum of Art).

Guston's perceptions of the rhythmic correspondences between substance and space in Piero's painting parallel Romare Bearden's definition of his paintings and collages, in which "figures, foliage, and objects are conceived as a continuum." Bearden came of age during the Harlem Renaissance; he studied art with Carl Holty in New York during the 1940s and in Europe after World War II. His paintings and collages are often linked to Cézanne and Matisse, but his balanced constructions of color and form also belong to the school of Piero and early Italian painters. Holty taught his students Picasso's lessons in unified composition. He admired certain early Italian artists for their planes of color. "Holty could see the great composition in . . . Uccello, Giotto, Piero della Francesca," Bearden remarked in an interview, adding that painting lost ground for his teacher with the illusionism of the High Renaissance after Raphael.[21]

In Bearden's collages, color retains its primacy: "color, in a certain sense, can vitiate itself by illusionism." Bearden diagramed mosaics from

Ravenna – minute pieces of color coalescing into figures and settings. He studied Italian trecento and quattrocento artists. A painted sketch of a panel from Duccio's *Maesta* appears in the background of his *Artist with Painting and Model,* 1981 (Fig. 62). This collage of dazzling pattern – in which figure, easel, painting, and model are flattened close to the picture plane – depicts a memory from the 1930s of the young artist displaying his work in his studio. A photograph of Bearden in his studio from the 1940s – taken around the time of his *Passion of Christ* series – contains revealing reproductions tacked to the wall: Cézanne's *Card Players* and, beneath it, Fra Angelico's *Naming of the Baptist* (Fig. 63).[22] In Fra Angelico's painting, stately women gather before Zacharias. Their quiet restraint foreshadows Piero's emissaries in his *Meeting of King Solomon and the Queen of Sheba* (see Plate 10). Fra Angelico paints his figures in fresh color – blues, reds, and greens – tempered by lessons in light and shadow that descend from Masaccio to Domenico Veneziano, Piero's teacher. We see Fra Angelico's influence on Piero: though his figures are more decorative – with colorful robes etched in gold – the soft folds of their garments, their clearly delineated profiles, and their clarity of form and spirit inform the simplified surfaces of Piero's queen and her entourage.

Simplified surfaces also describe much of Bearden's art. Clark's comment – that in Piero's art, scenes remain parallel to the surface – applies to both Guston and Bearden. Keeping color "up front," Bearden's collages share with Piero and Uccello the delight in pattern that Guston recognized – the interplay between space and form – from Bearden's *Artist with Painting and Model,* to Piero's *Battle of Constantine and Maxentius* (see Plate 13), to Uccello's *Battle of San Romano.* "Intervals," said Bearden, whose work is deeply influenced by jazz, "reinforce the more solid forms and objects . . . it is in the spacing." And yet, Piero's painting resonates in Bearden's lifelong vow, "not to seek surface elements but essences." Both artists – one of the Italian Renaissance, one of the Harlem Renaissance – made art about human beings and their histories. Their compositions share a common ground: an equilibrium of geometric shapes and spaces, sharp contours, and volumes formed by color and light, through which Piero and Bearden both capture the "essence" of existence, in Berenson's words.[23]

Beyond Guston's and Bearden's places in our Parnassus, we would find British artist David Hockney. His work loops around Guston and Bearden, through Picasso, and back to Piero. Cubism, says Hockney, "is about our bodily presence in the world . . . where we are in it, how we are in it."[24] His very definition, conveying a powerful sense of order, summons up Piero, characterized by Vasari as the "great master of the problems of regular bodies, arithmetical and geometrical." Hockney sees cubism as a step toward figurative painting as much as it is a step toward abstraction.

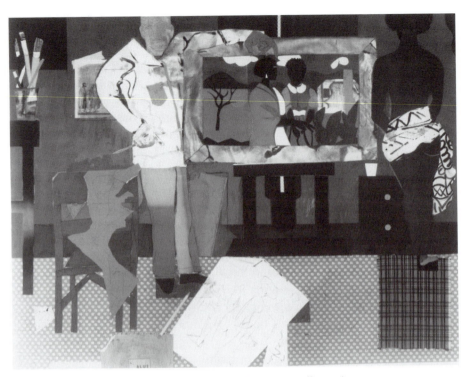

62. Romare Bearden, *Artist with Painting and Model* (private collection).

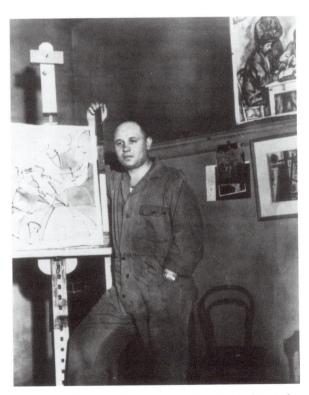

63. Romare Bearden, Photograph of the artist in his studio (whereabouts of the original unknown).

Picasso's simultaneous depictions of figures from multiple viewpoints have fascinated Hockney as he has faced the challenges of figurative painting – "putting our bodies back into space." So has Piero's pictorialism.

Piero's paintings have been touchstones for Hockney, who seeks visual clarity, if emotional ambiguity, in his pictures. "I have always been attracted to clarity in pictures; that is why I love Piero: it seems to me that space is so clear in his paintings. The magic seems to me to be in the space, not in the objects."[25] Hockney's sensibilities indeed have certain affinities with Piero and fellow "primitives" of the early Italian Renaissance: a passion for painting the human figure in illusory spaces and for communicating directly with the viewer. In his pool series from the mid-1960s and early 1970s – for example, *Portrait of an Artist: Pool with Two Figures* – the purity of color, orderly spatial planes, and clarity of air, water, light, and shadow are essentially Piero's. From the 1970s, Hockney's paintings titled *My Parents* and *Looking at Pictures on a Screen* share the luminous stillness of Piero's *Baptism,* a reproduction of which appears in the central background of each picture (Fig. 64).

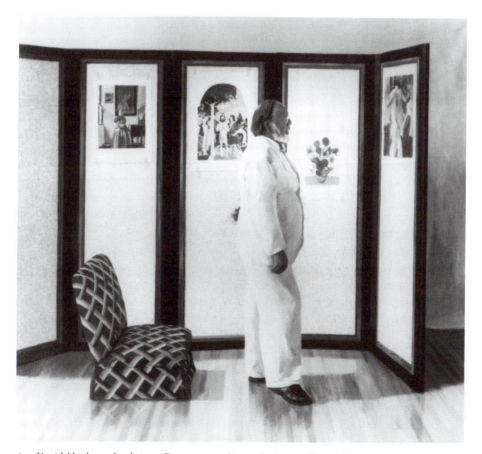

64. David Hockney, *Looking at Pictures on a Screen* (private collection).

Hockney shares Piero's attentiveness to the visual world – copied from nature, in Vasari's words, and transformed into art. So does the American still-life and figure painter William Bailey. Bailey talks about the nature of pictorial space and the problems that it poses just as Hockney does, though their art is vastly different. Bailey defines the essence of his painting, whether figurative or nonfigurative, as flat surface and spatial plane at once; he thinks about literal shapes on surfaces and illusory forms in illusory depths. He describes his work as metaphorical: paintings about places and ideals.

"My paintings," says Bailey, "are like imagined towns." *Still Life, Monterchi*, of 1981, the artist says, "reminded me of Monterchi, a town that looks like it comes right out of Piero della Francesca . . . greenish bluish grays and pinks and ochres." Piero's palette – soft blues, greens, grays, ochers, reds – has been compared to the elemental colors that Leon Battista Alberti prescribed for artists in his mid-fifteenth-century treatise on painting. We see Piero's quattrocento palette reborn in Bailey's paintings of glazed pottery (Fig. 65). He silhouettes a tureen striped in deep blue, a cream-colored pitcher, muted-green and gray vases, ocher jugs and bowls against a slate background. Bailey renders the smooth and soothing surfaces of his still life, his "imagined town," in Piero's colors, once described by Kenneth Clark as restrained to the "point of parsimony."[26]

Monterchi was the birthplace of Piero's mother and is still the home of Piero's *Madonna del Parto* (see Plate 24). Piero's sturdy Madonna stands in the center of an overarching tent, painted to receive the prayers of the faithful and located, from the late eighteenth century until recently, in a tiny cemetery chapel. Flanking angels have drawn back curtains to reveal her to us. Almost absent-mindedly, and yet purposefully, she unbuttons her dress to reveal a mystery – her pregnancy. We appreciate Piero's mastery of volume as he situates her within the soft-red tent; gives dimension to her body, elliptical halo, and blue dress; renders her deep-set eyes; and defines her long, bony fingers. We also see Piero's attention to physical surface in the carefully drawn contours of her face, neck, and shoulder, and in the repeated use of one angel, dressed in bluish green with deep rose boots, then rotated, as Longhi first observed, to become the other angel, wearing a robe and boots of inverted color, to frame this young girl of "melancholic purity."[27]

Again the poet Zbigniew Herbert offers a clue to the magnetism of Piero's art for modern painters as diverse as Bailey and Hockney. Herbert's observation that the "absence of psychological expression unveils the pure artistic movement within mass and light," may begin to reveal in part Piero's appeal. In Piero's paintings – the *Baptism*, the Aretine frescoes, the *Madonna del Parto* – water, earth, sky, and shelter harmonize with figures in his foreground dramas. Color, space, and plane have been described as "uniting figures, architecture, and landscapes in a single complex web," a

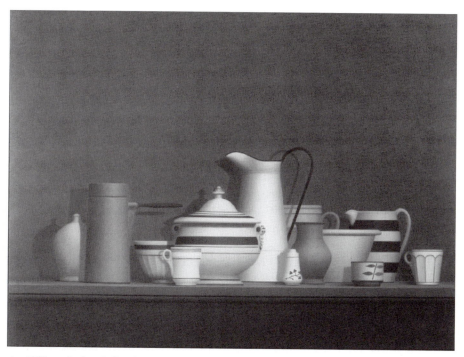

65. William Bailey, *Still Life Monterchi* (private collection).

web that has been called a "family of things . . . affinities between volumes and their intervals."[28] From Cézanne's landscapes to Carrà's, from Bearden's rhythms of void and substance to Hockney's, from De Chirico's imagined towns to Bailey's, from Picasso's structured still lifes to Morandi's, we see the search to establish the integrity of painting, a synthesis of elements at once based on nature and autonomous within it.

Herbert reminds us that Piero's impassive figures and unobtrusive personality attracted writer Bernard Berenson early in this century. Piero "never asks what his actors feel," Berenson writes in his history of the artist. Instead, Berenson suggests, we respond to the figures' solemnity and greatness, without knowing them. Berenson saw emotional detachment not only in what Piero painted but also in how he painted. He cautioned the viewer about Piero's detachment from conventional standards of beauty: "Those who are on the outlook for their favorite type of beauty will receive shocks from certain of Piero's men and women." He admired Piero's impassive figures and hidden self, and he wrote perceptively about Piero's impersonality: "that is the quality whereby he holds us spellbound, that is his most distinguishing virtue."[29] Herbert remarked after Berenson that we know little about Piero's life, "the quiet chanting of the air and the immense planes are the choir against which Piero's persona remains silent . . . his entire being is in his *oeuvre*."

Piero, Guston says, "is so remote from other masters; without their 'completeness' of personality . . . he is like a visitor to the earth, reflecting on distances, gravity and positions of essential forms." We have so few facts about Piero that we have imagined an impersonal life for him, as well as for the seemingly enigmatic figures in his paintings.[30]

In *The Sacred Wood: Essays on Poetry and Criticism*, T. S. Eliot wrote: "The emotion of art is impersonal. And the poet cannot reach this impersonality without surrendering himself wholly to the work to be done. . . . Emotion . . . has its life in the poem, not in the history of the poet." We think of Piero and modern painters as disparate as Mondrian, Edward Hopper, and Balthus, whose art may be described as detached and impersonal. The French painter Balthus proclaimed his painting to be self-sufficient, and himself to be "a painter about whom we know nothing." His figures and spaces have been said to exist between what has happened and what is to come, to synthesize Piero's transcendence and Cézanne's search for new depths.[31] They also embody Guston's tension between the impossible and possible.

Those who see relationships between Piero, Mondrian, Hopper, and Balthus would agree with Eliot's insight that no poet, no artist, has complete meaning alone, that poetry is "a living whole of all the poetry that has ever been written."[32] Piero's balanced, unemotional eye and transcendent vision appeal not only to many modern painters but also to certain contemporary poets after Eliot, who are conscious that their art belongs to larger history, a "living whole."

Former poet laureate Mark Strand muses that in San Sepolcro, "Piero's faces escape triviality because they are incarnations of something beyond this world; or perhaps it is beyondness itself that they seem so much a part of."[33] What Strand calls "beyondness," Jorie Graham describes as the "blazing not-there" of Piero's painting, and Gjertrud Schnackenberg, the "force behind the wall pressing toward you from the other side," in poems inspired by Piero's *Resurrection* (see Plate 1).[34] These poems, like their painted inspiration, express an awareness of Eliot's "present moment of the past . . . not of what is dead but of what is already living."

"Everyone has written about Piero," Strand recently remarked.[35] Seemingly off-handed, his deceptive comment resonates as deeply as Piero's pictures themselves, enticing us to look more closely at these select poets since Eliot who might join the painters in our pierfrancescan *Parnassus*. To do so, we once again return to Vasari and to Raphael.

The Poets

Vasari tells us that Piero was overtaken by blindness – cataracts – in his old age. But he does not recount the poignant story that captured later writers' imaginations, though it dates to his own day.

In the 1550s a lantern maker, Marco, testified
That as a child he had "led Piero by the hand"
Through the streets of Borgo San Sepolcro.
Piero, blind, and following a child guide along

The chessboard of his native city's streets . . .
To the Civic Palace, within the tumbled walls
Of the Town of the Holy Sepulchre. Piero, blind –
Who once, with earth imported from the Black Sea,

Had dusted pinhole pricks on tracing sheets,
To trace the Dream of Constantine on the wall . . .

So begins "The Resurrection" in Gjertrud Schnackenberg's *A Gilded Lapse of Time*. A record in San Sepolcro's archives states that in 1556 Marco di Longaro told Berto degli Alberti that when he was small, he had led the blind Piero della Francesca by the hand.[36] In her poem, Schnackenberg uses the story to compress ancient and modern time, from the pagan era to the age of Christianity and from Piero's century to our own. We participate in an imaginary moment when the aged Piero, standing before his fresco of the *Resurrection:*

 . . . lifts his outstretched hand from Marco's shoulder,
 As if he groped for the lip of a stone coffin

 From antiquity set only inches away from where
 The blind man appears to be staring in fright
 Into God's face. Behind him the pink twinkle
 Of twilight is a banner moist with one drop

 Of Jewish blood; before him, the distant
 Blue mountain of Purgatory. His fingertips touch
 Only the picture-shadowing earth from the Black Sea.
 Once he could squint at *The Resurrection* through

 An ever-smaller pinhole of light. . . .

In a later stanza, Schnackenberg writes:

 Now he stands sightless with his empty hand

 Outstretched at the rough edge of the sepulchre
 Recently broken open, before which
 Jesus has turned to Piero, holding out to him
 Death's unraveled, pitiful bandages.

Schnackenberg allows us to imagine seeing the resurrected Christ through the dimming eyesight of his painter. Doing so, she revives the Renaissance idea of artist as creator, touching his frescoed god, who in turn reaches out

to him. The power of the painting elicits powerful poetry, its perfect coun-
terpart. The poem places Piero within the context of "what is already liv-
ing," in Eliot's words. The poet writes of what has come before Piero's
painted *Resurrection* – the ancient Roman crucifixion – and what has
come after – the Russian and European persecutions of our own age.

In Piero's painting, Christ rises from his sepulcher while soldiers sleep.
One of those sleeping soldiers – said to be Piero's self-portrait – is pictured
by Schnackenberg at the tomb after the Crucifixion "counting stars to stay
awake," aware that the world, a "stone sphere," is grinding past on the eve
of a new era that has already transformed Palestine and Rome.

> Don't let your head
> Tilt back, don't look up toward
> The heaven's starry gulf and close your eyes,
> Because you must not fall
> Asleep. You must not sleep. . . .
>
> There is an atrocious
> Implication here.
> So lower your head,
> Keeping your eyes
> Closed, as if that way nothing
> Will be disclosed.
> But you must not fall asleep,[37]

Lingering in the poem is something of the solemnity that Berenson saw in
Piero's resurrected Christ, who emerges in "the grey watered light of
morning." Berenson's perceptions haunt Schnackenberg's verses and,
before her poem, Kenneth Clark's poetic writings about the painting: "This
country god, who rises in the grey light while human beings are still
asleep, has been worshipped ever since man first knew that seed is not
dead in the winter earth, but will force its way upwards through an iron
crust. . . . His first emergence is painful and involuntary. He seems him-
self to be part of the dream which lies so heavily on the sleeping soldiers,
and has Himself the doomed and distant gaze of a somnambulist."[38] Piero's
Christ in the *Resurrection* – whom Clark calls a "slain god" – looks out
from hollow eyes, as though he has seen the harrowing of hell.

Piero's *Resurrection* may well exemplify "great art," characterized by
poet Charles Wright as tending "toward the condition of the primitive . . .
and toward the mysteries."[39] Great art, Wright says, provides "lifelines to
the unseen." Although written in an essay on Giorgio Morandi's drawings
– embodiments of Platonic form and divine perfection – Wright's con-
templations lead us back, through Morandi, to Piero and the *Resurrection*.
Wright has shared thoughts about this painting in language reminiscent of
Clark's: "The stare and look that come from another world and that keep
our own eyes focused, our own feelings reticent but seeping like ground

water up through the roots of things. . . . I wish I had a few strokes of his edgy and difficult grace. I wish I had that gaze from the *Resurrection,* and saw what it saw."[40]

That grace, that gaze – sharp-edged and hard won – draw us to Piero's painting and to Wright's poetry. Among his keen observations about our place in nature, Wright locates one poem, "With Eddie and Nancy in Arezzo at the Caffe Grande," in the piazza outside San Francesco. Inside, Piero's cycle is "in wraps, the True Cross *sotto restauro*":

> No matter if one is young or old –
> The pain of what is present never comes to an end,
> Lightline moving inexorably
> West to east across the stones
> cutting the children first, then cutting us.[41]

Wright concludes the poem: "One life is all we're entitled to, but it's enough." Lifelines and lightlines to the unseen. Piero may not ask what his "actors" feel, as Berenson has said, but his "actors" ask us to wonder – as do Wright, Schnackenberg, Berenson, and Clark – about what they see, fixed in their "present moment of the past." Schnackenberg's poem entices us to see the image and historical consequences of a slain god through a blinded painter's eye. Wright's words encourage us to consider the cold nature of temporal things through a poet's vision, inspired by the painter.

Great art – lifelines to the unseen, aspiring to the primitive and to the mysterious at once – may emerge from Piero's epiphanies. His paintings synthesize form and content, substance and spirit. Piero's resurrected Christ rises from his Holy Sepulcher, painted for the town of San Sepolcro (Holy Sepulcher) and Piero's birthplace, said to have been founded by pilgrims bearing relics from Christ's tomb. In Arezzo's *Legend of the True Cross,* Constantine's spiritual enlightenment illuminates the night scene, at once natural, miraculous, and cyclic, re-creating Christian mysteries such as the Liberation of St. Peter, later to be painted by Raphael. In Monterchi, a tent (*tabernaculum*) enshrines Piero's *Madonna del Parto* – Mary, the mother of God. She is, herself, the very tabernacle of the Lord, as art historians have observed, bearing her son, the fruit of her womb, as in the ageless prayers and salutations to her.[42]

Jorie Graham's poem, "San Sepolcro," cuts to the quick of Piero's painting.[43]

> It is this girl
> by Piero
> della Francesca, unbuttoning
> her blue dress,
> her mantle of weather
> to go into

labor. Come we can go in.
 It is before
the birth of god.

Kenneth Clark found Piero's image astonishing: the Madonna, a "buddhist sculpture in its calm detachment," her gesture natural, shameless, and miraculous.[44] "This is what the living do: go in," Graham perceives:

 It's a long way.
And the dress keeps opening
 from eternity

to privacy, quickening.
 Inside, at the heart,
is tragedy, the present moment
 forever stillborn,
but going in, each breath
 is a button

coming undone, something terribly
 nimble-fingered
finding all of the stops.

"No painter," writes Clark, "has shown more clearly the common foundations of medieval culture of Christianity and paganism." Clark's response and Graham's vision echo W. B. Yeats's poetry earlier in this century: "What rough beast, its hour come round at last/slouches toward Bethlehem to be born?"[45] Piero's image poses the compelling question (see Plate 24).

"At Monterchi there was the *Madonna del Parto* by Piero della Francesca, located in the chapel next to the town graveyard," so writes Michael Ondaatje in *The English Patient*.[46] He begins chapter 3 of his book with a statement as poignant and troubling as the novel itself: "The last mediaeval war was fought in Italy in 1943 and 1944." Though Europe has seen more medieval wars in the Balkans since then, the novelist describes the English patient's war, World War II. "Mediaeval scholars were pulled out of Oxford colleges and flown into Umbria. . . . They were billeted with the troops. . . . They spoke of towns in terms of the art in them."[47]

Art serves as a leitmotif throughout the novel. Raphael's *Stanze* are mentioned, but Piero's frescoes play a prominent role. As Piero's own backgrounds provide harmonious settings for his dramas, so Piero's art in Ondaatje's novel serves as a stabilizing backdrop against which the chaos of war unfolds and the protagonists, Kip, Hana, and the English patient struggle to survive.

"Character, that subtle art, disappeared among them during those days and nights, existed only in a book or on a painted wall." Ondaatje's narrative persists: "There was no order but for the great maps of art that showed

judgement, piety, and sacrifice." Troops in the novel see Eliot's "present moment of the past," finding the faces of their dead contemporaries in Piero's *Legend of the True Cross* at Arezzo, where soldiers' throats have been run through by enemy swords.

Piero's Queen of Sheba provides comfort for Kip, a sapper among mud-drenched soldiers who diffuse bombs and find "river after river of destroyed bridges," fortifying or demolishing as they go. In Piero's fresco, the Queen of Sheba kneels before a bridge built of the sacred wood. She knows that it is wood from the Tree of Knowledge, that a branch from the tree had grown over Adam's grave, and that the wood will later become the cross of Christ's Crucifixion and Christian redemption. Piero paints her with a simple veil and dress, long neck, long hands. Her entourage of regal women balances King Solomon's male courtiers in the next scene (see Plate 10).

The young Sikh sapper put his cheek against the mud and thought of the Queen of Sheba's face, the texture of her skin. . . . He would pull the veil off her hair. He would put his right hand between her neck and olive blouse. . . . Who was sadder in that dome's mural? He leaned forward to rest on the skin of her frail neck. He fell in love with her downcast eye. This women who would someday know the sacredness of bridges.

We visualize Piero's Queen of Sheba, her head bowed, her olive-brown robe draped in a blue mantle. Kip's longing to remove the Queen's veil reminds us of the Renaissance belief that poetry is veiled truth itself, and thus, so is painting.

The meeting of Solomon and the Queen of Sheba has been interpreted as an Old Testament prefiguration of the New Testament's Adoration of the Magi, as a moment of transformation between the Judaic and Christian traditions, and as a reference to exchanges between Byzantium and Italy in Piero's day. The meeting of Eastern and Western cultural histories is a thread that Ondaatje weaves throughout his novels and his poems. A native of Sri Lanka and a resident of Toronto, the author spins his war-torn tale about the intertwining lives of the Indian Kip and Canadian Hana in Catholic Italy, played out against Piero's painted history of the Jewish faith and Christian church. The atomic bomb finally severs the protagonists' connection, separating Asia and Europe in Kip's mind. Yet the story contains moments of grace and redemption. He hoists himself by rope into the vaulted apse of San Francesco to view Piero's frescoes up close; "he pulleyed himself across to her face, his Queen of Sadness, and his brown hand reached out small against the giant neck."

The sapper's gesture may be metonymous for our responses to Piero, as we continue to measure ourselves against his art. Piero's has become an epic tale of an epic painter – a mysterious master of mathematical and light-filled art – synthesizing the lessons of early quattrocento painting and

continuing to influence artists centuries later. Clark describes the poetry of Piero's painting as filled with both "unforgettable simplicity and completeness of imagination." Piero sings visually of medieval Christian Europe's gods, battles, heroes, villains, and peasants who follow the footprints of ancient Greece, Rome, and Jerusalem. Piero paints "profoundly antique" subjects, humanity, seasons, and miracles, with the harmony and proportion worthy of Pythagorus's divine geometry, immortalized in Raphael's *School of Athens* adjacent to the *Parnassus*.[48] If Raphael's art elevates and idealizes saints and apostles, philosophers and poets with grace and goodness, Piero's plumbs the rustic and primordial depths of the Christian kingdom to its pagan roots.

It is said that poetry is "painting that speaks" and painting "silent poetry." Piero – as a silent poet and, we remember, as a blind painter, according to Vasari and Schnackenberg – stands within a timeless, imaginary *Parnassus* of sightless and insightful poets and protagonists: Homer, Shakespeare's Lear, Milton, Eliot's Tiresias. The blind Piero shares the quality of insight with Raphael's blind Homer as depicted in his *Parnassus*.

In Raphael's *Parnassus,* Homer descends from Dante's "singing master of the earth," the poetic soul whom Dante and Virgil encounter with Ovid, Horace, and Lucian in the *Inferno*."[49] Vasari describes Raphael's imaginary portrait of Homer as we see it today, "with his head raised up . . . reciting verses which are being written down by a boy sitting at his feet."[50] Reflecting on Piero's archival anecdote that grew into a similar legend – that is, Piero as the aged, blind artist led by the boy Marco di Longaro – the poet Zbigniew Herbert says: "Little Marco could not have known that his hand was leading light."

These are analogous images of insight. Poet and painter: one boy listening to Homer, to record his poetry; one boy guiding Piero, to touch his painting. Renaissance painting about an ancient poet; contemporary poetry about a Renaissance painter: Eliot calls this heritage "tradition," an artistic "mind" that "changes" but "abandons nothing en route," meaning the painters and poets within it.[51] The archives may leave Piero in the darkness and anonymity of old age. The poets restore him, blinded but reaching out to an art that elevates life.

Piero's art retains its mysteries. His virtual *Parnassus* – the place of his modern reception – continues to gather painters and poets, scholars and critics, readers and viewers who perceive order and meaning there. Romanticists or scientists, we continue to measure ourselves against it.[52] Piero's painting has thus far survived wars, restorations, and the "isms" of academia – neoplatonism, neoimpressionism, modernism, formalism, new criticism, futurism, magical realism, postmodernism, new formalism. It lends itself to Wright's numinous visions of nature; Graham's metaphysics, her irradiating poems of body and spirit; Schnackenberg's visionary lyricism, as searing as it is subtle:

If I could begin again,
Time is something I would measure
In the generations of roses, evolving across
Gulfs we have no records of,
Eons without archives,
Eras without witnesses . . .

Roses and not the succession
of rulers of men . . .

Flowering past . . .

portraits of
The heads of households,
Of beloved daughters, blind rhapsodists,
Of gods reduced to begging with
Their delicate hands held out midair, . . .[53]

Like palimpsests, these closing stanzas from *A Gilded Lapse of Time* give way to Piero's images. Piero's *Resurrection* underlies this verse, as it does Graham's "Easter Morning Aubade," in which a soldier awakens at the tomb and his "skull feels itself to be/inside of something which it cannot see."[54]

In our ongoing search to know "the great maps of art," Piero offers us a glimpse of sacred bridges, of Eliot's sacred wood, of "what is already living." Piero's paintings allow us to imagine "an eternal order of light and balance. . . . Little Marco could not have known that his hand was leading light."

Notes

INTRODUCTION

1. Giorgio Vasari, *The Lives of the Artists,* trans. George Bull, vol. 1 (Harmondsworth, 1980), 194–96.

2. Ibid., 191.

3. Vasari, 193–94, proclaimed it "the best work he did either in Borgo or anywhere else." For its original position higher on the wall, see R. Lightbown, *Piero della Francesca* (New York: Abbeville, 1992), 197–98. Also see Lightbown, 196–98, and the essay by D. Cole Ahl in this volume for the relics, which included stone from Christ's burial site. The fresco offers a glimpse into communal politics. Under Florentine rule Sansepolcro retained a legislative council and its four magistrates, but decisions had to be authorized by the Florentine *capitano.* Local resentments simmered beneath the surface after the Florentines revoked the office of *Gonfaloniere della Giustizia* in 1441 and appropriated the municipal palace for themselves. In 1456 the Florentines increased communal autonomy, mostly symbolically, by allowing the *Conservatori* to reside again in the building, and in 1460 by reinstating the *gonfaloniere,* as the *capitano* Ludovico Accaiuoli requested. The *Resurrection* was probably commissioned soon after the refurbishment of the magistrates' chamber in 1458 (Lightbown, 197–98), and the town commemorated Accaiuoli by commissioning Piero to paint a fresco of his patron saint, Louis of Toulouse (and a now lost inscription praising him) in the Palazzo del Capitano. Lightbown, 203–5, points out that authority still rested with the Florentines, who appointed Accaiuoli himself as the first *gonfaloniere.*

4. For the history of the town, see J. R. Banker, *Death in the Community: Memorialization and Confraternities in an Italian Commune in the Late Middle Ages* (Athens, GA, 1988), 75–76, and L. Coleschi, *Storia della città di Sansepolcro* (Città di Castello, 1886; reprint ed. 1964 by Polcri).

5. Piero, the son of Benedetto di Piero della Francesca and his second wife Romana, of nearby Monterchi, was born sometime between 1415 and 1420. Romana was the daughter of Pierino di Carlo di Monterchi, who was also apparently prosperous. Piero had an older sister and two surviving brothers, Marco and Antonio. For an explanation of the family name dei Franceschi or

della Francesca, see Lightbown, 11–12, and J. R. Banker, "The Altarpiece of the Confraternity of Santa Maria della Misericordia in Borgo Sansepolcro," in *Piero della Francesca and his Legacy, National Gallery of Art Studies in the History of Art,* 48, ed. M. Aronberg Lavin (Washington, DC, 1995), 21 (hereafter Lavin, 1995). For Piero's birth date, also see Banker, in Lavin, 1995, 24.

6. For Piero's training and education, see Lightbown, 12–18, and P. Grendler, "What Piero Learned in School: Fifteenth-Century Vernacular Education," in Lavin, 1995, 161–73. Also see F. Dabell, "Piero della Francesca e la committenza francescana: appunti per un'indagine," in *Piero della Francesca: Pollitico di Sant'Antonio,* ed. V. Garibaldi (Milan, 1993), 73–78, for Piero's "networking."

7. His assistance to Antonio d'Anghiari included the main altarpiece for the church of San Francesco, which was recommissioned from the Sienese artist Sassetta in 1437. See J. R. Banker, "The Program for the Sassetta Altarpiece in the Church of San Francesco in Borgo S. Sepolcro," in *I Tatti Studies: Essays in the Renaissance* 4 (1991): 11–58, for the documentation. The amount of the payment indicates that he was either a collaborator or assistant to Domenico, see Lightbown, 14–16.

8. Illustrations of the works cited in this paragraph are in F. Hartt, *Italian Renaissance Art,* 4th ed. revised by D. G. Wilkins (New York, 1994).

9. L. B. Alberti, *On Painting,* trans. C. Grayson (London, 1991). By 1436 Alberti had translated the Latin original of 1435 into an Italian version, which he dedicated to the architect Brunelleschi.

10. For a detailed discussion of this project, see the essay by D. Ahl in this volume, and Banker in Lavin, 1995, 21–35.

11. Ibid., for the relationship with the Pichi family; also see Lightbown, 27–31. The date of this treatise is uncertain: some scholars suggest c. 1450, but most others propose a date in the 1480s; see the essays by M. Daly Davis and J. V. Field in this volume.

12. Sansepolcro was ruled by the Malatesta family of Rimini from 1371 until Carlo Malatesta's death in 1429, when the papacy gave the town to the mercenary captain Niccolò Fortebraccio for a brief period and then sold it to Florence in 1441 as payment for debts incurred at the 1439 Council of Florence. Sigismondo was the nephew of Carlo. For Piero and Sigismondo, see J. Woods-Marsden's essay in this volume.

13. The *Saint Jerome* in Berlin is inscribed PETRI DE BVRGO OPVS and dated 1450 on a *cartellino. Saint Jerome with Girolamo Amadi* (a patrician of Venice) is signed PETRI. DE BV/RGO. SCI. SEP/VLCRI.OPVS and reasonably dated c. 1452 by Lightbown, 76–82. See T. Verdon's essay in the present volume for this kind of small devotional painting.

14. Vasari mistakenly names Federigo's son Guidobaldo as Piero's chief patron. For Piero's work in the North Italian courts, see Woods-Marsden's essay in this volume.

15. The altarpiece was commissioned by Angelo di Giovanni di Simone, his brother Simone, and the latter's wife Giovanna (Lightbown, 207–8). For a discussion of the clothing in what remains of this altarpiece, see J. Bridgeman's essay in this volume; for the historical context of Piero's altarpieces in Sansepolcro, see C. Gardner van Teuffel, "Niccolò di Segna, Sassetta, Piero della Francesca and Perugino: Cult and Continuity at Sansepolcro," *Städel Jarhrbuch* 17 (1999):

163–208. For an illustration of the S. Louis of Toulouse, see Lightbown, 204, fig. 81.

16. For the dating of Piero's house to about 1470, his possible responsibility for the architectural design, and the extant *Hercules* (now in the Isabella Stewart Gardner Museum, Boston) from the lost fresco cycle, see Lightbown, 65–68, and fig. 112.

17. For the dating of Piero's treatises, see the essays by Davis and Field in this volume. Piero also painted the Williamstown Madonna for Cristoforo Gherardi in c. 1480–81; see Lightbown, 270–74, for the Williamstown Madonna as well as for the *Adoration of the Child*. In her essay in this volume M. Aronberg Lavin alternatively proposes that the *Adoration* was intended for Piero's tomb.

18. In 1476 Pedro Berruguete repainted the duke's hands and painted out a jewel crowning the Madonna's head, see Lightbown, 254, and Carlo Bertelli, *Piero della Francesca* (New Haven: Yale University Press, 1992), 137–38.

19. Tucked behind these four are two distinguished monastic preachers, the Franciscan Bernardino of Siena on the left, and the Dominican Peter Martyr on the right.

20. Approximately one-ninth of the length has been cut from the Brera Altarpiece; see Lightbown, 245. The altarpiece is a *sacra conversazione,* a type of religious painting that dates back to Fra Angelico's San Marco Altarpiece of the late 1430s in which a celestial court of judgment comprised of the Virgin and saints acts as advocates for the soul of the donor. As Lightbown, 250–53, observed, the notion that the soul is judged immediately after death (the "particular judgment") is inherent to the *sacra conversazione.*

21. Like the "congestion" of figures in the foreground of Piero's *Baptism of Christ,* observed by Michael Baxandall; see his *Patterns of Intention: On the Historical Explanation of Pictures* (New Haven: Yale University Press, 1985), 127.

22. See Baxandall, 13, for Pacioli's remark. The egg has elicited much commentary from scholars; see Lightbown, 252–53, for a concise summary of previous interpretations and his own connection of the egg with Easter celebrations.

23. The translation is from Baxandall, 112; for a slightly different English version see J. V. Field's essay in this volume. For the Italian, see Piero della Francesca, *De prospectiva pingendi,* ed. G. N. Fasola (Florence, 1984), 63–64.

24. The modern term "horizon line" compares to Alberti's "centric line"; see Alberti, 40–41.

25. As Baxandall, 113, explains it: "*Commensurazione's* reference can be taken as to a general mathematics-based alertness in the total arrangement of a picture, in which what we call proportion and perspective are keenly felt as interdependent and interlocking."

26. Piero's slightly enlarged Madonna unobtrusively implies her queenly stature within the celestial court; as Lightbown observed, 252, the Brera Altarpiece represents a *curia* or court in heaven.

27. In spite of the popularity of the Madonna, he does not specify how to draw a woman.

28. See the essays by Field and Davis included in this volume. Field, emphasizing Piero's use of instructional rather than numerical terminology in the treatise, proposes the *Prospectiva* was a training manual for apprentices in painting (one assumes using an Italian version), though also remarking upon the

fact that later borrowings from the treatise exclude the lengthy expositions in Book 3. Davis argues that Piero's examples – houses, columns, doorways – indicate its greater importance for architects and for designers of *intarsia* (marquetry) than for painters. She refers to the intarsia crafted by Piero's friends the Lendinara family of Ferrara, who are also mentioned in Pacioli's *Summa,* which incorporates Piero's treatise. By the 1470s Piero had supervised several complicated projects, such as the Arezzo frescoes; thus, when he guides the reader by means of exacting directions and drawings, we are reminded of the preparation required for quality control on enterprises that employed numerous assistants of varying competence. Such practicality surely would have interested masters like Francesco di Giorgio, who faced comparable responsibilities at the busy Montefeltro court.

29. The chronology of Piero's treatises has sparked debate among historians of art and mathematics. For the possible dates of the abacus treatise (ranging from c. 1450 to 1480s) and the Urbino treatises (1480s to 1492), see the essays by Davis and Field in this volume.

30. Guidobaldo's 1472 birth date points to composition in the late 1480s (see Davis's essay in this volume). Piero may well have dedicated the *Libellus* to the young duke as a reminder of his past work for his father – his paintings as well as *De prospectiva* – and his willingness to continue his services for the court.

31. That is, during the years in which he painted the portraits of Duke Federigo and Battista Sforza, and in which he likely began the Brera Altarpiece. The rationally designed architecture of the latter (unfinished but probably known through a presentation drawing) likely elicited a favorable response from the duke as well. For Piero's projects for the Duke of Urbino, see Woods-Marsden's essay in this volume.

32. The intellectual and artistic climate at Urbino during these years would have been especially inclined to give a positive reception to Piero's treatise. In addition to humanist literary scholars and mathematicians, Federigo's court included several architects, engineers, painters, and sculptors (i.e., Luciana Laurana, Giovanni Santi, and Francesco di Giorgio) apparently educated in mathematics and classical texts. The long-term projects under way at Urbino during the 1470s and 1480s – the intarsia doors and the *studiolo* among others – are suggestive in light of Davis's emphasis on the value of Piero's geometry for architects and designers of intarsia.

33. The painting in Urbino, as well as two similar pictures in Berlin and Baltimore, have also been assigned to Luciana Laurana, the first architect of the palace, his successor Francesco di Giorgio, and the Urbinese painter-architect Bramante. For the representations of ideal cities, see P. Jacks's essay in this volume.

34. Alberti, 88. The copies of Piero's *Prospectiva* in both Latin and Italian, like the complementary editions of Alberti's *De Pictura* for patrons and painters, hint at a secondary readership comprised of artists. Francesco di Giorgio, the architect of the palace in the late 1470s and early 1480s, composed treatises on architecture, and the painter Giovanni Santi refers to the importance of mastering the art of perspective throughout his rhymed encomium to the Montefelto dukes. For an English translation of a section of Santi's *Cronaca rimata,* see C. Gilbert, *Italian Art, 1400–1500, Sources and Documents* (Evanston, IL, 1992), 94–100.

35. For a table listing the various dates proposed for Piero's paintings, see Lavin, 1995, 14–16.
36. Giovanni da Piamonte returned to repair damage to the paintings in 1486–87; see Lightbown, 131, and G. Centauro, *Dipinti murali di Piero della Francesca: La basilica di S. Francesco ad Arezzo* (Milan: Electa, 1990), 113. Also see Vasari, 196–97; and for the mysterious Piero da Castel della Pieve, D. Franklin, "The Identity of a Perugian Follower of Piero della Francesca," *Burlington Magazine* 135 (1993): 625–27.
37. His subsequent contracts for a processional banner, a now lost *Annunciation* commissioned in 1466, and a fresco of Mary Magdalen in the cathedral also support the notion of a shop at Arezzo; see Lightbown, 180–85.
38. Lavin, 1995, 14, for the widely varying dates proposed for this work.
39. For the dating of the True Cross frescoes, see the bibliography for my essay in this volume.
40. For analysis of the clothing of the three men, who wear a Greek hat on the left and fifteenth-century Italian brocade on the right, see Bridgeman's essay in this volume. The garment Piero usually reserves for angels, worn by the barefoot youth in the center, is inexplicable as well. For the various identifications of the figures, see Lavin, 1995, 17. Discerning a resemblance between the brocade-attired man and Francesco Sforza, Lightbown, 67–69, recently has proposed the duke's consort Bianca Maria Sforza, who favored the crusades, as the patron, and an early dating of c. 1448–49 to accommodate a provenance in Pesaro (before Sforza's move to Milan in 1450). By this reasoning, the painting could have been moved to Urbino at any time before the eighteenth-century inventory because of the kinship among the Sforza, Montefeltro, and della Rovere families, who ruled both towns.
41. See V. Garibaldi, *Piero della Francesca, Il polittico di Sant'Antonio* (Perugia: Electa Editori Umbri, 1993), 19–44. Several of the essays in this volume, which commemorates the 500th anniversary of Piero's death, have reevaluated the iconography and historical context of the polyptych.
42. The Baglioni connection was advanced by Battisti, and more recently in Lightbown, 218–20. For the 1468–69 documents referring to transactions regarding this property (which date back to c. 1458), see F. Mancini, "'Depingi ac fabricari fecerunt quandam tabulam. . . .' Un punto fermo per la cronologia del polittico di Perugia," in Garibaldi, 68. According to S. Balzani, "Il monastero e il polittico: dati d'archivio e memorie," in Garibaldi, 45–46, Ilaria was permitted to leave the convent of S. Maria in Vangloria at Spello in 1460; at Sant'Antonio she was the *ministra* (roughly equivalent to an abbess) for the first time in 1479, and again in 1481 and 1485.
43. Based on what can be gleaned from the surviving lateral panels, see Lightbown's discussion, 207–18, and Gardner van Teuffel, 194–95, and fig. 67 for a reconstruction of its appearance.
44. For example, Niccolò d'Alunno's polyptych now in the Vatican, see Garibaldi, 40, fig. 19.
45. That is, the gold cloth functions like a traditional gold background. Placed in its original setting with Matteo di Giovanni's wings of Saints Peter and Paul standing before gold backgrounds, Piero's "naturalistic" *Baptism* produces a similar effect (for a color illustration, see Lightbown, 110). For a stimulating discussion of the contrast between the temporal and the infinite, see Y. Bon-

nefoy, "Time and the Timeless in Quattrocento Painting," in *Calligram: Essays in New Art History from France,* ed. N. Bryson (Cambridge and New York, 1989), 8–26.

CHAPTER 1. *THE MISERICORDIA POLYPTYCH:* REFLECTIONS ON SPIRITUAL AND VISUAL CULTURE IN SANSEPOLCRO

1. From diocesan report published in Maria Zita Miliani, "I disciplinati di Sanse-polcro e l'orazione delle Quarant'ore," *tesi di laurea,* Università degli Studi di Perugia, Facoltà di Magistero Corso di laurea in materia letterarie, 1967–68, 155.

2. Sansepolcro, Museo Civico. Central panel: *Madonna of Mercy with worshippers,* 139 × 91 cm. *Crucifixion,* 81 × 52.5 cm. Left panel: *Saint Sebastian,* 108 × 45 cm. *Saint John the Baptist,* 108 × 45 cm. Right panel (on same panel): *Saints John the Evangelist and San Bernardino of Siena,* 109 × 90 cm. Small panels: *Saint Benedict of Nursia,* 54 × 21 cm; *Archangel Gabriel,* 55 × 20.5 cm; *Virgin Annunciate,* 54 × 21 cm; *Saint Francis of Assisi,* 54.5 × 21 cm. Left pilaster: *Penitent Saint Jerome, Saint Anthony of Padua, Saint Arcanus.* Right pilaster: *Saint Augustine, Saint Dominic, Saint Giles of Sansepolcro.* On the base of each: MIA (MI[SERICORDI]A), the insignia of the Misericordia. Predella: *The Agony in the Garden, The Flagellation of Christ, The Entombment of Christ, Noli me tangere, Three Maries at the Sepulcher,* 22.5 × 260 cm.

3. Miliani, 134–61; and James R. Banker, *Death in the Community: Memorialization and Confraternities in an Italian Commune in the Late Middle Ages* (Athens: University of Georgia Press, 1988), 150–53, passim, who considers its history through the early fifteenth century.

4. The original frame was destroyed in the seventeenth century and the altarpiece sawn into separate panels in an effort to "modernize" it; the present reconstruction dates to 1975. For proposals on its original appearance and its condition, see Anna Maria Maetzke and D. Galoppi Nappini, *Il Museo Civico di Sansepolcro* (Florence: Arti grafiche Giorgi & Gambi, 1988), 31–34; and Carlo Bertelli, *Piero della Francesca,* trans. Edward Farelly (New Haven: Yale University Press, 1992), 172–74. James R. Banker, "The Altarpiece of the Confraternity of Santa Maria della Misericordia in Borgo Sansepolcro," in *Piero della Francesca and His Legacy,* ed. Marilyn Aronberg Lavin, Studies in the History of Art 48, Center for Advanced Study in the Visual Arts, National Gallery of Art, Washington (Hanover, NH: University Press of New England, 1995), 22–23, 29 (doc. 2), has established definitively that it was a buttressed altarpiece. This type is described by Christa Gardner von Teuffel, "The Buttressed Altarpiece: A Forgotten Aspect of Tuscan Fourteenth Century Altarpiece Design," *Jahrbuch der Berliner Museen* 21 (1979): 21–65.

5. Roberto Longhi, *Piero della Francesca,* 1st ed. (Florence: Sansoni, 1927), 34; followed by Kenneth Clark, *Piero della Francesca* (London: Phaidon Press, 1951), 223; and Philip Hendy, *Piero della Francesca and the Early Renaissance* (New York: Macmillan, 1968), 50; identified the saint as Andrew, a conclusion correctly disputed by Eugenio Battisti, *Piero della Francesca,* 2 vols. (Milan: Istituto editoriale italiano, 1971), 1: 97 n. 122.

6. Lorenzo Coleschi, *La storia di Sansepolcro dalle origini al 1860,* ed. Franco Polcri (Sansepolcro: Editrice C.L.E.A.T., 1966), 9–28; and Mario Sensi, "Arcano e Gilio, santi pellegrini fondatori di Sansepolcro," in *Vie di pellegrinaggio*

medievale attraverso l'Alta Valle del Tevere, Atti del convegno, Sansepolcro, September 27–28, 1996, ed. Enzo Mattesini (Sansepolcro: Petruzzi Editore, 1998), 17–58.

7. Ronald Lightbown, *Piero della Francesca* (New York: Abbeville Press, 1992), 11, 30.

8. For the early works noted here, see Frank Dabell, "Antonio d'Anghiari e gli inizi di Piero della Francesca," *Paragone* 35 (1984): 73–94; and James R. Banker, "Piero della Francesca as Assistant to Antonio d'Anghiari in the 1430s: Some Unpublished Documents," *Burlington Magazine* 135 (1993): 16–21.

9. James R. Banker, "Un Documento Inedito del 1432 sull'Attività di Piero della Francesca per la Chiesa di San Francesco in Borgo San Sepolcro," *Rivista d'arte* 43 (1990): 245–47.

10. James R. Banker, "The Program for the Sassetta Altarpiece in the Church of S. Francesco in Borgo S. Sepolcro," *I Tatti Studies: Essays in the Renaissance* 4 (1991): 11–58.

11. See the many publications of Ercole Agnoletti, especially *Sansepolcro nel periodo degli abati, 1012–1521* (Sansepolcro: n.p., 1976).

12. Sensi, 26–27.

13. Sensi, 47, from account of c. 1441–49.

14. Sensi, 44.

15. Alberto Fatucchi, "Borgo Sansepolcro, nodo viario dei pellegrini," in Mattesini, 59–90.

16. The authoritative study is by Banker, 1988.

17. The vast literature on Italian confraternities is too extensive to cite here. Konrad Eisenbichler, "Italian Scholarship on Pre-Modern Confraternities in Italy," *Renaissance Quarterly* 50 (1997): 567–80, surveys recent contributions. See also the Introduction to *Confraternities and the Visual Arts in Renaissance Italy: Ritual, Spectacle, Image,* eds. Barbara Wisch and Diane Cole Ahl (Cambridge: Cambridge University Press, 2000), 1–19.

18. Banker, 1988, 153.

19. See the proceedings of two conferences, *Il movimento dei disciplinati nel settimo centenario del suo inizio, 1260* (Perugia: Deputazione di Storia Patria per l'Umbria, 1962); and *Risultati e prospettive della ricerca sul movimento dei disciplinati* (Perugia: Deputazione di Storia Patria per l'Umbria, 1972). English scholarship on the flagellant movement includes John Henderson, "The Flagellant Movement and Flagellant Confraternities in Central Italy, 1260–1400," *Studies in Church History* 15 (1978): 147–61; Ronald F. E. Weissman, *Ritual Brotherhood in Renaissance Florence* (New York: Academic Press, 1982), 50–80, 92–105; and Nicholas Terpstra, *Lay Confraternities and Civic Religion in Renaissance Bologna* (Cambridge: Cambridge University Press, 1995), 38–82.

20. Banker, 1988; and Banker, "Death and Christian Charity in the Confraternities of the Upper Tiber Valley," in *Christianity and the Renaissance: Image and Religious Imagination in Fifteenth-Century Florence,* eds. Timothy Verdon and John Henderson (Syracuse: Syracuse University Press, 1990), 302–37.

21. The statutes, partly transcribed by Miliani, 135–51, are preserved in Sansepolcro, Archivio della Biblioteca Comunale, Archivio di Santa Maria della Misericordia (henceforth SS, AC, AM), no. 154 (Capitoli di Santa Maria della Misericordia).

22. Preserved in Sansepolcro, Museo Civico. Enrico Bettazzi, "Laudi della città

di Borgo S. Sepolcro," *Giornale storico della letteratura italiana* 18 (1891): 242–76, and *Laudario della Compagnia di S. Maria della Notte*, eds. Giuliana Maggini e Luigi Andreini (Sansepolcro: Cooperativa Culturale "Giorgio La Pira," 1979), ascribe it to a *laudesi* confraternity on the basis of its Marian lauds. However, the Marian emphasis, the references to the Madonna of Mercy, and the Misericordia's insignia (MIA) on its fifteenth-century cover, indicate that it belonged to Santa Maria della Misericordia, as Lightbown, 285 n. 11, has concluded.

23. Maggini and Andreini, 180–81; laud dated 19 January 1449.

24. Ivano Ricci, *La fraternità di S. Bartolomeo* (Sansepolcro: Tipografica "La Resurrezione," 1936), 19–20.

25. Agnoletti, 1976, 91; Banker, 1988, 150.

26. The complex has been accorded insufficient scholarly attention. See Daniela Cinti, *Le mura medicee di Sansepolcro: La storia e il recupero di un sistema difensivo* (Florence: Edizioni medicea, 1992), 133–37; and Angelo Tafi, *Immagine di Borgo San Sepolcro: Guida storico-artistica della Città di Piero* (Cortona: Calosci-Cortona, 1994), 397–403, who illustrates the facades of the church and oratory.

27. Amintore Fanfani, "La beneficenza in un comune toscana dal XIII al XV secolo," in Fanfani, *Saggi di storia economica italiana* (Milan: Società editrice "Vita e pensiero," 1936), 37–82, identifies the grave economic problems in Sansepolcro, which reached crisis proportions in the 1460s.

28. Documents in Battisti, 2: 426–29, 609–14, supplemented by those in Banker, 1995, 21–35. My interpretation condenses the detailed discussions of these scholars and differs from theirs in some respects.

29. Battisti, 2: 427. The archival evidence is ambiguous, rarely distinguishing between the oratory, accessible only to the brethren, and the church, open to all.

30. Dabell, 81–82 (doc. 2). In contrast to Lightbown, 31, I do not believe that Ottaviano ever painted the altarpiece, which was received directly from the woodworker and not from the painter, for whom no payments are recorded.

31. Battisti, 2: 427.

32. Banker, 20, 30 (doc. 8), 31 (doc. 12).

33. Banker, 1995, 21, 24, who posits the probable influence of Piero's father, one of four governors of Sansepolcro in 1444, in obtaining the commission. On Don Francesco, see Banker, "Piero della Francesca, il fratello Don Francesco di Benedetto e Francesco dal Borgo," *Prospettiva* 68 (1992): 54–56.

34. Banker, 1995, 23, 35 n. 47.

35. First published by Gaetano Milanesi, "Documenti inediti dell'arte toscana dal XII secolo," *Il Buonarroti* 2 (1885): 116 n. 108, and more accessible in Battisti 2: 609 (doc. XXIV); English translation in D. S. Chambers, *Patrons and Artists in the Italian Renaissance* (Columbia: University of South Carolina Press, 1971), 52–53, from which these excerpts are taken. Michael Baxandall, *Painting and Experience in Fifteenth Century Italy* (Oxford: Oxford University Press, 1972), 1–27, provides an illuminating discussion of artists' contracts and typical stipulations.

36. Lightbown, 49–205, traces his activity. Piero is securely documented in Sansepolcro on 4 October, 1454, and 22 September, 1458; see Banker, 1995, 26.

37. Lightbown, 207–18.

38. Banker, 1995, 25–26. These years also coincided with a serious economic decline in the town; see n. 27.

39. Battisti, 2: 610 (doc. XLI).

40. Banker, 1995, 21, 25–26, has offered this convincing proposal.

41. Published by Georg Gronau, "Piero della Francesca oder Piero dei Franceschi," *Repertorium für Kunstwissenschaft* 23 (1900): 27–28.

42. Banker, 1995, 27, 35 n. 47.

43. Mario Salmi, "Piero della Francesca e Giuliano Amedei," *Rivista d'Arte* 24 (1942): 26–44, made the attribution, which has been confirmed by documentary evidence found by Banker, 1995, 27. Other works by Giuliano Amedei are identified by Giovanni Damiani, "Intorno a Piero," in *Nel raggio di Piero: La pittura nell'Italia centrale nell'età di Piero della Francesca,* ed. Luciano Berti (Venice: Marsilio Editori, 1992), 67–71, 84–87.

44. Banker, 1995, 27, 30 (doc. 7).

45. Battisti, 2: 427–29, recognized the significance of the indulgence; my translation is from SS, BC, AM 8, Entrata e uscita 1400–1472, f. 99r.

46. Charles Hope, review of Lightbown and John Pope-Hennessy, *The Piero della Francesca Trail,* in *Times Literary Supplement* 4667 (September 11, 1992), 16; Banker, 1995, 27.

47. For the conventions in local altarpieces, see Stefano Casciu, "Antecedenti a Piero nell'aretino," in Berti, 33–66; for Tuscan polyptychs with buttresses, see Gardner von Teuffel, 21–65.

48. See note 4 and Lightbown, 31. Restoration reports have not been published.

49. Rona Goffen, "*Nostra Conversazione in caeli est:* Observations on the *Sacra Conversazione* in the Trecento," *Art Bulletin* 61 (1979): 198–222, discusses the origins of this new type, which was popularized in the 1430s by Fra Angelico.

50. Jane Bridgeman, "'Belle Considerazioni': Dress in the works of Piero della Francesca," *Apollo* 136 (1992): 218.

51. Peter Francis Howard, *Beyond the Written Word: Preaching and Theology in the Florence of Archbishop Antoninus 1427–1459* (Florence: Leo S. Olschki Editore, 1995), 117.

52. Bridgeman, 218.

53. Confraternities distinguished themselves by the color of their robes and by identifying badges; see Ellen Schiferl, "Corporate Identity and Equality: Confraternity Members in Italian Paintings, c. 1340–1510," *Source: Notes in the History of Art* 8 (1985): 12–18.

54. Erick Wilberding, "Embracing the Cross: A Liturgical Gesture," *Source: Notes in the History of Art* 8 (1985): 1–5.

55. See Diane Cole Ahl, "A New Chronology for the 1430s," *Zeitschrift für Kunstgeschichte* 44 (1981): 146–49; and William M. Hood, *Fra Angelico at San Marco* (New Haven: Yale University Press, 1993), 77–83.

56. See Banker, 1991, for the contract and iconography of Sassetta's altarpiece; Banker, 1990, 245–47, discusses the commission.

57. The classic study is F. Mason Perkins, "Pitture senesi poco conosciute," *La Diana* 5 (1950): 244–61. Gardner von Teuffel, 34–35 n. 21, discusses its location.

58. Clark, 1951, 10.

59. See Vera Chiasserini, *La pittura a Sansepolcro nella alta valle tiberina prima di Piero della Francesca* (Florence: Leo S. Olschki, 1951); Maetzke and Nappini; Casciu; and Damiani for a survey of Sansepolcro and its art.

60. The collected essays in *Il Volto Santo di Sansepolcro: Un grande capolavoro medievale rivelato dal restauro,* ed. Anna Maria Maetzke (Cinisello Balsamo: Amilcare Pizzi, 1994), illuminate many aspects of this work.

61. Enzo Carli, *La scultura lignea italiana* (Milan: Electa Editrice, 1960), 22–23.

62. See Hans Belting, *Likeness and Presence: A History of the Image before the Era of Art,* trans. Edmund Jephcott (Chicago: University of Chicago Press, 1994), 387, 595 n. 30.

63. The statuesque quality of Piero's Madonna is emphasized by Bruce Cole, *Piero della Francesca: Tradition and Innovation in Renaissance Art* (New York: HarperCollins, 1991), 30, 71 n. 6.

64. SS, BC, AM, no. 241, f. 27r (no date, 1431); f. 36r (16 April 1432); f. 59r (25 March 1434); and f. 72v (13 April 1435), from which the quotation is taken.

65. For the phenomenon, see Richard C. Trexler, "Habiller et déshabiller les images: Esquisse d'une analyse," in *L'Image et la production du sacré,* eds. Françoise Dunand, Jean-Michel Spieser, and Jean Wirth (Paris: Méridiens Klincksieck, 1991): 195–231; and the well-documented example of processional sculpture of seventeenth-century Spain, explored by Susan Verdi Webster, *Art and Ritual in Golden-Age Spain: Sevillian Confraternities and the Processional Sculpture of Holy Week* (Princeton: Princeton University Press, 1998), esp. 159, 173.

66. For Maundy Thursday rituals, see (for Florence) Weissman, 99–105, 195–235; and (for Rome) Barbara Wisch, "The Passion of Christ in the Art, Theater, and Penitential Rituals of the Roman Confraternity of the Gonfalone," in *Crossing the Boundaries: Christian Piety and the Arts in Italian Medieval and Renaissance Confraternities,* ed. Konrad Eisenbichler, Early Drama, Art, and Music Monograph Series-15 (Kalamazoo, MI: Medieval Institute Publications, 1991): 240–44, 252–53.

67. Information in this paragraph is extracted from three major studies of this iconography: Paul Perdrizet, *La Vierge de la Miséricorde: Étude d'un thème iconographique,* Bibliothèque des Écoles Françaises d'Athènes et de Rome, 101 (Paris: E. de Boccard, 1908); Vera Sussmann, "Maria mit dem Schutzmantel," *Marburger Jahrbuch für Kunstwissenschaft* 5 (1929): 323–32; and Christa Belting-Ihm, *"Sub matris tutela:" Untersuchungen zur Vorgeschichte der Schutzmantelmadonna,* Abhandlungen der Heidelberger Akademie der Wissenschaften, Philosophisch-historische Klasse, 3 (Heidelberg: Carl Winter Universitätsverlag, 1976).

68. Wisch, 237; and Wisch, "New Themes for New Rituals: The *Crucifixion Altarpiece* by Roviale Spagnuolo for the Oratory of the Gonfalone in Rome," in Wisch and Ahl, 206, 211, 213.

69. Carl Brandon Strehlke, "Madonna of Mercy," in *Painting in Renaissance Siena 1420–1500,* eds. Keith Christiansen, Laurence B. Kanter, and Carl Brandon Strehlke, catalogue for exhibition at the Metropolitan Museum of Art, New York, December 20, 1988 to March 19, 1989 (New York: Metropolitan Museum of Art, 1988), 254–57 (illustrated p. 255).

70. Henk W. van Os, *Vecchietta and the Sacristy of the Siena Hospital Church: A Study of Renaissance Religious Symbolism,* trans. Eva Biesta (Maarssen, The Netherlands: Gary Schwartz), 1–15.

71. The translation is from Strehlke, 254, who discusses the fresco and its iconography extensively.

72. For example, Giorgio Vasari, *Le vite de' più eccellenti pittori scultori ed architettori,* 9 vols., ed. Gaetano Milanesi (Florence: G. C. Sansoni Editore, 1906), 2: 283–84, describes the great homage paid to Parri's *Madonna of Mercy with Saints Pergentinus and Lorentinus* (Arezzo, Pinacoteca). Since the small

church where it was kept could not accommodate all of the adoring populace, the *Madonna* was carried outside in a solemn procession by members of the Fraternità di Santa Maria della Misericordia.

73. The sculpture is discussed by Anne Markham Schulz, *The Sculpture of Bernardo Rossellino and his Workshop* (Princeton: Princeton University Press, 1977), 18–24; and Louise Marshall, "Confraternity and Community: Mobilizing the Sacred in Times of Plague," in Wisch and Ahl, 32. The same confraternity commissioned the altarpiece described by Vasari; see n. 72.

74. Vasari, 2: 279–80; and Mark Zucker, "Parri Spinelli: Aretine Painter of the Fifteenth Century," Ph.D. diss., Columbia University, New York, 1973, 92–99.

75. Sensi, 43.

76. Maggini and Andreini, 140, 143.

77. Maggini and Andreini, 130.

78. Baxandall, 1972, 1.

CHAPTER 2. THE SPIRITUAL WORLD OF PIERO'S ART

1. Bernard Berenson, *The Central Italian Painters of the Renaissance* (New York and London: Putnam, 1897), 69–75.

2. Roberto Longhi, "Piero dei Franceschi e lo sviluppo della pittura veneziana," *L'Arte* (1914): 198–221.

3. Kenneth Clark, *Piero della Francesca* (London: Phaidon, 1951), 40–41.

4. See, for example, *Christianity and the Renaissance: Image and Religious Imagination in the Quattrocento,* ed. Timothy Verdon and John Henderson (Syracuse University Press, 1990).

5. For the concept of 'environments of experience', see T. Verdon, "Christianity, the Renaissance and the Study of History. Environments of Experience and Imagination," ibid., 1–40.

6. Maria Grazia Ciardi Dupre Dal Poggetto, "Il colloquio di Girolamo Amadi con San Girolamo," in *Piero e Urbino, Piero e le corti rinascimentali,* ed. Paolo Dal Poggetto (Venice: Marsilio, 1992), 107–12.

7. See the essay by Diane Cole Ahl in this volume.

8. See, for example, Marilyn Aronberg Lavin, *Piero della Francesca's Baptism of Christ* (New Haven and London: Yale University Press, 1981), and Timothy Verdon, "Symbol and Subject in Piero's 'Baptism of Christ'," in *Musagetes: Festschrift fur Wolfram Prinz,* ed. Ronald Kecks (Berlin: Mann Verlag, 1991), 245–53. At the suppression of the monastery in 1808, the painting passed into the possession of the cathedral, and in due course was sold to an English collector, who in 1861 sold it to the National Gallery.

9. Adolfo Venturi, *L'Arte a San Girolamo* (Milan: Treves, 1924), 6–8.

10. Jacopo da Voragine, *La Légende Dorée,* trans. J. B. M. Roze (Paris: Garnier-Flammarion, 1967), 246.

11. Ibid., 249.

12. Saint Jerome, *Commentary on Isaiah,* Prologue, no. 1. *Corpus Christianorum Latinorum* (Turnhout: Brepols, 1954–1994), vol. 73: 1–3. Cited in *The Divine Office: The Liturgy of the Hours According to the Roman Rite* (London: Collins, 1974), vol. 3: 301.

13. Saint Jerome, Homily 80, in *Homilies of Saint Jerome,* trans. Marie L. Ewald, *The Fathers of the Church Series,* vol. 57 (Washington, DC: Catholic University of America Press, 1964), 168.

14. Saint Jerome, Letter to Heliodorus, in *Letters of Saint Jerome*, trans. C. Mierow (London: Newman Press, 1963), 68–69.

15. *"De siti, fame, vigilis et omni corporis attritione de dolorum tolerantia per omnem aetatem declarata."* Giovanni Urbani, ed., *Vita di San Lorenzo Giustiniani primo Patriarca di Venezia scrita dal suo nepote Bernardo Giustiniani* (Città del Vaticano: Libreria Editrice Vaticana, 1962), 96.

16. Jerome, Letter to Heliodorus (see above, note 14).

17. See Angelo Giuseppe Roncalli, *La Sacra Scrittura e San Lorenzo Giustiniani* (Venice: Patriarcato di Venezia, 1956), 20–21.

18. Ibid.

19. Mario Righetti, *Manuale di storia liturgica* (Milan: Ancora, 1950), vol. 1, 406–19; see also O. B. Hardison, Jr., *Christian Rite and Christian Drama in the Middle Ages* (Baltimore: Johns Hopkins University Press, 1965), 35–79 ("The Mass as Sacred Drama").

20. Tractatus 48, 1. *Corpus Christianorum Latinorum* (Turnhout: Brepols, 1954–94), vol. 138A: 279–80.

21. Canonized only in 1447, while the altarpiece was being executed. On the meaning of the eucharistic celebration, see (for example) Louis Bouyer, *Eucharist: Theology and Spirituality of the Eucharistic Prayer,* trans. Charles Quinn (University of Notre Dame Press, 1968).

22. Ibid., 227–43.

23. Hanna Kiel, *Il Museo del Bigallo a Firenze* (Florence: Cassa di Risparmio di Firenze, 1977), 118–19.

24. *Libretto della dottrina cristiana attribuito a Sant'Antonino arcivescovo di Firenze,* ed. Gilberto Aranci (Florence: Angelo Pontecorboli, 1996), 27.

25. *Niccolò Cusano: Predica sul Padre Nostro,* ed. Gilberto Aranci (Turin: Società Editoriale Internazionale, 1995), 45–50. Renaissance awareness of the Eucharist as a 'builder of community' was not limited to Italy. For analogies in pre-Reformation England, see Eamon Duffy, *The Stripping of the Altars: Traditional Religion in England, 1400–1580* (New Haven and London: Yale University Press, 1992), chap. 3: "The Mass", 91–126.

26. Sermo 195, 1–3, in *Patrologiae cursus completus: Series latina* ed. Jacques Paul Migne (hereafter 'PL'), 221 vols. (Paris: Migne, 1841–1865), vol. 38: 1015–18.

27. Sermo 51, Migne, PL, 194: 1862–63.

28. The two wings by Matteo di Giovanni added to Piero's panel c. 1465 may have nothing to do with the work's original conception.

29. The Annunciation account in Luke 1:26–38, which similarly mentions the three Persons, precedes the Baptism in the narrative order of the New Testament, but not in order of composition of the text.

30. *"Beatus vir qui non abiit in consilio impioum . . . et erit tamquam lignum quod plantatum est secus decursus aquarum."*

31. *Saint Augustine on the Psalms* (*Early Christian Writers* series), ed. S. Hebgin and F. Corrigan (Westminster, Md., 1960), vol. 1: 21–22.

32. Migne, PL, 14: 987; 9: 249; 26: 871; 70: 30. And *Patrologiae cursus completus: Series graeca,* ed. Jacques Paul Migne (hereafter 'PG'), 242 vols (Paris: Migne, 1857–67), 12: 1087–90; 23: 78; 27: 62. See also E. T. DeWald, *The Stuttgart Psalter* (Princeton University Press, 1930), 7.

33. Marilyn Lavin, *Baptism of Christ,* 129–133, develops a series of hypotheses on the possible patronage and provenance of the altarpiece. See also Martin Davies, *National Gallery Catalogue: The Earlier Italian Schools* (London: National Gallery of Art, 1951), 427.

34. Mircea Eliade, "Methodological Remarks on the Study of Religious Symbolism," in *The History of Religions: Essays in Methodology,* ed. M. Eliade and J. M. Kitagawa, 6th ed. (Chicago University Press, 1973), 3–30.

35. Letter 55, chapter 11, no. 21. See Peter Brown, *Augustine of Hippo* (Berkeley and Los Angeles: University of California Press, 1967), 261–63.

36. Karl Rahner, "The Theology of the Symbol," in K. Rahner, *Theological Investigations IV,* trans. K. Smyth (Baltimore: Helicon, 1966), 221–52, esp. 224. See also Avery Dulles, "The Symbolic Structure of Revelation," in *Theological Studies* 41 (1980): 51–73; Paul Ricoeur, "The Hermeneutics of Symbols and Philosophical Reflection," *International Philosophical Quarterly* 2 (1962): 191–218; P. H. Wheelwright, *Metaphor and Reality* (Bloomington: Indiana University Press, 1962), 94ff.; M. Polanyi and H. Prosch, *Meaning* (Chicago: Chicago University Press, 1975), 66–71; T. Fawcett, *The Symbolic Language of Religion* (Minneapolis: Augsburg, 1971), 21–25; I. G. Barbour, *Myths, Models and Paradigms* (New York: Harper and Row, 1974), 58ff.

37. Paul Tillich, "Art and Ultimate Reality," *Cross Currents* 10 (1960): 2.

38. Louis Dupré, *The Other Dimension* (Garden City, NY: Doubleday, 1972), 164–65.

39. Ibid.

40. Tillich, 4.

41. "εικων του Θεου του αορατου".

42. Rahner, 235–36.

43. Dupré, 185.

44. See Cardinal Gabriele Paleotti's *Discorso intorno alle immagini sacre e profane,* in *Italian Art 1500–1600* (*Sources and Documents* series), ed. R. Klein, H. Zerner (Englewood Cliffs, NJ: Prentice Hall, 1966), 125.

45. Mircea Eliade, *Patterns in Comparative Religion* (New York: Sheed and Ward, 1958), 446.

46. Ibid. 190–202.

47. Ibid. 267, 275, 300.

48. See *The Hymns of the Breviary and Missal,* ed. Matthew Britt (New York: Benziger Brothers, 1924), 123–24.

49. Dulles, 56.

50. Rahner, 231–33.

51. Ibid., 225.

52. Ibid., 239.

53. Ibid., 226–27.

54. Ibid., 228.

55. Ibid., 230 and 236.

56. Ibid., 237.

57. Hilary of Poitiers, *Commentary on the Gospel of Saint Matthew,* PL, 9: 926–27.

58. Gregory Nazianzen, *Oratio 39 in Sancta Lumina,* PG, 36: 350–51.

59. Rahner, 242.

60. Tillich, 8.

CHAPTER 3. PIERO'S *LEGEND OF THE TRUE CROSS* AND THE FRIARS OF SAN FRANCESCO

1. Jacobus da Voragine, "The Invention of the Holy Cross" in *The Golden Legend,* ed. G. Ryan and H. Ripperger (New York, 1941), 271.

2. Saint Bonaventure records Saint Francis's restoration of civic tranquillity,

describing Arezzo as "torn with faction fights and threatened with destruction" in his *Legenda Maggiore*; see M. A. Habig, *St. Francis of Assisi, Writings and Early Biographies (English Omnibus of the Sources for the Life of St. Francis)* (Chicago, 1973), 677–78. The anecdote also appears in Thomas of Celano, *Second Life of S. Francis* (Habrig, 451), and in the *Legend of Perugia* (Habig, 1056–57). For factional violence among the nobility and the long-standing conflict between imperial (Ghibelline) and papal (Guelf) supporters in Arezzo, see P. Rambin, "Franciscan Spirituality and Papal Reform: True Cross Cycles in Tuscany," Ph.D. diss. (University of Georgia, 1999). Saint Bernardino destroyed the well of Apollo, where the ancient ritual of cleansing children took place, when he preached at Arezzo during Lent of 1428; see E. Borsook, *The Mural Painters of Tuscany* (Oxford: Oxford University Press, 1980), 95; R. Lightbown, *Piero della Francesca* (New York: Abbeville Press, 1992), 123; and Bernardino da Siena, *Prediche volgari sul Campo di Siena, 1427*, ed. Carlo Delcorno (Milan, 1989), vol. 2: 151. J. Moorman, O.F.M., *A History of the Franciscan Order from Its Origin to the Year 1517* (Oxford, 1968), 462, gives the date as 1425. According to Giorgio Vasari's life of the Aretine painter Parri Spinelli: "When Parri was working at Arezzo, Fra Bernardino preached and converted. Evil things were going on in a wood near a fountain, a mile distant from the city, he went there one morning, followed by the whole people of Arezzo, with a great wooden Cross in his hand." See G. Vasari, *The Lives of the Most Eminent Painters, Sculptors, and Architects* (Florence, 1568; English ed. Gaston du Vere), vol. 1: 312–13.

3. My concentration on the local circumstances underlying the commission complements existing political and religious interpretations in which events such as the Council of Florence in 1438–39 (for the reunification of the Latin and Greek churches), the Franciscan custody of Christian sites in the Holy Land, and the fall of Constantinople to Islam in 1453 are cited as influencing the pictorial program. In addition to all of the monographs on Piero (see the Bibliography of this volume), major studies of the frescoes include L. Schneider, "The Iconography of Piero della Francesca's Frescoes dealing with the Story of the True Cross in the Church of San Francesco in Arezzo," Ph.D. diss. (Columbia University, 1967); M. Aronberg Lavin, *The Place of Narrative: Mural Decorations in Italian Churches, 431–1600* (Chicago: University of Chicago, 1990 and 1994); and G. Centauro, *Dipinti Murali di Piero della Francesca: La basilica di S. Francesco ad Arezzo* (Milan: Electa, 1990). The most concise English summary of the program, its condition (before the most recent restoration), and its dating to c. 1452–66 is in Borsook, 91–102. For an earlier Franciscan reading of the program, see M. Aronberg Lavin, "Piero della Francesca's Iconographic Innovations at Arezzo," in *Iconography at the Crossroads*, ed. B. Cassidy (Princeton: Princeton University Press, 1993), 139–55. For the restoration of the frescoes, see M. Lenzini Moriondo and M. Seracini, "Le indagini eseguite per determinare lo stato di conservazione e degrado degli affreschi di Piero in S. Francesco ad Arezzo," *Problemi del restauro in Italia: Atti del convegno nazionale tenutosi a Roma nei giorni 3–6 novembre 1986* (Udine, 1988): 265–74.

4. *Vita et Miracoli Beati Sinigardi de Arretio*, Ms. Codice Francisci Redi Patricij Arretini no. 57, fol. 314r, in P. Girolamo Golubovich, OFM, *Biblioteca Bio-Bibliografica della Terra Santa dell'Oriente Francescano*, vol. 1 (Florence, 1906), 143–47. Unless otherwise cited, what follows is from Nanni's legend in

Golubovich, whose volume includes two other versions of Benedetto's life from the *Chronica XXIV Generalium* (147–48), and the *Liber de Conformitate Vitae Beati Francisci ad Vitam Domini Nostri Jesu Christi* by Fra Bartolomeo Pisano (148–49). Benedetto confirms that he took vows from Francis in his testimony of 1277, which verified the Indulgence of the Porziuncola, an event commemorated in Marcilliat's sixteenth-century rose window on the facade of San Francesco (Golubovich, 142–43). P. Domenico Cresi, OFM, *Beato Benedetto Sinigardi e Angelus Domini* (Florence, 1958), 13–22, disputes the traditional date of 1211 for the Aretine's conversion (proposing 1214) and explains that the Beato is called the *"primus"* Provincial Minister of Antioch (when he was actually the third) because the area was divided into two regions in 1220–21. He believes that Benedetto was the Provincial of the Greek (Constantinople) rather than the Syrian (Antioch) province.

5. Golubovich, 135–39; and for an early life of John of Brienne, whom contemporaries compared to Solomon, 178–80.

6. Or he was carried by an angel; see Golubovich, 146–49, for the three versions of the anecdote. Enoch and Elias (representing the laws of nature and scriptural revelation, respectively) were thought to live in the Garden of Eden awaiting the end of time when they would combat the Anti-Christ. Saint Bernardino referred to the prophets in a sermon on the Last Judgment, declaring that they not only represented faith but also the truth that would be revealed on the last day, see Bernardino, 2: 151.

7. For the correct year of his death, see Golubovich, 146–47, and Cresi, 28–29. Nanni's manuscript is dated September 1302, thus he likely refers to the Franciscans' second monastery. The day of Sinigardi's death is unknown (one wonders if it was on or near September 14, the Feast of the Exaltation of the Cross); he is listed on 3 March in the Franciscan Martyrology, see *Biblioteca Sanctorum* (Rome, 1968), 1229–30.

8. Originally residing outside of Arezzo at Maccagnolo, the friars moved to Poggio del Sole in c. 1232. After they moved for the second time, they were also finally in compliance with the Minister General Bonaventure's edict of 1260, which required Franciscan friars and nuns to live inside town walls. For their relocation into town in c. 1318, as well as Giovanni da Pistoia's 1346 plan for the new monastery, see Salmi, "Un Antica Pianta di San Francesco ad Arezzo," *Archivium Francescanum* (1920), 27–29, 101–5 (and the appendix of documents); Lightbown, 119; and Centauro, 79–89. Papal indulgences, donations of property, and individual legacies underwrote the building and decoration of the church; the acquisition of a house and endowments from 1364 to 1374 provided the site and funds for the *cappella maggiore* (see the documents in Centauro, 90–100, 119, and the summary in Borsook, 92).

9. See Salmi, 1920, 26–51, for the complex history of the various family chapels; and M. Zucker, "Parri Spinelli's Lost *Annunciation to the Virgin* and Other Aretine *Annunciations* of the Fourteenth and Fifteenth Centuries," *Art Bulletin* 57 (March, 1975): 192–95, for dating Spinello's frescoes c. 1401–04. The chapel of Pagno di Maffeo was reassigned to Francesco Accolti in 1470. The dedications of the apsidal altars resemble but do not exactly duplicate those in the transept at Assisi, which includes an altar dedicated to Saints Peter and Paul (I thank Marilyn Lavin for this information); for the various dedications of the altars and chapels at Assisi, see Centauro, 119–20, 124.

10. Bacci's wills and codicils of 1408, 1411, and 1416 refer to the chapel; in 1416 he

requested burial near the entrance to the friar's choir, provided funds for paintings and a stained-glass window, and stipulated the continuation of the project by his heirs if it remained incomplete at his death. Niccolò di Piero Tedesco finished the window in 1416, but Bacci's heirs did not fund the murals for almost thirty years after his death. For a concise history of the commission, see Borsook, 92, who includes details about Lazzaro Bracci, another contender for patronage of the chapel. Centauro, 94–96, includes Bacci's first will and Lazzaro Bracci's will of 1410.

11. His frescoes are noted in a 1466 contract with the Aretine Confraternity of the Annunziata; see Borsook, 92–93, and E. Battisti, *Piero della Francesca*, 2nd ed. (Milan: Electa, 1992), vol. 1: 100, and vol. 2: 615–16. Piero may have been hired as early as the late 1440s when it became apparent that Bicci could not continue, or in 1452, the year of that painter's death. The conspicuous Cross in the *Last Judgment* suggests that Piero inherited a fully determined program, but he must have reworked existing drawings or originated new designs, because the frescoes exemplify his compositional approach and little resemble Bicci's production. See Battisti, 1: 103–7, 120–39, and 2: 463; Borsook, 95–97; and C. Gilbert, *Change in Piero della Francesca* (Locust Valley, NY: J. J. Augustin, 1968), 72–73, for Piero's extensive use of cartoons in the chapel.

12. His tomb is in the reconstituted chapel of Giuliano Bacci; for documentation of its various sites, see Centauro, 125, 128. The inscription reads: CORPVS BEATI BENEDICTI SINIGARDI ARRETINI ORDMINCON; however, OSSA, which has been scraped away, is still visible underneath the first word. The friars probably also transferred the great wooden Cross by the Master of San Francesco and the finger of Daniel. Published inventories do not mention the relic of Daniel; however, a 1480 Inventory lists a finger of Bartholomew, which suggests confusion over the identity of the relic by this time. See Pasqui, "Inventario," *Miscellanea Francescana* (1901).

13. The continuous work in the church and the absence of family chapels until the late 1360s makes Sinigardi's conservation in a chapel improbable. He may have been kept in the "cemetery" labeled along the west flank of the church on Fra Giovanni's plan (Salmi, 1920). For the burial sites of the other *beati*, see G. E. Solberg, "A Reconstruction of Taddeo di Bartolo's altar-piece for S. Francesco a Prato, Perugia," *Burlington Magazine* 134 (1993), 653–55, which argues for the original burial of Beato Egidio (another early companion of Francis) in the crypt at San Francesco al Prato to imitate the founder's interment at Assisi; later his remains were transferred to a sarcophagus placed beneath the altar mensa. Whether Sinigardi was originally buried in the Roman sarcophagus is unclear. Pasqui says he was in an *"antichissima urna"* in the second chapel to the left of the entrance [*Guida ad Arezzo* (Arezzo, 1882), 72]. Sinigardi was apparently dismembered at some point, because a 1480 inventory of the sacristy lists an ivory reliquary that contained his head (Pasqui, 1901). Important relics were moved from the sacristy to beneath the new high altar in 1577.

14. Centauro, 101 and 107, plate XI, proposes a niche on the wall adjoining the Guasconi Chapel in his reconstruction of the chancel before Piero's frescoes, but sixteenth-century documents mention the sarcophagus at the *cornu evangelii* (at the left when facing the high altar). This would have been near or in the Tarlati Chapel. Because the Beato's mother was Elisabetta Tarlati di

Pietramala, he may have been kept in their chapel whose altar to the *Concezione* was appropriate for the author of the *Angelus*. The history of the Tarlati-Sinigardi Chapel is complicated. Bonifazio Sinigardi endowed a family chapel at an unknown location in 1453, and in 1599 Orazio Sinigardi was ceded the altar near that of the Crucifix, to the left of the high altar, for constructing an altar dedicated to the *Concezione* of Mary (*"l'altare vicino a quello del Crocefisso a cornu evangeli dell'altar maggiore dedicato alla Concezione di Maria,"* Salmi, 1920, 50, and Centauro, 125). A document of 10 May 1589 says the *urna* of the Beato was at the head of the church near the Chapel of the Crucifix; a reference to the opening of his tomb on 4 May 1627 by a member of the Sinigardi family places the remains "a canto al Altare Maggiore"; and an eighteenth-century document refers to the tomb in the Chapel of the Crucifix at the *cornu evangeli* endowed by the Sinigardi family, whose *stemma* is still visible in the vault (Centauro, 128).

15. That is, on the far side of the choir from the high altar, see Salmi, 1920, 103, and Centauro, 94, 99, for the documents.

16. Taddeo's altarpiece dates to 1403 and Sassetta's to 1437–44; see Solberg, 646, 654. The first mention of an altarpiece in the Aretine chancel is the 1527–29 *Epiphany with Saints Francis and Anthony* by Giovanni Antonio Lappoli (Borsook, 95). Churches and altars could not be consecrated to *beati*, see J. Gardner, "Altars, Altarpieces, and Art History: Legislation and Usage," in *Italian Altarpieces, 1250–1550: Function and Design*, ed. E. Borsook and F. Superbi Gioffredi (Oxford, 1994), 11–12.

17. All four extant fresco cycles are in Tuscany and three are in Franciscan churches. Agnolo Gaddi's late fourteenth-century paintings in the main chapel of Santa Croce, Florence, illustrate the dedication of the church [see B. Cole, *Agnolo Gaddi* (Oxford, 1977), figs. 25–33]. Cenni di Francesco's paintings of 1410 were for the Confraternity of the Holy Cross in San Francesco, Volterra. For comparison of these two cycles, see Lavin, *The Place of Narrative,* chap. 4, and Schneider, 1967, 33–38; for the *sinopia* (underdrawings) remaining from the cycle by Masolino da Panicale in the Chapel of Saint Helena in Sant'Agostino, Empoli (c. 1424), Schneider, 1967, 39–46. The friars established a library in 1450, see Lightbown, 123, and Centauro, 33, 34, 98. Moorman, 479–80, discusses the 1449 General Chapter.

18. The solemn exchange between the monarchs may reflect Piero's observation of state visits at the court of Rimini. For Piero's experience at northern Italian courts, see Lightbown, chaps. 4 and 5, and the essay by J. Woods-Marsden in this volume.

19. Most scholars assume the men are prophets because the right-hand figure holds a scroll, but specific identification is problematical, with Jeremiah, Ezechial, Jonah, and Daniel suggested (see Battisti, 2: 457–59; Borsook, 94; and Lightbown, 133–35). Lightbown proposed Daniel because of the relic; however, he does not mention the disastrous fire that occurred during a religious festival reenacting the story of Daniel and King Nabuchodonosor on 29 September 1556 (documented in Centauro, 121–23, and described by Vasari). I have not been able to ascertain if this was an annual feast. It is also tempting to speculate that the two represent Enoch and Elias because of the Beato's vision. Gilbert, 78, alternatively suggests the figure without a scroll on the right is a saint because he is on the dexter side of the chapel; in that case,

possibilities would include John the Evangelist, whose *Revelations* was the source for the Tree of Life imagery favored by Franciscans, or his brother James the Less, an apostle and the first bishop of Jerusalem.

20. The manner of reading the frescoes, which proceeds chronologically on the right wall but not on the left, has been much debated. See Lavin's reading of Piero's complex narrative, 167–94; and Schneider, 1967, 47–138, Gilbert, 1968, 77–85, and Lightbown, 121–22, for the typological approach.

21. For the Hebrew legends comprising the story of Seth, see E. Quinn, *The Quest of Seth* (Chicago, 1962).

22. Voragine, 269. The derivation of the nude youth leaning on a shepherd's crook from the Capitoline Pothos of Scopas and other classical references in the cycle have been explored by, among others, Battisti, 2: 459, fig. 313.

23. For Honorius's text, see Quinn, 73–84, who also underscores the importance of the name Seth meaning "plant" to the legends, and Schneider, 20–22.

24. Voragine, 270. Restorations disclose that this tree was once leafy; Piero usually paints the trunk and then adds the leaves, which have flaked off over time, both here and perhaps in his *Resurrection* at Sansepolcro. For iconographical interpretations based on the leafless tree, see Schneider, 49–51, and Battisti, 1: 112, and 2: 371, nn. 195 and 196. Though often conflated, the tree of mercy, the tree of knowledge, and the tree of life were different, see Quinn, 25–45. This is Piero's only depiction of a background episode in the chapel; thus, some scholars have proposed that he completed a fresco begun by Bicci di Lorenzo (see Gilbert, 73–75).

25. Voragine, 270. According to the text, Solomon attempted to incorporate the wood of the beautiful tree into the temple he was building at Jerusalem. Unaware of its origin and discouraged because it was too large or too small wherever they placed it, the king's laborers rejected the wood, using it instead to bridge a stream.

26. An observation made in M. Podro, *Piero della Francesca's Legend of the True Cross,* Charleton Lectures on Art Delivered in the University of Newcastle upon Tyne (Newcastle upon Tyne: University of Newcastle upon Tyne, 1974), 8–9.

27. Voragine, 270. Piero not only omits the king's command to bury the ominous wood but also subtly shifts the *Golden Legend's* emphasis from Solomon to the Queen of Sheba, the only kneeling and bowing figure in the paintings. For comparisons of the scenes in Arezzo and Florence, see Schneider, 1967, 33–38.

28. C. Ginzburg, *The Enigma of Piero: Piero della Francesca, the Baptism, the Arezzo Cycle, the Flagellation* (London: Verso, 1985), 41–45, among others, suggested that Solomon is a portrait of Cardinal Bessarion and that the courtier looking out to his left is Piero's self-portrait.

29. The subject has been variously interpreted. For arguments that the scene is either the moving of the wood from the temple to make the bridge or the removing and disposing of the wooden bridge, see Battisti, 2: 463, and Lightbown, 147–48. Piero's clownish characterization of the laborers conveys the foolishness of trying to outwit destiny with unusual sharpness: the man at the left exposes his genitals; the fellow next to him seems to bite his lip; and a garland of vine leaves suggestive of bacchic revels tops the head of the flush-faced man on the right. Vasari's description of Michelangelo's drawing for the

Battle of Cascina in which he says an old man had put on a garland to shade his head offers another reason for Piero's depiction of the latter figure (see Vasari, 341). Jacopo's *Legend of the True Cross* is filled with anti-Jewish sentiments; the buffoonish workers may reflect those sections as Lightbown (147–48) suggests.

30. Like Gaddi, Piero omits the Crucifixion, moving immediately from Judaic to Roman History. Similarly, the *Golden Legend* (271) states: "After the Passion of Christ the precious wood of the Cross remained hidden in the earth for more than two hundred years, and was at last found by Helena, the mother of the Emperor Constantine."

31. Voragine, 271. That the illumination does not mimic the direction of light in the chapel underscores its celestial origin, see Lightbown, 149–50. For the vestiges of the angel's cross and the formal connection between the left-hand guard and the nude youth in the *Death of Adam,* see Battisti, 1: 188–93, and 2: 586–87.

32. Despite severe paint losses on the right side, the fresco clearly represents the "bloodless" rout of Constantine. The friars' singular interpretation required Piero to conflate several contradictory commentaries in the *Golden Legend* (270–71): Constantine's defeat of the barbarians in a bloody battle at the Danube River while carrying a wooden cross (predicted in a dream in which an angel awakens him to an image of the cross surrounded by the same phrase mentioned above) and the Battle at the Pontus Albinus from the *Ecclesiastical History* (angels and a cross appear in the sky with the same inscription, but Christ later appears in a vision advising the emperor to fight under the aegis of the Cross). B. Cole, *Piero della Francesca: Tradition and Innovation in Renaissance Art* (New York: HarperCollins, 1991), 100–102, argues that Piero painted the Danube version.

33. Like Donatello's *Gattamelata* and Uccello's battle scenes for the Medici palace, Piero's fresco combines fifteenth-century and ancient Roman armor, and he borrows compositional ideas from Roman sarcophagi; see Lightbown, 169–70, and J. Bridgeman's essay in this volume. Constantine wears a pink and green peaked hat of Eastern origin; that he and Maxentius wear similar imperial headgear is appropriate to their joint rulership of the Roman empire at the time of the battle. The former founded Constantinople as the Eastern capital of the empire after he had consolidated his power by defeating Maxentius, a fact surely underlying the resemblance between his physiognomy in the fresco and Pisanello's profile portrait medal of the contemporary Eastern ruler John Paleologus. For this resemblance, see Battisti, 1: 205–6, Schneider, 1967, 76–77, Borsook, 95, Ginzburg, 43–45, and Lavin, *The Place of Narrative,* 179–80.

34. Maxentius's fate is implied by a partially submerged horse and soldier at the river's edge. Battisti, 1: 205–6, and 2: 467, fig. 330, identified him based on nineteenth-century copies of the fresco. According to M. Tanner, "Imperial Themes in Piero della Francesca's True Cross Legend," *Città e Corte nell'Italia di Piero della Francesca,* ed. C. Cieri Via (Venice, 1996), 185–88, the insignia on the flags refer to the Saraceni, a Guelf family of Arezzo, as well as to the Turks or the devil.

35. See Ginzburg, 39–45, and Lavin, *The Place of Narrative,* 179–81.

36. The Franciscans received custody of the holy places from Robert d'Anjou of

Naples in 1327, and they survived Benedictine attempts to take over the Eastern sites in 1441, just a few years before the frescoes were begun; see R. M. Huber, OFM. Conv., *A Documented History of the Franciscan Order* (1182–1517) (Milwaukee, 1944), 745–46, P. Mazzoni, *La leggenda della Croce nell'arte italiana* (Florence, 1914), and Lavin, 1993 (as in note 3), 145–49.

37. Whether to begin reading the narrative on this wall on the lowest level with the *Battle of Heraclius and Chosroes* (as the typological counterpart to the *Battle of Constantine and Maxentius*) or to resume a chronological reading in the middle tier with the *Discovery and Proving of the True Cross* is open to debate. (After his victory Constantine sent his mother Saint Helena to Jerusalem to search for the Cross.) See Lightbown, 119–20, and Lavin, 181–90, for various readings of the narrative.

38. Voragine, 273. An imperial official, whose hat bears a small paper inscribed "Prudentia vinco" (I will conquer you through wisdom), grasps Judas by the hair, while two others apply their weight to pull him from the well. The awkward position of the official vis-à-vis the well and the pulley, the white patch where the pulley timbers should have covered the front of the well, and the planks obscuring the weight at the summit of the machine have often been noted. See Borsook, 95–97, for Piero's use of assistants.

39. The *Golden Legend*, 274–76, which contains a long discourse on Judas's conversion, bishopric, and martyrdom by Julian the Apostate, clearly plays on the association between the names of the converted Jew and Christ's betrayer.

40. Voragine, 274, recounts two stories: in one a youth is revived, and in the other a woman comes to life after Bishop Macarius suggested a way of identifying the Cross (he may be the praying, gray-bearded cleric behind the Cross in Piero's fresco). Both Gaddi's and Cenni's frescoes portray the resuscitation of the woman. See Schneider, 1967, 72–78, and Lightbown, 164.

41. Voragine, 274.

42. Some scholars believe that Piero's view of Jerusalem resembles Arezzo (see Battisti, 1: 159 and 2: 375 n. 238, and Lavin, *The Place of Narrative*, 184), still others believe it to be a generic hill town (Lightbown, 159).

43. For these *ampullae,* small oil flasks imprinted with images resembling the church, see J. Wilkinson, *Egeria's Travels to the Holy Land* (London, 1981), 246–48. For the transfer of the custody, see Huber, 373–74.

44. Voragine, 544, elaborates: "Then, as he wished to be adored as a god by all, he built a tower of gold and silver, studded with shining gems, and placed upon it the images of the sun, moon, and stars, then, handing over his kingdom to his son, the profane king seated himself in this fane, and placed the Lord's Cross at his side, demanding that all salute him as God."

45. Piero does not seem to illustrate a particular version or conflate the several battles described in the *Golden Legend*, 544–46, where the author himself obfuscates: "in some chronicles, however, these deeds are otherwise narrated."

46. What the green banner with a bird (a phoenix or goose?) signifies is unknown; see M. Tanner for the flags and Aretine *stemme* (as in n. 34).

47. According to one version, the spoils of the emperor's victories not only were distributed to soldiers, but also used to build churches. Heraclius does not kill Chosroes, as in some variants of the text, see Voragine, 545–46.

48. Voragine, 205. For the use of the same cartoon for God the Father and Chosroes, see Gilbert, 1968, 72, and Borsook, 96.

49. Piero unifies the usual two-part narrative by portraying the angel only once, thereby accentuating the moment of conception (for Aretine Annunciations, see Zucker, 190–95). That the Annunciation occurred on 25 March, a date fraught with auspicious anniversaries (the death of Christ, the creation and death of Adam, the Fall into sin, the murder of Abel, and the sacrifice of Isaac), as well as the notion of Mary as the New Eve, suggested by several scholars, partially explains the unusual appearance of the subject in Piero's frescoes; see R. Kahsnitz, "Zur Verkundigung im Zyklus der Kreuzlegende bei Piero della Francesca," in *Schülerfestgabe für Herber von Einem* (Bonn, 1965): 116–36, and Schneider, 1967, 100–101.

50. The *Angelus* reads: "The angel of the Lord declared unto Mary./And she conceived of the Holy Spirit./Behold the handmaid of the Lord./Be it done unto me according to thy word./And the Word was made flesh. And dwelt among us,/Pray for us O holy Mother of God./That we may be made worthy of the promises of Christ" [*Saint Pius X Daily Missal*, ed. W. van de Putte (New York, 1956), 981]. Traditional practice was to intersperse the Hail Mary after each verse and response (i.e., three times); originally, it was recited at sunset after compline. See Cenci, for an explication of Nanni's text, its complicated subsequent history, and the extension of the ritual to three times a day.

51. Thirteenth-century Franciscan legislation particularly promoted devotion to the Virgin, see Gardner, 7–19. It is also worth recalling the *Annunciation's* proximity to the altar of the *Concezione* in the adjacent Tarlati Chapel.

52. Following the standard text, Gaddi painted an angel at S. Croce (Cole, 1977, fig. 83). Lightbown, 170–71, cites the Franciscan Office of 1377 as a source for the cleric. For the discalced emperor, see Lavin, 1993, 148–49.

53. See the accounts of Bonaventure and Celano in Habrig, 729–31, 308–11. Saint Francis bore the wounds of the Crucifixion on his body from 14 September 1224 until his death in 1226. This change from Gaddi's cycle is especially interesting because the saint's stigmatization occurred after a forty-day fast in honor of Saint Michael the Archangel.

54. Chapter 16 of Saint Francis's 1221 rule specifically addresses the conduct of the friars who go as "missionaries among the Saracens and other unbelievers" (Habrig, 43–44). Schneider, 1967, 75–77, 117–18, and Borsook, 95, suggest that Piero's frescoes are a fictive pilgrimage to the Holy Land.

55. The stigmatization was represented by Parri Spinelli on the right nave wall near the sacristy. For Saint Francis as *alter Christus,* see H. van Os, "St. Francis as a Second Christ in Early Italian Painting," *Semiolus* 7 (1974): 115–32.

56. For the history of the Conventual-Observant division, see Huber, 365–74, and Moorman, 352–53, 479–86.

57. For the effects of the 1446 bull *Ut Sacra,* see Huber, 365–74. The decoration of the Aretine chapel spanned the pontificates of Eugenius IV (1431–47), Nicholas V (1447–55), Calixtus III (1455–58), Pius II (1458–64), and Paul II (1464–71).

58. Several grand projects in Conventual churches, such as Donatello's bronze altarpiece for the Santo in Padua, were finished at mid–fifteenth century. See S. B. McHam, *The Chapel of St. Anthony of Padua and the Development of Venetian Renaissance Sculpture* (Cambridge, 1994), 1–16, and G. A. Johnson, "Approaching the Altar: Donatello's Sculpture in the Santo," *Renaissance Quarterly* (Autumn, 1999): 627–61.

59. An inscription in the Carbonati Chapel (second chapel on the right of the

nave) praises Bernardino's canonization in 1450. Interestingly, the four miracles below the image of S. Anthony in Arezzo coincide with Donatello's reliefs on the high altar in the Santo at Padua from the 1440s.

CHAPTER 4. PIERO'S MEDITATION ON THE NATIVITY

1. This text is an updated version of "Piero's Meditation on the Nativity," *Monarca della Pittura: Piero della Francesca and His Legacy*, ed. Marilyn Aronberg Lavin (Washington, DC, 1995), Studies in the History of Art, 48, Center for Advanced Study in the Visual Arts, Symposium Papers XXVIII, National Gallery of Art: 126–41. It is published here with the kind permission of the Center for Advanced Study in the Visual Arts, National Gallery of Art, Washington, DC. Translated into Italian, it appeared as "Meditazione di Piero sulla Natività di Cristo," *Città e Corte nell'Italia di Piero della Francesca*, ed. Claudia Cieri Via (Venice, 1996), 219–31.

2. The fullest publication of documents to date is that in Eugenio Battisti, *Piero della Francesca*, ed. Marisa Dalai Emiliani, 2 vols. (Milan, 1992), 2: 608–30.

3. All major monographs and catalogues discuss the *Adoration* and its dating; Roberto Longhi, *Piero della Francesca*, 2d ed., 1948, 28; 3rd ed. (Milan, 1963), 70 [1470–85]; Kenneth Clark, *Piero della Francesca* (London, 1951), 44 [1472–75]; Philip Hendy, *Piero della Francesca and the Early Renaissance* (London, 1968), 10–12 [after 1480]; Creighton Gilbert, *Change in Piero della Francesca* (Locust Valley, NY, 1968), 115–16 [after 1475]; Battisti, 1992, 1: 335–43; 2: 415–17, 537–40 [1482–85]; Mario Salmi, *La Pittura di Piero della Francesca* (Novarra, 1979), 138 [1483–85]; Antonio Paolucci, *Piero della Francesca* (Florence, 1989), 63, 73–74 [1472–75]; Ronald Lightbown, *Piero della Francesca* (Oxford, 1992), 273–78 [1482–84]; Carlo Bertelli, *Piero della Francesca* (New Haven and London, 1992), 218 [1473–74].

4. Battisti, 1992, 2: 628–29.

5. Martin Davies, *The Earlier Italian Schools* [cat., National Gallery], 2d ed. (London, 1961), 433–34; Kenneth Clark, *Piero della Francesca*, 2d ed. (London, 1969), 230.

6. The area of the family tomb still exists in a chapel off the cloister of the cathedral of Sansepolcro. It will be recalled that before 1518 this building was the abbey church of the Camaldolites; Piero's brother Francesco (d. 1458) had been a friar here, and the burial site had been in the family for at least two generations; cf. Attilio Brilli, *Borgo Sansepolcro* (Sansepolcro, 1972), 20.

7. Planned for Sant'Andrea in Mantua; see *Andrea Mantegna*, ed. Jane Martineau et al. [exh. cat., Royal Academy of the Arts and Metropolitan Museum of Art] (London, 1992), 253–54, no. 64, fig. 84a.

8. As it is called in the inventory; see above, references in note 4.

9. Jacobi a Voragine *Legenda Aurea vulgo Historia Lombardica dicta*, ed. Johannes George Theodore Graesse (Breslau, 1890), part 6: 43–46; the original Latin text was written c. 1262–64 and almost immediately translated into many languages. By the mid–fourteenth century, the *Legenda* was used as a textbook in vernacular schools in Italy; cf. Paul Grendler, *Schooling in Renaissance Italy: Literacy and Learning, 1300–1600* (Baltimore, 1989), 285, and "What Piero Learned in School: Fifteenth-Century Vernacular Education," *Piero della Francesca and His Legacy*, 161–76. A modern English adaptation is

The Golden Legend of Jacobus de Voragine, trans. Granger Ryan, 2d ed. (Princeton, 1995), 37–43.

10. This variation on the Nativity subject was first defined by Rosalind Schaff, "The Iconography of the Nativity in Florentine Painting of the Third Quarter of the Quattrocento with Particular Reference to the Madonna and Child," Masters thesis (Institute of Fine Arts, New York University, 1942); see also Henrik Cornell, *The Iconography of the Nativity of Christ* (Uppsala, 1924); and Gertrude Schiller, *Ikonographie der christlichen Kunst,* 6 vols. (Kassel, 1966), 1: 88–90.

11. Saint Bridget described her vision, which occurred in Rome in 1370, in her Revelations (ed. Rome, 1628), 2, bk. 7, chap. 21, 230–21.

12. *Bibliotheca Sanctorum,* 14 vols. (Vatican City, 1963), 3: 439–533.

13. Maestro Pisano, *Nativity,* Naples, Gallerie Nazionali di Capodimonte. See also Schiller, 1966, 1: 88–90.

14. Compare Ruth Wedgewood Kennedy, *Alesso Baldovinetti* (New Haven, 1938): 101–3, 218–19 (with discussion of Piero's possible influence on the younger artist); Baldovinetti, incidentally, is documented in Arezzo in 1482 (Kennedy, 1938, 218–19 n. 234); the fresco is reproduced in color (but reversed) in Lightbown, 1992, fig. 116.

15. Bianca Hatfield Strens, "L'arrivo del trittico Portinari a Firenze," *Commentari* 19 (1968): 315–19.

16. Namely, the Sassetti Chapel; see Eve Borsook and Johannes Offerhaus, *Francesco Sassetti and Ghirlandaio at Santa Trinita, Florence: History and Legend in a Renaissance Chapel* (Doornspijk, 1981), discuss the altarpiece in its context; see fig. 24. By the 1460s the motif of Christ lying on his mother's robe was a commonplace; e.g., Fra Filippo Lippi, *Annalena Adoration,* Uffizi, Florence; see Jeffrey Ruda, *Fra Filippo Lippi* (London/New York, 1993), pls. 124–126, pp. 219–221, cat. no. 48, p. 441. Like many of Fra Filippo's Infants, Ghirlandaio's Christ Child also points to his own mouth, in clear reference to the passage "Ego sum via, veritas, et vita" (John 14:6).

17. The concept of Piero's exaltation of lowly forms of nature is developed more fully in my monograph *Piero della Francesca* (New York, 1992).

18. See reference in note 57 below for the Golden Legend's description of darkness banished at the Nativity.

19. See Marilyn Aronberg Lavin, *Piero della Francesca's 'Baptism of Christ'* (New Haven, 1981), chap. 2, for descriptions of the topography around Sansepolcro, discussions of the history of the city, and analysis of its self-conception as a "New Jerusalem." See also Franco Polcri, "Sansepolcro: La città in cui Piero della Francesca prepara il suo rapporto con le corti," *Città e Corte nell'Italia* 1996: 97–118, who calls it "una città teologica."

20. The various discussions on this point are reviewed by Battisti, 1992, 2: 538–39.

21. Battisti, 1992, 1: 295–302; 2: 406; Lavin, 1992, 120 and pl. 38.

22. But see the analysis by Angeli Janhsen, *Perspektivregeln und Bildgestaltung bei Piero della Francesca* (Munich, 1990): 96–103.

23. For a summary of Piero's writings, the manuscript copies, and the published editions, see Lightbown, 1992, 291–92, 297.

24. The expression "bread of angels" is from the Bible: Psalm 77 [78]:25, "panem angelorum manducavit homo ("the bread of angels was eaten by men"), and Wisdom 16:20, "proquibus angelorum esca nutrivisti populum tuum" ("as

against this, you nourished your people with food of angels"); the phrase is quoted in the liturgy: "Ecce Panis Angelorum, factus cibus viatorum" (in *Festa Santissimi Corporis Christi: Sequentia*) *Liturgicae Orationis Concordantia Veralia. Prima Pars: Missale Romanum* (Rome, 1964): 455. Dante refers to this phrase in the *Purgatorio*, Canto 2, line 11 ("Voi altri pochi che drizzaste il collo/per tempo al pan de li angeli") he recalls it in a line in the *Convivio* (1, i, 6–7), and *Paradiso*, Canto 12, lines 151–54, and 22 at the end; see *The Divine Comedy*, trans. Charles S. Singleton (Princeton, 1977): 254–55, 369–70. For the Latin area (the word from which *aiuola* derives) in the sense of "threshing floor," see Vergil, *Georgics* I: 187–91. I thank Dr. Kim Veltman for calling my attention to Dante's allusion, and Prof. Robert Hollander for help with the references. Clark, 1951, 75, in speaking poetically and in general of the sacrificial nature of Piero's types, mentions the threshing floor: "No painter has shown more clearly the common foundations in Mediterranean culture, of Christianity and Paganism. His Madonna is the great mother, his risen Christ the slain god; his altar is set up on the *threshing floor,* and his saints have trodden the wine press." The Eucharistic allusion is more overt in Van Der Goes's *Nativity*, where a sheaf of wheat lies on the ground next to the infant. See Barbara G. Lane, "'Ecce Panis Angelorum,' The Manger as Altar in Hugo's Berlin *Nativity*," *Art Bulletin* 58 (1975): 476–86 for further references.

25. The musical activities of these angels have been discussed at length; see Battisti, 1992, 337–38; also Marco Bussagli, *Storia degli Angeli: Racconto di immagini e di idee* (Milan, 1991): 272–85.

26. W. B. McNamee, "The Origin of the Vested Angel as a Eucharistic Symbol in Flemish Painting," *Art Bulletin* 54 (1972): 263–78.

27. In this element, these angels differ from the winged boys in the *Brera Madonna* and the *Senigallia Madonna*.

28. Schiller, 1966, 1: 70; e.g., fig. 143 (sarcophagus lid, end of the fourth century, San Ambrogio, Milan).

29. See next note.

30. *The Hours of the Divine Office in English and Latin,* Liturgical Press ed., 3 vols. (Collegeville, MN, 1963), 1: 198; from Sunday at Lauds I (from the Canticle of the three young men). This observation was first made by Sidney Don in a graduate seminar paper entitled "Piero and the Franciscans," (Yale University, 1977); Paul Barolsky made a similar point in "Piero's Native Wit," *Source: Notes in the History of Art* 1. 2 (1982): 21–22. Like many animals given symbolic meaning during the Middle Ages, the ass had both bad and good connotations. Erwin Panofsky wrote a lengthy footnote about the ox and the ass in Nativity scenes, in his *Early Netherlandish Painting,* 2 vols. (Cambridge, MA, 1953), 1: 470, n. 1, demonstrating that, along with many representations in which both animals show their affection for the Christ Child, there are those in which the ass, identified with the Old Testament, exhibits ignorance or lack of piety. See also Schiller, 1966, 2: 158, 160. Battisti, 1992, 1: 338 and 416 n. 604) develops this idea to the extreme, saying that the donkey's braying indicates (in) ". . . connessione col gesto del pastore, verso il cielo . . . la disperazione per l'impossibilità della grazia" and "un segno apocalittico." However, there is also a continuous tradition in medieval art in which this animal represents a deep sense of religious understanding. As early as the ninth century, illustrations to Psalm 103 (104), in the Utrecht Psalter (fol. 59v), for example, in which all the beasts praise the Lord, include two braying/singing

asses (*Latin Psalter in the University Library of Utrecht (formerly Cotton MS Claudius.vii)* Facsimile (London, 1920) pl. 119. The story of Balaam's ass with its typological symbolism is an instance in which the animal's rapport with divinity is even greater than that of the human being who owns him; see Ilene H. Forsyth, "L'âne parlante: The Ass of Balaam in Burgundian Romanesque Sculpture," *Gesta* 20, 1 (1981) (Essays in Honor of Harry Bober), 59–66; and Gregory Penco, "Il simbolismo animale nella letteratura monastica," *Studi monastica* 6 (1964): 7–38, especially 13–14. One of the legends of Saint Anthony of Padua (before 1231) concerns the ass in Rimini that knelt before a transubstantiated host, recognizing, it was said, "the host in Christ and Christ in the Host." From the same period, and demonstrating a positive attitude toward the ass, is the liturgical drama by Pierre Corbeil, archbishop of Sens (d. 1222); see below, note 34. In the Florentine *Fior di Virtù,* another late medieval text (1300–1323) commonly read in Renaissance vernacular schools (see Grendler reference, note 9), the virtue of abstinence is compared to the thirsty wild ass who will wait for two or three days for the water to clear before drinking; *The Florentine Fior di Virtù of 1491,* trans. Nicholas Fersin (Washington, DC, 1953), chap. 27, 98; Carlo Frati, "Ricerche sul 'Fiore di virtù'," *Studi di filologia romanza* 6 (1893), 247–447; (reference from Paul Grendler). Of course, the figure of the ass can also refer to obstinacy and buffoonery. See Helen Adolf, "The Ass and the Harp," *Speculum* 25 (1950), 49–57, and Francis Klingender, *Animals in Art and Thought to the End of the Middle Ages,* ed. Edward Antal and John Harthan (London, 1971), 289, 298.

31. The earliest example known to me (called to my attention by Marci Freedman) is that by Biagio di Goro Ghezzi in the apse frescoes (left wall), in San Michele, Paganico, c. 1375; Gaudenz Freuler, *Biagio di Goro Ghezzi a Paganico: L'affresco nell'abside della chiesa di S. Michele* (Milan, 1986), 50, 53, pl. III, fig. 42. The figure of the ass here is perhaps the most prominent in the composition, placed in the geometric center behind the crib and under the peak of the double-sloping roof. The animal is only one of many music makers, however: on the second tier on either side of the shed is a choir and orchestra of angels; to the left behind Mary is a bagpiping shepherd, and to the right, behind Joseph, is a sheep that raises its muzzle in the air to add its voice. See further the small *Nativity* by Simone dei Crocifissi, c. 1380, reproduced in *Gli Uffizi, Catalogo Generale,* 2d ed. (Florence, 1980), 519, no. 3475, where Joseph's cross-legged pose seated on a saddle also forecasts Piero's. Not all donkeys with heads raised, however, are braying; some are eating hay from a wall-crib; for example, the *Nativity* by Petrus Christus, c. 1445, in the National Gallery of Art, Washington, DC; *Preliminary Catalogue of Paintings and Sculpture, National Gallery of Art* (Washington, DC, 1941): 39–40, no. 40, and in the *Adoration of the Magi* by Joos van Gent, c. 1467, the Metropolitan Museum of Art, New York (Leo van Puyvelde, *The Flemish Primitives,* trans. Doris I. Wilton (Brussels, 1948), 76. This motif, in fact, constitutes a second stream of meaning for the motif: Eucharistic, in the sense that the hay again refers to the sacrament. Another example of the eating motif, coupled now with a magpie on the roof of the shed, is the much-disputed *Adoration of the Child* in the Glasgow Art and Museum Gallery, Kelvingrave, no. 158, wood 50 × 40 cm. This peculiar painting, whose relationship to Piero has yet to be worked out, is variously attributed to Antonello da Messina, Valenzano Jacomart Baço, a Burgundian Master, and Colantonio, and dated by all to about

1475 (Greta Ring, *A Century of French Painting, 1400–1500* [London, 1949], 225, no. 212), except for Albert Chatelet, French Painting from Fouquet to Poussin (Geneva, 1963), 24 (color photo), who oddly calls it "The Nativity of St. Sixtus," by a painter from the "entourage of the Limbourg Brothers," and dates it c. 1410–16. The braying donkey in Michelangelo's *Sacrifice of Noah* on the Sistine Chapel ceiling, and Juseppe Ribera's *Drunkenness of Silenus,* painting and engraving, are both related to the derision of pre-Christian religions, Judaism in the first case and paganism in the second; for the Sistine version, see Edgar Wind, "The Ark of Noah, a Study in the Symbolism of Michelangelo," *Measure* 1 (1950), 411–29.

32. Barolsky (1982) suggested that the donkey, in fact, completes the symmetry of the choir, made up of three singers and three musicians.

33. Marilyn Aronberg Lavin, *The Place of Narrative: Mural Painting in Italian Churches 431–1600 A.D.* (Chicago, 1990), fig. 147.

34. This interpretation of the voice of the ass parallels precisely that expressed in the early fourteenth-century liturgical drama by Pierre Corbeil, known as the *Prose de l'âne.* In the performance, an ass carries on its back a young woman who represents the Virgin. The verse text describing the action says that the donkey is "strong and fair" ("pulcher et fortissimus") and that his repeated braying signifies Amen ("Amen dicas, asine"), in praise of the Lord; see Félix Clément, "Drame liturgique: l'âne au Moyen Age," *Annales archéologiques* 16 (1856), 26–38, especially 34, and Louis Charbonneau-Lassay, *La mystérieuse emblématique de Jésus-Christ: Le Bestiaire du Christ* (Bruges, 1940): 228–29; Karl M. Young, *Drama of the Medieval Church* 2 vols., 3d ed. (Oxford, 1967), 2: 169–70. I am indebted for all references to the play to my husband, Irving Lavin, who will develop the theme of the virtuous donkey in a forthcoming essay on Caravaggio's *Rest on the Flight to Egypt.*

35. The building in a state of dilapidation had a long tradition. See the passage in the *Golden Legend,* 48, concerning the night of Christ's birth when the "Eternal Temple of Peace" crumbled to the ground. For Ghirlandaio's architecture, see above, Borsook and Offerhaus, 1981.

36. Paolo Bensi has recently shown that Piero produced the surface texture of this shed with his finger tips; prints are visible behind and around the Virgin's head in some photographs (e.g., Battisti, 1992, 1: fig. 252). Bensi observes that this technique was often used by Jan van Eyck; "Il ruolo di Piero della Francesca nello sviluppo della tecnica pittorica del Quattrocento," *Piero della Francesca tra arte e scienza* ed. Marisa Dalai Emiliani and Valter Curzi (Venice, 1996): 167–82.

37. E.g., Schiller, 1966, 1: 70, fig. 147, Museo Lateranense (Vatican), 190, fourth century. Jacobus de Voragine quotes Peter Comestor's *Scholastic History,* where the place is described simply "as a shelter against the uncertainties of the weather" (*Golden Legend,* 47).

38. See Ernst Kitzinger, with Slobodan Ćurčić, *The Mosaics of Santa Maria dell'Ammiraglio at Palermo* (Washington, DC, 1990), 175–82, figs. 108–12; and Schiller, 1966, 1: figs. 213, 214, and 276; also in the *Meditations on the Life of Christ,* trans. and ed. Isa Ragusa and Rosalie B. Green (Princeton, 1961), fig. 32. It has been suggested more than once that there was an actual representation of the dove of the Holy Ghost or of God the Father in the original frame made for this painting, to which the shepherd would be pointing.

39. Lavin, 1981, 61–62. Piero used the same gesture for the imperial figure of Her-
aclius in the battle scene on the lowest tier of the left wall in the cycle of the
True Cross in Arezzo, basing himself on a drawing after a lost equestrian
statue thought to be Heraclius himself. See Michael Vickers, "Theodosius,
Justinian, or Heraclius?" *Art Bulletin* 58 (1976): 281–82; also reproduced in
Lavin, 1992, 98, fig. 51, and pl. 27.

40. See Richard Brilliant, *Gesture and Rank in Roman Art,* Memoirs of the Con-
necticut Academy of Arts and Sciences 14 (New Haven, 1963): 59–68, espe-
cially figs. 2.34 and 2.42, "adlocutio." The motif is most clearly seen in the
statue of Augustus of the Prima Porta, not discovered until the nineteenth
century; see Erika Simon, *Augustus Kunst und Leben in Romum die Zeiten-
wende* (Munich, 1986), pl. opp. 52 (Prima Porta); but see also Harold Mat-
tingly, *The Roman Coins in the British Museum* 12 vols. (London, 1923–66), 1:
pl. 7, nos. 16–20, pl. 15, reverse no. 4.

41. Borsook and Offerhaus 1981, fig. 19; see discussion in n. 100. Accounts of the
legend appear in the *Mirabilia urbis Romae,* the *Speculum humanae salvatio-
nis* and in *La leggenda aurea;* see Antonio Monteverdi, "La leggenda d'Au-
gusto e dell'Ara Celeste," *Atti del V Congresso Nazionale di Studi Romani*
(Rome, 1940), 2: 463–67; Philippe Verdier, "A Medallion of the 'Ara Coeli' and
the Netherlandish Enamels of the Fifteenth Century," *Journal of the Walters
Art Gallery* 24 (1961): 9–37, especially nn. 2, 47. The medieval history appar-
ently stems from the inscription on one of the columns in the left nave colon-
nade of the church of Ara Coeli in Rome, which reads in part: *cubiculum
augustae,* meaning that it was part of the entrance to the office of a func-
tionary of the emperor. The Latin was misread in the Middle Ages to mean
the "bedroom of Augustus," and hence the connection with his home. The
full iconography was represented by Rogier van der Weyden in the early 1460s
in his *Middelburger Altarpiece* painted for Peter Bladelin (Berlin, Staatliche
Museen, Gemäldegalerie), where the vision scene is on the wing to the left of
the central Nativity scene. Although there is no way to prove that Piero some-
how gained knowledge of this altarpiece, his work shows many similarities to
it: Rogier had also included the Bridgetine motif, the oblique shed, a land-
scape vista on the left and townscape on the right, along with the scene of
Augustus and the Sibyl; see Panofsky, 1953, 276–78, 469–71; Shirley N. Blum,
Early Netherlandish Triptychs: A Study in Patronage (Berkeley, CA, 1969),
17–28, 121–26; Martin Davies, *Rogier van der Weyden* (London, 1972): 10–11,
22, 201–3; Odile Delenda, *Rogier van der Weyden* (Zurich, 1987), 48–52. For
further connections between Piero and Rogier, in this case the Pesaro Altar-
piece, see Bert W. Meijer, "Piero and the North," *Piero and His Legacy,* 1995,
143–59.

42. *Meditations* 1962, figs. 25–31; the saddle is seen again in figs. 34–35, 37–38,
42–44.

43. Color reproduction in Stefano Borsi, *Art e Dossier* 69, supplement (1992),
26–27; predella di Quarata, Museo diocesano, Florence; from a lost altarpiece
that was in San Bartolomeo a Quarata (Antella). In the *Adoration of the Magi,*
which was the central section of three, Saint Joseph is seated to the left on
the saddle, with his left foot over his right knee and his head supported by his
left hand, in the typical gesture of worried concern.

44. J. J. Tikkanen, *Die Beinstellungen in der Kunstgeschichte,* Acta societatis

scientiarum fennicae 42.1 (Helsingfors, 1912), 150–86, especially 163, 168; see also Brilliant 1963, 108–9, 125, 133, 149, 151,

45. William S. Heckscher, *Sixtus IIII Aeneas insignes statuas romano populo restituendas censuit* (The Hague, 1955), 20–21, 43.

46. See Lavin, 1992, pls. 16 and 18.

47. See the collection of references, starting with Roberto Longhi, *Piero della Francesca* (Milan, 1927), in Bertelli, 1992, 114 n. 44.

48. In such scenes Judas is usually shown in the well; compare the Wessobrunner Betebuch manuscript, ninth century: Andreas and Judith Stylianou, *In Hoc Vinces . . . , By this conquer* (Nicosia, Cyprus, 1971), 179: and a predella on the Saint Helen Altarpiece by Michele di Matteo, 1427: *Catalogo dell'Accademia di Venezia*, ed. Sandra Moschini Marconi (Venice, 1955), 172, no. 195.

49. Reproduced in Lavin, 1992, pl. 17 and fig. 52.

50. Vittore Branca, *Boccaccio medievale* (Florence, 1981): 402–3; reproduced in Lavin, 1990, fig. 155; also Giovanni Boccaccio, 3 vols., intro. Vittore Branca (Florence, 1966), 1: 118, 124, and 3: 966–68.

51. In the story of the True Cross, after Judas reveals to Saint Helena where the cross is hidden, he is appointed the Bishop of Jerusalem and helps to restore the cross relic to the people. Ernst H. Kantorowicz, "The 'King's Advent' and the Enigmatic Panels in the Doors of Santa Sabina," *Art Bulletin* 26 (1944): 207–31; Gisela Jeremias, *Die Holztur der Basilika S. Sabina in Rom* (Tübingen, 1980), pl. 38 (see also pl. 23 for a representation of the cross-legged motif on the doors); see also Lavin, 1990, 181–83.

52. Herbert Friedmann, *The Symbolic Goldfinch* (New York, 1946): 88, discusses this tradition and comments on Piero's finch.

53. Salvatore Battaglia, *Grande dizionario della lingua italiano* (Turin, 1972), 4: 622 (col. 2), gazza, no. 5 (Proverbi Toscani, 103); also 1986, 13, 331, pica. Compare Dante's *Convivio*, 3, vii, 9: "Se alcuno volesse dire contra, dicendo che alcuno uccella parti . . . massimamente de la gazza e del pappagallo, . . . rispondo che non è vero che parlino." In mythology, the nine Pierides, daughters of a king of Macedonia, were transformed into magpies for having dared to challenge the Muses to a singing contest; Ovid, *Metamorphoses* V, 294–678; also Dante, *Purgatorio*, Canto 1, 11; Singleton, 6. It will be recalled that one of Piero's early patrons (sponsors of the *Madonna della Misericordia Altarpiece*) were members of the prominent Sansepolcro family of the Pichi, another Italian word for magpie; see James R. Banker, "The Altarpiece of the Confraternity of Santa Maria della Misericordia in Borgo Sansepolcro," *Piero and His Legacy* (1995), 21–35.

54. Continuing the thought of Battisti (see above, note 30), Marco Bussagli discusses the combination of donkey and magpie briefly in his survey of Piero's career, "Piero della Francesca," *Art e Dossier* 71, supplement (1992): 47, and more fully in "Note sulla *Natività* di Londra: La gazza e l'asino, due motivi dissonanti," *Città e Corte nell'Italia*, 233–41, claiming that the noisy intrusion of both animals carries allusions to apocalyptic dissonance, in marked contrast to the angels' celestial harmony. Unfortunately, Bussagli's observations do not take into account Piero's very pointed variations on the themes: the chattering magpie is silent, and the braying donkey sings with the angels. It is precisely the inversion of tradition that Piero uses to make his point.

55. Lavin, 1981, 23–25.

56. Lavin, 1992, 37–39, 108–10, pl. 32.

57. *Golden Legend*, 49–51; the Nativity's banishment of darkness is described in this passage.

CHAPTER 5. *"TROPPO BELLI E TROPPO ECCELLENTI"*: OBSERVATIONS ON DRESS IN THE WORK OF PIERO DELLA FRANCESCA

1. Giorgio Vasari, *Le Vite de' più eccellenti pittori scultori ed architettori*, ed. Gaetano Milanesi (Florence 1878), vol. 2: 496.

2. Probably finished by 1469. James Banker, "Piero della Francesca's S. Agostino Altarpiece: some new documents," *Burlington Magazine* 129 (Oct. 1987): 645–51. Banker disputes the identification of John the Evangelist, see below note 8.

3. Augustine (354–430) was Bishop of Hippo but sometimes depicted as a university teacher. In frescoes (1465) at San Agostino, San Gimignano, Benozzo Gozzoli portrays him in the scarlet gown and cap of a Doctor of Law. Gozzoli's patron, Fra Domenico Strambi, was a professor at the Sorbonne, Paris.

4. Simone and Angelo di Giovanni di Simone, and Simone's wife Giovanna. In her will (August 1446) Giovanna bequeathed the equivalent of eighty florins for, "a pair of vestments, a chasuble, a dalmatic, and a tunicle and a splendid cope," each to be beautiful and costly ("pulcra et sumptuosa"). James Banker, 1987, 649.

5. A similar, extant, crimson cloth-of-gold cope was commissioned by Pope Nicholas V (1447–1455) for the canonization of San Bernardino of Siena in 1450. Paolo Peri, *Il parato di Niccolò V*, Museo Nazionale del Bargello (Florence, 1981).

6. A cope of this quality required about twelve *braccia* of velvet (1 braccio = 58 cm). The total cost of the velvet alone being c. 72 florins: an embroidered orphrey might cost over 100 florins. Lisa Monnas, "The vestments of Sixtus IV at Padua," *Bulletin de Liason du Centre International d'Etudes des Textiles Anciens* I and II (1983): 120.

7. Ronald Lightbown, *Piero della Francesca* (London, New York, Paris, 1992), 204–5.

8. Banker, 1987, 646, identifies this figure as Saint Peter. Millard Meiss, *The Painter's Choice: Problems in the Interpretation of Renaissance Art* (New York and London, 1976), 89, argued persuasively for Saint John the Evangelist, who, as Lightbown (209) points out, was the patronal saint of Borgo San Sepolcro. The *colobium* and *pallium*, adopted from about the sixth century onwards, are still used for present-day depictions of the clothing of Christ and the apostles.

9. A powerful wide-bladed sword with a single-edged, curved, blade designed specifically for cutting. It is often depicted in scenes of decapitation.

10. L. G. Boccia and E. T. Coelho, *L'arte dell'armatura in Italia* (Milan, 1967), 134; Stuart W. Pyhrr and José A. Godoy, *Heroic Armour of the Italian Renaissance, Filippo Negroli and His Contemporaries,* Exhibition, Metropolitan Museum of Art, New York, October 1998 to January 1999 (New York, 1998), 7. An alternative source may have been theatrical armor; see Stella Mary Newton, *Renaissance Theatre Costume and the Sense of the Historic Past* (London, 1975), 116–30.

11. White velvet was rare, because it was difficult to keep white (heavy silks were never washed). *Cloth-of-gold* is defined here as a patterned silk woven with such substantial quantities of gold brocading wefts it seems woven chiefly of gold. A *brocade* is a silk weave only partially patterned (brocaded) with gold or silver wefts. I am grateful to Lisa Monnas and to Rembrandt Duits for their help with these definitions.

12. For a contemporary description, see *L'arte della seta in Firenze: Trattato del secolo xv*, ed. Girolamo Gargiolli (Florence, 1868), 90–91. There are many extant examples of textiles with this motif. Lisa Monnas, "Italian silks (1300–1500)," *5000 Years of Textiles*, ed. Jennifer Harris (London, 1993), 167–71; Dora Liscia Bemporad and Alessandro Guidotti, eds., *Un parato della Badia Fiorentina* (Florence, 1981); Lisa Monnas, "The vestments of Sixtus IV at Padua (1477–82)," *5000 Years of Textiles*; Paolo Peri, 1981.

13. Bona of Savoy wore "regal white," for her marriage by proxy to the Duke of Milan in May 1468, "Nozze di Bona Sforza e lettere di Tristano e Galeazzo Maria Sforza," *Archivio storico lombardo*, ser. 1, 2 (Milan, 1875): 181. Ercole d'Este wore cloth-of-gold, when he married Eleonora d'Aragona, in July 1473. C. Corvisieri, "Il trionfo Romano d'Eleonora d'Aragona nel giugno 1473," *Archivio della Società Romana di storia Patria* 10 (1887): 660. All Doges of Venice wore cloth-of-gold in public after 1473–74, and gold and white silks for nonpublic duties. Marin Sanudo il Giovane, *De origine, situ et magistratibus urbis Venetae, ovvero la città di Venetia (1493–1530)*, ed. Angela Caracciolo Arico (Milan, 1980), 88–89.

14. Jane Bridgeman, "'Belle considerazioni': Dress in the works of Piero della Francesca," *Apollo* 136 (October 1992): 219 n. 368.

15. Sigismund, King of Burgundy (516–23), was the first Gaullish king to convert to Christianity. Angelo Maria Raggi, "S. Sigismundo," *Biblioteca Sanctorum*, ed. Pietro Cannata and Maria Chiara Celletti (Rome, 1968), vol. 9: 1043–47.

16. The contemporary name of this garment is not yet identified. For the construction of Malatesta's grave clothes of crimson cloth-of-gold, see Mechtild Flury-Lemberg, *Textile Conservation and Research* (Bern, 1988), 440, 454, 470. A green garment of this same design is worn by the second figure behind Saint Francis's father in Benozzo Gozzoli's *Saint Francis denies his father and is clothed by the Bishop of Assisi* (Montefalco, Museum of S. Francesco, Cappella Maggiore, 1452).

17. ". . . un vestito, due vestiti di panno d'oro, uno filetti d'ermellino, e uno con la frangia d'oro e di seta nero . . ." (one gown, two gowns of cloth of gold, one with ermine edging, one with a fringe of gold and black silk), Mario Tabanelli, *Sigismondo Pandolfo Malatesta* (Faenza, 1977), 398. (All translations are the author's unless stated otherwise.)

18. Charles Hope and Paul Taylor incorrectly state the queen's "undergarment [*sic*] and head-dress [*sic*] are the same on both occasions." "Piero's Flagellation and the Conventions of Painted Narrative," *Piero della Francesca (Incontri del Dizionario Biografico degli Italiani)*, ed. Alessandra Uguccioni (Rome, 1995), 76. For Sheba's dress, see Bridgeman, 1992, 219.

19. Essential for roads dusty in summer and muddy in winter and for a long journey when riding garments became sweaty or damp according to the season.

20. A travelling hat is worn by Tanai de' Nerli, as ambassador, in the background of Filippino Lippi's *Nerli Altarpiece* 1495–98 (Santo Spirito, Florence). Jane

Bridgeman, "Filippino Lippi's Nerli Altarpiece-a new date," *Burlington Magazine* 130 (Sept. 1988): 68–71.

21. Christ announced that the Queen of Sheba would "rise up in judgment" at the Day of Judgement (Matthew 12:42 and Luke 11:31).

22. C. Malagola, ed. *Statuti delle Università e dei Colleghi dello Studio Bolognese* (Bologna, 1888) (*Constitutiones sacri collegii doctorum iuris civilis civitatis Bononiae*), 372 and 432; H. Rashdall, *The Universities of Europe in the Middle Ages,* ed. F. M. Powicke and A. B. Emden (1936), vol. 1: 194, vol. 3: 390.

23. See above note 3. Sacchetti describes a judge from Montefalco "dressed in scarlet cloth, who wore a cap whose brim was wrapped with an entire ermine fur." F. Sacchetti, *Opere,* ed. Aldo Borlenghi (Milan, 1957), Novella clxiii, 544. Eugenio Battisti suggests this clothing identifies one of Piero's patrons, *Piero della Francesca* (Milan, 1971), 1: 131 n. 107.

24. Battisti, 1: 332–35, proposes 1472–74; Meiss, *The Painter's Choice,* 132, c. 1472; Lightbown, 254, c. 1475. John Shearman is one of the few who dates it earlier, "before 1466" in "The Logic and Realism of Piero della Francesca," *Festschrift Ulrich Middeldorf* (Berlin, 1968), 181–85. The Brera altarpiece was restored in 1981, see Giulia Orofino, *Catalogo, Pinacoteca di Brera, Scuole dell'Italia centrale e meridionale* (Milan, 1992), 174ff.

25. The Madonna originally had a large jewel holding her veil in place. The only portion of the Brera Altarpiece not painted by Piero is Federico's hands, where a third ring was also added to the two originally planned. See Orofino, 179.

26. See note 37.

27. Leonello Boccia dated the armor c. 1450–60. "L'armatura è complessivamente situabile negli anni cinquanta, e piuttosto nel secondo lustro" (The armour is as a whole located in the fifties, and especially in the second half). Elements of Federico's armor in the Brera Altarpiece, including the helmet, are earlier than those depicted in *Federico da Montefeltro and his son Guidobaldo* attributed to Joos van Wassenhove and Berruguete (c. 1475, Galleria Nazionale delle Marche, Urbino), and in the marquetry of the *studiolo* at Urbino (c. 1476). Boccia rejected any likelihood that Federico da Montefeltro would have been portrayed in obsolete armor. See L. G. Boccia and E. T. Coelho, *L'arte dell'armatura in Italia* (Milan, 1967), 143. Ian Eaves, formerly Keeper of Armour at the Royal Armouries (H.M. Tower of London) agrees with a 1450s dating for Federico's armor; as does Karen Watts, Senior Curator of Armour, The Royal Armouries Leeds (verbally to author, January 2000). Also see Cecil Clough, "Federigo da Montefeltro: The Good Christian Prince," *Bulletin of the John Rylands University Library of Manchester* 67 (1984): 321.

28. Lightbown, 1992, 253; Clough, 1984, 321. No evidence substantiates such a practice.

29. Both tabard and half-tabard were military garments. Saint Bernardino provides an excellent description of the former. *Le prediche volgari di San Bernardino da Siena dette nella Piazza del Campo l'anno mccccxxvii,* ed L. Banchi (Siena, 1880), vol. 3, 187, 189. For contemporary descriptions of half-tabards *Ricordo di una giostra fatta a Firenze a dì 7 di febbraio 1468 sulla Piazza di Santa Croce,* ed. P. Fanfani (Florence, 1864), 20.

30. In June, 1474 Federico was made a Knight of the royal Neapolitan Order of the Ermine by his then employer King Ferdinand of Naples. On 18 August

1474 he was elected a Knight of the English Order of the Garter. On 20 August he was invested in Rome by Pope Sixtus IV as a papal Duke, Gonfaloniere of the Church, and Captain General of the allied Papal and Neapolitan armies. C. H. Clough, "Federico da Montefeltro and the Kings of Naples: A Study in Fifteenth Century Survival," *Renaissance Studies* 6, no. 2 (Oxford, 1992): 134–35, 137.

31. Gentile Brancaleoni died on 27 July 1457 in Urbino, probably from elephantiasis. She was in her mid-thirties and childless. G. Franceschini, "La morte di Gentile Brancaleoni (1457) e di Buonconte da Montefeltro (1458)," *Archivio Storico Lombardo* 5th ser., 51 (1937): 489. When they married Battista Sforza was thirteen, Federico thirty-eight; see Clough, 1992, 126.

32. Comparisons are sometimes drawn with Mantegna's *Madonna della Vittoria* (Louvre, Paris) of 1496. This was commissioned by Francesco II Gonzaga, Marquis of Mantua, to celebrate his victory against the French at Fornovo (6 July 1495), and his wife Isabella d'Este was not included on the left, as it was a votive altarpiece. Mantegna portrays Gonzaga kneeling at the Virgin's *right* in the up-to-date armor he wore at Fornovo, which was hung up beside the painting in the Cappella della Vittoria. Ronald Lightbown, *Mantegna* (Oxford, 1986), 177–80.

33. Held in Urbino on February 25, 1450 to celebrate the acquisition of Milan by Francesco Sforza, then Federico's employer. Gino Franceschini, *Federico da Montefeltro: Dalla concessione del vicariato apostolico alla pace di Lodi 1447–1454* (Sansepolcro, 1961), 53–54.

34. On campaign in the Tuscan Maremma for Alfonso V King of Aragon and Naples, Federico contracted in July 1453 a near fatal attack of plague (or malaria). During his convalescence, in September 1453 Alfonso appointed him Captain General of the Kingdom of Naples. (Federico held this post for the rest of his life.) In April 1454 Montefeltro received a substantial salary advance of 36,000 ducats. Alfonso generously allowed him to keep this despite signing the Peace of Lodi – the money arrived three days after the peace treaty was signed. Walter Tommasoli, *La vita di Federico da Montefeltro (1422–82)* (Urbino, 1978), 94, 97–98, 103.

35. Christine Smith, "Piero's painted architecture: analysis of his vocabulary," in *Piero della Francesca and his legacy*, ed. Marilyn Aronberg Lavin, Studies in the History of Western Art, 48 (National Gallery of Art, 1995), 223–53, esp. 246–49.

36. The contract for the *Misericordia* (11 June 1445) might suggest that the Virgin's garments in this altarpiece were vetted by his patrons. For the *Misericordia* contract, see Battisti, 2: 220.

37. Martin Davies, *The Earlier Italian Schools* (London, 1986), 433, notes the apparent "Netherlandish influence" in this work and supports Longhi's suggestion that it is a late work, without suggesting a date. It is dated c. 1470–75, by J. Dunkerton, S. Foister, D. Gordon, and N. Penny, in *Giotto to Dürer: Early Renaissance Paintings in the National Gallery* (London, 1991), 306. Lightbown, 1992, 273–74, suggests a date c. 1483 coinciding with the arrival of Hugo van Goes's Portinari Altarpiece in Florence, and (approximately) the marriage of Piero's nephew.

38. Helen Ettlinger, "The Portraits in Botticelli's Villa Lemmi frescoes," *Mitteilungen des Kunsthistorisches Institutes in Florenz* 20, no. 3 (1976): 406, iden-

tifies her as Nanna di Niccolò Tornabuoni (cousin of Lorenzo de' Medici) and wife of Matteo di Andrea degli Albizzi, whom she married c. 1485.

39. Lightbown, 1992, 190, argues that this is a canopy and not a pavilion. Princely domestic hangings are seen in Mantegna's Court Scene, *Camera Picta*, Palazzo Ducale, Mantua (c. 1470). For an extant example, see D. Liscia Bemporad, "Un parato della Badia Fiorentina," *Aspetti e problemi degli studi sui tessili antichi. Il Convegno C.I.S.S.T.* (Florence 1981), 23–32. See Lightbown, 1992, no. 13.

40. Laces tipped with metal points were threaded through eyelet holes along the openings to close the garment.

41. A smock or shift was worn next to the skin, the *gamurra* was worn over that. For public semiformal wear a woman wore a gown (*cioppa*) over the *gamurra* and outdoors a mantle over the gown. The *gamurra* was seen only by those at home, as is made clear in letters from Alessandra Strozzi to her son Filippo in 1465. Alessandra Macinghi Strozzi, *Lettere di una gentildonna fiorentina del secolo xv ai figliuoli esuli*, ed. Cesare Guasti (Florence, 1877), 553, Letter 66, 25 January 1465; and 445, Letter 49, 26 July 1465.

42. Brendan Cassidy, "A relic, some pictures and the mothers of Florence in the late fourteenth century," *Gesta* 30, no. 2 (1991): 91–99. For some documentary sources for fifteenth-century pregnancy clothing, Jacqueline Marie Musacchio, *The Art and Ritual of Childbirth in Renaissance Italy* (New Haven and London, 1999), xi–xii, 37–38.

43. G. Vasari, *Le Vite*, 496. Cosimo Tura (1430–95) was employed by Duke Borso d'Este from 1451 and had rooms in the Castello Estense from 1467. Eberhard Ruhmer, *Cosimo Tura. Paintings and Drawings* (London, 1958), 1.

44. Tura was paid for the organ shutter on 11 June 1469; see Ruhmer, 173. For the *Allegorical Figure*, see M. Davies, *The Earlier Italian Schools* (London, 1986), 518–19; Dunkerton et al., 115; Jill Dunkerton, Ashok Roy, and Alistair Smith, "The Unmasking of Tura's 'Allegorical Figure': A Painting and its Concealed Image," *National Gallery Technical Bulletin* 11 (London, 1987): 5–35.

45. Separate sleeves were frequently made in contrasting fabric and are often listed in inventories.

46. Cassidy, esp. figs. 7 and 8. It is exceptionally rare for *any* images of the Virgin to depict her without a mantle.

47. Piero depicts her with hair pulled back tightly from the forehead, braided with white ribbon and pinned over the crown of her head. Originally she wore a fine transparent silk veil bordered with pearls.

48. Bridgeman, 1992, 222–23.

49. Jeanne van Waadenoijen, "La Flagellazione di Piero della Francesca," *Arte Cristiana* 81 (1991): 186; Enrico Ferdinando Londei, "La scena della Flagellazione di Piero della Francesca. La sua identificazione con un luogo di Urbino del Quattrocento," *Bollettino d'Arte* 77, no. 65, ser. 6 (1991): 34; Hope and Taylor, 48–98.

50. Creighton Gilbert, "Piero della Francesca's *Flagellation*: The Figures in the Foreground," *Art Bulletin* 52 (1971): 49. Gilbert identifies the textile as "Flemish" because it was worn by "Joseph" in Rogier van der Weyden's *Descent from the Cross* (Museo del Prado, Madrid, 1438).

51. Lisa Monnas, "Contemplate What Has Been Done: Silk Fabrics in Paintings by Jan van Eyck," *Hali* (December, 1991): 103–13 and Monnas, "The Artists

and the Weavers: The Design of Woven Silks in Italy 1350–1550," *Apollo* 135, no. 304 (June, 1987): 416–24. For the import of Italian silk textiles into Burgundy and England, Raymond de Roover, *The Rise and Decline of the Medici Bank 1397–1494* (New York, 1966), 190–93.

52. Male citizens in Venice (when not in office) generally wore an ankle-length black gown and hood (or cap); in Florence, a black gown, scarlet cloak and scarlet rolled hood. Silk textiles are rarely documented in Florentine inventories, unless associated with marriage or childbirth in exceptionally rich families such as the Medici and Rucellai. For Florentine dress and republican ideology, see J. Bridgeman, *Aspects of Dress and Ceremony in Quattrocento Florence,* Ph.D. diss., Courtauld Institute of Art, London University, 1986. For Venetian dress, see note 63 below.

53. Londei, 34, calls it "il prezioso manto fiammingo" *[sic]*, and makes the extraordinary statement that no garment like this existed in fifteenth-century Italy. Subsequent authors suggest it "has obvious analogies to types of dress thought to originate in the distant past," but do not elucidate. See Hope and Taylor, 78–80.

54. Dominique Cordellier, *Pisanello: Le peintre aux sept vertus,* Exhibition Musée du Louvre, May–August (Paris, 1996), 382.

55. I am grateful to Rembrandt Duits (University of Utrecht and Warburg Institute, London), for confirming that the gown in the *Flagellation* cannot be Flemish. He agrees a date for its textile c. 1440s, and c. 1430s for the textile in the Bellini.

56. Known as a *cioppa* in Tuscany and a *vesta* in Venice, it required 9 to 18 meters (15–32 *braccia*) of silk or woollen fabric, and might cost from 20 to over 100 florins, depending on the quality of its fabric and lining. For documented comparative costs, and quantities of fabric for garments, see Jane Bridgeman, "Pagar le pompe: Why the Sumptuary Laws Did Not Work," *Women in Italian Renaissance Culture and Society,* ed. Letizia Panizza (Oxford, 2000), 215–18. For the prices (and exports) of various types of Florentine silk textiles 1425–67, see Florence Adler de Roover, "Andrea Banchi, Florentine Silk Manufacturer and Merchant in the Fifteenth Century," *Studies in Medieval and Renaissance History,* ed. W. M. Bowsky (Lincoln, NE, 1966), vol. 3, 223–79.

57. Leonardo recommended an old man be depicted in a long gown [ch'il vecchio sia togato], *Treatise on Painting* (Codex Urbanus Latinus 1270), ed. and trans. A. Philip McMahon (Princeton, 1956), vol. 1: 208. Florentine ambassadors at the French court in 1461 were strongly censured by Pius Aeneas Piccolomini (later Pope Pius II); quite exceptionally, they dressed in very short French jerkins instead of long gowns. *The Commentaries of Pius II,* trans. Florence Alden Gragg, *Smith College Studies in History* 22, no. 1–2 (Oct–Jan., 1937): 456.

58. The ankle-length crimson gowns with wide sleeves worn by Italian judges today are still called *togas.*

59. Probably members of the Della Rovere family of Perugino's patron Pope Sixtus IV.

60. Battisti, 2: 325, suggests a scarf *or* folded mantle; also see Lightbown, 1992, 64. A cloak or mantle has been suggested by numerous authors: Carlo Ginzburg, *The Enigma of Piero* (London, 1985), 135; Marilyn Aronberg Lavin, *The Flagellation* (London, 1972), 53.

61. Carlo Bertelli, *Piero della Francesca* (New Haven, 1992), 117; Hope and Taylor, 78.

62. Only the nine Procurators of Saint Mark wore crimson stoles; Venetian knights probably wore cloth-of gold. Marin Sanudo il Giovane, *De Origine, situ et magistratibus urbis Venetae, ovvero la città di Venetia (1493–1530),* ed. Angela Caracciolo Arico (Milan, 1980), 22; Stella Mary Newton, *The Dress of the Venetians 1495–1525* (Aldershot, 1988), 12–16. In Tura's fresco for *September* (Sala dei Mesi, Palazzo Schifanoia, Ferrara, c. 1470) a Venetian ambassador in a crimson *vesta* with a short cloth-of-gold *stola* over his left shoulder is received by Borso d'Este. Red *silk* textiles are here termed crimson and red *woollen* cloth scarlet.

63. For a examples of rolled hoods worn on the head (and legal and academic dress), see Benozzo Gozzoli's *Augustine Teaching in Rome* (Cappella Maggiore, Sant'Agostino, San Gimignano, 1465).

64. Davies, 1986, 122–27.

65. The *capuccio* or rolled hood was also worn in northern Europe, see Francis M. Kelly and Randolph Schwabe, *A Short History of Costume and Armour Chiefly in England* (London, 1931), 30–32.

66. In *Astronomy,* the kneeling man, perhaps King Ferdinand of Naples (1423–94), or the Greek Astronomer Ptolemy of Alexandria, requires a crown to identify him as both monarch *and* scholar. Olga Raggio, "The Liberal Arts Studiolo from the Ducal Palace at Gubbio," *Metropolitan Museum of Art Bulletin* (Spring 1996), 31–33. *Astronomy* and *Dialectic* (Kaiser Friedrich Museum, Berlin) were destroyed in World War II. Martin Davies, *Early Netherlandish School* (London, 1987), 73–78; Mark Evans, "'Un maestro solenne,' Joos van Wassenhove in Italy," *Nederlands Kunsthisttorisch Jaarboek* 44 (1993): 75–110.

67. Leon Battista Alberti, *I libri della famiglia,* ed. Ruggiero Romano and Alberto Tenenti (Turin, 1972), 247.

68. Hope and Taylor, 82, suggest this figure is a wealthy Jew of the first century, following Gilbert's suggestion, 1971, 49, that it might be Joseph of Arimathea. For contemporary Jewish-Italian dress, see Bridgeman, 1992, 223.

69. He is identified by Lightbown, 1992, 67–69, as Francesco Sforza; by Battisti, 2: 325, as either Francesco Sforza or Filippo Maria Visconti, and by Lavin, 1972, 53–59, as Lodovico III Gonzaga, Marquis of Mantua.

70. Bridgeman, 1992, 220–21.

71. ". . . there were many gentlemen . . . also dressed very richly in the Greek style, their garments being extremely dignified, both those of the prelates and of the laity." Vespasiano da Bisticci, *Vite di uomini illustri del secolo xv,* ed. Gugliemo Vita (Florence, 1938), 23.

72. The "Union" of the Greek Orthodox and Latin Catholic Churches was declared on July 6, 1439. Other Eastern Christians – Armenians, Syrian Maronites, and Coptic Ethiopian clerics – came to Florence between 1440 and 1441.

73. *Vite degli uomini illustri,* 23–24. Philippi is near Drama, north of Salonika in Greece. It was a strategic Roman town and its ruins are now an important archaeological site.

74. For late Byzantine dress, Jean Ebersolt, *Les arts somptuaires de Byzance* (Paris, 1923), 120–41; Elizabeth Piltz, *Kamelaukion et mitra: Insignes byzantines imperiaux et ecclésiastiques,* Acta Universitatis Uppsaliensis (Uppsala, 1977); Paul A. Underwood, *The Kariye Djami* (New York, 1966), vol. 1: 272–92.

CHAPTER 6. PIERO DELLA FRANCESCA'S RULER PORTRAITS

I would like to record the importance of the scholarship of Creighton Gilbert – who first published on the subject some sixty years ago – and Eugenio Battisti for this essay, which was written in summer 1999. I wish to thank Jeryldene Wood for inviting me to write it and for making valuable editorial suggestions, Dawson Carr, Peter Fusco, David Kunzle, Alison Luchs, Carolyn Malone, and John Pollini for their generosity with bibliographic references, Lorne Campbell for lending me his photograph of the reconstructed Memlinc double portrait, Jennie Wehmeier for her valuable research sleuthing in summer 1999, and the participants in University of California, Los Angeles, Art History seminar 230/240 in winter 2000 for helpful suggestions. Research was conducted at Villa I Tatti and the Kunsthistorisches Institut in Florence, at the Warburg Institute in London, and at the libraries of UCLA and the Getty Research Institute in Los Angeles. I am deeply appreciative of all these institutions and the helpful endeavors of their librarians on my behalf, especially Linda Warren of the UCLA Arts Library. This essay is for Rowan on his second birthday.

1. "C'est un dur métier pour un haut personnage, que d'affirmer sans cesse à nos propres yeux son importance et son droit, quand les glaces lui renvoient la fadeur trop humaine de son reflet, quand il ne découvre en lui-même que des humeurs tristes et brouillées. De là vient la nécessité des portraits officiels: ils déchargent le prince du soin de penser son droit divin. Napoléon n'existe nulle part ailleurs que sur des portraits." This is adapted from Anne P. Jones's translation of Jean-Paul Sartre, *Visages, précédé de Portraits Officiels* (Paris, 1948), 14.
2. Philip J. Jones, *The Malatesta of Rimini* (Cambridge, 1974), 191.
3. Pier Giorgio Pasini, "Note su Matteo dei Pasti e la medaglistica Malatestiana," in *Atti del Primo Congresso Internazionale di Studio della Medaglia d'Arte 1970* (Udine, 1973), 41–75. Fert Sangiorgi, *Iconographia Federiciana* (Urbino, 1982). Joanna Woods-Marsden, "How Quattrocento Princes Used Art: Sigismondo Pandolfo Malatesta of Rimini and *cose militari*," *Renaissance Studies* 3 (1989): 387–414.
4. Maria Grazia Pernis and Laurie Schneider Adams, *Federico da Montefeltro and Sigismondo Malatesta: The Eagle and the Elephant* (New York, 1996), chap. 2.
5. Helen S. Ettlinger, *The Image of a Renaissance Prince: Sigismondo Malatesta and the Arts of Power*, Ph.D. diss. (University of California, Berkeley, 1988), 20.
6. Cecil Clough, "Federigo da Montefeltro's Patronage of the Arts, 1468–1482," *Journal of the Warburg and Courtauld Institutes* 36 (1973): 138.
7. Michel Laclotte, "Le portrait de Sigismondo Malatesta par Piero della Francesca," *Revue du Louvre* 28 (1978): 255–66; Marilyn A. Lavin, "Piero della Francesca's fresco of Sigismondo Pandolfo Malatesta before St. Sigismund . . ." *Art Bulletin* 56 (1974): 345–74; Eugenio Battisti, *Piero della Francesca*, vol. 1 (Milan, 1971), 56–75.
8. Piero worked at the Ferrarese court in the late 1440s. For Pisanello's painting, see *Pisanello: Le peintre aux sept vertus* (Paris, Musée du Louvre, 1996), cat. 265.
9. Sigismondo's corpse was dressed in clothes of a similar pattern (Battisti, 1971, 1: 69–70).

10. Ronald Lightbown, *Piero della Francesca* (New York and London, 1992), 100.

11. Cennino Cennini, *The Craftsman's Handbook: "Il libro dell'arte"*, trans. Daniel V. Thompson (New Haven, 1933), chap. 8.

12. Joanna Woods-Marsden, "Ritratto al naturale": Questions of Realism and Idealism in Early Renaissance Portraits," *Art Journal* 46 (1987): 209–16, and Cesare Clementini, *Raccolto istorico della fondazione di Rimini e dell'origine e vite de' Malatesti,* vol. 2 (Rimini, 1607), 296.

13. For the following, see Woods-Marsden, 1989, 389.

14. 1450 was the same time in which his illegitimate sons were legitimized; see Jones, 1974, 203. For the building projects, see now Stanko Kokole, "Agostino di Duccio in the Tempio Malatestiano 1449–57: Challenges of Poetic Invention and Fantasies of Personal Style," Ph.D. diss. (Johns Hopkins University, Baltimore), 1997.

15. See Laclotte, 1978, fig. 10, for Cristofano dell'Altissimo's sixteenth-century portrait of Sigismondo in armor (Uffizi), copied perhaps from a medal.

16. Ettlinger, 1988, 2.

17. See Cecil H. Clough, "Federico da Montefeltro and the Kings of Naples: A Study in Fifteenth-Century Survival," *Renaissance Studies* 6 (1992): 116.

18. Ettlinger, 1988, 184.

19. See Woods-Marsden, 1989.

20. Guarino da Verona, *Epistolario,* ed. R. Sabbadini, II (Venice, 1915–19), 459, no. 796.

21. Ettlinger, 1988, 8; Woods-Marsden, 1989, 401–2.

22. Battisti, 1971, 1: 355–69; 2: 56–58. For a technical analysis of the diptych, see P. Dal Poggetto, ed., *Piero e Urbino: Piero e le Corti rinascimentali* (Venice, 1992), 456ff., cat. 26.

23. The best summaries of the literature on the date are by Alessandro Cecchi, in Bellosi, Luciano, ed. *Una Scuola per Piero: Luce, colore e prospettiva nella formazione fiorentina di Piero della Francesca* (Venice, 1992), 139–44, and Martin Warnke, "Individuality as Argument: Piero della Francesca's Portrait of the Duke and Duchess of Urbino," in *The Image of the Individual: Portraits in the Renaissance,* ed. Nicholas Mann and Luke Syson (London, 1998), 87.

24. The papal dukedom also coincided with the engagement of Federico's daughter Giovanna to Sixtus IV's nephew.

25. Creighton Gilbert, "New Evidence for the date of Piero della Francesca's 'Count and Countess of Urbino,'" *Marsyas* 1 (1941): 41–53.

26. CLARVS INSIGNI VEHITVR TRIVMPHO / QVEM PAREM SVMMIS DVCIBVS PERHENNIS / FAMA VIRTVTVM CELEBRAT DECENTER / SCEPTRA TENENTEM. The source is Virgil, *Aeneid,* X, 501–4. Battisti's assumption (1971, 2: 56–58) that the DVCIBUS of Federico's inscription refers to the dukedom cannot be sustained given the term's common usage to signify "leader" or *condottiere.* See also Creighton Gilbert, *Change in Piero della Francesca* (Locust Valley, NY: J.J. Augustin, 1968), 101 n. 49.

27. QVE MODVM REBVS TENVIT SECVNDIS / CONIVGIS MAGNI DECORATA RERVM / LAVDE GESTARVM VOLITAT PER ORA / CVNCTA VIRORVM. The source is an epitaph by the poet Ennius (referring to posthumous reputation), quoted by Cicero, *Tusculan Disputations,* Bk. 1, XV, 34.

28. Gilbert, 1941.

29. Included in the context of funeral panegyrics for statesmen and princes, the passage can be interpreted as having been placed under a portrait of the deceased

Ennius. Gilbert, 1968, 101 n. 49: Maurizio Calvesi, *Piero della Francesca* (Milan, 1998), 168.

30. For the encomia, see Gilbert, 1941; Lightbown, 1992, 234; and for the cause of her death, see Marinella Bonvini Mazzanti, "Per una Storia di Battista Sforza," in *Piero e Urbino, Piero e le corti rinascimentali,* ed. Paolo Dal Pogetto (Venice, 1992), 146, 147 n. 37, and M. Bonvini Mazzanti, *Battista Sforza Montefeltro; Una principessa nel rinascimento italiano* (Urbino, 1993), 162ff., 175.

31. Battisti, 1971, 1: 356; 2: 518 n. 480.

32. Joanna Woods-Marsden, "Per una tipologia del ritratto di stato nel Rinascimento," in *Il Ritratto e la Memoria: Materiali 3,* ed. Augusto Gentili, Philippe Morel, and Claudia Cieri Via (Rome, 1993), 54–56.

33. Clementini, 1607, 2: 296.

34. For the eagle's associations, see Guy de Tervarent, *Attributs et Symboles dans l'art profane, 1450–1600* (Geneva, 1958), 5; Pomponius Gauricus, *De Sculptura,* ed. A. Chastel and R. Klein (Geneva, 1969), 147; Battisti, 1971, 1: 357.

35. "Questo naso adunco . . . rappresenti un non so ché di regale, perché l'Aquila è Regina delli uccelli, e però par che prometta una magnificenza d'un regal animo." Giovanni Battista della Porta, *Della Fisonomia dell'Huomo,* Naples, 1598 edition. For the accompanying illustration, see Flavio Caroli, *Storia della Fisiognomica* (Milan, 1995), 71, pl. 31.

36. Haskell, Francis, "Patronage," in *Encyclopedia of World Art* (New York, 1972), vol. 11: 122.

37. Gino Franceschini, *I Montefeltro,* Varese, 1970, 23.

38. Pasquale Rotondi, *Il Palazzo Ducale di Urbino* (Urbino, 1950), vol. 1: 168ff.; 2: pls. 57–86, 167, 176, 308, 338, 389, 452–57.

39. Cinquiglini, 1984, 481.

40. Battisti, 1971, 1: 357; 2: 519 n. 482.

41. See Woods-Marsden, 1987.

42. Remarkably, Burckhardt characterized the portrait as "Flemish pitilessness" (Warnke, 1998, 82), and recently Lightbown (1992, 238) stated that the "cool Flemish realism that portrays objectively, without suppression or emphasis, the actual characteristics of a man's features, warts and all." The alternative attribution is to the Spanish Pedro Berruguete. For the attribution, Jacques Lavalleye, *Le Palais Ducal d'Urbin* (Brussels, 1964), 109–26, cat. 106 (who attributes the work to Justus); Clough, 1974 (who argues that Berruguete never worked in Urbino). Also see Charles M. Rosenberg, "The Double Portrait of Federico and Guidobaldo da Montefeltro: Power, Wisdom, and Dynasty," in *Federico di Montefeltro: Le Arti,* ed. G. Cerboni Baiardi, G. Chittolini, and P. Floriani (Rome, 1986), 213–22.

43. Lorne Campbell, *The Early Flemish Pictures in the Collection of Her Majesty the Queen* (Cambridge, 1985), 17–24; Woods-Marsden, 1987.

44. Alberti, Leon Battista, *On Painting and On Sculpture,* trans. Cecil Grayson (London, 1972), 78–81, para. 40.

45. See Sangiorgi, 1982.

46. Laclotte, 1978, 258–60. Lavin, 1974, 349–51, justifies the donor's central location by relating the composition to nondevotional scenes of secular narrative in which the emperor is centered.

47. Sigismondo was knighted by Emperor Frederick III in 1433.

48. Woods-Marsden, 1989, and Lightbown, 1992, 93.

49. Lavin, 1974, 363, 373.

50. Lightbown, 1992, chap. 14. See also Marilyn A. Lavin, "Piero della Francesca's Montefeltro Altarpiece: A Pledge of Fidelity," *Art Bulletin* 51 (1969): 367–71.

51. For the date, see Gilbert, 1968, 91–92 n. 43. For the technical relationship of Piero's two profiles of Federico, see Roberto Bellucci and Cecilia Frosinini, "Ipotesi sul metodo di restituzione dei disegni preparatori di Piero della Francesca: Il caso dei ritratti di Federico da Montefeltro," *La pala di San Bernardino di Piero della Francesca. Nuovi studi oltre il restauro,* ed. Filippo Trevisani and Emanuela Daffra, in *Quaderni di Brera* 9 (1997): 167–87.

52. Lightbown (1992, chap. 14) suggests that Battista's absence from the altar-piece is due to her burial elsewhere.

53. Ronald Lightbown, *Mantegna* (Berkeley and Los Angeles, 1986), cat. 36.

54. So strong was de Tolnay's sense of the donor's disengagement in the Monte-feltro altarpiece that he argued that the figure of Federico was added later. See Charles de Tolnay, "Conceptions religieuses dans la peinture de Piero della Francesca," *Arte Antica e Moderna* 23 (1963): 235.

55. Jacqueline Herald, *Renaissance Dress in Italy 1400–1500* (London, 1981), 152. The quotation comes from Giovanni Sabadino degli Arienti, *Gynevera de le Clare Donne,* ed. Corrado Ricci and A. Bacchi della Lega (Bologna, 1888), 298.

56. Lightbown, 1992, 238. For the expense of pearls, see Frick, Carole Collier, *Dressing Renaissance Florence: Honorable Families, Economics, and Tailors* (Baltimore, 2002), chap. 6.

57. Manca, Joseph, "Blond hair as a Mark of Nobility in Ferrarese Portraiture of the Quattrocento," *Musei Ferraresi* 17 (1990/91): 51–60, and Lightbown, 1992, 238.

58. The reverse happens in the panorama; the terrain behind the countess lies in greater shadow than the body of water and hills behind the count.

59. First noted by Adolfo Venturi, *Piero della Francesca* (Florence, 1921–22), 56; also see Charles Seymour, Jr., *Sculpture in Italy, 1400–1500* (Harmondsworth, Middlesex, 1966), 164.

60. Schuyler, Jane, "Death Masks in Quattrocento Florence," *Source* 5 (1986): 1–6.

61. Hanno-Walter Kruft, *Francesco Laurana: Ein Bildhauer der Frührenaissance* (Munich, 1994), 371, cat. 6. The work measures 51 × 47 × 22.5 cm.

62. Italian Quattrocento princes had been using the terms *divus* and *diva* on medals since the middle of the century. In antiquity the words signified "man/woman made into a god" or, alternately, "god who was previously a mor-tal," but in the Roman world, only the emperor or a member of the imperial family could be so deified. Apotheosis as a *divus* or *diva* could only take place after death and then only by decree of the Roman Senate. See Joanna Woods-Marsden, "Art and Political Identity in Fifteenth-Century Naples: Pisanello, Cristoforo di Geremia, and King Alfonso's Imperial Fantasies," in *Art and Pol-itics in Late Medieval and Early Renaissance Italy, 1250–1500,* ed. Charles M. Rosenberg (Notre Dame – London, 1990), 17f.

63. Gilbert, 1968, 104 n. 52, links the RG to a poem by Porcellio addressed to "Divae Baptistae Urbini Reginae;" See Clarence Kennedy and Ruth Wedg-wood Kennedy, *Four Portrait Busts by Francesco Laurana* (Northampton, MA,

1962), n.p. From the front, the whole inscription only is visible to the viewer. Since slight polychromy survives inside the letters of the inscription, it is possible that this and Laurana's other marble busts were all originally as polychromed as the one today in Vienna.

64. Warnke, 1998, 84, reads the line as a retaining ribbon.

65. Fritz Burger, *Francesco Laurana: Eine Studie zur Italienischen Quattrocentoskulptor* (Strasburg, 1907), pl. xxvi. The head tilted up is also evident in views from the front.

66. Marilyn A. Lavin, "The Altar of Corpus Domini in Urbino: Paolo Uccello, Joos van Ghent, Piero della Francesca," *Art Bulletin* 49 (1967): 17 n. 118.

67. E. Mognetti, in *Le Roi René en son temps 1382–1481* (Musée Granet, Aix-en-Provence, 1981), 151–55; Kruft, 1994. Florentine portrait busts were rarely if ever carved with a base. See Irving Lavin, "On the Sources and Meaning of the Renaissance Portrait Bust," *Art Quarterly* 33 (1970): 207–26. The standard article on the subject is still Wilhelm Bode, "Abteilung der Bildwerke der Christlichen Epochen: Die Ausbildung des Sockels bei den Büsten der italienischen Renaissance," *Amtliche Berichte aus den Preussischen Staatssammlungen* 40 (1919): 100–20. Of the few surviving Italian instances, three are other female busts by the same sculptor; see Kruft, 1994, cats. 3, 16, 33. Curiously, the bust is reproduced *without* its (attached) base in Benedetto Patera, *Francesco Laurana in Sicilia* (Palermo, 1992), 69, fig. 59. I am very grateful to Alison Luchs for her valuable comments and bibliographic advice on this aspect of the bust.

68. Eva Kovacs, *Kopfreliquiare des Mittelalters* (Budapest, 1964). Anita Moskowitz, "Donatello's Reliquary Bust of Saint Rossore," *Art Bulletin* 63 (1981): 43. Luba Freedman, "Donatello's Bust of a Youth and the Ficino Canon of Proportions," in *Il Ritratto e la Memoria. Materiali 1,* ed. Augusto Gentile (Rome, 1989), 121. For medieval reliquary busts of female saints, see Joan A. Holladay, "Relics, Reliquaries, and Religious Women: Visualizing the Holy Virgins of Cologne," *Studies in Iconography* 18 (1997): 67–118.

69. Fusco, Peter, "An Image of Saint Cyricus by Francesco Laurana," *Antologia di Belle Arti* n.s. 52–55 (1996): 8–16.

70. This hypothesis would be neither sustained nor negated by Laurana's three other busts with bases (Frick Museum, New York; National Gallery of Art, Washington; and formerly Berlin), since these are both undated and unidentified, despite their designation, without proof, by some art historians, as "Ippolita Maria Sforza" or "Isabella of Aragon."

71. Two works by Ghirlandaio make the point: the posthumous portrait of an old man (Louvre) probably based on a drawing (see Thiébaut, 1996), and the posthumous portrait of Giovanna degli Albizzi (Thyssen, Prado) probably derived from the artist's frescoed portrait (see Maria K. DePrano, "Uxor Incomparabilis: The Marriage, Childbirth, and Death Portraits of Giovanna degli Albizzi," M.A. thesis, University of California, Los Angeles, 1997.). The phenomenon probably emulated the Roman wax images of ancestors described by Pliny; see Schuyler, 1986. Death masks were used by royalty in the Middle Ages in the sepulchral context of tomb effigies.

72. Seymour, 1966, 164–65.

73. Ernst H. Kantorowicz, *The King's Two Bodies: A Study in Medieval Political Theology* (Princeton, NJ, 1957).

74. Lorne Campbell, *Renaissance Portraits: European Portrait-painting in the 14th, 15th and 16th Centuries* (New Haven and London, 1990), 120–21.

75. Cocke, Richard, "Piero della Francesca and the Development of Italian Landscape Painting," *Burlington Magazine* 122 (1980): 631. Van Eyck's landscapes were a feature of Flemish painting that appealed greatly to Italians. Adopted by Mantegna in the late 1450s, their "plateau" compositional format was quickly disseminated across Northern Italy. See Millard Meiss, "Jan Van Eyck and the Italian Renaissance," in *The Painter's Choice: Problems in the Interpretation of Renaissance Art* (New York, 1976), 28ff.

76. Christiansen, Keith, "The View from Italy," in *From Van Eyck to Brueghel: Early Netherlandish Painting in the Metropolitan Museum of Art*, ed. Marian W. Ainsworth and Keith Christiansen (New York, 1998), 45–46. See also Bert W. Meijer, "Piero and the North," in *Piero della Francesca and His Legacy*, ed. Marilyn A. Lavin, *Studies in the History of Art*, 48 (1995): 144. It has been suggested that the initial stimulus for a panorama background in portraiture may have come from Memlinc's Italian sitters who formed a large segment of his clientele; see Philippe Lorentz, *Hans Memling au Louvre* (Paris, 1995), 70. It has been estimated that over 20 percent of Memlinc's portraits were commissioned by Italians (see Maximiliaan P. J. Martens, "Hans Memling and his Patrons: A Cliometrical Approach," in *Memling Studies: Proceedings of the International Colloquium 1994*, ed. Hélène Verougstraete, Roger Van Schoute, and Maurits Smeyers [Louvain, 1997]).

77. The sitters in this *Double Portrait* may have been Italian; see Lorentz, 71. See also Memlinc's *Double Portrait of Willem Moreel and Barbara von Vlaenderbergh*, c. 1480, in what was perhaps originally a triptych with a Virgin and Child in a central panel to whom the couple pray (Angelica Dulberg, *Privatporträts* (Berlin, 1990), cats. 9 and 10). Given Count Federico's enthusiasm for Flemish painting and the presence of Justus van Ghent in Urbino at the same time that Piero was painting the diptych (c. 1472–75), a work similar to Memlinc's *Double Portrait* may have been available, or otherwise known by Piero for use as a model. See Dirk De Vos, *Hans Memlinc: The Complete Works* (Ghent, 1994), 115–17; Lorne Campbell, "A Double-Portrait by Memlinc," *Connoisseur* 194 (1977): pl. 59. Federico may have been introduced to Flemish painting by Battista's father, Alessandro, who commissioned a *Crucifixion*, in which Battista herself figured as worshipper, by the Van der Weyden workshop on a trip to Flanders in 1458 (Germano Mulazzani, "Observations on the Sforza Triptych in the Brussels Museum," *Burlington Magazine* 113 (1971): 252–53).

78. Battisti, 1971, 1: 357, 365; 2: 58.

79. See below, 112–113.

80. As Leonardo da Vinci codified the theory, the strength of color diminished to four-fifths of its previous value for every twenty *braccia* in depth, so that a mountain that was "five times distant" should be "five times bluer" [Martin Kemp, *Leonardo da Vinci: The Marvellous Works of Nature and Man* (Cambridge, MA, 1981), 133].

81. ARAGONVM SICILIARVM VALENCIAE HIEROSOLYMAE HVNGARIAE MAIORCARVM SARDINIAE CORSICAE REX . . .; see George F. Hill, *A Corpus of Italian Medals of the Renaissance before Cellini*, vol. 2 (London, 1930), cat. 43.

82. Nor, in my view, should the walled city behind Battista's head on the front be

read as a "portrait" of Volterra (Carlo Bertelli, *Piero della Francesca* [New Haven and London, 1992]).

83. See Martin Warnke, *Political Landscape: The Art History of Nature* (London, 1994); and J. W. T. Mitchell, "Imperial Landscape," in *Landscape and Power* (Chicago, 1994), 5–34, who argues for the rise and development of landscape as a symptom of the rise and development of capitalism and colonialism.

84. Ernst H. Gombrich, "The Renaissance Theory of Art and the Rise of Landscape," in *Norm and Form* (London, 1966), 111–13.

85. Joanna Woods-Marsden, "Visual Constructions of the Art of War: Images for Machiavelli's *Prince*," in *Perspectives on the Renaissance Medal*, ed. Stephen K. Scher (New York, 2001), 47–73.

86. The reverses of Raphael's likenesses of Angelo Doni and Maddalena Strozzi (c. 1507, Uffizi) bear stories in grisaille from Ovid's Metamorphoses (Dulberg, 1990, cats. 189–90).

87. Gilbert, 1941, 43.

88. See Sangiorgi, 1982.

89. See notes 26 and 27 above. Nonetheless, some of the forms, such as the inclusion of the uncial E and two different kinds of M (side by side in SVMMIS), were not correct by classical standards. Many painted classical inscriptions still contained mistakes in this period, and it was not until later in the century that their style started to conform to Roman usage. See Dario Covi, "Lettering in Fifteenth-Century Florentine Painting," *Art Bulletin* 45 (1963): 7–8.

90. See Claudia Cieri Via, "I Trionfi di Piero," in *Piero e Urbino, Piero e le corti rinascimentali*, ed. Paolo Dal Poggetto (Venice, 1992), 126–33; and Antonio Pinelli, "Feste e trionfi: Continuità e metamorfosi di un tema," in *Memoria dell'Antico nell'arte italiana*, ed. Salvatore Settis (Turin, 1984), vol. 2: 279–350.

91. Ettlinger, 1988; Cieri Via, 1992.

92. Thomas Martone, "Piero della Francesca's *Triumphs of the Duke and Duchess of Urbino*," in *Petrarch's Triumphs: Allegory and Spectacle*, eds. Konrad Eisenbichler and Amilcare A. Iannucci (Toronto, 1990), 211–22.

93. Hill, 1930, cat. 43. See Warnke, 1998, 214 n. 31, for the caution that Federico's celebration by Florence in 1472 after his conquest of Volterra may have been transformed by art historians from a reception into a "triumph."

94. Cieri Via, 1992, 127.

95. Gilbert, 1968, 93 n. 44.

96. Ettlinger, 1988, 155; Cieri Via, 1992, 131–32, citing Castiglione, *Book of the Courtier*, Bk. IV, chap. 18.

97. Ettlinger, 1988, 134.

98. The unusual attribute of a pelican was also given to Charity on the so-called tarocchi cards of Mantegna (Jay A. Levenson, Konrad Oberhuber, and Jacquelyn L. Sheehan, *Early Italian Engravings from the National Gallery of Art* [Washington, DC, 1973], cat. 51, who date them c. 1465–70). See also Tervarent 1958, 302–3; R. Freyhan, "The Evolution of the Caritas Figure in the Thirteenth and Fourteenth Centuries," *Journal of the Warburg and Courtauld Institutes* 11 (1948): 68–86. The pelican features on the reverse of four posthumous medals (Gilbert, 1968, 99–100 n. 48).

99. Triumphal imagery also featured in the Montefeltro ducal palace on doors leading to each spouse's apartments: a Triumph of Modesty leading to Battista's personal quarters in the Iole wing of the palace, and an intarsied Tri-

umph of Fame, again with the four cardinal virtues, on the doors opening into the Sala degli Angeli, close by Federico's own suite of rooms (Cieri Via, 1992).

100. Lavin, 1992, 114; Lightbown, 1992, 235. By a privilege granted in 1470, the Vice-General of the Observant Province admitted the couple and their children to full participation in the privileges of the Observant Franciscans after death (Lightbown, 1992, 250, 289 n. 14). It is also possible that Gilbert was correct in identifying Battista's attendants as the virtues of Honesty *(Onestate)* in white and Shame *(Vergogna)* in grey who accompanied Petrarch's figure of *Pudicitia* in her Triumph. See Gilbert, 1968, 93 n. 44.

101. See Joanna Woods-Marsden, *Renaissance Self-Portraiture: The Visual Construction of Artistic Identity and the Social Status of the Artist* (New Haven and London, 1998), chap. 20.

102. For the following, see Bonvini Mazzanti, 1992.

103. Pernis and Schneider Adams, 1995, 51; Cecil H. Clough, "Daughters and Wives of the Montefeltro: Outstanding Bluestockings of the Quattrocento," *Renaissance Studies* 10 (1996): 31–55.

104. See Arienti, 1888, 295.

105. Ibid., 294. He was writing in the 1480s at the Bolognese court of Battista's sister, Ginevra Sforza.

106. Ibid, 293.

107. Ibid., 294: "troppo proveduta et saghace, che bastarebbe havesse gubernato el regno di Franza."

108. Dennistoun, James, *Memoirs of the Dukes of Urbino,* 3 vols. (London, 1851), vol. 1: 95. Pernis and Schneider Adams, 1995, 109. As it happens, Sigismondo had an equally cogent reason for wishing to position himself in the left-facing, subordinate, profile. The protruding bone on his upper right cheek, which was revealed on his skull when his tomb was opened in 1920, may well have penetrated through the skin on his face and have been very unsightly. See Corrado Ricci, *Il Tempio Malatestiano* (Milan, 1924), 356, figs. 421 and 422.

109. Pernis and Schneider Adams, 1995, 109.

110. Arienti, 1888, 290.

111. Cieri Via, 1992, 133 n. 10.

112. Woods-Marsden, 1987, 213. Husband and wife pendants were produced at the courts of Milan and Bologna for the Sforza and their relatives in the third quarter of the century. The earliest may be the diptych of Duke Francesco Sforza of Milan and Bianca Maria Visconti formerly attributed to Bonifacio Bembo (see Sandra Bandera Bistoletti, *Pinacoteca di Brera, I: Scuole Lombarde e Piemontese* (Milan, 1988), vol. 1, 390–92, cats. 180–81.) This undocumented work reasonably dates to c. 1460; it must in any case precede Francesco Sforza's death in 1468. The diptych asserts the legitimacy of Sforza rule of Milan and confirms the continuation of his dynasty. Having seized Milan in a coup d'etat in 1450, Sforza's rule was illegitimate; in the eyes of the law he was a usurper and the duchy was officially vacant. The strongest argument for his rule was his marriage to Bianca Maria, the legitimized heir to the last Visconti duke (see Gary Ianziti, *Humanist Historiography under the Sforzas: Politics and Propaganda in Fifteenth-Century Milan* (Oxford, 1988), 20–29, 127–44). Sforza likely used his wife's presence as a kind of conjugal validation of his usurpation of her father's state. A diptych with the same pro-

tagonists was presented by Niccolò Teutonico to Borso d'Este in 1455 (see Warnke, 1998, 213 n. 12).

113. Lightbown, 1992, 231. See also Battisti, 1971, 1: 356. The reference given by Lightbown (1992, 231) to Guasti, 1863, no. 63, for an object recorded in "the form of a book, on which is the image of the most illustrious Duke Federico" is inaccurate. See C. Guasti, "Inventario della Libreria Urbinate compilato nel secolo XV," *Giornale Storico degli Archivi Toscani* 6 (1863): 127–47; 7 (1863): 46–55; 130–54.

114. See also Cecchi, 1992, 144.

115. Campbell, 1990, 120–21; Lightbown, 1992, 234; Dülberg, 1990, cats. 174–75 and fig. 114; Charles Sterling and Helène Adhemar, *Peintures: École française, XIVe, XVe et XVIe siècles* (Paris, 1965), 14–15, cat. 36.

116. Antonio Averlino called Filarete, *Treatise on Architecture,* trans. John R. Spencer, vol. 2 (New Haven and London, 1965), 320. See also Dülberg, 1990, 76, for similar conclusions.

117. Pope-Hennessy, John, assisted by Laurence B. Kanter, *The Robert Lehman Collection I: Italian Paintings* (Princeton, 1987), 240–43, cats. 96 and 97; Dülberg, 1990, cats. 183–84. For a reconstruction of the case in which a Cranach hinged double portrait was stored, see Dülberg, 1990, fig. 452. Queen Isabella is recorded as having kept many of her portraits in cases or boxes (Lorne Campbell, *Renaissance Portraits: European Portrait-Painting in the 14th, 15th, and 16th Centuries* (New Haven and London, 1990), 254 n. 121).

118. Filarete, 1965, 320.

119. See Robert Baldwin, "Politics, Nature, and the Dignity of Man in Piero della Francesca's Portraits of Battista Sforza and Federico da Montefeltro," *Source* 6 (1987): 14–17, for a reading that relates the portraits to the history of ideas.

CHAPTER 7. THE RENAISSANCE *PROSPETTIVA:* PERSPECTIVES OF THE IDEAL CITY

1. The panels are in the Walters Art Gallery in Baltimore, the Berlin Gemälde-galerie, and the Galleria Nazionale delle Marche in Urbino. All three are executed on poplar and roughly commensurate in length. For a thorough summary of their *fortuna critica,* see Alessandro Conti, "Le prospettive urbinati: Tentativo di un bilancio ed abbozzo di una bibliografia," *Annali della Scuola Normale Superiore di Pisa: Classe di lettere e filosofia,* ser. iii, VI, 3 (1976): 1221f.

2. Giorgio Vasari, *Le Vite de' più Eccellenti Pittori, Scultori ed Architettori* (Florence, 1568; rev. ed. by Gaetano Milanesi, Florence: Sansoni Editore, 1981), vol. II, 546–47.

3. Vitruvius, *De architectura* V, 6, 8. See Richard Krautheimer, "The Tragic and Comic Scene of the Renaissance: The Baltimore and Urbino Panels," *Gazette des Beaux-Arts,* ser. vi, 33 (1948): 329f. For Alberti's reading of the tragic, comic, and satyric modes in the context of artistic decorum, see Anne B. Barriault, *Spalliera Paintings of Renaissance Tuscany: Fables of Poets for Patrician Homes* (University Park, PA, 1994), 98–99.

4. *De re aedificatoria* VIII, 7. Leon Battista Alberti, *On the Art of Building in Ten Books,* trans. J. Rykwert, N. Leach, R. Tavernor (Cambridge, 1988), 273.

5. Cf. Eugenio Battisti, "La visualizzazione della scena classica nella commedia umanistica," *Rinascimento e Barocco* (Turin, 1960), 106–11.

6. Giovanni Sulpizio da Veroli, in the dedication of his Vitruvius edition (1486), speaks of a painted backdrop *(picturatae scenae faciem)* erected in the house of his patron, Cardinal Raffaele Riario, for the production of a comedy by the learned antiquarian and academician, Pomponio Leto. Other performances of plays by Terence, Seneca, and Plautus soon followed; however, no visual record survives of any of these scenographic backdrops. The earliest evidence comes from a letter of Baldassare Castiglione, which gives a vivid account of the stage sets for Bibbiena's play, *Calandria,* performed in Urbino in 1513. These *tableaux vivants* featured a street scene replete with churches, taverns, palaces, a triumphal arch to one side of the stage and an octagonal *tempio* in the center. See Krautheimer, "The Tragic and Comic Scene of the Renaissance," 339–40.

7. Bernardino Baldi, *Descrizione del Palazzo Ducale di Urbino,* in F. Bianchini, *Memorie concernenti la Città di Urbino dedicate alla Sagra Real Maestà di Giacomo III, Re della Gran Brettagna* (Rome, 1724), 44–45: "certe tavolette, nelle quali sono tirate con ragioni di prospettiva, e colorite alcune scene, delle quali non può dubitarsi se siano sue, essendovi scritto il suo nome, ed alcune altre cose co' caratteri, e linguaggio Schiavone."

8. Cornelius Budenich, *Un quadro di Luciano Dellauranna* (Trieste, 1902), 117. Another series of numbers in the right titulus begins "149 . . . ," making it dubious that these have anything to do with the date of the painting. See Federico Zeri, *Italian Paintings in the Walters Art Gallery,* with notes by Elizabeth C. G. Packard, ed. Ursula E. McCracken (Baltimore, 1976), vol. 1, 145, with complete bibliography.

9. In 1472, with the death of his wife Battista Sforza, Federigo put an abrupt halt to work on the palace. Laurana, effectively discharged from his duties, probably returned to the Aragonese court in Naples. In 1474 he entered the employ of Costanzo Sforza in Pesaro, remaining there until his death. During this period there is no documentation of additional activities at the court of the Montefeltro.

10. ". . . uno quadro longo d'una prospetiva antica ma bella di mano di Fra Carnevale," see Fert Sangiorgi, *Raffaello e i duchi di Urbino* (Urbino, 1971), 43, 63. The measurements from an Inventory of 1582 list the same work as mounted over a doorway (*"quadro lungo tre braccia o poco più et alto un braccio e mezzo in circa conuna prospettiva sopra una porta delle camere ducali"*). Although the Urbino panel measures 67 × 238 cm, visible saw-marks would indicate that the panel was trimmed on either side. The Urbinate painter Giovan Francesco Micalori in 1670 describes two works he had seen in private collections: one "una Prospettiva lunga 7 piedi in circa e alta 4 ½ in circa dipinta in tavola di Fra Carnevale" and "un'altra prespettiva diferente da questa fatta dal medesimo [i.e., Fra Carnevale] . . . nella Galaria dell'Eccellentissimo S. Cardinale Antonio." There is little basis for the claim by Alessandro Parronchi, "Quadri in vendita a Urbino negli anni 1670," *Labyrinthos* 13 (1994): 184–85, that these are indeed the works today in Baltimore and Urbino.

11. Stefano Borsi, "Il maestro di Bramante: Fra Carnevale," in *Bramante e urbino: Il problema della formazione* (Rome, 1997), 11–26. Fra Carnevale's name recurs in a document from 1651 relating to a "long perspective" in the ducal palace. On this basis alone, Martin Kemp considers him "the best of all the candidates" for attribution of the Urbino panel. See *Circa 1492: Art in the Age of Exploration,* ed. Jay A. Levenson (New Haven and London, 1991), 249–50; and Sangiorgi, 43.

12. Johann Gaye, *Carteggio inedito d'artisti dei secoli XIV, XV, XVI* (Florence, 1839), I: 276. Sometime before 1867 the painting was transferred to the Istituto di Belle Arti in the Palazzo Ducale, whose collection eventually became the core of the Galleria Nazionale delle Marche. Thus, the panel has remained in one form or another within the patrimony of the Montefeltro at least since the sixteenth century.

13. See Pasquale Rotondi, *The Ducal Palace of Urbino: Its Architecture and Decoration* (London, 1969), 8–9.

14. Marilyn Aronberg Lavin, *Piero della Francesca: The Flagellation* (New York, 1972), 82.

15. Christine Smith, "Piero's Painted Architecture: Analysis of His Vocabulary," in *Piero della Francesca and His Legacy* (National Gallery of Art, Studies in the History of Art, 48), ed. Marilyn Aronberg Lavin (Hanover and London, 1995), 232–35. Pier Giorgio Pasini, *Sigismondo Pandolfo Malatesta e il suo tempo* (Rimini, 1974), 132.

16. Kenneth Clark, *Piero della Francesca*, complete edition (New York and London: Phaidon, 1969), 70.

17. J. V. Field, "A Mathematician's Art," in *Piero della Francesca and His Legacy*, 181, fig. 3, from *De prospectiva pingendi, Book 2, Proposition 6*. Inventories of the library at Urbino indicate that this treatise and the *Libellus de quinque corporibus regularibus* were shelved next to one another. Also see the essays by Field and Davis in this volume.

18. Clark, 230–31, specifically compares the round temple in the center to a passage in *De re aedificatoria* VII, 15. Earlier Fiske Kimball, "Luciano Laurana and the 'High Renaissance,'" *Art Bulletin* 10 (1927): 143, pointed more generally to the planning of streets, arches, and piazze in Bk. VIII, chap. 6.

19. See Gabriele Morolli, "Nel cuore del palazzo, la città ideale: Alberti e la prospettiva architettonica di Urbino," in *Piero e Urbino, Piero e le Corti rinascimentali*, ed. Paolo Dal Poggetto (Venice, 1992), 220f.

20. La prospettiva, qual drieto se tira/ Arithmetrica e insiem Geometria, / E l'alta Architectura se invia.//. See August Schmarsow, *Giovanni Santi, der Vater Raphaels* (Berlin, 1887), 88. The English translation is from Creighton E. Gilbert, *Italian Art, 1400–1500, Sources and Documents* (New York, 1980; new ed., Evanston, IL, 1992), 96. Further, see Lise Bek, "La prospettiva nell'ambiente urbinate: un concetto spaziale ed il suo significato," *Analecta Romana Instititi Danici*, 25 (1998): 130f.

21. As shown by infrared and x-ray photography; see Maurizio Seracini, "Ricerche Diagnostiche," in *Piero e Urbino*, 469–73.

22. Howard Saalman, "The Baltimore and Urbino Panels: Cosimo Rosselli," *Burlington Magazine* 110 (1968): 379–80.

23. Although the ring of columns derives from the ancient tholos, that by itself hardly defines the monument as a tomb or martyrium. Richard Krautheimer, "The Panels in Urbino, Baltimore and Berlin Reconsidered," in *The Renaissance from Brunelleschi to Michelangelo: The Representation of Architecture*, ed. Henry A. Millon and Vittorio Magnago Lampugnani (Milan, 1994), 233, has corrected his earlier identification of this structure as a *templum* or *macellum* ("The Tragic and Comic Scene of the Renaissance," 336). Other scholars connect the centralized building to the architectural *invenzioni* of Giuliano da Sangallo, citing his reconstruction of an antique sepulcher at

Capua Vecchia from the Vatican sketchbook. See Christian Hülsen, *Il Libro di Giuliano da Sangallo: Codice Vaticano Barberiniano latino 4424* (Leipzig, 1910), fol. 8r. Cf. Piero Sanpaolesi, "Le prospettive architettoniche di Urbino, di Filadelfia *[sic]* e di Berlino," *Bollettino d'Arte*, ser. iv, 34 (1949): 333.

24. Mario Salmi, *Piero della Francesca e il palazzo ducale di Urbino* (Florence: Le Monnier, 1945), 62, 113–14. Baldi notes a model of "un Tempio ritondo" that then stood in the guardaroba of the ducal palace. See Sangiorgi, *Documenti urbinati*, 43 n. 2.

25. Carole F. Lewine, *The Sistine Chapel Walls and the Roman Liturgy* (University Park, 1993), 66–68, discusses the liturgical allusions to Solomon's temple in the Passion week liturgy. An inscription on one of the triumphal arches reads: IMENSU [M] SALAMO TEMPLUM TU HOC QUARTE SACRASTI SIXTE OPIBUS DISPAR RELIGIONE PRIOR.

26. Maria Grazia Ciardi Duprè Dal Poggetto, "La 'Città Ideale' di Urbino," in *Urbino e le Marche prima e dopo Raffaello,* ed. M. G. C. Duprè Dal Poggetto and Paolo Dal Poggetto (Florence, 1983), 74f.

27. See the notary acts dated 17 May, 22 May, and 25 May 1477, transcribed in Giuseppe Chironi, "Appendice documentaria," in *Francesco di Giorgio architetto,* ed. Fiore and Tafuri, 402–3. On 8 November of that year, Francesco requested from the Ufficiali sopra l'Ornato in Siena permission to build a bridge between his house and another *casella* across an alleyway, explaining his absence from the city "per trovarsi a servigi dell'illustrissimo Duca di Urbino." Francesco Paolo Fiore, "L'architettura civile di Francesco di Giorgio," in *Francesco di Giorgio architetto,* 75, argues that Francesco's dissolution of his *società* with the Sienese painter Neroccio de' Landi in July 1475 coincided with the decision to take up residence in Urbino.

28. Corrado Maltese, "Opere e soggiorni urbinati di Francesco di Giorgio," in *Studi artistici urbinati* (Urbino, 1949): 59, 74.

29. Roberto Papini, *Francesco di Giorgio architetto* (Florence, 1946), 150–56.

30. Sanpaolesi, "Le prospettive architettoniche di Urbino, di Filadelfia *[sic]* e di Berlino," 322–37.

31. See Conti, "Le prospettive urbinate," 1196–98, nos. 5–6.

32. Krautheimer, 1994, 239.

33. Borghino and Francesco di Niccolò Cocchi had acquired this building site from the Peruzzi, who also owned the fourteenth-century palace abutting to the west. The eldest brother, Donato, a noted jurist, had been a faithful ally of Cosimo: the two men died within months of one another in 1464.

34. One speculation is that the initiative for the rebuilding might have owed to Francesco di Niccolò, *gonfaloniere di Giustizia* in 1469. Whoever the patron, he made no secret of his fealty to Lorenzo il Magnifico, whose device of the flaming sun with the motto *In lumine solis* is carved on the capitals across the *piano nobile.* Giampaolo Trotta, *Palazzo Cocchi Serristori a Firenze: Una dimora quattrocentesca in lumine Solis* (Florence, 1995), 26–27. Benedetto Varchi, in his *Storia fiorentina,* mentions the palace in a list of buildings erected after 1478, from which Trotta concludes a dating between 1485 and 1491.

35. Pasquale Rotondi, 1969, 84–85, credits the general conception of the ensemble to Bramante, various of the figures (e.g., Charity) to Botticelli, and the architectural landscapes to Francesco di Giorgio. Rotondi, *Francesco di*

Giorgio nel Palazzo Ducale di Urbino (Novilara, 1970), 34–37. For earlier bibliography, cf. Luciano Cheles, *The Studiolo of Urbino: An Iconographic Investigation* (University Park, PA, 1986), 53 n. 2. Most recently, Francesco Paolo Fiore, "L'architettura civile di Francesco di Giorgio," *Francesco di Giorgio architetto,* ed. F. P. Fiore and M. Tafuri (Milan, 1993), 91–92, relates the architectural vocabulary of the scene with a squirrel and basket of fruit to the cloister of Santa Chiara, both here attributed to the architect.

36. André Chastel, "Les 'vues urbaines' peintes et le théâtre," in *Bollettino del centro internazionale di studi di architettura Andrea Palladio* XVI (1974): figs. 61, 63.

37. Maddalena Trionfi Honorati, "Prospettive architettoniche a tarsia: Le porte del Palazzo Ducale di Urbino," *Notizie da Palazzo Albani* 1/2 (1983): 478, fig. 12. Trionfi Honorati, in *Piero e Urbino,* 238–39, cat. no. 44. The author maintains that these chests are Urbinate, not Florentine, in origin and traces the introduction of intarsia to the circle of Ferrara. Further, Trionfi Honorati, "Tarsie e intagli rinascimentali," in *Arte e cultura nella provincia di Pesaro e Urbino dalle origini a oggi,* ed. Franco Battistelli (Venice, 1986), 211–15.

38. The panel measures 80.3 × 220 cm. Its location is a mystery before 1897, when the painting hung in the Palazzo Accoramboni in Rome; the panel then belonged to the collector Don Marcello Massarenti. See Edouard van Esbroeck et al., *Catalogue du musée de peinture, sculpture et archéologie au Palais Accoramboni* (Rome, 1897), no. 121 (attributed to Pintoricchio). Henry Walters purchased the work in 1902.

39. Only a few of the arches are incised on the surface. I owe this observation to Pietro Roccasecca, who is studying the perspective systems of fifteenth-century panel paintings.

40. Martin Kemp, *Geometrical Perspective from Brunelleschi to Desargues: A Pictorial Means or an Intellectual End?* (Oxford, 1985). Margins running along the top and bottom of the Baltimore panel were originally left bare. Later restorers covered these areas with gesso and added color to blend with the painted surface. Underneath, however, one can still decipher the numerals "1" through "30" intercalated across the panel from left to right, which were evidently used to construct the perspective. Krautheimer intuited from the median of these intervals that the unit was a Vitruvian *passus minor,* equalling 7.3 cm, however the measurements vary randomly from 6.3 cm to as wide as 9.2 cm. Given such inconsistencies, it would be hazardous to assume the painter rationally plotted out his grid on an ancient module, and one for which, like the Roman foot (*pes*), there was no precise standard on which to rely. See the report of E. Melanie Gifford, head of painting conservation, prepared for Martin Kemp (2 April 1992) in the curatorial files of the Walters. Dr. Gifford notes a number of vertical lines intercalated between numerals 8 and 9, 10 and 13, 13 and 14, 17 and 18, 18 and 19, 19 and 20, 20 and 24.

41. Arguably, the elevation of the south facade in Giuliano da Sangallo's Vatican *Libro* (fol. 19v), as well as two details of the Hadrianic roundels and Antonine reliefs in the Codex Escurialensis (fol. 44r), postdate the Baltimore panel. For later copies and a reassessment of Ghirlandaio's authorship, see Arnold Nesselrath, "Il Codice Escurialense," in *Domenico Ghirlandaio 1449–1494: Atti del convegno internazionale, Firenze, 16–18 ottobre 1994,* ed. Wolfram Prinz and Max Seidel (Florence, 1996), 82, 194–95, figs. 22, 23, 58a–c.

42. Originally created for a fountain in the Medici villa at Careggi it was sold to the government in 1476 and moved to the courtyard of the Palazzo Vecchio. Evidently Verrocchio had considered a similar project, though never executed, for a fountain in the center of Piazza della Signoria. See Charles Seymour, Jr., *The Sculpture of Verrocchio* (Greenwich, CT, 199), 26.

43. Charles Rosenberg, *The Este Monuments and Urban Development in Renaissance Ferrara* (Cambridge, 1997), 54–68. The original monument to Niccolò III d'Este, destroyed during the Napoleonic occupation of the city, was an equestrian statue. In the twentieth century, a seated figure of Niccolò was mounted on a solitary column beside the Volto del Cavallo, while a bronze effigy of Borso replaced that of Niccolò. Rosenberg takes at face value Alberti's claim in his treatise *De equo animante* that he judged the competition. The finalists were two Florentine sculptors, Antonio di Cristoforo and Niccolò Baroncelli. For medieval examples of honorific columns, see Werner Haftmann, "Das Italienische Säulenmonument," *Beiträge zur Kulturgeschichte des Mittelalters und der Renaissance*, ed. Walter Goetz (Leipzig and Berlin, 1939).

44. See Leopold D. Ettlinger, *Antonio and Piero Pollaiuolo: Complete Edition with a Critical Catalogue* (London, 1978), 144–45. In the Porta delle Virtù, four cardinal virtues and three theological virtues sit on thrones in parallel array. Inserted in the odd panel is *Hercules and the Nemean lion,* copied from one of the lost wall hangings painted by Pollaiuolo for the *salone* of the Palazzo Medici. See A. Busignani, *Pollaioulo* (Florence, 1970), 102. Carlo Ragghianti, "Pollaiuolo: Ercole sbarra il lione nemeo," *Critica d'Arte* 41 (1976): 72–73, identifies a drawing in the Louvre as Pollaiuolo's study for the composition (Inv. 2519), but without substantiation.

45. L. White, Jr. "The Iconography of 'Temperantia' and the Virtuousness of Technology," in *Action and Conviction in Early Modern Europe,* ed. T. K. Rabb and J. E. Siegel (Princeton, 1969), 197–219. Luciano Cheles, *The Studiolo of Urbino: An Iconographic Investigation* (University Park, 1986), 64 n. 42.

46. In Giovanni Pisano's pulpit in Pisa cathedral, Temperance appears in the guise of a nude figure based on the Venus Pudica. See John Pope-Hennessy, *Italian Gothic Sculpture* (London and New York, 1972), pl. 6, which incorrectly labels the figure as "Pudicitia" rather than Temperance.

47. The association is not without precedent: in Ambrogio Lorenzetti's *Allegory of Good Government,* a pensive figure of Pax sits beside Fortitude and Prudence. Fortitude's diminutive column assumes the aspect of a scepter – strength being a prequisite of the virtuous ruler – just as in the panel of *Fortitude* painted by Botticelli for the Mercanzia.

48. In the Pisa Duomo pulpit, Prudence holds a cornucopia and compass – perhaps to signify that moderation, or a just mean, ensures against deprivation in times of dearth. See P. Bacci, *La Ricostruzione del pergamo di Giovanni Pisano nel duomo di Pisa* (Milan, 1926), 63, pl. 23. Further on the representation of the virtues, cf. Erwin Panofsky, *Studies in Iconology: Humanistic Themes in the Art of the Renaissance* (New York, 1972), 157 n. 97.

49. Cheles, *The Studiolo of Urbino,* 64–65, pl. VII.

50. Cheles, 64 n. 43. Wolfgang Liebenwein, *Studiolo: Die Entstehung eines Raumtyps und seine Entwicklung bis zum 1600* (Berlin, 1977), 211–12 n. 334, interprets the squirrel in the context of the *vita activa.*

51. *The Vespasiano Memoirs: Lives of Illustrious Men of the XVth Century,* trans. W. George and E. Waters (New York, 1926), 84.

52. Florentines, who saw themselves as upholding the institutions of the *res publica,* recognized that providing for the welfare of the poor was a fiscal responsibility of the state. See Sarah Blake, "Donatello's *Dovizia* as an Image of Florentine Political Propaganda," *Artibus et Historiae* 14 (1986): 26–27.

53. *De re aedificatoria* V, 3; *On the Art of Building in Ten Books,* 121–22.

54. Dimensions 131 × 233 cm; there is no evidence of trimming on either side. *Gemäldegalerie Berlin: Gesamtverzeichnis* (Berlin, 1996), Kat. Nr. 1615, fig. 1937, attributes the panel to Francesco di Giorgio Martini, c. 1490/1500.

55. Stormy seascapes provide the setting for numerous *cassoni* paintings, whether depicting Theseus's battle with the Amazons from Boccaccio's *Teseida* or the encounters of Trojan fleets from Virgil's *Aeneid.* Cristelle L. Baskins, *Cassone Painting, Humanism, and Gender in Early Modern Italy* (New York, 1998), 32, fig. 9; 34, fig. 11; 52, fig. 15.

56. Heinrich von Geymüller, "Nachtrag zur Monographie Albertis," in *Die Architektur der Renaissance in Toscana* (Munich, 1906), vol. 3: 10. Kimball, "Luciano Laura and the 'High Renaissance,'" 131. Sanpaolesi, "Le prospettive architettoniche di Urbino, di Filadelfia *[sic]* e di Berlino," 328.

57. Barriault, 15–16.

58. ". . . uno letuzo a chassone e caplinaro apicato depinto d'una perspetiva," *see* John Shearman, "The Collection of the Younger Branch of the Medici," *Burlington Magazine* 117 (Jan. 1975): 18, 24 n. 18.

59. The panel is in the Kunstgewerbe (Schloss) Museum. It had been in a villa on the outskirts of Florence before coming on the market in 1896, when it was acquired by the Kaiser Friedrich Museum. *Beschreibende Verzeichnis der Gemälde in Kaiser Friedrich Museum* (Berlin, 1906), 140. It later entered the Bode Museum (Gemäldegalerie, Inv. 1615) of the Staatliche Museen, Preuszischer Kulturbesitz. Wilhelm Bode himself, in "Der Hl. Hieronymus von Piero della Francesca," *Jahrbuch der königl. preuszichen Kunstsammlungen* 45 (1924): 203, attributed all three panels to Piero della Francesca.

60. Paul Schubring, *Cassoni: Truhen und Truhenbilder der italienischen Frührenaissance* (Leipzig, 1923), p. 399, no. 795, plate CLXVII, dates the chest to 1512. Roberto Papini, *Francesco di Giorgio architetto* (Florence, 1946), vol. 1: 150f; vol. 2: figs. 75–84, concluded a date of 1508 from the betrothal of Clarice de' Medici to Filippo Strozzi.

61. Heinz Lehmann, "Une vue de la place Ognissanti à Florence," *Gazette des Beaux-Arts,* ser. vi, 15 (1936): 244–47.

62. André Chastel, "The City in Perspective," in *MFR* 2 (May–June 1987): 80. Chastel, "Marqueterie et perspective au XVe siècle," *La Revue des Arts* (1953): 141–54, is the earliest discussion of intarsia in relation to the Urbino and Baltimore panels.

63. Kimball, "Luciano Laurana and the 'High Renaissance,'" 131–32, sees the panel as imitative of Florentine architecture in the same way as Francesco di Giorgio's early designs. André Chastel, *Art et humanisme à Florence au temps de Laurent le Magnifique* (Paris, 1959), 150–51, 371 n. 4. The argument made by Conti, "Le prospettive urbinati," 1202–3 n. 13, for Pietro del Donzello, a minor Florentine painter who worked at Santo Spirito, is not particularly cogent.

64. Alessandro Parronchi, "Due note," *Rinascimento* 8 (1968): 362. Parronchi, "La prima rappresentazione della Mandragola," *La bibliofilia* (1962): 37–80. The Urbino panel he attributes instead to Franciabigio, arguing that it too was a model for the backdrop of Machiavelli's comedy, *La Mandragola,* performed for that same event. Alessandro Parronchi, "Urbino, Baltimora, Berlino – fronti di cassoni quattrocenteschi o modelli di scena del 1518?" in *Kunst des Cinquecento in der Toskana,* ed. Monika Cämmerer (Munich, 1992), 102.

65. See Maria Walcher Casotti, "Pittura e scenografia in Peruzzi: le fonti, le realizzazioni, gli sviluppi," in *Baldassare Peruzzi: Pittura, scena e architettura nel Cinquecento,* ed. Marcello Fagiolo and Maria Luisa Madonna (Rome, 1987), 339–61.

CHAPTER 8. PIERO'S TREATISES: THE MATHEMATICS OF FORM

1. Giorgio Vasari, *Le vite de' più eccellenti architetti, pittori, et scultori italiani, da Cimabue, insino a' tempi nostri, nell'edizione per i tipi di Lorenzo Torrentino* (Firenze, 1550), ed. L. Bellosi and A. Rossi (Turin, 1986), 337–43. For Piero della Francesca, see especially Eugenio Battisti, *Piero della Francesca,* rev. ed. Marisa Dalai Emiliani, 2 vols. (Milan: Electa, 1992). For his treatises: Margaret Daly Davis, *Piero della Francesca's mathematical treatises: The "Trattato d'abaco" and "Libellus de quinque corporibus regularibus"* (Ravenna: Longo, 1977); Martin Kemp, *The Science of Art: Optical Themes in Western Art from Brunelleschi to Seurat* (New Haven and London: Yale University Press, 1990), and "Piero and the Idiots: The Early *fortuna* of his Theories of Perspective," in *Piero della Francesca and his Legacy* (Studies in the History of Art 48), ed. M. Aronberg Lavin, (Washington, DC: National Gallery of Art, 1995), 199–211; J. V. Field, *The Invention of Infinity: Mathematics and Art in the Renaissance* (Oxford, 1997), with further biblio.; and Filippo Camerota: "Misurare 'per perspectiva': geometria pratica e *prospectiva pingendi,*" in *La prospettiva: Fondamenti teorici ed esperienze figurative dall'antichità al mondo moderno.* Atti del Convegno internazionale di studi, Istituto Svizzero di Roma, Roma 11–14 settembre 1995, ed. Rocco Sinisgalli (Florence, 1998), 293–422.

2. Richard Goldthwaithe, "Schools and Teachers of Commercial Arithmetic in Renaissance Florence," *Journal of European Economic History* 1 (1972): 418–33; Diane Finiello Zervas, "The Trattato d'abaco and Andrea Pisano's Design for the Florentine Baptistery Door," *Renaissance Quarterly* 28 (1975): 483–503; Warren Van Egmond, *The Commercial Revolution and the Beginnings of Western Mathematics in Renaissance Florence* (Ann Arbor, 1983).

3. See Camerota as in note 1.

4. Antonio Manetti, *Vita di Filippo Brunelleschi,* ed. D. De Robertis (Milan 1976), 70: "Nella sua tenera età, Filippo apparò a leggere ed a scrivere e l'abaco, come s'usa per gli uomini da bene e per la maggioranza parte fare a Firenze."

5. Vasari, 573: "Oltre il leggere e lo scrivere si esercitò grandemente nello abaco."

6. Vasari, 546: "Ecco nell'abaco egli in pochi mesi che e' v'attese, fece tanto acquisto, che movendo di continuo dubbi e difficultà al maestro che gli insegnava, bene spesso lo confondeva."

7. Piero della Francesca, *Trattato d'abaco dal codice Ashburnhamiano 280*

(*359–291*) *della Biblioteca Medicea Laurenziana di Firenze,* ed. Gino Arrighi (Pisa, 1970).

8. The treatise was first identified as Piero's only in 1917, when Girolamo Mancini recognized the same hand in the pen drawings as in those of Piero's *Prospectiva pingendi* and his *Libellus de quinque corporibus regularibus.* Mancini also compared the script with that of Piero's autograph manuscript of the *Prospectiva pingendi* in Parma.

9. Piero della Francesca, *Abaco,* xx: "Esendo io pregato de dover scrivere alcune cose de abaco necesarie a' mercatanti. . . ."

10. Michael Baxandall, *Painting and Experience in Fifteenth-Century Italy,* 2nd ed. (Oxford and New York, 1988), 95.

11. Piero, *Abaco,* xx: "Et perchè qui intendo dire alcune cose necesarie ad algibra, il quale tracta de' numeri rocti et interi et de radici et de' quadrati, ho vero de' numeri semplici."

12. Ibid., xx: "Quando i numeri se montiplicano in sè, aloro quelli numeri se dicono radici et quelli producti se dicono quadradate o vero censi. Et quano e' numeri non ànno respecto a le radici o vero quadrati, alora se dicono numeri semplici."

13. Leonardo Pisano, *Scritti di Leonardo Pisano, matematico del secolo decimoterzo,* ed. Baldassarre Boncompagni, 2 vols., (Rome, 1857–1862).

14. See the detailed exposition in S.A. Jayawardene, "The 'Trattato d'Abaco' of Piero della Francesca," in *Cultural Aspects of the Italian Renaissance. Essays in Honor of Paul Oskar Kristeller,* ed. C.H. Clough (Manchester and New York, 1976), 229–243, esp. 232–235.

15. Piero, *Abaco,* xx: "Quando le cose e i censi et i cubi e censi de censi sono equali al numero, se dèi partir nei censi di censi e poi partir le cose per il cubi et, quello che ne vene, recare a radici e ponere sopra del numero; et la radici de la radici di quella somma meno la radici de le cose che ne venne partite per li cubi, tanto vale la cosa."

16. See Enrico Giusti, "Fonti medievali dell'algebra di Piero della Francesca," in *Piero della Francesca tra arte e scienza, atti del Convegno internazionale di studi, Arezzo, 8–11 ottobre 1992, Sansepolcro, 12 ottobre 1992,* ed. M. Dalai Emiliani and V. Curzi (Venice, Marsilio, 1996), 313–329.

17. Gugliemo Libri, *Histoire des sciences mathématiques en Italie depuis la Renaissance des lettres jusqu'à la fin du dix-septième siècle,* vol. III, (Paris, 1840), Note XXXI, 302–349.

18. Moritz Cantor, *Vorlesungen über Geschichte der Mathematik,* 2nd ed. (Leipzig, 1892), 144–150.

19. Leon Battista Alberti, *Opera inedita et pauca separatim impressa,* ed. G. Mancini (Florence, 1890), 47–65. See also A. Gambuti, "Nuove ricerche sugli Elementa picturae," *Studi e documenti di architettura* (1972), no. 1, 133–172.

20. See Daly Davis, 14–16.

21. See S.A. Jayawardene, 235.

22. See the entries in "Architectural Proportion" (by John Musgrove) and "Golden Section" (by Daniel Robbins) in *The Dictionary of Art,* n.p. (1996), vol. 2: 345, and 12: 871.

23. Plato, *Timaeus,* trans. and intro. H. D. P. Lee (Baltimore, 1965), 75.

24. *The Thirteen Books of Euclid's Elements,* ed. T. L. Heath, 2nd ed. rev. (New York, 1956), which also includes Book XIV and a discussion of Book XV. Also

see the 15 books in *Euclidis Megarensis philosophi acutissimi . . . Opera*, ed. Luca Pacioli (Venice: A. Paganius Paganinus, 1509).

25. Piero della Francesca, *L'opera, De corporibus regularibus' di Pietro Franceschi detto Della Francesca, usurpata da Fra' Luca Pacioli,* ed. Girolamo Mancini (Rome, 1916), dedication: "Poterit namque, saltem sui novitate, non displicere. Etenim licet res apud Euclidem, et alios geometras nota sit, per ipsum tamen nuper ad arithmeticos translata est." See also Piero della Francesca: *Libellus de quinque corporibus regularibus,* corredato della versione volgare di Luca Pacioli (Edizione nazionale degli scritti di Piero della Francesca) (Florence: Giunti, 1995), which includes facsimile edition of the Vatican manuscript (Vat.Urb.lat. 632). See in this publication the thorough analyses of Piero's drawing methods by Francesco di Teodoro.

26. See Luca Pacioli, *De divina proportione* (Venice: Paganius Paganinus, 1509), fol. 16r.

27. Camerota, 296, mentions a problem in the geometrical section of Fibonacci's *Liber abbaci,* dealing with the division of a triangular ciborio into three zones of equal surfaces to be painted by three different masters.

28. Daly Davis, Appendices I and II, Tables I and II.

29. The works by Vitruvius and Alberti had appeared in their first printed editions in 1486. Luca Pacioli, *Summa de arithmetica, geometria, proportioni, et proportionalità* (Venice: Paganino de Paganini da Brescia, 1494), *Epistola,* fol. [2] recto writes: "Alarchitectura ancora, Vitruvio in suo volume, e Leon Batista de gli amberti fiorentino in sua perfetta opera de architectura, molto dimostrano esserli accomodata proportionando suoi magni et excelsi hedifitii." The *Summa* has been reprinted in a facsimile edition: Luca Pacioli, *Summa . . . ,* introd. Carlo Antinori (Rome: Istituto poligrafico e Zecca dello Stato), 1993.

30. Pacioli, Summa, fol. [2] recto:

 Admiranda fabrica del degno pallazzo de U.D.S. per la felicissima suo paterna memoria initiata e consumata manifesta. Nel qual certamente ben mostro natura suo forza e arte, fra quanti per altri sienno stati visti. Qual lengue et bell'ordine de tutta sua degna dispositione potria exprimere certo niuna seria bastante. Se non la sua eloquentissima, el qual non solo ala vista subito veduto piaci, ma ancor piu riman stupefatto chi con intelletto va discorrendo, con quanto artifitio e ornamento e stato composto.

31. Pacioli, Summa, fol. 2 verso: "De larti tutte Mecchaniche. discorendo in tutti exerticii, e mistiri, non si vede oculata fide. Che toltoli de mano la squadra, el sexto, con la lor proportione non fanno che ripeschino. Chi de tarsia, si nobilmente con tanta diversita de legnami per tutto apieno lunico. U.D. palazzo ha disposto, se non le doi linee curva e retta, con suoi pontuali termini proportionata."

32. Pacioli, Divina proportione, fol. 23r. Pacioli also recounts other intarsiasts in the family and their works. For the Lendinara family, see Pier Luigi Bagatin, *L'arte dei Canozi lendinaresi* (Trieste, 1987); Massimo Ferretti, "I maestri della prospettiva," *Storia dell'arte italiana,* part 3, vol. 4 (Turin, 1982), III, 4, 585, and esp. 496–505; Bruna Ciati, "Cultura e società nel secondo Quattrocento attraverso l'opera ad intarsio di Lorenzo e Cristoforo da Lendinara," in *La prospettiva rinascimentale: Codificazioni e trasgressioni, Atti del convegno*

internazionale di studi, Milano, 11–15 ottobre 1977, ed. M. Dalai Emiliani (Florence, 1980), 201–14.

33. Albrecht Dürer, *Underweysung der messung mit dem zirckel und richtscheyt* (1525: facsimile ed. Dietikon-Zurich 1966), Book IV. At diagram 29, he writes: "Corpora die allenthalben gleych sind, von felderen, ecken und seyten, die der Euklides corpora regularia nennet, der beschreibt jr fünffe, darumb das jr nit mer künnen sein, die in ein kugel darin sie allenthalben an rüren verfasst mügen werdenn, die selben nach dem sie zü vill dingen nutz sind, wil ich hie anzeygen." In the *Libellus* (above, note 25), 489, Piero writes: "Multa sunt corpora lateribus constituta quae in sperico corpore locari queunt, ita ut eorum anguli sperae superficiem omnes contingunt. Verum quinque ex eis tantummodo sunt regularia: hoc est, quae aequales bases habent et latera." See Daly Davis, chap. 4, and Kemp, 1995.

34. M. Daly Davis, "Luca Pacioli, Piero della Francesca, Leonardo da Vinci: Tra proportionalita e prospettiva nella Divina proporzione," in *Piero della Francesca tra arte e scienza* (as in note 16), 355–62.

35. Dürer, at diagram 43, writes: "Aus disen dingen mag man gar manicherley machen, so jr teyl aufeinander versetzt wirt, das zü dem aushauen der seulen und jren zirden dinet."

36. Wenzel Jamnitzer, *Perspectiva corporum regularium, das ist ein fleyssige fürweisung wie die fünff Regulirten Cörper, darvon Plato in Timaeo unnd Euclides inn sein Elementis schreibt durch einen sonderlichen newen behenden unnd gerechten Weg . . . gar künstlich inn die Perspectiva gebracht . . . werden mögen* (1568: facsimile ed., Graz, 1973).

37. "Wenceslao Giannizzero Norinbergense, il quale ha messi in Prospettiva li corpi regolari, et altri composit, si come fece Pietro dal Borgo, se bene Fra Luca gli stampò sotto suo nome." Jacopo Barozzi Vignola, *Le due regole della prospettiva pratica di M. Iacomo Barozzi da Vignola con i comentarij del R.P.M. Egnatio Danti* (Rome: F. Zannetti, 1583), preface.

38. Piero della Francesca, *De prospectiva pingendi*, ed. G. Nicco Fasola, (Florence: Casa Editrice le Lettere, 1984). Pacioli, Summa, fol. [2] recto, refers to Piero's "compendioso trattato che de larte pictoria e de la lineal forza in perspectiva compose."

39. See Camerota as in note 1.

40. Pacioli, Divina proportione, fol. 33 r, writes: "Che dele mathematici lo rende chiaro el monarcha ali di nostri della pictura e architectura, Maestro Pietro deli franceschi con suo penello mentre pote comme apare in urbino bologna ferara arimini ancona e in la terra nostra in muro e tavla a oglio e guazzo maxime in la citta darezzo la magna capella dela tribuna delaltar grande und dele dignissime opere de italia e da tutti commendata. E per lo libro de prospectiva compose qual si trova in la dignissima bibliotheca delo Illustrissimo Duca de urbino nostro. Si che ancora voi ingegnative el simile fare." In this regard see the stimulating study of Alessandro Gambuti, "Il disegno degli ordini architettonici nell'opera di Piero della Francesca," in *Studi di storia dell'arte sul medioevo e il Rinascimento nel centenario della nascita di Mario Salmi. Atti del Convegno internazionale, Arezzo-Firenze, 16–19 novembre 1989* (Florence, 1993), S. 465–87, esp. 471. Gambuti treats Piero's use of the orders relationships to Brunelleschi, Buggiano and Francesco di Giorgio. See also A. Gambuti, *L'architettura dei pittori nel Quattrocento italiano* (Florence, 1994).

41. M. Daly Davis, "Carpaccio and the perspective of regular bodies," in *La prospettiva rinascimentale* (as in note 32), 183–97.

42. The cupola is treated in Book III, prop. IX (Piero-Fasola, 202–9): "Quando tu avesse a mectere una cupula per ragione, la quale fusse commo uno quarto de unapalla dal canto concavo e fusse devisa in quadrati nelli quali fussero rossoni, volse tenere questo modo."

43. Lendinara's representations in wood of Saints Agostino and Gregory the Great are also closely related to Piero's perspectival representations of the human head in the *Prospectiva pingendi*. See the illustrations in Bagatin (as in note 32).

44. Daly Davis, "Carpaccio," 195.

45. "darve piena notitia de prospectiva medianti li documenti del nostro conterraneo e contemporale di tal faculta ali tempi nostri Monarcha Maestro Petro de Franceschi, see Pacioli, *Divina proportione,* fol. xx.

46. See above, note 37.

47. Danti, 72: "si può chiaramente conoscere la conformità che la Regola del Vignola ha con questa ordinaria de gl'antichi, da esso chiamata Regola di Baldassarre da Siena, perche da lui fu riformata, & ridotta in quella eccellenza & facilità, che hoggi si trova: il quale hebbe in ciò per Precettore Francesco di Giorgio Sanese. . . . Et primo di tutto io porrò la regola ordinaria, che è quella di Baldessarre da Siena, scritta prima da maestro Pietro da Borgo à S. Sepolcro & poi da Sebastiano Serlio."

48. Kemp, 1995, especially for Daniele Barbaro's indebtedness to Piero. See also Thomas Frangenberg, "Piero della Francesca's De prospectiva pingendi in the sixteenth century," in *Piero della Francesca tra arte e scienza* (as in note 11), 423–46. Most useful for the *"fortuna"* of Piero's work is the section "Fonti" in Battisti, 2: 638–47.

49. Daniele Barbaro, *La pratica della prospettiva*, Venice, Bibl. Marciana, MS. It. IV, 39 (= 5446). See Daly Davis, and M. Kemp, 1995, as in note 1.

CHAPTER 9. PIERO DELLA FRANCESCA'S MATHEMATICS

1. See Paul Grendler, "What Piero Learned in School: Fifteenth-Century Vernacular Education," in Piero della Francesca and his Legacy, ed. M. A. Lavin (Washington, DC: National Gallery of Art, Studies in the History of Art 48, 1995), 161–74.

2. The story of the rise of algebra, often treated as if it were the whole history of mathematics in this period, has been told many times, usually relying heavily on the classic H. G. Zeuthen, *Geschichte der Mathematik in XVI. und XVII. Jahrhundert,* ed. B. Meyer (Leipzig, 1903). For the earlier part of the story, see R. Franci and L. Toti Rigatelli, "Towards a History of Algebra from Leonardo of Pisa to Luca Pacioli," *Janus* 72 (1985): 17–82.

3. This story is told in more detail in J. V. Field, *The Invention of Infinity: Mathematics and Art in the Renaissance* (Oxford: Oxford University Press, 1997, reprint ed. 1999).

4. This period is now known to historians of science as the Scientific Revolution, a name derived from the title of A. R. Hall, *The Scientific Revolution* (London, 1954).

5. *Reappraisals of the Scientific Revolution,* ed. D. C. Lindberg and R. S. West-

man (Cambridge, Mass., 1990); and *Renaissance and Revolution: Humanists, Craftsmen and Natural Philosophers in Early Modern Europe,* ed. J. V. Field and F. A. J. L. James (Cambridge, 1993: reprint ed. 1997).

6. Such a claim is made, for instance, in S. Y. Edgerton, *The Renaissance Rediscovery of Linear Perspective* (New York, 1975).

7. The correct modern term for this would be "the line segment AB."

8. On Piero's education see Grendler, as in note 1.

9. On Piero's knowledge of Latin see Giovanna Derenzini, "Note autografe di Piero della Francesca nel codice 616 della Bibliothèque Municipale di Bordeaux: Per la storia testuale del *De prospectiva pingendi," Filologia Antica e Moderna* 9 (1995): 29–55; and J. V. Field, *Piero della Francesca: A Mathematician's Art* (forthcoming).

10. See the introduction in the modern edition of Piero's *Trattato.* Piero della Francesca, *Trattato d'abaco: Dal Codice Ashburnhamiano 280 (359*.291*) della Biblioteca Medicea Laurenziana di Firenze,* ed. G. Arrighi (Pisa, 1970). Since a facsimile edition of the manuscript is in preparation, my further references will include the manuscript pages (which are given in Arrighi's edition).

11. Printed in Piero della Francesca, "L'Opera "De corporibus regularibus" di Pietro dei Franceschi detto della Francesca, usurpata da Fra' Luca Pacioli," ed. G. Mancini, *Memorie della R. Accademia dei Lincei,* series 5, 14.8B (1916), 441–580; and Piero della Francesca, *Libellus de quinque corporibus regularibus,* ed. M. Dalai Emiliani, C. Grayson, C. Maccagni *et al.,* including a facsimile of Vatican Codex Urbinas 632 (Rome, 1996).

12. See Piero ed. Arrighi, 1970, and Franci and Toti Rigatelli, 1985.

13. A Tuscan pound, which contained 12 ounces, weighed less than the modern Imperial pound (of 16 ounces): about 340 gm as against about 454 gm. That is, the Tuscan ounce is about equal to the modern one [see H. J. von Alberti, *Mass und Gewicht* (Berlin, 1957), 415]. See Piero ed. Arrighi, 1970, 64; Cod. Ashb. folio 17 recto. The word I have translated "body" is *busto.* In view of the proportions of the weights, a better translation might be "middle cut."

14. This use of "cosa" for the unknown eventually earned algebra the Latin name "cossa."

15. This is known as the "method of double false position."

16. Luca Pacioli, *De divina proportione* (Venice, 1509). There is no evidence that Pacioli was Piero's pupil in a formal sense, though he certainly knew Piero's work and made use of it in his own publications. However, before we join Vasari in his complaint about Pacioli's plagiarism, it is as well to reflect that almost all the arithmetical or algebraic problems in Piero's *Trattato* have been identified as derived from earlier sources, see S. A. Jayawardene, "The *Trattato d'abaco* of Piero della Francesca," in *Cultural Aspects of the Italian Renaissance: Essays in Honour of Paul Oskar Kristeller* (Manchester, 1976), 229–43, and M. Daly Davis, *Piero della Francesca's Mathematical Treatises: The "Trattato d'abaco" and "Libellus de quinque corporibus regularibus"* (Ravenna: Longo, 1977).

17. Piero ed. Arrighi, 1970, 202, Cod. Ashb. fol., 95r.

18. Euclid, *The Thirteen Books of Euclid's Elements,* ed. and trans. T. L. Heath (Cambridge, 1908), vol. 2, 85.

19. See J. V. Field, *The Invention of Infinity* as in note 3.

20. The name cuboctahedron, and the modern names for all the other Archimedean polyhedra, are due to Johannes Kepler (1571–1630), who described and illustrated all thirteen of the solids in his *Harmonices mundi libri V* (Linz, 1619), Book 2. English translation: Johannes Kepler, *The Harmony of the World*, trans. with introduction and notes, by E. J. Aiton, A. M. Duncan, and J. V. Field, *Memoirs of the American Philosophical Society*, vol. 209 (Philadelphia, 1997).

21. Two are discussed in the *Trattato* and four more in the *Libellus*, see later.

22. Piero ed. Arrighi, 1970, 231–32; Cod. Ashb. fol., 108r.

23. These diagrams may be autograph in some manuscripts. Others may be presumed to be derived from originals drawn by Piero himself or drawn under his supervision.

24. Piero ed. Arrighi, 1970, 231; Cod. Ashb. fol., 107v.

25. See Davis, 1977, 121–23, and above in this volume.

26. In order of appearance these are the truncated icosahedron (20 hexagonal faces, twelve pentagonal), the truncated dodecahedron (20 triangles, twelve decagons), the truncated octahedron (six squares, eight hexagons), and the truncated cube (six octagons, eight triangles). See Piero ed. Mancini, 1916, Tractatus IV, sections 2 to 5 inclusive, 559–64, and Pacioli, 1509, second part, fol. 20v to fol. 22v.

27. Piero ed. Mancini, 1916, Tract. IV, sect. 6, 564; Pacioli 1509, second part, fol. 22v.

28. The illustrations to the Italian version of the *Libellus* in Pacioli, 1509, are not exactly the same as those Mancini records as present in the single known manuscript of the *Libellus*. For a more detailed treatment of the rediscovery of the Archimedean solids in the Reaissance, see J. V. Field, "Rediscovering the Archimedean polyhedra: Piero della Francesca, Luca Pacioli, Leonardo da Vinci, Albrecht Dürer, Daniele Barbaro, and Johannes Kepler," *Archive for History of Exact Sciences* 50, nos. 3–4 (1997), 241–89.

29. Piero ed. Arrighi, 1970, 234; Piero ed. Mancini, 1916, 578.

30. See Piero ed. Mancini, 1916, and Davis, 1977 (and above in this volume).

31. The translator has now been identified. He was a jurist. See James R. Banker, "Piero della Francesca's friend and translator: Maestro Matteo di Ser Paolo d'Anghiari," *Rivista d'Arte*, ser. 4, vol. 8 (1992): 331–40. On the differences between the vernacular text and the Latin one, see J. V. Field, "Piero della Francesca and the "distance point method" of perspective construction," *Nuncius* 10 (1995): 509–30.

32. We may note that Pacioli seems to have made this kind of choice in regard to *De divina proportione* (Venice, 1509), which, like Piero's *Libellus*, contains numerous references to Euclid.

33. *De prospectiva pingendi* was not printed in the Renaissance, but large parts of it were reproduced, with due acknowledgement to the original author, in Daniele Barbaro's *La Pratica della Perspettiva* (Venice, 1569). See M. J. Kemp, "Piero and the Idiots: The Early Fortuna of his Theories of Perspective," in *Piero della Francesca and His Legacy* (as in note 1), 199–211.

34. Piero della Francesca, *De prospectiva pingendi*, ed. G. N. Fasola (Florence, 1942; reprint Florence: Casa Editrice le Lettere, 1984), 63–64.

35. My reference here is to the initial intended readership of the works in the fifteenth century. For a more detailed discussion of the relation between Piero's

work and that of Alberti, see J. V. Field, "Alberti, the Abacus, and Piero della Francesca's proof of perspective," *Renaissance Studies* 11 (1997): 61–88.

36. Piero ed. Fasola, 1984, Book I, prop. 4, 67.

37. See J. V. Field, "Piero della Francesca's treatment of edge distortion," *Journal of the Warburg and Courtauld Institutes,* 49 (1986): 66–99, and plate 21c. Pecham's work, probably written between 1277 and 1279, was the most widely-read optical text of Piero's time. See D. C. Lindberg, *John Pecham and the Science of Optics* (Madison, 1970), and D. C. Lindberg, *Theories of Vision from al-Kindi to Kepler* (Chicago, 1976; reprint 1981).

38. Piero ed. Fasola, 1984, I: 8, 70.

39. For the proposition just mentioned the reference is to *Elements* 6, prop. 21.

40. Pace James Elkins, "Piero della Francesca and the Renaissance proof of Linear Perspective," *Art Bulletin* 69 (1987): 220–30.

41. See J. V. Field, "Piero della Francesca as practical mathematician: The painter as teacher," in *Piero della Francesca tra arte e scienza: Atti del convegno internazionale di studi, Arezzo, 8–11 ottobre 1992, Sansepolcro, 12 Ottobre 1992,* ed. Marisa Dalai Emiliani and Valter Curzi (Venice: Marsilio, 1996), 331–54; and Field, *The Invention of Infinity* (as in note 3).

42. The most notable example of this is in I.30, see below.

43. Piero has actually proved, but not stated, a more general proposition, and one that has some historical importance, see J. V. Field, "When is a proof not a proof? Some reflections on Piero della Francesca and Guidobaldo del Monte," in *La Prospettiva: Fondamenti teorici ed esperienze figurative dall'Antichità al mondo moderno: Atti del Convegno Internazionale di Studi, Istituto Svizzero di Roma. Roma, 11–14 Settembre 1995,* ed. R. Sinisgalli (Firenze: Edizioni Cadmo, 1998), 120–32, figs. pp. 373–75.

44. See Field concerning Piero and distance point method (as in note 35).

45. Piero's proof and its scientific background are discussed in more detail in Field, 1986.

46. These examples were chosen as being in principle calculable. For further details see M. A. Lavin, *Piero della Francesca's "Baptism of Christ"* (New Haven and London, 1981), and M. J. Kemp, "New Light on Old Theories: Piero's Studies of the Transmission of Light," in *Piero tra arte e scienza,* 33–45.

47. Piero ed. Fasola, 1984, 128; Parma MS 1576, fol. 32r; British Library MS Add 10, 366, fol. 37r.

48. Vitruvius does not mention Apelles, but with this exception Piero's list agrees closely, in its nonclassical orthography, with that given in the *editio princeps* of Vitruvius (Rome, 1486) and therefore presumably to be found in the manuscript tradition.

49. Piero ed. Fasola, 1984, 129; Parma, fol. 37v, BL f. 37r.

50. Ibid.

51. The reference to the use of a nail and string suggests large-scale drawing, possibly for a paper cartoon, see later.

52. The *Finding of the Crosses,* the *Battle of Heraclius and Chosroes,* the *Exaltation of the Cross,* the *Removal of the Jew from the Well,* and the *Annunciation.*

53. See Roberto Bellucci and Cecilia Frosinini, "Piero's methods of preparatory drawing: recent discoveries" (lecture given at the Courtauld Institute, London, 21 November 1997); and Roberto Bellucci and Cecilia Frosinini, "Ipotesi sul metodo di restituzione dei disegni preparatori di Piero della

Francesca: il caso dei ritratti di Federigo da Montefltro," in *La pala di San Bernardino di Piero della Francesca. Nuovi Studi oltre il restauro, Quaderni di Brera,* 9, ed. Emanuela Daffra and Filippo Trevisani (Florence: Centro Di, 1997), 167–87.

54. R. Wittkower and B. A. R. Carter, "The perspective of Piero della Francesca's 'Flagellation,'" *Journal of the Warburg and Courtauld Institutes,* 16 (1953): 292–302; and M. A. Lavin, *Piero della Francesca. The Flagellation of Christ* (New York, 1972; reprint with additional bibliography, Chicago, 1990).

CHAPTER 10. PIERO'S PARNASSUS OF MODERN PAINTERS AND POETS

Author's note: This essay largely concerns Piero della Francesca as perceived and studied by English, American, and Italian artists, poets, and art historians, see notes 6, 8, 10, 11. Many thanks go to Jeryldene Wood for the invitation to develop this paper; to Paul Barolsky for sharing his ideas and for his ever essential critiques; to Norman Land for his thoughtful suggestions; to Charles Wright, Mark Strand, Jorie Graham, and William Bailey for their spirit of cooperation; and to Suzanne Freeman, Sarah Falls, Douglas Litts, and Denise Lewis at the Virginia Museum of Fine Arts for helping to provide reference materials and photographs.

1. Giorgio Vasari, *The Lives of the Artists,* trans. George Bull (Harmondsworth [1965] 1977), 191–98.
2. Giorgio Vasari, *Le Vite de' Piú Eccellenti Pittori Scultori ed Architettori,* ed. Gaetano Milanesi (Firenze, 1981), vol. 2: 553, 561. For more on Lazzaro Vasari, see Paul Barolsky, *Giotto's Father and the Family of Vasari's Lives* (University Park, 1992), 47–50. For Piero and Raphael, see Vasari's *Lives,* 291. For Piero and Giovanni Santi, see Michael Baxandall, *Painting and Experience in Fifteenth-Century Italy,* 2nd ed. (Oxford, 1988), 113, and Creighton Gilbert, *Italian Art, 1400–1500: Sources and Documents* (Englewood Cliffs, NJ, 1980), 99.
3. See Vasari's *Lives,* 194–95, 300.
4. See Rensselaer W. Lee, *Ut Pictura Poesis: The Humanistic Theory of Painting* (New York, 1967), Introduction.
5. Paul Barolsky writes about Raphael, Dante, and the poetic tradition in Renaissance painting in *The Faun in the Garden* (University Park, PA, 1994), 54. See also, Dante Alighieri, *Inferno,* Canto IV, in the *Divine Comedy,* trans. John Ciardi (New York, 1977).
6. Zbigniew Herbert, "Piero della Francesca," in *Writers on Artists,* ed. Daniel Halpern (San Francisco, 1988), 7–20. All quotations from Herbert in this essay may be found in this source. For Stendhal, see also David Wakefield, ed., *Stendhal and the Arts* (New York, 1973), and Stendhal, *L'histoire de la peinture en Italie* (Paris, 1924), vol. 1: 124.
7. Bruce Cole, *Piero della Francesca* (New York, 1991), 154.
8. For summaries of the nineteenth-century's rediscovery of Piero, see Cole, 141–56, and Herbert's essay, esp. pp. 12 and 19. John Addington Symonds wrote about Piero in 1877, Bernard Berenson in 1897, Kenneth Clark in 1951. For a review and analysis of publications on Piero by twentieth-century art historians and artists, many of whom are discussed here, see Albert Boime, "Piero and the Two Cultures" in *Piero della Francesca and His Legacy,* ed.

Marilyn Aronberg Lavin, Center for Advanced Study in the Visual Arts, National Gallery of Art, Washington, DC (Princeton, 1995), 255–65. During the past three decades alone, Piero can be found at the center of international conferences, symposia, exhibitions, publications, and art-historical debates. Studies by Eugenio Battisti, Marilyn Lavin, Creighton Gilbert, Carlo Ginzburg, Bruce Cole, and Ronald Lightbown, among numerous others, provide foundations for Piero's bibliography since the 1960s. For a comprehensive bibliography on Piero up through 1991, see Eugenio Battisti, *Piero della Francesca*. 2 vols. (Milano: Istituto Editoriale Italiano, 1971). For examples of proceedings from symposia and conferences, see Lavin, above, and *Convegno internazionale sulla "Madonna del Parto" di Piero della Francesca,* Commune di Monterchi, May 1980.

9. Roberto Longhi, *Piero della Francesca* (1927; 2nd ed. Milano, 1946), 114: "donde, per vie piu mediate, l'arte di Piero si continua ed opera nella maggiore pittura moderna."

10. Kenneth Clark, *Piero della Francesca* (London and New York: Phaidon, 1969), 53, 79, n. 46. Clark's observations quoted throughout this essay are from this monograph. See also Longhi, *Piero della Francesca,* 55; and J. Guillaud and M. Guillaud, *Piero della Francesca, poeta della forma: Gli affreschi di San Francesco d'Arezzo* (Paris, 1988); and Carlo Ginzburg, *The Enigma of Piero* (London: Verso, 1985).

11. Maurizio Fagiolo dell'Arco, "La Grande Ombra": Piero della Francesca e il Novecento," in *Piero della Francesca e il novecento,* ed. Maria Mimita Lamberti and Maurizio Fagiolo dell'Arco (Venice, 1991), 35ff.

12. See Cole, 154. See also *The Art of Paul Gauguin,* National Gallery of Art, Washington and the Art Institute of Chicago (New Haven, 1998), cat. no. 135 by Charles F. Stuckey and Peter Zegers; cat. no. 219 by Richard Brettell with Peter Zegers.

13. For Piero's treatises on measure and geometry, see Michael Baxandall, *Painting and Experience in Fifteenth-Century Italy,* 2nd ed. (Oxford, 1988). For Piero and Cézanne, see Bernard Berenson, *Piero della Francesca, or the Ineloquent in Art* (New York: Macmillan, 1954), esp. 6, 7; and Giancarlo Maiorino, "The Legend of Geometry Fulfilled: Abstraction and Denaturalization of Matter in the Paintings of Piero della Francesca and Piet Mondrian," *Gazettes des Beaux-Arts* 57 (March 1986): 111–17.

14. See Adrian Stokes, *Art and Science: A Study of Alberti, Piero della Francesca, and Giorgione* (London, 1949), 31–32, 35–36. For Mondrian and Piero, see Maiorino, 1986, 111–17. For Piero, Cézanne, Picasso, Seurat, and the Novecento, see Michael F. Zimmermann, "Die 'Erfindung' Pieros und seine Wahlverwandtschaft mit Seurat," in *Piera della Francesca and His Legacy,* 269; see also Rosalind E. Krauss, "The Grid, the True Cross, the Abstract Structure," in that publication, 303.

15. See Maurizio Fagiolo dell'Arco, "La Grande Ombra . . . ," 35ff. For quotations, further discussion, and reproductions of the illustrations from that study, cited in this essay, see esp. DeChirico, 36, Morandi, 37, Carrà, 44, 45, and catalogue entries under part 3, "Pittura Murale." For further discussion of Piero's influence on the Novecento, see also Michael F. Zimmermann, in *Piera della Francesca and His Legacy,* 269ff.

16. See Berenson, 1954, 10.

17. See "La Grande Ombra," 37 and Boime in *Piero della Francesca and his Legacy*, 262.

18. See "La Grande Ombra," 44, 45.

19. See Irving Sandler, *The Triumph of American Painting* (New York, 1970), 261, illus. 19–26; Sandler cites Piero della Francesca only once in this book, as an influence on Philip Guston. See also Dore Ashton, *A Critical Study of Philip Guston* (Berkeley and Los Angeles, 1976).

20. See "A Conversation between Philip Guston and Joseph Ablow" in Kim Sichel and Mary Drachs McInnes, *Philip Guston 1975–1980: Public and Private Battles*, Boston University Art Gallery (Seattle and London: University of Washington Press, 1994), 35, 36. See also Philip Guston, "Piero della Francesca: The Impossibility of Painting," *Art News* (May 1965): 38–39.

21. Myron Schwartzman, *Romare Bearden, His Life and Art* (New York, 1990), 106, 110.

22. For Bearden, Duccio, and Angelico, see Schwartzman, 129; illus. 115, 129.

23. For Bearden on the essences of art, see Schwartzman, 128. For Berenson on Piero and the essence of art, see *Ineloquent Art*, 7, 38.

24. Peter Clothier, *David Hockney* (New York, 1995), 105; see illus. 43, 60, for reproductions of works discussed here.

25. Clothier, 1995, 107.

26. For Bailey on Piero's art and color, see "William Bailey," in *Art of the Real*, ed. Mark Strand (New York, 1983), 24–25. See also Clark, 24.

27. Longhi, 78. The portions of the tent and the feet of one angel have been damaged and reworked, see Cole on the *Madonna del Parto* in *Piero della Francesca*.

28. John White, "Piero della Francesca," in *The Thames and Hudson Encyclopaedia of the Italian Renaissance*, ed. J. R. Hale (London, 1981), 250, and Adrian Stokes, *Art and Science*, 36.

29. Bernard Berenson, "The Central Italian Painters," in *Italian Painters of the Renaissance* (New York, [1952] 1953). Berenson's remarks on Piero's actors, his impersonality, and his standards of beauty are quoted from pages 109–10. Berenson first published the essays in this volume separately between 1894 and 1907.

30. See n. 20. See Ginzburg, 1985, for the history of efforts to identify figures from Piero's lifetime in his paintings.

31. T. S. Eliot, "Tradition and Individual Talent" in *The Sacred Wood: Essays on Poetry and Criticism* (London [1920]; reprint 1967), 59, 49. All of Eliot's quotations here are taken from that essay. For a discussion of Balthus, see Rene Micha, "Balthus: Des gloses essentielles sur l'un des grands peintres de ce temps," *Art International* 27 (April–June 1984): 3–6. Nicholas Fox Weber's recent biography of the artist refers to him as "the Piero of Paris," see *Balthus: A Biography* (New York, 1999).

The detachment and equilibrium found in Piero's painting, and in Hopper and Balthus, have influenced the stark and enigmatic social commentaries of American painters Paul Cadmus, Jared French, and George Tooker. The profile figures in French's *The Double* and Tooker's *Doors*, painted in the early 1940s and 1950s, respectively, seem to have stepped directly out of Piero's *Adoration of the Sacred Wood* and *Meeting of King Solomon and the Queen of Sheba*, stripped of their clothes and placed in airless spaces. See the

exhibition brochure by Josephine Gear, *Cadmus, French, and Tooker: The Early Years,* Whitney Museum of American Art, March 1 to May 5, 1990.

32. See Eliot, *The Sacred Wood,* 59.

33. Mark Strand's comments were made in his essay on Umbrian art, the landscape, and the wine in "Tasting Freedom," *Food and Wine* (March 1999): 50, and in an informal conversation, 21 January 1999.

34. Jorie Graham, "Easter Morning Aubade," in *The Errancy* (Hopewell, NJ: Ecco Press, and Ontario: Penguin Books [1997] 1998), 101–2; Gjertrud Schnackenberg, "Soldier Asleep at the Tomb: Piero della Francesca," in *A Gilded Lapse of Time* (New York: Noonday Press/Farrar, Strauss, Giroux [1992], 1994), 54–62.

35. See note 33.

36. Schnackenberg, "The Resurrection," in *A Gilded Lapse of Time,* 83–86. For the legend of the aged, blind Piero, see Berto degli Alberti, "Codicetto di memorie," in Battisti, 2: 642.

37. Schnackenberg, "Soldier Asleep at the Tomb," in *A Gilded Lapse of Time,* 54, 58.

38. Berenson, 110; Clark, 57.

39. Charles Wright, "Giorgio Morandi," in *Writers on Artists,* ed. Daniel Halpern, 270.

40. Correspondence with the poet, 2 December 1998. See also Wright's reference to Piero's *Resurrection* in "Tattoos," published in *Country Music: Selected Early Poems* (Hanover, NH, and London: Wesleyan University Press and University Press of New England, 1991), no. 7, p. 63.

41. Charles Wright, "With Eddie and Nancy in Arezzo at the Caffe Grande," in *Chickamauga* (New York: Noonday Press/Farrar, Straus, Giroux, 1995), 71.

42. Cole, 77. See also Ronald Lightbown, *Piero della Francesca* (New York: Abbeville Press, 1992), 193.

43. Jorie Graham, "San Sepolcro," in *Erosion* (Princeton: Princeton University Press, 1983), 2, 3.

44. Clark, 57, 54. See also Lightbown, 193, who notes that Piero was working within an established visual tradition of the Madonna of childbirth, though only rare examples survive.

45. W. B. Yeats, "The Second Coming," in *Selected Poems and Two Plays,* ed. M. L. Rosenthal (New York, [1962] 1970), 91.

46. Michael Ondaatje, *The English Patient* (New York: Vintage/Random House, 1992). The passages in this essay have been quoted from chapter 3, 69–72.

47. Among those scholars actually assigned to protect Italian art and "billeted with the troops" were art historians Frederick Hartt and Sydney Freedberg. Among the treasures they protected was Bernard Berenson, who chose to remain at his villa in Tuscany for the war's duration. Hartt and Freedberg, in the tradition of Berenson, have shed light on Piero and Raphael, respectively, in the company of writers on the visual arts Kenneth Clark and, later, Paul Barolsky, as well as poets Herbert, Strand, Graham, Schnackenberg, and Ondaatje.

48. Clark, 75, 76.

49. See note 4. For Plutarch and Simonides on painting as "silent poetry" and poetry as "painting that speaks," as well as Leonardo da Vinci's variations, "mute poetry" and "blind painting," see Norman E. Land, *The Viewer as Poet:*

The Renaissance Response to Art (University Park, PA, 1994), 3–14. On Homer and Dante, see Dante's *Inferno,* Canto IV.

50. Vasari, *Lives,* 295.
51. Eliot, *The Sacred Wood,* 51.
52. See Boime, "Piero and the Two Cultures," as in note 8.
53. Schnackenberg, "A Moment in Utopia," in *A Gilded Lapse of Time,* 121, 124.
54. Graham, "Easter Morning Aubade," in *The Errancy,* 101, and note, 112: "There is no need to recognize Piero della Francesca's 'Resurrection' here, but it provides this particular rendition of the sleep of the soldiers at Christ's grave."

Selected Bibliography

Alpatov, M. "Les fresques de Piero della Francesca a Arezzo: Semantique et stylistique." *Commentari* 14 (1963).

Angelini, Alessandro. *Piero della Francesca*. Florence: Scala, 1985.

Baker, Christopher. "Piero della Francesca's Saint Anthony Polyptych Restored." *Apollo* 138 (October 1993): 257–58.

Baldwin, Robert. "Politics, Nature, and the Dignity of Man in Piero della Francesca's Portraits of Battista Sforza and Federico da Montefeltro." *Source* 6 (Spring 1987): 14–19.

Banker, James R. "Piero della Francesca's S. Agostino Altarpiece: Some New Documents." *Burlington Magazine* 129 (1987): 642–51.

 "Un Documento Inedito del 1432 sull'Attivita di Piero della Francesca per la Chiesa di San Francesco in Borgo San Sepolcro." *Rivista d'arte* 42 (1990): 245–47.

 "The Program for the Sassetta Altarpiece in the Church of S. Francesco in Borgo S. Sepolcro." *I Tatti Studies* 4 (1991): 11–58.

 "Piero della Francesca as Assistant to Antonio d'Anghiari in the 1430s: Some Unpublished Documents." *Burlington Magazine* 135 (January 1993): 16–21.

Barolsky, Paul. "Piero's Native Wit." *Source* 1 (Winter 1982): 21–22.

Battisti, Eugenio. *Piero della Francesca*. 2 vols. Milano: Istituto Editoriale Italiano, 1971; 2nd rev. ed. Milan: Electa, 1992.

Baxandall, Michael. "Truth and Other Cultures: Piero della Francesca's *Baptism of Christ*," in *Patterns of Intention: On the Historical Explanation of Pictures*. New Haven: Yale University Press, 1985.

Beck, James H. "Una data per Piero della Francesca." *Prospettiva* 15 (October 1978): 53.

Bellosi, Luciano. *Una scuola per Piero: Luce, colore e prospettiva nella formazione fiorentina di Piero della Francesca*. Venice: Marsilio, 1992.

Berenson, Bernard. *Piero della Francesca, or the Ineloquent in Art*. New York: Macmillan, 1954.

Bertelli, Carlo. *Piero della Francesca*. New Haven: Yale University Press, 1992.

Borgo, Ludovico. "New Questions for Piero's 'Flagellation.'" *Burlington Magazine* 121 (1979): 547–53.

Borri Cristelli, Luciana. "Il palazzo della Residenza e la Resurrezione di Piero della

Francesca: Documenti," in *Richerche su Piero*. Siena: Università degli Studi, 1989: 7–33.

Borsook, Eve. *The Mural Painters of Tuscany*. Oxford: Oxford University Press, 1980.

Botticelli, Guido, et al. *Il Restauro della Madonna del Parto di Piero della Francesca*. Poggibonsi: Lalli, 1994.

Bridgeman, Jane. "'Belle considerazioni': Dress in the Works of Piero della Francesca." *Apollo* 136 (October 1992): 218–25.

Cappel, Carmen Bambach. "On 'la testa proportionalmente degradata': Luca Signorelli, Leonardo, and Piero della Francesca's De prospectiva pingendi." *Florentine Drawing at the Time of Lorenzo the Magnificent: Papers from a Colloquium Held at the Villa Spellman, Florence, 1992*. Ed. E. Cropper. Baltimore: Johns Hopkins University Press, 1994: 17–43.

Carrier, David. "Piero della Francesca and His Interpreters: Is There Progress in Art History?" *History and Theory: Studies in the Philosophy of History* 26 (1987): 150–65.

Centauro, Giuseppe. *Dipinti murali di Piero della Francesca: La basilica di S. Francesco ad Arezzo, indagnini su sette secoli*. Milan: Electa, 1990.

Centauro, Giuseppe, and Margherita Moriondo Lenzini, eds. *Piero della Francesca ad Arezzo: Atti del convegno internazionale di studi*. Venice: Marsilio, 1993.

Christiansen, Keith. "Piero della Francesca." *Connaissance des Arts* (1980) 1993: 98–103.

Ciera Via, Claudia, and Marisa Emiliani Dalai, eds. *Piero 500 Anni*. Venice, 1995.

Clark, Kenneth. *Piero della Francesca*. 2nd ed. London: Phaidon, 1969.

Cocke, Richard. "Masaccio and the Spinario, Piero and the Pothos; Observations on the Reception of the Antique in Renaissance Painting." *Zeitschrift für Kunstgeschichte* 43 (1980): 21–32.

"Piero della Francesca and the Development of Italian Landscape Painting." *Burlington Magazine* 122 (September 1980): 627–31.

Cole, Bruce. *Piero della Francesca: Tradition and Innovation in Renaissance Art*. New York: HarperCollins, 1991.

Cook, Albert. *Temporalizing Space: The Triumphant Strategies of Piero della Francesca*. New York: P. Lang, 1992.

Cortesia e geometria: Arte malatestiana fra Pisanello e Piero della Francesca. Ed. Pier Giorgio Pasini. Rimini: Editori per L'Arte, 1992.

Cotteri, Luigi, ed. "Piero della Francesca (c. 1420–1492)." *Studi Italo-Tedeschi Deutsch-Italienische Studien* VI (1992).

Dabell, Frank. "Antonio d'Anghiari e gli inizi di Piero della Francesca." *Paragone* 35 (November 1984): 80–94.

"New Documents for the History and Patronage of the Compagnia della SS. Trinita in Arezzo." *Arte Cristiana* 79 (November-December 1991): 412–17.

Dalai Emiliani, Marisa, and Valter Curzi, eds. *Piero della Francesca tra Arte e Scienza*. Atti del Convegno Internazionale di Studi, Arezzo, 8–11 Ottobre, Sansepolcro, 12 Ottobre 1992. Venice: Marsilio, 1996.

Davies, M. *The Nativity by Piero della Francesca*. London, 1945.

Davis, Margaret Daly. *Piero della Francesca's Mathematical Treatises: The "Trattato d'Abaco" and "Libellus de quinque corporibus regularibus."* Ravenna: Longo, 1977.

Demling, Barbara. "The Meeting of the Queen of Sheba with Solomon: Crusade Propaganda in the Fresco Cycle of Piero della Francesca in Arezzo." *Bruckmanns Pantheon* 53 (1995): 18–28.

Dupre, Maria Grazia Ciardi, and Giuliana Chesne Dauphine Griffo. *Con gli occhi*

di Piero: Abiti e gioielli nelle opere di Piero della Francesca. Venice: Marsilio, 1992.

Edwards, Mary D. "Semi-circle and Square in Piero della Francesca's Baptism of Christ: Their Meaning, Their Antecedents and Their Possible Debt to Altichiero." *Santo* 33 (1993): 299–312.

Elkins, James. "Piero della Francesca and the Renaissance Proof of Linear Perspective." *Art Bulletin* 69 (1987): 220–30.

Feudale, Caroline. "The Iconography of the Madonna del Parto." *Marsyas* 6 (1954): 8–24.

Field, J. V. "Mathematics and the Craft of Painting: Piero della Francesca and Perspective." *Renaissance and Revolution: Humanists, Scholars, Craftsmen and Natural Philosophers in Early Modern Europe.* Ed. J. V. Field and Frank A. James. Cambridge: Cambridge University Press, 1993: 73–95.

"Piero della Francesca's Treatment of Edge Distortion." *Journal of the Warburg and Courtauld Institutes* 49 (1986): 66–90.

Focillon, Henri. *Piero della Francesca.* Paris: Armand Colin, 1952.

Franklin, David. "An Unrecorded Commission for Piero della Francesca in Arezzo." *Burlington Magazine* 133 (March 1991): 193–94.

Garibaldi, Vittoria, ed. *Piero della Francesca: Il Polittico di Sant'Antonio.* Perugia: Electa, Editori Umbri, 1993.

Geatti, Laura, and Luciano Fortunati. "The Flagellation of Christ by Piero della Francesca: A Study of Its Perspective." *Leonardo* 25 (1992): 361–67.

Gilbert, Creighton. "New Evidence for the Date of Piero della Francesca's Count and Countess of Urbino." *Marsyas* 1 (1941): 41–53.

"On Subject and Not-Subject in Italian Renaissance Pictures." *Art Bulletin* 34 (1953): 202–16.

"Piero della Francesca's *Flagellation*: The Figures in the Foreground." *Art Bulletin* 53 (1971): 41–51.

Change in Piero della Francesca. Locust Valley, NY: J.J. Augustin, 1968.

Ginzburg, Carlo. *The Enigma of Piero: Piero della Francesca, the Baptism, the Arezzo Cycle, the Flagellation.* London: Verso, 1985.

Goldner, G. "Notes on the Iconography of Piero della Francesca's Annunciation in Arezzo." *Art Bulletin* 56 (1974): 342–44.

Gombrich, Ernst. "The Repentance of Judas in Piero della Francesca's 'Flagellation of Christ.'" *Journal of the Warburg and Courtauld Institutes* 22 (1959): 172.

Gouma-Peterson, Thalia. "Piero della Francesca's Flagellation: An Historical Interpretation." *Storia dell'Arte* 26 (1976): 217–33.

Guillaud, Jacqueline, et al. *Piero della Francesca poete de la forme: Les fresques de San Francesco d'Arezzo.* Paris: Guillaud Editions, 1989.

Hatfield, Rab. "The Tree of Life and the Holy Cross: Franciscan Spirituality in the Trecento and the Quattrocento." In *Christianity and the Renaissance: Image and Religious Imagination in the Quattrocento.* Ed. Timothy Verdon and John Henderson. Syracuse: Syracuse University Press, 1990: 132–60.

Hendy, Philip. *Piero della Francesca and the Early Renaissance.* New York: Macmillan, 1968.

Hessler, Christiane J. "Piero della Francescas Panorama." *Zeitschrift für Kunstgeschichte* 55 (1992): 161–79.

Hoffmann, Joseph. "Piero della Francesca's Flagellation: A Reading from Jewish History." *Zeitschrift für Kunstgeschichte* 44 (1981): 340–57.

Hope, Charles. "In Pursuit of Piero: The Dating of the Madonna della Misericordia and Other Works." *Times Literary Supplement* 4667 (11 September 1992): 16–17.

Janhsen, Angeli. *Perspektivregeln und Bildgestaltung bei Piero della Francesca.* Munich: Fink, 1990.

Jayawardene, S.A. "The 'Trattato d'Abaco' of Piero della Francesca." In *Cultural Aspects of the Italian Renaissance,* Ed. Cecil H. Clough. Manchester: Manchester University Press, 1976: 229–43.

Laclotte, Michel, et al. *Piero della Francesca: Le portrait de Sigismond Malatesta.* Paris: Réunion des Musées Nationaux, 1978.

Lavin, Marilyn Aronberg. "The Altar of Corpus Domini in Urbino: Paolo Uccello, Joos van Ghent, Piero della Francesca." *Art Bulletin* 99 (1967): 1–24.

"Piero della Francesca's *Flagellation:* The Triumph of Christian Glory." *Art Bulletin* 50 (1968): 321–42.

"Piero della Francesca's Montefeltro Altarpiece: A Pledge of Fidelity." *Art Bulletin* 51 (1969): 367–71.

The Flagellation. London: Penguin, 1972.

"Piero della Francesca's Fresco of Sigismondo Pandolfo Malatesta before St. Sigismond." *Art Bulletin* 56 (1974).

"The Antique Source for the Tempio Malatestiano's Greek Inscription." *Art Bulletin* 59 (1977).

"Computers and Art History: Piero della Francesca and the Problem of Visual Order." *New Literary History* 20 (Winter 1989): 483–504.

The Place of Narrative: Mural Decoration in Italian Churches 431–1600. Chicago: University of Chicago Press, 1990 and 1994.

Piero della Francesca. New York: Abrams, 1992.

"Piero della Francesca's Iconographic Innovations at Arezzo." In *Iconography at the Crossroads: Papers From the Colloquium Sponsored by the Index of Christian Art.* Ed. Brendan Cassidy. Princeton, NJ: Princeton University Press, 1993: 139–55.

Piero della Francesca: San Francesco, Arezzo. New York: G. Braziller, 1994.

Lavin, Marilyn Aronberg, ed. *Piero della Francesca and His Legacy.* Studies in the History of Western Art 48. National Gallery of Art, 1995.

Lavin, Marilyn Aronberg, and B. A. R. Carter. *Piero della Francesca's Baptism of Christ.* New Haven: Yale University Press, 1981.

Lenzini Moriondo, Margherita, and Maurizio Seracini. "Le indagini eseguite per determinare lo stato di conservazione e degrado degli affreschi di Piero in S. Francesco ad Arezzo." *Problemi del restauro in Italia: Atti del convegno nazionale tenutosi a Roma nei giorni 3–6 novembre 1986.* Udine: Campanotto, 1988: 265–74.

Lightbown, Ronald. *Piero della Francesca.* New York: Abbeville Press, 1992.

Longhi, R. *Piero della Francesca: La leggenda della Croce.* Milan: Edizioni d'Arte "Sidera," 1951.

Maetzke, Anna Maria, et al. *Piero della Francesca: La Madonna del Parto: Restauro e iconografia.* Venice: Marsilio, 1993.

Maiorino, Giancarlo. "The Legend of Geometry Fulfilled: Abstraction and Denaturalization of Matter in the Paintings of Piero della Francesca and Piet Mondrian." *Gazette des Beaux-Arts* 57 (March 1986): 111–17.

Marin, Louis. "Narrative Theory and Piero as History Painter." *October* 65 (Summer 1993): 106–32.

Marinesco, C. "Echos byzantins dans l'oeuvre de Piero della Francesca." *Bulletin de la Société Nationale des Antiquaires de France* (1952): 192ff.

Martone, Thomas. "Piero della Francesca e la prospettiva dell' intelletto," in *Piero: Teorico dell'Arte.* Ed. Omar Calabrese. Rome: Gangemi, 1985.

"Piero della Francesca's Triumphs of the Duke and Duchess of Urbino." In *Petrarch's Triumphs: Allegory and Spectacle.* Ed. Konrad Eisenbichler and Amilcare A. Iannucci. Ottawa: Dovehouse, 1990: 211–22.

"Piero e Petrarca ad Astra per Virtutibus." *Atti e Memorie della Accademia Petrarca di Lettere, Arti e Scienze* 54 (1992): 223–46.

Meiss, Millard. "A Documented Altarpiece by Piero della Francesca" and "Ovum Struthionis: Symbolism and Allusion in Piero della Francesca's Montefeltro Altarpiece." In *The Painter's Choice: Problems in the Interpretation of Renaissance Art.* New York: Harper & Row, 1976.

Nardi, Antonio. "La Divina Proporzione Nella Pala di San Bernardino di Piero della Francesca." *Notizie da Palazzo Albani* 14 (1985): 7–12.

Naumann, Francis M. "New Light on Some Old Perspective Problems and Piero's Egg for the Dozenth Time." *Iris, Notes on the History of Art* 1 (February 1982): 3–5.

Oertel, R. "Petri de Burgo Opus." In *Studies in Late Medieval Painting in Honor of Millard Meiss.* Ed. I. Lavin and J. Plummer. New York: New York University Press, 1977: 341–51.

Paolini, Maria Grazia. "Precisazioni sul S. Ludovico di Tolosa: Le idee 'spaziali' di Piero." In *Ricerche su Piero.* Siena, 1989: 69–83.

Paolucci, Antonio. *Piero della Francesca: Catalogo completo dei dipinti.* Florence: Cantini, 1990.

Paolucci, Antonio, and Margherita Moriondo Lenzini. *Piero della Francesca.* Florence: Cantini, 1989.

Parronchi, Alessandro. "Ricostruzione della Pala dei Montefeltro." *Storia dell'arte* 28 (1976): 235–48.

"Per la ricostruzione del Polittico di Sant'Agostino." In *Piero teorico dell'arte.* Ed. O. Calabrese. Rome: Gangemi, 1985: 37–48.

Pasini, P. G. "Piero della Francesca nel Tempio Malatestiano." In *Piero della Francesca a Rimini: L'affresco nel Tempio Malatestiano.* Bologna, 1984: 105–19.

Peterson, Mark. "The Geometry of Piero della Francesca." *The Mathematical Intelligencer* 19 (Summer 1997): 33–40.

Piero della Francesca. "L'opera 'De Corporibus Regularibus' di Pietro Franceschi detto Della Francesca, usurpata da Fra' Luca Pacioli." Ed. Girolamo Mancini. *Memorie della R. Accaeamia di Lincei* 14. Rome, 1916.

De Prospectiva pingendi di Piero della Francesca. Ed. Giusta Nicco-Fasola. Florence: Casa Editrice Le Lettere, 1984.

Podro, Michael I. *Piero della Francesca's Legend of the True Cross.* Newcastle upon Tyne: University of Newcastle upon Tyne, 1974.

Poggetto, Paolo Dal, ed. *Piero e Urbino, Piero e I Corti rinascimentali.* Venice: Marsilio, 1992.

Pope-Hennessy, John. "Whose Flagellation?" *Apollo* 124 (1986): 162–65.

The Piero della Francesca Trail. New York: Thames and Hudson, 1992.

Poseq, A. W. G. "Ambiguities of Perspective in the Murals of Piero della Francesca." In *Asaph, Studies in Art History* I. Tel Aviv, 1980: 191–200.

Progetto per Piero della Francesca: Indagini diagnostico-conoscitive per la conservazione della Leggenda della Vera Croce e della Madonna del Parto. Florence: Alinari, 1989.

Ragghianti, Carlo Ludovico. "Il dittico urbinate di Piero dei Franceshi." *Critica d'arte* L/4 (1985): 93–96.

Salmi, M. *Piero della Francesca e il Palazzo Ducale di Urbino.* Florence: Le Monnier, 1945.

La Pittura di Piero della Francesca. Novara: Istituto Geografico De Agostini, 1979.

Sangiori, Fert. "Ipotesi sulla collocazione originaria della Pala di Brera." *Commentari* 24 (1973): 211–16.

Scapecchi, Piero. "Enea Silvio Piccolomini, Piero della Francesca e gli affreschi di Arezzo." *Prospettiva* 32 (1983): 71–76.

Schneider, Laurie. "Piero della Francesca's Polyptych della Misericordia and Divine Maternal Imagery." *Storia dell'Arte* 52 (1984): 157–71.

"The Iconography of Piero della Francesca's Frescoes Illustrating the Legend of the True Cross in the Church of San Francesco in Arezzo." *Art Quarterly* 21 (1969).

"Shadow Metaphors and Piero della Francesca's Arezzo *Annunciation.*" *Source* 5 (1985): 18–22.

Shearman, John. "The Logic and Realism of Piero della Francesca." In *Festschrift Ulrich Middeldorf.* Ed. A. Kosegarten and P. Tigler. Berlin: De Gruyter, 1968.

Sindona, E. "Problemi di prospettiva: Paolo Uccello e Piero della Francesca." *L'Arte* 1 (1980): 7–10.

Solway, Susan. "Piero della Francesca's *Flagellation:* The Rhodian Connection." In *Apochrypha* IV. Ed. Lynne Kirby and Carolyn Cushman. Binghamton, NY: 1980.

Tanner, Marie. "Concordia in Piero della Francesca's *Baptism of Christ.*" *Art Quarterly* 35 (1972): 1–21.

Turchini, Angelo. "The Emperor, the Saint, and the Knight: Notes on Sigismondo Pandolfo Malatesta and Piero della Francesca." *Arte cristiana* 74 (May–June 1986): 165–80.

Ugolini, Guido. "L'Architettura nella Pala di San Bernardino." *Notizie di Palazzo Albani* 11 (1982): 36–41.

Vajer, Lajos. "Problemi iconologici nel ciclo di affreschi di Piero della Francesca ad Arezzo." *Arte cristiana* 78 (1990): 737–39.

Van Egmond, Warren. "A Second Manuscript of Piero della Francesca's Trattato d'Abaco." *Manuscripta* 24 (1980): 155–63.

Vecchi, Pierluigi de. *The Complete Paintings of Piero della Francesca.* Intro. Peter Murray. New York: H.N. Abrams, 1967.

Verdon, Timothy. "Symbol and Subject in Piero's Baptism of Christ." In *Musagetes: Festschrift fur Wolfram Prinz zu seinem 60. Geburtstag am 5 Februar 1989.* Ed. Ronald G. Kecks. Berlin: Mann Verlag, 1991: 245–53.

Waadenoijen, Jeanne van. "La Flagellazione di Piero della Francesca." *Arte Cristiana* 81 (May–June 1993): 183–98.

Welliver, Warman. "The Symbolic Architecture of Domenico Veneziano and Piero della Francesca." *Art Quarterly* 36 (1973): 1–30.

"The Flagellation of Christ and the Brother of the Duke of Urbino and Two Councilors." *Gazette des Beaux-Arts* 81 (1973).

Wittkower, Rudolph, and B. A. R. Carter. "The Perspective of Piero della Francesca's 'Flagellation.'" *Journal of the Warburg and Courtauld Institutes* 16 (1953): 292–302.

Wohl, Hellmut. "In Detail: Piero della Francesca's Resurrection." *Portfolio* 3 (March–April 1981): 38–43.

Index

Page and plate numbers in *italics* indicate illustrations.